MW00995843

Art and Revolution

John Richard Cooper

Denton, Texas

24 May 2016

SEMIOTEXT(E) ACTIVE AGENTS SERIES

Originally published as: Kunst und Revolution. Künstlerischer Aktivismus im langen 20. Jahrhundert, Wien: Turia+Kant 2005

Published by Semiotext(e)
2007 Wilshire Blvd., Suite 427, Los Angeles, CA 90057
www.semiotexte.com

Special thanks to Sarah Wang and Andrew Berardini.

The Index was prepared by Andrew Lopez.

Cover Photograph by Jürgen Schmidt
Design by Hedi El Kholti

ISBN-10: 1-58435-046-6
ISBN-13: 978-1-58435-046-0

Distributed by The MIT Press, Cambridge, Mass. and London, England
Printed in the United States of America

10 9 8 7 6 5 4 3 2

Art and Revolution

Transversal Activism in the Long Twentieth Century

Gerald Raunig

Translated by Aileen Derieg

\<e\>

Contents

The Concatenation of Art and Revolution

"…to say the revolution is itself utopia of immanence is not to say that it is a dream, something that is not realized or that is only realized by betraying itself. On the contrary, it is to posit revolution as plane of immanence, infinite movement and absolute survey, but to the extent that these features connect up with what is real here and now in the struggle against capitalism, relaunching new struggles whenever the earlier one is betrayed."

— Gilles Deleuze/Felix Guattari[1]

"In this short article I could sketch only with a couple of strokes the peculiar zigzag line of the relationships between revolution and art that we have hitherto observed. It has not been broken off. It continues even further."

— Anatoly Lunacharsky[2]

IN THE LONG ECHO of a revolution, Richard Wagner and Anatoly Lunacharsky each wrote their texts about the "zigzag line of the relationships between revolution and art." In 1849, in the wake of the failed bourgeois revolution in Germany, Wagner sketched "Art and the Revolution,"[3] and about seventy years later Lunacharsky—

influenced by the first experiences of post-revolutionary cultural policies following the successful October Revolution—published the two sections of his short article "Revolution and Art"[4] as the powerful Commissar for Education and Enlightenment. The two titles evince a minimal and yet significant variation of the concatenation of art and revolution reflecting the contrary ideological positions of the two authors. For Wagner revolution seems to follow art, for Lunacharsky art follows the revolution: on the one side there is the royal court conductor of Saxony and proponent of the *gesamtkunstwerk* Wagner, whose later nationalist, chauvinistic and anti-Semitic tirades were to make him a useful point of reference both aesthetically and politically for National-Socialist ideology; on the other Lunacharsky, member of the government for twelve years under Lenin and Stalin until 1929, an important figure especially in the early years of the Proletkult for the development of cultural policies in the Soviet Union.

The preconditions could hardly be more different, and yet the two texts converge in several paradigmatic aspects due to specific biographic as well as to structural similarities in the cultural-political strategies of the two very different authors. In the years around 1848, under the vague influence of the ideas of Proudhon, Feuerbach and Bakunin, Wagner included diffuse revolutionary tones beyond his tight, mostly musical theory radius of reflection. Lunacharsky's attitude developed in attempting to bridge the gap between the utilization of art already brought up by Lenin on the one hand, and the radical left-wing experiments of the leftist Proletkult wing on the other, into a strangely conservative position, which blocked not only socialist innovation, but also placed itself vehemently before the cultural heritage of bourgeois society. Against this backdrop of the ambivalence, volatility and diffusiveness

of both positions, it is understandable that there is a certain degree of congruence in the two very different texts, especially where they are most relevant for our considerations here.

Wagner wrote "Art and the Revolution" in 1849, the year of his exile in Zurich following the failure of the Dresden Revolt, in which he had played a certain role, not only as a writer.[5] Starting from the "lament of our modern artists and their hatred for the revolution," the essay was intended to provide "a brief survey of the outstanding moments of European art history," and despite the defeat in Dresden Wagner still clung to ideas and the concept of the revolution. In 1848/49, however, a certain oscillation in his position was already noticeable: Wagner's stance, which was even in revolutionary times clearly focused on the conditions of art production and on reforming the administration and financing of art, ranged from radical democratic demands on the one hand to more moderate visions of restoration and reconciliation with the German princes on the other.

According to Wagner, the "thousand-year long revolution of humanity," which he said also crushed the Greek tragedy together with the Athenian state, had now, at the time of writing his essay on revolution, created a situation that first made the artwork of the future possible. According to Wagner, art was to be understood as "social product," and more precisely as a "faithful mirror image" of the "dominant spirit of the public." Accordingly, the dissolution of the Athenian state corresponds to the downfall of the "great *gesamtkunstwerk* of the tragedy." An artwork, which would be able to encompass "the spirit of free humanity beyond all limitations of nationalities," could not emerge from contemporary society and art as an "industrial institution." The drama as perfect art work could only be reborn from revolution: "True art can only rise up from its state of civilized barbarism to its dignity on the shoulders of our

great social movement." Wagner's attitude, swaying between cultural pessimism and revolutionary pathos, although not yet ultimately decided in its tendency toward totality and authoritarianism, already moved him to grand pronouncements in 1849. "Only the great *revolution of humanity*, the beginning of which once crushed the Greek tragedy, can attain for us this art work, because only the revolution can newly and more beautifully, nobly, generally give birth from its greatest depths to *that*, which it snatched from the conservative spirit of an earlier period of more beautiful—but limited—education, and devoured."[6]

Anatoly Lunacharsky wrote his article, "Revolution and Art," in two steps, the first part in 1920 as a newspaper article, the second as an interview on the occasion of the fifth anniversary of the October Revolution. This means that the text was produced in a period that was no longer permeated by the fresh energy of the Russian Revolution, but in which the terminology and programs of this initial phase continued to be characteristic. For Lunacharsky, in the conventional diction of the revolutionary context, bourgeois art is initially denigrated as formalistic, as having "advanced merely a whimsical and absurd eclecticism." Revolution, on the other hand, "is bringing ideas of remarkable breadth and depth." For this reason—and Lunacharsky is still writing futuristically here in 1920—the highest cultural politician of the Soviet Union anticipates "a great deal from the influence of the Revolution on art, to put it simply: I expect art to be saved from the worst forms of decadence and from pure formalism." Conversely, art is defined as a means of revolution, particularly because of its function in agitating the masses and as the appropriate form of the expression of revolutionary policies: "If revolution can give art its soul, then art can give revolution its mouthpiece."[7]

Lunacharsky and Wagner thus begin their analyses from extremely different experiences, standpoints and even concepts of revolution, yet surprising points of congruence are recognizable. Most of all, there are two figures that they have in common, which not only come up in both texts, but generally represent dubious twins in the different conceptualizations of the relationship between art and revolution.

For texts propagating the concept of "revolution" in their titles, the first figure is the surprisingly profane question of the *function and financing of art,* which characterizes both texts as belonging to the genre of *art policies.* Contrary to the general tendency of his essay, namely that only revolution engenders the art of the future, Wagner proposes, especially toward the end of his text, recognizing a sense of art production even in bad reality, that real art is revolutionary precisely because it "exists only in opposition to valid generality."[8] Instead of being anchored in the "public consciousness," it exists specifically in opposition to this, only in the consciousness of the individual: "The real artist, who has even now taken the correct stance, is thus even now capable of working on this art work of the future, as this stance is indeed truly eternally present."[9] The artist, indeed the "real artist," thus seems for Wagner to represent the medium of the transition from the bad status quo to future aspirations.

Since Soviet society after the revolution regarded itself altogether as a society of transition, it might be expected that something similar to Wagner's idea of art would have to apply to this society as a whole, that art on the other hand would be affirmed as "conservative" or simply become obsolete. Yet in his article Lunacharsky describes how art is still needed in the transition to socialist society, in order to animate and promote

revolutionary contents. The state needs art, he maintains, for agitation, because its form has the advantage of quasi-synaesthetic effects over other forms: "Agitation can be distinguished from propaganda by the fact that it excites the feelings of the audience and readers and has a direct influence on their will. It, so to say, brings the whole content of propaganda to white heat and makes it glow in all colors."[10]

This kind of foundation for the social significance of art both *before* (Wagner) and *after* the revolution (Lunacharsky) prepares the ground for the somewhat more trivial question of resources for art production. Even though Wagner rejects the complaint that artists have ended up impoverished particularly due to the revolution, just as he describes future art as self-sustaining ("*this* art does not follow *money!*"), once art practice has become established as socially relevant—and what could be more relevant than the revolution?—calls for its material support can be put forth in the next step. "Let us begin…with the liberation of public art, because, as I suggested above, an incredibly high task, a tremendously important activity in our social movement is assigned especially to art." The goal of this kind of "liberation"—as Wagner unceremoniously explains—would be most quickly reached by "liberating" art from "the necessity of industrial speculation," and if the state and communality would decide to "recompense the artists for their achievements as a whole, not as individuals."[11]

Similarly Lunacharsky regrets the cultural-political effects of the turn in Lenin's economic policies strategy, the New Economic Policy, which led in 1921 to the situation that the state "virtually ceased buying and ordering" art "…and in fact, we can see, almost side by side with the complete disappearance of the agitational theater, the emergence of a corruptive theater, the emergence of the

obscene drinking place, which is one of the poisons of the bourgeois world."[12] This kind of perennially contemporary-sounding criticism of the "return to a miserable once-upon-a-time," however, also according to Wagner could be prevented by support by the state: "If you upright statesmen are truly concerned to instill the turnover of society that you pursue...with a vital pledge for a future, a most beautiful civilization, then help us with all your powers...."[13] And as though this topos were a universal one transcending the boundaries of bourgeois and socialist society, Lunacharsky also affirms the desire toward the state: "If our calculations are correct, and they are, then will the state, like a capitalist, with its heavy industry and vast trusts in other branches of industry, with its tax support, with its power over issue of currency, and above all, with its vast ideological content—will the state not prove ultimately to be far stronger than any private capitalists, big or small? Will it not draw unto itself all that is vital in art, like a grand Maecenas, truly cultured and truly noble?"[14]

Both positions, that of the "leftist right-winger" Wagner and that of the "right-wing leftist" Lunacharsky, are not without a certain peculiarity: whereas Wagner, after a failed revolution and flight, paradoxically applies to the heads of state by the roundabout way of art for the means for a new revolution, as a high-ranking member of the government Lunacharsky seeks impotently to invoke the state as a patron of the arts. In the framework of writing to legitimize art policies it is not unusual that "cultural" particular interests (enriched with the pathos of revolution) present themselves as universal, but Wagner and Lunacharsky are early and striking high points here.

Beyond narrowing the relationship between art and revolution to financial issues, there is a second, almost contrary figure in

Wagner's and Lunacharsky's texts, which also frequently recurs all the way up to the present: the topos of the *totalizing confusion of art and life*. The spread of art to the streets, to the masses, into life, slogans like "everyone is an artist," "art for everyone" and "from everyone," transgressing the boundaries of art into the social field and the political field—none of these are the invention of the avant-garde of the 20th century, of Beuys' generation or of the cultural policies of the 1970s, but they are instead, so to speak, trans-historical patterns of art practice and politics: Tragedies would become celebrations of humanity, asserts Wagner, education in a free society must become a purely artistic education, "...and every man will become in some respect truly an artist."[15] For Lunacharsky, in mass celebrations encircling all arts, art becomes "the expression of national ideas and feelings."[16]

In art-political fantasies of totality, as both authors tend to propound, not only the merging of all art genres into a total *gesamtkunstwerk* is called for, but the integration of "the masses of the people"—still within a cultural framework to begin with—is also tested. Contrary to the contemporaneous experiments of the left-wing Proletkult to politicize the theater—from the Theater of Attractions to the relocation of the performances to the factories[17]—the aestheticization of the political is echoed in Lunacharsky's enthusiasm for the "overall action" of the mass spectacle, which necessarily produces effects of hierarchization, structuralization and totalization. At an early stage and in a striking formulation, Walter Benjamin pointed out not only this instrumental relation between the aesthetical and the political, but in the first version of the "Art Work" essay he had already called attention to the fascist attempts at aesthetical mass organization and stressed that especially the mass reproduction of the reproduction

of masses particularly accommodates the fascist strategy of aes-theticizing political life: fascism gives these masses not their right, but instead a chance to *express* themselves.[18]

This is precisely what is at stake when "integrating" the masses by means of art, not just from Riefenstahl to contemporary mass productions, but already in Wagner and Lunacharsky's concepts. This kind of integrative conjunction of masses and art does not engender assemblages of singularities, nor organizational concate-nations seeking to change production circumstances. Instead it deletes differences, territorializes, segments and striates space, achieving a uniformity of the masses through the means of art. In his essay, Lunacharsky even expresses his enthusiasm for this kind of unification endeavor in the spirit of world peace: "And just think what character our festive occasions will take on when, by means of General Military Instruction, we create rhythmically moving masses embracing thousands and tens of thousands of people—and not just a crowd, but a strictly regulated, collective, peaceful army sincerely possessed by one definite idea."[19] Some ten years later, particularly against the background of the success of fascist mass events, Benjamin wrote tersely: "All efforts to render politics aes-thetic culminate in one thing: war."[20] And Wagner's idea of a totalizing confusion of art and life takes exactly that track—also as a precursor of later totalitarian concepts: "The tragedies will become celebrations of humanity; freed from every convention and etiquette, the free, strong and beautiful human being will celebrate the delights and the pains of his love in them, carrying out the great sacrifice of love with his death in dignity and sublimeness."[21]

Contrary to models of totally diffusing and confusing art and life, this book investigates other practices, those emerging in neigh-boring zones, in which transitions, overlaps and concatenations of

art and revolution become possible for a limited time, but without synthesis and identification. In the course of investigating exemplary practices, which differ not only from the figure of diffusion but also from that of synthesis, we find models of the sequence, the hierarchy and the unconnected juxtaposition of art and revolution. These kinds of *sequential* practices, from Gustave Courbet's stormy metamorphosis from artist to (art) politician in the Paris Commune to the continuous passage of the Situationist International from the art field into the political field, can already be taken as plans that are contrary to the pattern of art/life synthesis. The same is true for the presumed subordination, the *hierarchy* of revolution and art in the Soviet Proletkult, or the incommensurable *juxtaposition* of art and revolution, as it occurred in the collision between the Viennese Actionists and the student activists in 1968 as a *negative concatenation*.

Yet, what is beyond these kinds of sequences, hierarchies and juxtapositions are the temporary overlaps, micropolitical attempts at the *transversal concatenation* of art machines and revolutionary machines,[22] in which both overlap, not to incorporate one another, but rather to enter into a concrete exchange relationship for a limited time. The way and the extent to which revolutionary machines and art machines work as parts, cogs of one another is the most important subject of investigation in this book. The aspects of overlapping, as examined in the chapters on the basis of historical examples, refer to a tendency, a virtuality, a more-or-less, yet without dispersing into the fields of fiction and utopia. The concatenation of revolutionary machines and art machines is actualized in more or less well developed forms in the practices that are analyzed here. In some cases the overlapping remains murky or fragmentary, sometimes it is only a potentiality. Yet even where the

rapprochement of art and revolution fails, traces of the overlap can still be recognized.

This persistent element of failure is due to difficult conditions at different levels. Artistic activism and activist art are not only directly persecuted by repressive state apparatuses because they operate in the neighboring zones of art and revolution, they are also marginalized by structural conservatisms in historiography and the art world. As a consequence of the reductive parameters of these conservatisms, such as rigid canons, fixation on objects and absolute field demarcations, activist practices are not even included in the narratives and archives of political history and art theory, as long as they are not purged of their radical aspects, appropriated and coopted into the machines of the spectacle. In order to break through mechanisms of exclusion like these, the as yet missing theorization of activist art practices not only has to avoid codification inside and outside the conventional canon, it also has to develop new concept clusters in the course of its emergence and undertake to connect contexts not previously noticed in the respective disciplines.

For this philosophical and historiographical project of analyzing and problematizing the concatenation of revolutionary machines and art machines, a (dis-) continuity could be imagined, which persistently eludes every narrative of an origin. This is certainly a history of currents *and* bridges, outside the realm of flat notions of linear progress or a movement from one point to another. As the overlaps of art and revolution can not at all be described as a linear learning process, but have always engendered new attempts (and often similar "aberrations" as well) in new situations, the exposition of these attempts is in no way indebted to a historical philosophical concept of linear progress. The aim is to break

open the constructed continuum of a homogeneous time, not to compound the catastrophes—as which the progressive accumulation of the rubble of the past appeared to Benjamin's "Angel of History"—with the reiteration of violence that makes up the methods of historicist, objectivistic historiography. Neither filling an empty, homogeneous time with objective facts nor a pure theory of emergence are to be promoted here; instead the present becomings of revolutionary machines are to be associated with a suitable singular "tiger's leap into the past" "in the open air of history."[23]

Since pragmatic reasons nevertheless suggest providing this investigation with a beginning and an end, I decided to utilize an operative periodization, which I would like to call the "long 20th century."[24] Although the majority of historians have characterized this century as "short,"[25] due to massive ruptures in the 1910s (World War I and the October Revolution) and the erosion of socialist societies in the 1980s and 90s, from the perspective of a poststructuralist theory of revolutionary micropolitics it is evident that, on the contrary, this century virtually bursts its temporality. Positing the "long 20th century," however, also involves ruptures, which have specifically not fixed this century exclusively as one of the battle between fascism and communism, between capitalist and socialist forms of society, ultimately as a teleology of the capitalist victory. It does not revolve around the major key facts between two molar powers, but rather the molecularity and singularity of events, which have produced various phenomena of the approximation, referencing and overlapping of aesthetic and political strategies.

The long 20th century of specific concatenations of art and revolution covers 130 years. It begins—as posited in this book— with the struggles of the Paris Commune of 1871 and ends—provisionally and mainly operatively from the perspective of

the investigation—in the turbulent summer of 2001 and the counter-globalization protests against the G8 summit in Genoa. As with all delimiting definitions of processual phenomena, it is just as easy to argue about the issues selected here as about the choice of art practices that are discussed, to which other authors might add different practices. With the molecules of my book, however, I would like to focus on specific lines, of which the singular specificity and their more or less explicit conjunctions and similarities should become evident in the course of the text. Even though the search for successful concatenations of art and revolution is inherent to these lines, this is by no means intended to pave the way for revolutionary romanticism or heroic legends of artists. No history of revolutionary transgression can compensate for Gustave Courbet's lonely end in Switzerland or Franz Pfemfert's in Mexican exile, for the execution of Sergei Tretyakov in a Siberian gulag, for the criminalization and media persecution of the participants in the action "Art and Revolution" in Vienna, for the death of the Italian activist Carlo Giuliani and the mistreatment not only of members of the PublixTheatreCaravan in prisons around Genoa, for the women of the Paris Commune who were raped, sentenced to death or deported by the tribunals of the counter-revolution, not to mention the ten thousand dead in the Bloody Week of Paris.

Examining the neighboring zones of revolutionary machines and art machines can thus not be undertaken without reference to the recurring figures of more or less tragic failure and unequivocal disaster. Nor can it overlook the constantly immanent possibility of the "revolutionary schizoid flows" tipping into "fascist paranoid formations."[26] Richard Wagner's ambivalence as a revolutionary and anti-Semitic propagandist may be an example here, another is the turn of a considerable number of German radical leftists after

1968 to various right-wing and radical right-wing niches.[27] In their appendix to *Anti-Oedipus* Deleuze and Guattari[28] particularly stress the two extreme poles of the desiring-machine between revolution and fascism and the difficulty of disentangling these extremes. Regarding the forms of exchange and connections between revolutionary machines and art machines, Deleuze/Guattari examine this problem on the basis of the most important avant-garde currents of the 1910s, specifically by proposing a distinction between four attitudes to machines exemplifying possible concatenations of art and revolution and their various types of failure in marginalization or political perversion.

According to this approach, Italian Futurism focuses on the machine to increase national productive forces and create the national new human being. Whereas what is new about this "new human being" is primarily determined by a radically affirmative relationship to the machine as a mechanism, the machine as a social assemblage is largely ignored (or determined by sexism, chauvinism, nationalism, bellicism). Indifference to all content seemed to make Italian Futurism open for every possible ideology;[29] nevertheless, due to a certain omission, namely the non-problematization of production conditions, which remained just as external to the technical machines as to the fantasized "a-human," "mechanized man," Futurist practices created organizational conditions for a fascist desiring-machine, as well as for nationalist and militarist lines of argumentation among the (pseudo) left-wing.

According to Deleuze/Guattari, humanist anti-machinism includes Surrealism (counter to Dadaism) and Charlie Chaplin (counter to Buster Keaton); in the present investigation this current is covered by Kurt Hiller's post-expressionist "Activism/Spiritism." Humanist anti-machinism seeks to salvage desire in the midst of a

mesh of alienation felt to be total, and to turn this *against* the machine. In the process, however, it largely remains caught in the pathos of the spectacular representation of revolutionary ideas and revolutionary tendencies without taking technology and its own position in the production conditions into consideration. Roughly speaking, it thus opposes the a-human formalist ambitions of Italian Futurism with a fixation on content or with psychologism, but as its mirror image. At the same time, it supplies the capitalist production apparatus with desire, but without changing its form.[30]

In comparison, Russian Futurism, Constructivism and Productivism address the conditions of production and envision the machine in the context of new production conditions determined by collective appropriation. However, the extent to which production conditions continue to remain external to the machine here as well (as Deleuze and Guattari allege, although I disagree), only becomes evident in a more precise analysis of post-revolutionary art practices in the early Soviet Union. Between the Cubist and Suprematist works, the early variations of Socialist Realism and the Production Art of the leftist Proletkult wing, there is a broad field of very different strategies, also in terms of overcoming the mechanisms of the art field and various methods of becoming-machine on the part of the recipients. Intensive attempts to organize the participants and involve the audience in the production of the art machine distinguish at least the radical leftist protagonists of the Proletkult, who later dropped out of both Soviet and "western" art history, from earlier avant-gardes. Especially the Agit-Theater of Attractions investigated new links of human-machine, technical machines and social machines.[31] With all its utilitarian ambitions and all the technicism of a "Theater of the Scientific Age," here the production conditions are understood as being immanent to the

machine. Since the theater people subordinated (had to subordi-nate) the machine to the Soviet state apparatus, however, it was—and here I follow Deleuze/Guattari again—successively appropriated, controlled and crushed by this apparatus.

The molecular Dadaist machine, finally, subjected production conditions to an examination with the desiring-machine, igniting a cheerful deterritorialization beyond all territorialities of nation and party with its anti-militarist, internationalist, anarchic prac-tice. As long as it undertook this risk within the framework of the strongest attacks on art and under threat of beatings or forced labor for artists specifically within the manageable and limited spaces of art, it remained successful. Yet when it attempted to transgress the boundaries into the political field, it failed, because "politics is not the strongest facet of the Dadaists."[32]

Following this problematization of the various machine quali-ties of the four most important avant-garde currents of the 1910s by Deleuze and Guattari, one could assume that it is easier to find connections between art and revolution on the side of "fascist para-noid formations." Against this background—and on the basis of structurally founded lacunae and omissions in art historiography with regard to political aspects—there is a strong need for inter-weaving political aesthetics and a post-structuralist theory of revolution and for illuminating the other pole: to examine the endeavors more closely, which in one way or another could be called, in Deleuze/Guattari's sense, "revolutionary flows."[33]

The Three Components of the Revolutionary Machine

"It is time to ask ourselves whether there does not exist, from a theo-
retical and practical point of view, a position which avoids absorption
within the opaque and terrible essence of the State. In other words,
whether there does not exist a viewpoint which, renouncing the
perspective of those who would construct the constitution mecha-
nistically, is able to maintain the thread of genealogy, the force of
constituent praxis, in its extensivity and intensity. This point of view
exists. It is the viewpoint of daily insurrection, of continual resistance,
of constituent power." — Antonio Negri [1]

IN ORDER TO MORE FULLY EXPLORE the concatenation of art and
revolution up to the present, an updated concept of revolution is
developed here, which evades the narratives of the major ruptures,
particularly of the French and Russian Revolutions, but which ties
into the diversity of constituent and revolutionary practices of the
19th and 20th century. From this perspective there is little signifi-
cance left in the lines of argumentation that learned nothing from
Karl Marx's insight from 1871 that all revolutions "only perfected
the State machinery instead of throwing off this deadening
incubus." [2] Hence this study concentrates on the discursive and

activist lines that have regarded revolution as an uncompleted and uncompletable, molecular process, which does not necessarily refer to the state as being essential and universal, but rather emerges before the state, outside the state. Following Antonio Negri, the post-structuralist theory of revolution that is to be developed here proposes the revolutionary machine as a triad. The three components of the revolutionary machine, as far as they can be clearly distinguished in the analysis, are mutually differentiated and actualized in relation to one another. Their partial overlapping determines the consistency of both the occurrence and the concept of revolution. The revolutionary machine continuously runs through its components, insurrection, resistance and constituent power.

THE ONE-DIMENSIONAL REVOLT AS TAKEOVER OF THE STATE APPARATUS

"In contradiction to the police interpretation, which views the revolution exclusively from the standpoint of street disturbances and rioting, that is, from the standpoint of 'disorder,' the interpretation of scientific socialism sees in the revolution above all a thorough-going internal reversal of social class relations." — Rosa Luxemburg [3]

THE MASSES OF THE FEBRUARY REVOLUTION were given their protagonist in April 1917, when the revolution was re-imported from Zurich through Germany to Petersburg in a sealed train carriage in the person of Lenin. For his part Lenin, who had lived for several months in the Spiegelgasse in Zurich across from the Cabaret Voltaire and did not particularly appreciate the vociferousness of Dadaist excesses, was

given a chance to become involved in revolutionary events, first in the July Revolt, then in the October Revolution. With the storming of the Winter Palace in Petrograd on October 25, 1917, the way was clear for the Bolsheviks, who carried out the Great Socialist Revolution.

There is little truth in this briefly summarized plot of a dramatic revolution film and its heroic protagonists, and it would be equally impossible to adequately depict the rich discursive structures and the diversity of revolutionary actions of the decades before and after this in any kind of form. Nevertheless, this or a similar account has provided the foil for thousands of revolutionary narratives: those that produced socialist spectacles in the re-stagings of October 25th, those that sought to promote the subversive role of Germany in fanning the Russian Revolution, those that attempted to erase Trotsky as the military organizer and Lenin's congenial partner from the history books, or those that were simply launched by simpler minds without access to the more complex and longer lasting revolutionary processes.

The course of the Russian Revolution and its later interpretations have marked the ideas of a successful revolution more than all the other rebellions, uprisings and revolts and more than the conventional theories of revolution as well, yet they have also paralyzed these ideas at the same time. It seems as though the moving images of revolution were halted with the Leninist rupture of 1917, and the terms, interpretations and fantasies of revolutionary movement were fixed for some time. The long, uninterrupted movement that is already present in the Latin word *revolvere*, revolution as a constant turning of the circumstances, as in Virgil's image of the rising and falling of the ocean, and that has resurfaced in modern applications of the term revolution in astronomy as a revolving motion of the stars,[4] this irresistible processual meaning of the term revolution is lost in the fixation on the image of the major rupture.

As different and sometimes mutually contradictory as their theories may be, the icons of the revolutionary movements of the 19th and 20th century also strangely agree on a common goal, although what they have in common is what limits this goal at the same time: the one-dimensional constraint of the revolution to a single point, the idea of revolution as the takeover of state power. Revolution is thus reduced to the process of taking power as an armed revolt, through which the monopoly of state power is to be transferred to other, "better" hands. Only a few saw that taking over the increasingly autonomized state apparatus would be counterproductive for revolutionary goals, but one of these few was Marx in his analysis of France in the first half of the 19th century: "Each overturn, instead of breaking up, carried this machine to higher perfection. The parties that alternately wrestled for supremacy looked upon the possession of this tremendous governmental structure as the principal spoils of their victory."[5] Although Marx already problematized the takeover of the state apparatus as early as 1852, it remains the simplistic recipe behind the most diverse Marxist-Leninist discourses of the 20th century: the core of revolution overshadowing all else is to take over the state to create a new society *afterward*.

Much has already been written about this kind of one-dimensional concept and its aspects, from the centralist organizational form of the (avant-garde) party to the modes of subjectification of class-aware or organic intellectuals as the mediators of the liberation of *others*. Here, however, two mutually correlative aspects of these strategies of constraint are to be emphasized particularly: first of all the linear, teleological idea that posits the various components of the revolutionary machine as phenomena like points on a timeline that are clearly distinguished from one another in a

temporal *sequence*, placing them in a model of one after another and thus producing, most of all, a hierarchy of the components; and secondly the problematic stance that seeks to improve the state apparatus simply with new *persons* and *contents*, without fundamentally changing or renewing its form and thus fundamentally questioning the state *form*.

"La théorie des étapes est ruineuse pour tout mouvement révolutionnaire," wrote Gilles Deleuze,[6] referring primarily to Lenin's instructions in "State and revolution:" to allow mass spontaneity in a first phase, riding on this wave of spontaneity to the point of upheaval in order to introduce an even greater centralization in a post-revolutionary phase; first a grassroots democracy and mobilization through the councils, then violent revolt, then the dictatorship of the proletariat (with the vaguely remote horizon of the "death of the state").[7] A pre-revolutionary party functionary can invent this kind of phase model on the drafting table, putting the components of the revolutionary machine into a planned and seemingly necessary sequence. And as the course of the Russian Revolution has shown, it is not impossible to successfully put this sequence into action in reality, in a sense. Yet what is also evident in the concrete development of the Soviet Union is that it is precisely the introduction of this kind of phase model that anticipates and fixes power relations, increasingly measuring the success of the revolutionary process with the event of civil war and the takeover of the state apparatus, which ultimately effects an elimination of all the other components.

In Deleuze/Guattari's political theory that is counter to all phase-type concepts of revolution, the concatenation of the components of the revolutionary machine in neighboring zones is not taken to be linear. The components are neither absolute alternatives

that could be pitted against one another, nor are they to be idealized in a phase model of initially justified spontaneity, followed by centralization, and then purportedly at some later point (in fact never) by a decentralization of the organization and dispersion of the program into society. They can be assessed separately in the analysis, if need be, but in fact the components form a constantly moving assemblage, where before and after, beginning and end are irrelevant. The revolutionary machine does not function by starting from an origin, moving through a sudden break to a different end. It moves across and through the middle, through a rampant and lasting middle, where things pick up speed. This movement *across the middle* means, most of all, that it does not go from one point to another, from one realm into the next, or from the here and now of capitalism to the hereafter of socialism. On the contrary, no hereafter can be imagined at the plane of immanence of the revolutionary passage, no transition to socialism or anywhere else, no notion of stages or phases of revolution, no linear progression from one revolutionary stage to the next.

What was played through in the variant of the Russian Revolution and has been frequently badly copied since then, has proved least promising of success: the attempt to use a *political party*, whose organizational setup is oriented in form and goal to take over the state, to create a new society after coming to power. Yet, in the establishment of a party a power is already constituted, which excludes every constituent power. The constituted power of the party sets the condition of the impossibility of allowing a renewing, constituent power to emerge from it. The party is created to take part in the state apparatus or to take it over. Due to the mutual conditioning of a fixation on the party and the state, the

search for alternative forms of organization and organizing is often overlooked. "The theoretical privilege given to the State as an apparatus of power to a certain extent leads to the practice of a leading and centralizing party which eventually wins State power; but on the other hand, it is this very organizational conception of the party that is justified by this theory of power."[8]

The affirmation (sometimes even worship) of the state form is not only a fundamental problem of the left, it is also a recurring one in historical experience. Far more energy has been and still is expended to satisfy the desire to take over the state than in searching for and trying out alternatives to the state form. Revolutions as the takeover of the nation-state form a powerful aspect of historiography, which overruns practices not fixed on the state—such as that of anarcho-syndicalism, the soviets and the various council movements or the Yugoslavian experience of self-management—in a twofold way: first of all by imposing constituted power counter to constituent power and subsequently by banning alternatives to constituted power from the narratives.

Where socialist takeovers took place, there was no trace of a fundamental change in the organizational forms. Yet an offensive practice generating something different from copies and variations of what already exists can only be invented by permanently revising the forms of organization, constantly opening social structures and defending them against closure. Forestalling structuralization in the state apparatus is—in Félix Guattari's terminology—a matter of inventing machines that fundamentally elude this structuralization. "The problem of the revolutionary organization is basically that of setting up an institutional machine that is distinguished by a special axiomatic and a special praxis; what this means is the guarantee that it does not close itself off in various

social structures, especially not in the state structure, which seems to form the cornerstone of the dominant production circumstances, although it no longer corresponds to the means of production. The imaginary trap, the *miroir aux alouettes*, consists in the fact that there seems to be nothing more at all today that could be articulated outside of this structure. The revolutionary socialist project that set itself the *goal of taking over the political power of the state* and identified this with the instrumental carrier of the domination of one class over the others, with the institutional guarantee for the ownership of the means of production, was caught by this bait."[9] The state apparatus as "bait," as a constant of the left's desire, is a twofold reference here: it refers to the revolutionaries' desire for the state apparatus and to the "bait" function of party and state, as it has been in effect throughout almost the entire 20th century in post-revolutionary socialist societies.

In the setting of the beginning 21st century, in actual post-Real-Socialist circumstances as well as in those in which the nation-state appears to be losing its influence, the question of the state as "bait" is altogether different. "The state as we know it is now completely outside the fundamental economic processes. The institutionalization of 'large markets,' the perspective of the establishment of super-states multiplies the bait a thousand times over...."[10] Similarly to the way Michael Hardt and Antonio Negri downplay the responsibility and still relevant function of the nation-states three decades later in *Empire*,[11] Guattari runs into a paradox here that must be negotiated today on the basis of contradictions in the context of the simultaneous expansion of economic globalization and the "world police" function of one nation-state in the "War against Terrorism:" the argument for taking over the state-apparatus should actually become successively

less attractive as the growing network of global economies—which Guattari calls "the institutionalization of 'large markets'"—and supranational state organization increasingly limit the scope of actually existing (nation) states. Yet it still seems that the same bait has only moved to a different fishing pole. Even when new structures of power emerge, in which the form and function of the state change, the state apparatus continues to remain the central object of desire in its visibility and its assailability.

This has to do with the way the interweaving of global economy, the still existent nation-states and their supranational alliances continues to assign specific functions to all these components. At the same time, the discourse of liberal, representative democracy remains a terrain that presumes and invokes the nation-state as the center. In addition, the state attains new significance again and again as an instrument of repression steering neoliberal transformations. Hence we find ourselves in a situation that is simultaneously both within and beyond the nation-state. Beyond it the "bait" enlarges as supranational alliances and a mixed interweaving of politics and economy, while within it the state-fixation of revolutionary practices and fantasies of taking over power seem to be nourished simply from traditional and conventional revolution narratives, more or less ignoring the changed circumstances.

In their "Treatise on Nomadology" and the war machine in *A Thousand Plateaus* (1980), Deleuze and Guattari undertook a new attempt to describe the relationship between state institutionalization and revolutionary movement in its contemporary complexity:[12] they make a distinction here between the state apparatus with its binary segmentations and, outside the sovereignty and the law of the state, the war machine *"that in fact has war not*

as its primary object"[13] in its complexity and its becoming. In the rhizomatic theory world of Deleuze/Guattari, the concept of the war machine is wide-ranging and heavily significant. Here "war" does not mean either a natural state, as proposed by Hobbes, that must be overcome, nor a thoroughly subordinated means of the state apparatus. Conversely, the distinction between the war machine and the state apparatus does not follow a black and white pattern that would consistently posit the war machine as a revolutionary machine against the reactionary state.[14] The relationship of appropriation between war and state can turn in both directions. The classical model would be that the state appropriates the war machine, turning it into an instrument. However, the function of the machine changes according to the specific conditions of its application. The multinational network of the globalizing economy, for instance, is itself not a state apparatus that striates, segments and "counts" spaces. It is much more an abstract machine that creates a smooth space intended to cover and control the whole planet and thus also the state apparatuses. The state apparatus can deploy this machine through a specific concatenation of segments, yet the machine is not dependent on the state apparatus.

Here Deleuze and Guattari pick up Foucault's reversal of Clausewitz's famous statement: politics (of the abstract machine appropriated by the globalized economy) is the continuation of (potential) war (of the not yet appropriated war machine against the state apparatus) by other means (with the means of total war / of "total peace," which does not seek the destruction/takeover/control of the state apparatus and its army, but rather of the population). "We could say that the appropriation has changed direction, or rather that States tend to unleash, reconstitute, an immense war

machine of which they are no longer anything more than the opposable or apposed parts."[15]

This worldwide abstract machine—reissued from the state apparatuses—displays two successive figures according to Deleuze/Guattari: the first is that of fascism, which organizes total war as an unlimited movement. The second is the postfascist figure, which evolved in the Cold War in the combination of imperial Soviet Communism and the "War against Communism," the current form of which consists in the parallel movement of the increasing rigidity of the effects of economic globalization and police actions in the "War against Terror." For Deleuze/Guattari, this abstract machine, unlike the total war of fascism, has a total "peace" as its object, a form of totalitarian terror called peace. "Total war itself is surpassed, toward a form of peace more terrifying still. The war machine has taken charge of the aim, worldwide order and the States are now no more than objects or means adapted to that machine."[16] Although the global political situation eludes explanations that are all too simple, the complicated relationship of nation-states and transnational/global non-state networks can still be well explained, even after 9/11, with the relation between the state apparatus and the war machine: "…it is necessary to follow the real movement at the conclusion of which the states, having appropriated a war machine, and having adapted it to their aims, reimpart a war machine that takes charge of the aim, appropriates the States, and assumes increasingly wider political functions."[17]

In this context, the relation between revolution and the takeover of state power becomes increasingly complex. Whereas a takeover of the state still had at least a phantasmal quality at the beginning of the last century, beyond a more fundamental discussion of the *form* of the state, the state apparatus becomes

increasingly indistinct as a real, concrete target. Or must we assume that the goal of revolution has perhaps always been indistinct, and that because of this indistinctness it was repeatedly side-tracked to a simple desire to take over the state apparatus?

The crucial problem of a fundamental change, abolishing the state apparatus and thus developing new forms of organization without defining these forms beforehand was one that the leftist theorists of the 19th century were certainly well aware of. In "Civil War in France," for instance, despite a precise analysis of the Paris Commune, Marx does not indicate exactly what happened or should have happened after the breakdown of state power. There is a good reason for this in that neither the Council of the Commune nor the workers councils nor the soviets are to be reified as a fixed model, but rather every battle engenders new forms of organization of its own. In contrast to this, however, in socialist reality the idea is frozen into a phrase, for instance in Lenin's emphasis in "Electricity and Soviets," similar to later, well intentioned interpretations of the historical revolutions, in which new forms of organization were merely postulated, but never concretely tested.

In the introduction to his Lenin book, Slavoj Žižek presumes that Lenin's project in 1917 involved a radical imperative to smash the bourgeois state, indeed the state *as such*, and to invent a new communal form, "in which all could take part in the administration of social matters."[18] Taking subsequent historical events into consideration, this interpretation seems rather exaggerated. However, I see the point of Žižek's book—contrary to the author, in a sense—in that the name Lenin stands for an extended discourse about possible forms of politics, which emerged in the late 19th and early 20th century. This discourse was by no means unequivocally determined, not even in 1917, but drew instead from a multitude of

positions, which also explains the flexibility of Lenin's own political position and his writings. In a broad field of social-democratic, socialist, communist, individual anarchist and anarcho-syndicalist positions, which continuously opened up new fields of reference, there were endless possibilities for inventing and combining revolutionary machines. Finally, this discourse is also instructive for comparing and differentiating today's issues.

If Žižek's book thus represents an attempt to "repeat Lenin,"[19] specifically the Lenin that has vanished behind the proliferating dogmas of Marxism-Leninism, then I would more concisely claim to repeat the *discourse* "Lenin:" the discourse that arose especially in the years between the two revolutions in 1905 and 1917 in Europe, and certainly not only in Lenin's own writings, but which instead articulates much in the debates relating to the Second International, social democracy and the unions, to the relationship between socialist and anarchist movements, to Bolsheviks and Mensheviks, to suitable forms of organization, to the avant-garde party and the dictatorship of the proletariat, to the relationship between spontaneous actions and cadre-like organization, to proletarian and political mass strikes, all of which would be worth "repeating" today—or at least purposely *not* repeating. Almost like an analogy to Lenin's decision not to write the seventh and final chapter of "State and Revolution" on "Experiences of the Russian Revolutions of 1905 and 1917," Žižek increasingly stifles this discourse, focusing instead on the solitary decisions of his protagonist.

In analogy to the gap of the French Revolution between 1789 and 1793, according to Žižek the repetition of the Russian Revolution became necessary, because the "first revolution" did not fall short of the content, but rather of the form itself, which remained caught in the old form, thus necessitating a second revolution.[20] In

relation to the theorization of the insurrection—as a rupture that was by no means one-dimensional—this was undoubtedly the case, yet the other components of the revolutionary machine remain disregarded. Indeed, the fundamental question in this context is: Why was there not also a third revolution after the second? Why not even an endless succession of upheavals countering the figure of the takeover of the state apparatus and the phenomenon of the paralyzation and the structuralization of the organizational form through constantly reinventing the organization? For even after October 1917, the state as such was far from being smashed, and after the October Revolution there was soon little more to be heard of the slogan "all power to the soviets" and the heralded replacement of the state apparatus with new commune-like forms of social administration. Lenin and the Bolsheviks specifically did not radically replace the state apparatus with soviets; they dispensed with supporting the both spontaneous and successful organization of the workers and soldiers councils. Instead, under the title of the "dictatorship of the proletariat" and with the help of the ideological figures of "transition" and the "dying of the state," more than anything else the power of the party was further extended.

In connection with the decisions of the year 1917 before and during the October Revolution, Guattari has pointed out that the Lenin party in particular was in no way competent to "encourage an original process of institutionalization like that originally at work in the development of the soviets."[21] On the contrary: instead of making use of the opportunity of the lasting and potentially permanent rupture, the party, "yesterday still a modest clandestine device," was developed into "an embryonic state apparatus."[22] The abolition of the soviets was followed by the elimination and later persecution of every opposition. In the area

of organization the result was "a cancerous proliferation of technocracies in politics, in the police, in the military, in business."[23]

Slavoj Žižek, however, not only insists on the figure of the protagonist Lenin in 1917, that nearly extinguishes the discourse of "Lenin" from the long decade before by occupying the center of power, he also does not address the problematic developments—which certainly did not first occur with Stalin—in Lenin's post-revolutionary politics at all. He wants to recuperate the Lenin of 1917, who insists on the gap separating the manifold political struggle of parties and grassroots movements from what is concretely at stake: immediate peace, the distribution of land, soviets. "This gap is the gap between revolution *qua* the imaginary explosion of freedom in sublime enthusiasm, the magic moment of universal solidarity when 'everything seems possible,' and the hard *work* of social reconstruction which is to be performed if this enthusiastic explosion is to leave its traces in the inertia of the social edifice itself."[24] Behind the separation proposed by Lenin/Žižek between the revolutionary event and the continuous work of organization (conspicuously referred to here as *re*construction), between insurrection and constituent power, we face the basic problem again: two correlative components are forced into a stage or phase model. Yet, just as it is impossible to divorce the February and October Revolution from the revolutionary micropolitics of the year 1917, every separation violates the components of the revolutionary machine. Just as reducing the events of 1917 to the two Revolutions bypasses the molecularity and processuality of revolutionary practices, reducing the revolutionary machine to the insurrection obscures the components of resistance and constituent power that equally and inseparably constitute revolution.

THE TWO-DIMENSIONAL CRY

"We see that a certain revolutionary type is not possible, but at the
same time we comprehend that another revolutionary type becomes
possible, not through a certain form of class struggle, but rather
through a molecular revolution, which not only sets in motion social
classes and individuals, but also a machinic and semiotic revolution."

— Félix Guattari[25]

ON JANUARY 1, 1994 the Zapatista National Liberation Army
(EZLN) occupied San Cristóbal de las Casas and six other district
towns in Chiapas in south-eastern Mexico, following over ten years of
grassroots organization—although the Zapatistas themselves refer to
"500 years of indigenous resistance" since "discovery" by Columbus.
In the revolts of the indigenous population of the Lacandon jungle,
the Tzeltales, Tzotziles, Tholes and Tojolabales, the Zapatistas fought
under the motto "Ya basta!" ("Enough!") against the deplorable living
conditions of the Indígenas not only in Chiapas. After only twelve
days of armed conflict, the Mexican government called a ceasefire. In
the subsequent negotiations with the government, the rebels, masked
with balaclavas as a trademark of collective anonymity, insisted again
and again on the fundamental transparency and public character of
their activities. In the summer of 1996 several thousand people from
forty different countries were invited to an "intergalactical gathering"
in the jungle; a second gathering of this kind took place in Spain in
1997 as an example of the opening and transnationalization of the
Zapatista movement. The Peoples' Global Action was founded at
that time, a network that plays an important role in the counter-
globalization movement. In September 1997, 1111 Zapatistas

traveled to Mexico City to make their concerns public. In March 1999 there were 5000 Zapatista delegates traveling all around the country. In March 2001 twenty-four EZLN delegates embarked on the Zapa-Tour through several states, finally presenting to the national congress in the capital their conditions for resuming the dialogue with the government. Although the willingness to conduct negotiations with the government about legislation in order to improve the conditions may seem to follow the pattern of reformism, the revolutionary aspect of this practice consists of displacing forms of domination and organization in the midst of negotiations: daily press conferences during the talks with government representatives, inviting advisers and guests to the negotiations, collective and consensual decisions and the constant possibility of the delegates being recalled forces the deconstruction of the power relations and a politics of evading representation and classification, making it possible to try out alternative forms of social organization at the same time.

In his theory strongly influenced by the Zapatista movement, John Holloway warns against separating the existent from the imaginable, what is and what could be: "We stand out beyond ourselves, we exist in two dimensions.... We live in an unjust society but we wish it were not so..."[26] These two inseparably linked dimensions of the collective scream as a scream of horror and of hope at the same time, determine the equally conjoined components of the revolutionary machine, that of resistance and that of the experimental testing of constituent power. The presential formulation of the second dimension as well, standing beyond what is, is to be understood as an indication that this is not a dichotomy of resistance against a real, present world on the one hand and a utopia far removed from becoming on the other. It is more the first steps into seemingly new terrain, posited on the old terrain, fighting against this old terrain

and using it at the same time to transform it into something different. Indeed it only appears that a completely *new* terrain is at stake. The territorial gain can only take place in one and the same plane of immanence, as the only possible platform for change and emancipation, yet it is from here that everything is to be reorganized. At this hinge between what is real and what is possible, both cards are always played: "being outside measure as a destructive weapon (deconstructive in theory and subversive in practice); and being beyond measure as constituent power."[27]

The inextricably entwined dimensions of the "scream-against" and the "movement of power-to," as Holloway calls the two components of resistance and constituent power, are best revealed "in those struggles which are consciously prefigurative, in which the struggle aims, in its form, not to reproduce the structures and practices of that which it struggled against, but rather to create the sort of social relations which are desired."[28] Here again, the exhortation not to seek merely a takeover of the state is reiterated. It is precisely in the midst of the heterogeneous forms of resistance that experimenting with what is desired as a "just world" should occur, rather than projections to a distant future or an indeterminate point in time after the revolution. Holloway's examples for tying opposition and experiments to new forms of organization are less spectacular than they are specific: "Strikes that do not just withdraw labor but point to alternative ways of doing (by providing free transport, a different kind of health care); university protests that do not just close down the university but suggest a different experience of study; occupations of buildings that turn those buildings into social centers, centers for different sort of political action; revolutionary struggles that do not just try to defeat the government, but to transform the experience of social life."[29]

All these examples indicate the link between resistance and constituent power. In Deleuze and Guattari's comments on the war machine, the relation of the reciprocal involvement of the two components is also described as a supplementarity: "If guerrilla warfare, minority warfare, revolutionary and popular war are in conformity with the essence, it is because they take war as an object all the more necessary for being merely 'supplementary:' *they can make war only on the condition that they simultaneously create something else....*"[30] Taking Deleuze and Guattari's specific terminology into consideration, this passage becomes especially vivid in the example of the Zapatista revolts: the Zapatista war machine does not at all correspond to a way of conducting war that aims to "take over" power or eliminate those who are "in power." It revolves around a way of conducting war that sees revolution as the dissolution of the state apparatus in the local context, continuously reinventing the social networks of this context at the same time.

Yet the Zapatista war machine is not immune to being transformed into a state apparatus through structuralization either, or being appropriated by a state apparatus that misuses it to conduct war. However, because of the technique of permanent questioning in the movement (the relevant Zapatista motto is "preguntando caminamos," "questioning, we proceed"), and the incessant critical reflection on its own governing ("mandar obedeciendo," "governing obediently"), a structuralization of this kind becomes more unlikely than in the martial gesture of a takeover of power: "It is not necessary to conquer the world. It is enough for us to make it anew."[31]

RESISTANCE, INSURRECTION AND CONSTITUENT POWER AS INDIVISIBLE THREE-DIMENSIONAL PROCESS

MOVEMENTS AND AUTHORS who have spoken out against one-dimensional ideas of revolution as a takeover of the state apparatus have usually regarded themselves since the 19th century as anarchists, or they have been identified/stigmatized as such. Thus it is not surprising that in some aspects of the Zapatista practice we find echos of the inventor of anti-etatist societary anarchism, Pierre-Joseph Proudhon, who dreamed that in the shadow of political institutions society could gradually and quietly give itself a new order. But the idea of a constituent practice that quietly carries out a kind of mole labor underground—especially if it is so little offensive as the organic development that Proudhon suggested—evinces a significant deficiency in the terrain of capitalist (and also late capitalist) recuperation. To clarify this insufficiency, it is not even necessary to refer all the way back to Marx's criticism that the practice of cooperative banking, the elimination of the middleman in trade, and loans without interest were only a marginal reform within the framework of the existing political representation models that remained intact.[32] The dualism of revolution and reform is hardly appropriate in this context, because it theoretically constructs an insurmountable difference between two positions that are posited as absolute. In molecular revolutionary practice neither the revolutionary pathos of the major rupture nor the disregard for a fundamental critique of society is to be found in its pure form.

However, the idea that state apparatuses and revolutionary machines could simply live together in peaceful coexistence, as Proudhon's position implies, parallel to one another without reference or conflict, is an impossible one, similar to the way Robespierre

calls "revolution without revolution" impossible. Contrary to Proudhon, John Holloway therefore insists—making use of Spinoza's terminology—that *potentia* ("power-to," in other words, "creative" or constituent power) is not an alternative that simply lives in peaceful coexistence with *potestas* ("power-over:" "instrumental" or constituted power). "It may appear that we can simply cultivate our own garden, create our own world of loving relations, refuse to get our hands dirty in the filth of power, but this is an illusion…the exercise of power-to in a way that does not focus on value creation can exist only in antagonism to power-over, as struggle."[33] Maintaining alternatives to what Holloway calls "instrumental power" quasi "innocently" in parallel and on its own terrain tends to lead into "splendid isolation" rather than to impulses for changing society. Starting from the false possibility of a right way to live in a wrong world, the mistake is the idea that an independent terrain is possible alongside and outside globally integrated capitalism. This is why Holloway regards the relationship between "creative" and "instrumental" power as an antagonistic one. But in the force diagram of resistance and power, every counter-power, every anti-power—including Holloway's "creative power" in its antagonism to "instrumental power"—implies the potentiality of becoming coopted. In this setting a third component comes up in addition to resistance and constituent power, in addition to the "scream of rage" and "creative power," a component that takes the concatenation of the "screams" into consideration.

After the first years of self-management in labor associations, Proudhon soon had to abandon his optimism about the quasi automatic way that societary-anarchist self-management would prevail. The desired transformation of society could not take place quietly and discreetly. Resistance and constituent power can turn out to be

ineffective and harmless where they cannot be articulated, where they are not manifested in their confrontiveness, their massiveness, their disruptive events. Such non-manifestation of aspects that do not fall into the realm of the representable is also a technique of representation as domination. This technique of a separation into what is represented and what is not represented—less in terms of the visibility of individual groups than as a fundamental manifestation of the possible concatenation of resistance practices—can be attacked when revolution as a mole moves to the surface. This is where the dimension of revolt / insurrection finally comes into play again, but this time not as a one-dimensional idea of taking over state power, but rather as a third component in the indivisible triad of the revolutionary machine.

Antonio Negri began to develop the concept of this triad in 1993 in the essay on constitutional theory "Repubblica Costituente" ["Constituent Republic"]. The passage quoted at the beginning of the present chapter is taken from this essay. "It is time to ask ourselves whether there does not exist, from a theoretical and practical point of view, a position which avoids absorption within the opaque and terrible essence of the State. In other words, whether there does not exist a viewpoint which, renouncing the perspective of those who would construct the constitution mechanistically, is able to maintain the thread of genealogy, the force of constituent praxis, in its extensivity and intensity. This point of view exists. It is the viewpoint of daily insurrection, of continual resistance, of constituent power."[34]

Almost ten years after this reference to the three components of the revolutionary machine, the same idea comes up in a different text again as the "three elements of counter-power." In a lecture for Platform 1 of documenta 11, Negri and his co-author Michael Hardt presented essential aspects of their bestseller *Empire* and elaborated on them with thoughts on modern and postmodern

shapes of counter-power. "We must think of resistance, insurrection and constituent power as an indivisible process, in which these three are melded into a full counter-power and ultimately a new, alternative formation of society."[35] Hardt and Negri argue that resistance, insurrection and constituent power have been torn apart in a modernity marked by national space and national sovereignty that they have been regarded as mutually external and either deployed entirely separately as various revolutionary strategies, or else have functioned as different historical moments. Only now, following the Cold War and the tendential loss of the importance of the nation-state (and the national revolt, which has again and again led back to its point of origin, international war), is it possible to understand resistance, insurrection and constituent power as a continuum and the three components as mutually immanent.[36] As the subsequent example of the Paris Commune will show, this historical distinction between the period of the great revolts and the period of "Empire" on the basis of a vaguely constructed historical process is not consistently tenable, although the conclusion is undoubtedly cogent: the triad of the revolutionary machine is always to be imagined as interwoven, but each of the three components develops in form and appearance according to its context in time and space.

With regard to a precise analysis of the three components in current revolutionary contexts, Hardt/Negri's development and concretization of the triad so far leaves several questions open. They remain vague both in terms of theorization and examples. They do not explain the concatenation of the triad nor the question of how insurrection, in particular, is to be imagined in the days of "Empire."

Yet it is not only insurrection that seeks a different form in the age of the increasing limitation of sovereign nation-states and their

changing function; resistance and constituent power also follow different patterns in different historical and geopolitical contexts. Accordingly, the question about possible concatenations of micropolitical resistance, everyday insurrection and constituent power as the collective invention of a new social and political "constitution" has to be problematized differently in each case. Whereas the triad of concepts is not to be understood as a sequence in time, following the pattern of first resistance, then revolt, then the establishment of a new society, the three components develop as a manyfold process crossing different spaces in a plane of immanence. Nevertheless, the three components will be examined individually in the following, in order to rediscover and concretize them (implicitly or explicitly) along the lines of this book in different historical contexts.

THE PRIMACY OF RESISTANCE

> "The path of total police control over all human activities and the path of unlimited free creation of all human activities are one: …We are necessarily on the same path as our enemies—most often preceding them—but we must be there, without any confusion, as enemies. The best will win." — Situationist International[37]

ACCORDING TO MICHEL FOUCAULT, wherever there is power, there is resistance. "And yet, or rather consequently, this resistance is never in a position of exteriority in relation to power."[38] Even if power has no absolute outside, though, this does not mean that resistance is necessarily and absolutely subordinated to power. For Foucault, the "strictly relational character of power relations" specifically does not

mean, first of all, that resistance is merely a consequence, a negative form of power and thus the side that is always only passive and weaker. Secondly, resistance is to be understood as heterogeneous, as a multiplicity of points, nodes and focuses of resistance, not as a radical break at the *one* site of a great Refusal, not as a massive disruption that establishes two fundamental oppositions, not as an antagonism, but rather as an unevenly distributed multitude of points of resistance in an equally diverse landscape of shifting splits and boundaries. This kind of understanding of resistance as multiplicity corresponds to an idea of power that is no longer uniform. Rather than the totality of institutions and apparatuses that guarantee the order of the bourgeois state, Foucault understands power as a diversity of force relations that organize a territory.

In his *Foucault* book, Gilles Deleuze points out the concrete historical background of Foucault's theory of power and resistance: around and after 1968 there were attempts to establish theoretical approaches that were directed "against Marxism [here meaning Marxist-Leninist currents and parties in the framework of 'real Socialism' *and* in the western European countries, especially in France and Italy] as much as against bourgeois conceptions."[39] At the same time, there was also an influx here of the experience of specific struggles that Foucault and others had in the 1970s in various transversal groups. For a time these groups succeeded in not succumbing to the "childhood illnesses of communism," totalization, centralization and structuralization, but instead maintained relations among the different struggles. For Foucault, this related especially to his involvement in the "groupe information prison," which developed and impelled information and actions relating to the conditions in French prisons. Against the background of these experiences, Foucault saw power as being "exercised rather than possessed; it is not

the 'privilege,' acquired or preserved, of the dominant class, but the overall effect of its strategic positions."[40] Resistance is only thinkable in the strategic field of these power relations, which are not at all uniform or to be imagined as the linear domination of one group over another. In the densely woven fabric of power relations that runs through the apparatuses and institutions, resistance is not merely a negative function of power, a connection that must first detach itself from the system of power, an ultimately passive/reactive side of power. "They [the many different forms of resistances] are the odd term in relations of power, they are inscribed in the latter as an irreducible opposite."[41] In this "final caricature of power" (Judith Butler), Foucault thus insists on the juxtaposition rather than the succession of power and resistance in an assemblage that is no totality, but thoroughly heterogeneous, at the same time maintaining the impossibility of imagining an outside of this relation.

Leftist discourses have struggled with Foucault's analysis, especially with the immanence aspect of the intertwinedness of power and resistance that negates the possibility of a radical emancipation into an outside (in the sense of liberation into a realm that lies outside the power relations). The reception of Foucault accordingly tends to produce images of an impasse, a padded cell, an inescapable totality.[42] Many have misunderstood this as instructions for defeatism and as the denial of the possibility of revolution. The diversity and complexity of Foucault's understanding of resistance appears to John Holloway, for example, as "the richness of a still photograph or of a painting," without development, especially since "doing and its antagonistic existence" are not at the center of Foucault's deliberations. From this perspective, Foucault's analysis would offer any number of instances of resistiveness, but no possibility of emancipation. "The only possibility is an endlessly shifting constellation of

power-and-resistance."[43] And even Foucault himself seems to share this doubt, which probably led in the late 1970s and 1980s to the striking shift in focus from Foucault's research on the analysis of power and knowledge to the problematization of self-government and "care of the self." Deleuze writes about this turn in Foucault's work: "...had he not trapped himself within the concept of power relations? He himself put forward the following objection: 'That's just like you, always with the same *incapacity to cross the line*, to pass over to the other side....'"[44]

Even if this kind of change "to the other side" seems impossible within the framework of Foucault's thinking, though, this does not mean abandoning every kind of emancipatory impact of resistance. Judith Butler, for instance, points out the difference that indeed makes Foucault's concept of resistance, contrary to Lacan's, quite productive in emancipatory contexts.[45] Whereas Lacan locates resistance in an area where it is not at all able to change that which it opposes, with Foucault resistance is directed precisely against the power of which it is an effect, just as it produces this power. Corresponding passages can be found in Foucault's writing, which could not be less ambiguous: "Just as the network of power relations ends by forming a dense web that passes through apparatuses and institutions, without being exactly localized in them, so too the swarm of points of resistance traverses social stratifications and individual unities. And it is doubtless the strategic codification of these points of resistance that makes a revolution possible, somewhat similar to the way in which the state relies on the institutional integration of power relationships."[46]

The most obvious discrepancy between Foucault and Holloway is rooted in the two authors' different concepts of power. Foucault could well agree with Holloway that the world can be changed without taking over (state) power. Conversely, however, in Foucault's

theorization of power and resistance, everything is missing that Holloway calls the fundamental antagonism, instrumental power (power-over) as the *antagonistic* form of creative power (power-to). According to Holloway, dissolving instrumental power to emancipate creative power requires a radical anti-power. According to Foucault, the introduction of this kind of dichotomy into the question of power remains problematic. Whether the concept is one of anti-power, as with Holloway, or of counter-power, as with Negri/Hardt, Foucault does not envision the heterogeneous interlocking of power and resistance as opposites.

They obviously have something in common, however, in the thesis of power's dependency on resistance. For Holloway as well, instrumental power is nothing more than the metamorphosis of creative power and therefore completely dependent on it. In the interaction between the French post-structuralist theories and the Italian post-Marxist/operaist theories, this model—in which there is also an echo of the relationship between the "producing" and the "appropriating class" in Marx's writing—is applied to several different and related terms; it is most compactly formulated in Deleuze's *Foucault* book. "In fact, alongside (or rather opposite) particular features of power which correspond to its relations, a diagram of forces presents particular features of resistance, such as 'points, knots or focuses,' which act in turn on the strata, but in such a way as to make change possible. Moreover, the final word of power is that *resistance is primary....*"[47]

This play on words most compactly summarizes the Foucaultian concept of power and resistance. Power, for its part, retains the *final* word, yet resistance is *primary*. By indicating that resistance is primary, Deleuze introduces the minor methodological difference that finally makes it possible to "cross the line." Whereas Foucault

operatively enables the description of the concepts of power and resistance, Deleuze makes it clear, for instance also in relating the state apparatus and the war machine or desire and power, that the term "primary" does not chiefly denote a temporal succession, but rather a relationship of dependency.[48]

However, Deleuze makes the point that a social field offers resistance before it is organized according to strategies.[49] In other words, power can only build on resistance. Power is thus to be understood not only in the figures of recuperation and cooptation, but as a principally subordinate component in its relationship to *re*sistance. Counter to the superficial meaning of the word as *counter*position, *op*position, resistance becomes an offensive figure rather than a reactive one, a figure that is founded in nothing else than itself.

In a footnote Deleuze refers to an echo found in Foucault of the operaistic theses of Mario Tronti's *Operai e Capitale* [Workers and Capital] about the "workers' resistance" that precedes strategies of capital.[50] Hardt and Negri also pass on this echo through the line of the tradition of post-Marxist Italian operaism, where the two authors see "empire" and "multitude" in a similarly posited relationship, like in the image of the double eagle,[51] as mutually dependent. Yet, in some places they emphasize the precedence of the productive power of the multitude in relation to the empty, spectacular machine of imperial domination. "In all cases the effectiveness of imperial government is regulatory and not constituent…"[52] The activities of this imperial governmentality remain limited to a negative function, which essentially corresponds to a logic of reaction and misappropriation. The regulative and repressive empire, which itself has no positive reality at all, reacts to the multitude, is impelled by the resistance of the multitude. Resistance places itself, so to speak, before its object, becomes "prior to power."[53]

On this basis Hardt/Negri confirm the necessity of new *forms* of resistance. The "will to be against" in the modulating plane of immanence of globalization is no longer expressed in static forms of resistance, such as sabotage, for example, but rather in mobile modes. Here again Hardt/Negri borrow terms from Deleuze/Guattari, such as desertion, exodus and nomadism,[54] stressing processes of evacuation that destabilize and destroy power. These non-dialectical terms of movement seem to become especially relevant these days when it is not at all clear who or what could be the object of resistance in a global setting, how or where opposition could be defined. In the situation described above when the state as the object of revolutionary desire breaks away and the arrangements between power and resistance become more and more complex, it seems to be increasingly difficult to grasp a specific difference.

Hardt and Negri have described this difficult situation of increasingly incomprehensible power relations with the term "non-place of exploitation."[55] Exploitation and oppression become so amorphous that there no longer seems to be a place where one could feel safe from them. What can an offensive form of being-against be at this point, when we seem to be in danger of sinking into a single all-embracing anti-globalization commonplace, which is that "power is everywhere and nowhere at the same time?" For this situation without a conceivable outside and without a center of power, *Empire* proposes a surprisingly simple strategy: If the mechanisms of power function without a center and without central control, then it will simply be necessary to attack power from every place, from every local context.[56] This appears to be a suitable theoretical precondition for micropolitical practices that practice resistance in heterogeneous ways against specific partial aspects of an increasingly global commando and control.

POST-NATIONAL INSURRECTION AND
NON-CONFORMING MASS

AS PLAUSIBLE AND ATTRACTIVE as Negri/Hardt's thesis of the ubiquitous "being against" may be, it still remains arbitrary and vague: even if "being against in every place" is doubly coherent as a possibility of being able to be in opposition in every place as well as the necessity of having to be in opposition in every place, there are still places, where this kind of oppositionality suggests itself more strongly than in others. And these places are sought out, frequented and beleaguered, as were the Bastille or the Winter Palace in the old days of the great revolutions. This is especially true today of the places where arrangements condense that govern us more effectively and powerfully than the governments of representative democracy.

Towards the end of *Empire*, Hardt and Negri change their argumentation and supplement their argument of being against in *every place* with a more concrete suggestion for action: "...the action of the multitude becomes political primarily when it begins to confront directly and with an adequate consciousness the central repressive operations of Empire. It is a matter of recognizing and engaging the imperial initiatives and not allowing them continually to reestablish order..."[57] Even though the book was written before Seattle 1999, there seems to be an allusion here to the practice of insurrectionary mass demonstrations, especially of the counter-globalization movement with its reappropriation of public space, with its actions that touch the wounds of social and economic asymmetries, which are enhanced through the summit meetings of the G8, WTO, WEF, etc., with its attacks against these specific institutions. Here the goal is primarily "a matter of gathering together

these experiences of resistance and wielding them in concert against the nerve centers of imperial command."[58]

The examples of current insurrection in the counter-globalization movement may appear too little violent and too undramatic to deserve this name, but even the historical examples of insurrection did not always involve bloodshed: in the contrary, great insurrections—I am not referring here to the bloody suppression of revolutions, of restoration and counter-revolution—were mostly distinguished by as little violence as possible. At the storming of the Bastille, the soldiers loyal to the king laid down their arms; at the attack on the cannons of the Paris Commune, it was the physical presence primarily of the women of the Commune that prevailed; at the storming of the Winter Palace the sight of the cannons of the Aurora was sufficient. All these are examples for an understanding of insurrection that does not evoke martial, transgressive fantasies of violence, but rather raises the question of the quality and function of current forms of insurrection: as a collective protest—also limited in space and time, as a massive uprising, as open agitation, as outrage arising from the everyday micropolitical forms of resistance.

By focusing on insurrection, we look more closely at modes of becoming mass and at the singularity of the event. Here it becomes evident that revolutionary machines have two different concepts of time: a time of duration, of the permanent molecular revolution, and a time of rupture, of the event. Resistance and constituent power are the components of the revolutionary machine that represent duration. It is not the seemingly objective duration of a continuous progress, but rather a permanence of actuality. These are the components of social interaction, of direct exchange, of ongoing collective organizing. Insurrection is a temporary flare, a rupture, a flash of lightning, in short: the event. Unlike resistance and

constituent power, insurrection permanently insists on an immediate imminency. It allows no postponement.

Conventionally the term insurrection is used as a synonym for civil war, for war within a bounded space defined by the nation-state. Even though these kinds of variations of national revolts still take place, from the separatist regional insurrections and the African civil wars of recent decades, to South American examples in Argentina or Venezuela, to the insurrectionary aspects of the protests against right-wing governments in Europe, the phenomenon of the national revolt today seems to have become too large and too small at the same time. It is too large, because in its shadow the mass media mechanisms of exclusion and historification tend to marginalize less spectacular uprisings or those not aimed at taking over the state apparatus, which makes a broad spectrum of insurrection invisible. It is too small, because here the question arises again of the extent to which it even makes sense today to attack the nation-state as a center of power, and which contemporary forms of insurrection there might be outside the area exclusively defined by the nation-state.

The central question thus revolves around appropriate forms of *post-national* insurrection. This term is by no means intended to obscure the role of the nation-states, which still continue to have diverse impacts, but rather to describe the genealogical movement in the form of insurrection, in which aspects of the national revolt are conserved today, but which still goes beyond this. When the actors in regional revolts like the Zapatistas increasingly address how they are situated within global circumstances and aim to effect global changes, when there are simultaneous demonstrations in different places around the world on the same issue,[59] when the mobilization and discursivization of movements and activist networks is conducted transnationally,[60] then this is evidence of a growing

tendency to a transnationalization of insurrectionary practices. The rapid distribution of electronic communications, at least in parts of the world, accelerates and promotes this tendency and the competencies of the actors in merging the virtual space of the internet and physical confrontation in public space.[61]

Two paradigms of mass can be differentiated in the event of the insurrectionary mass demonstration:[62] mass as structure and mass as machine. Either the homogenization and segmentation of conventional hierarchized demonstrations prevails, or the becoming of machinic assemblages that I named "non-conforming masses."[63] Contrary to the denunciation of the mass as indifferent, which has marked the negative connotation of the term from Hegel[64] to Hardt/Negri,[65] the designation "non-conforming" is intended as an attempt to grasp the mass as neither formless nor uniform, neither as *Hetzmasse*[66] nor as "stagnating," "dense mass" striving for uniformity, but rather as a mass organized in difference: a permeable, fluctuating, dispersed mass. A mass that is not governed through segmentation, homogenization and structuralization develops a twofold non-conformity with respect to the inside and to the outside: outwardly the mass names its non-conformity in non-agreement with the form of how it is governed. Community is founded exclusively negatively in the rejection of the specific manner of being governed. Inwardly, non-conformity in this negation of any positive sense of community means the permanent differentiation of the singular. Counter to all demands of identity, the event of the insurrectionary mass demonstration can lead to a test of collectivity that promotes the concatenation of singularities instead of constructing collective identities.

Countering uniformity and homogenization *and* overcoming the fragmentation of struggles, insurrection is the component of the

revolutionary machine that makes singular images and statements appear beyond representation, thus allowing the world to happen and opening up possibilities of connection and concatenation. In the paradigms of representation and the mass as a structure trivial terms of "visibility" and "publicity" predominate, such as in the mainstream media, which invariably reproduce only two patterns in reference to insurrection: the mantle of silence or the spectacularizing and scandalizing of protest. As a machine, i.e. as a combination of physical assemblages of individual and collective singularities and of assemblages of images and statements the non-conforming mass creates something different from this kind of mediated visibility. It generates possible worlds counter to the logic of representation.[67] Instead of seeking to reach an imagined inner core of the society of the spectacle through spectacularity and quantity, entering into the "publicness without a public sphere" of mass media, in the context of insurrectionary mass demonstrations and in the paradigm of the event, articulation and public sphere do not mean mediation, but rather the permanent production of singular images and statements.

CONSTITUENT POWER:
"... AND THAT THE REVOLUTION NEVER COMES TO AN END"

CONSTITUTION MEANS MANY THINGS. First of all, it means the Constitution as the fundamental law, which remains unquestioned in everyday language, as though it had always existed as an abstract universal, as eternal constituted power, even though constitutions in this sense first arose in the late 18th century. The second meaning of constitution results from the question of the mode and method of founding these Constitutions: constitution as an act of

constituting a constitutional assembly, which comes *before* every Constitution in the first sense. Thirdly, even after having established a Constitution in the first sense, there follows the question of the further development of the abstract universal and with it the demand that it be constituted in permanence, which presumes that the constitution can and must be changed at certain intervals to adapt it to changing circumstances. And fourthly, the neighboring zones of the constitution also include the terms of constituent power and constituent practice.

Whereas constituent power correlates with the second and third concepts of the constitution, in the meaning used here it distances itself from the Constitution as abstract universal and legal foundation for the state. Here "power" relates neither to the material basis of state power, nor to Foucault's comprehensive concept of power, but rather to Spinoza's distinction of *potestas* and *potentia* and its adaptations by Holloway and Negri. In the term "constituent power" there is hence an echo following *potentia* as "potentiality," "capacity," also the capability of conjoining. Constituent power does not mean formulating and institutionalizing a Constitution as fundamental law, but rather collective subjectivation, instituation and formation beyond constituted power. As the third component of the revolutionary machine, constituent power relates primarily to the testing of alternative forms of social organization. Unlike the second and third concepts of constitution, here the aspect of political representation vanishes.

The concepts of constituent and constituted power, and thus also the distinction between the first and second meaning of constitution, were introduced by Emmanuel Joseph Sieyes, the protagonist of the French constitution of 1791. In his text "Qu'est-ce que le tiers état?" [What is the Third Estate?], the publication of

which fanned the flames of revolution and encouraged the French National Assembly to break with the *Ancien Régime* and proclaim the transition to the Republic, Sieyes made a distinction between the *pouvoir constitué* and the *pouvoir constituant*. For Sieyes, constituted power corresponds to the Constitution as fundamental law and constituent power to the assembly that defines the Constitution. The sequence must thus initially be reversed, since before there can even be a Constitution as constituted power, there must first be a process of creating the text of the Constitution by what Sieyes calls the *pouvoir constituant*.

Aside from the historical particularity of the French Revolution, the general problematic aspect of constituent power as the assembly defining the Constitution lies in the decision about how this assembly comes into being, in other words especially in the question of how this assembly is legitimized. In *On Revolution* Hannah Arendt emphasizes this "problem of the legitimacy of the new power, the *pouvoir constitué*, whose authority could not be guaranteed by the Constituent Assembly, the *pouvoir constituant*, because the power of the Assembly itself was not constitutional and could never be constitutional since it was prior to the constitution itself."[68] In this context Arendt particularly stresses the difference between the French and the American Revolution. In France it was the National Assembly that—in a "division of labor"—developed the first Constitution for the nation through its self-given *pouvoir constituant* according to a certain principle of representation. Unlike in France, in the US the Constitution was thoroughly discussed in 1787, paragraph for paragraph down to the last detail, in town hall meetings and state parliaments and supplemented with amendments. In other words, it emerged from countless constituent assemblies in a multi-stage process.[69] What is especially

important to Arendt is the aspect of participation in the federative system of the USA, which she sees as leading to completely different relationships between the Constitution and the people in the USA and Europe. At a closer look, however, the difference between the constitutional processes in France and in the US is not so fundamental as to explain Arendt's strong emphasis on the legalistic procedure of the American Revolution, which insisted most of all on better administration.[70] Aside from the multiple exclusions of Native Indians, slaves and women, the process of defining the constitution in the US was one that was borne by constituted assemblies and dominated by the principle of representation.

In addition to the problem of a somewhat uncritical celebration of the figure of participation, Arendt also evinces an especially affirmative attitude with regard to Thomas Jefferson. His laconic exhortation "Divide the counties into wards!"—stated after he had retired from politics and also otherwise without consequences— was well intentioned, but it also clearly reveals the extent of the problematic issue. When the retired statesman Jefferson called for the subdivision of larger political territories into many small and surveyable districts in the 1820s—he also called them "elementary republics"[71]—this was evidently an attempt at decentralization, yet at the same time it was the opposite of a constituent movement from below. As a procedure developed afterward—on the drawing board, to be decreed from above—it can be taken more as an act of government than as an emancipatory or revolutionary vision. It is thus wholly incongruous, when Arendt places Jefferson's idea on a par with the grassroots organizations of the French Revolution and promotes it as an anticipation of the council system, the soviets and *Räte*. Whereas the practice of the soviets corresponded to a distribution *in* space, which developed from below and spread out

autonomously, Jefferson's statement exemplified a belated under-
standing for smaller units, yet because of this delay it sanctioned
the division and subdivision *of* space from above, as the fragmentation
and segmentation of a previously occupied space and a previously
constituted social organization.

However, aside from this emphasis on Jefferson, which may
well be rooted in the invocation of the specific American target
group as a potential audience, Arendt's book is an enormously
instructive work on revolution; for instance in relation to the clear
distinction between the organizational modes of councils and
political parties: "The conflict between the two systems, the parties
and the councils, came to the fore in all twentieth-century revolu-
tions. The issue at stake was representation versus action and
participation. The councils were organs of action, the revolutionary
parties were organs of representation...." [72] In the examples that
Arendt discusses (including the sections of the first Paris Com-
mune, the Council of the Paris Commune in 1871, the soviets of
the Russian Revolution 1905 and 1917, the Bavarian *Räterepub-
lik*, and the councils of the Hungarian Revolution 1956),[73] she
finds a completely different form of constituent power in the most
important historical cases than Jefferson had in mind. This is also
contrary to many revolutionary theorists, who mistook the coun-
cils for "nothing more than essentially temporary organs in the
revolutionary struggle for liberation," without grasping "to what
an extent the council system confronted them with an entirely
new form of government, with a new public space for freedom
which was constituted and organized during the course of the
revolution itself." [74]

Antonio Negri further developed this concept of constituent
power as a form of social organization: "To each generation its

constitution," said Jean Antoine Condorcet even before the relevant principle was specified in the revolutionary French Constitution of 1793; one generation may not subject future generations to its laws. Negri takes this demand literally and thus goes far beyond the former meaning of the *pouvoir constituant*. He presupposes that constituent power can not only not arise from constituted power, but that constituent power does not even institute constituted power.[75] Instead there is conversely the danger of constituent power being coopted by constituted power: "...once the constituent moment is past, constitutional fixity becomes a reactionary fact in a society that is founded on the development of freedoms and the development of the economy."[76] Even if there were a permanent process of constituting the constitution in Condorcet's sense, in other words a continuous adaptation of the constitution as abstract universal to the concrete universal, there would still be the fundamental problem of representation, of the division of labor between those representing and those represented, the separation between constituted and constituent power.

One of the most recent examples of this problem is the process of democratization in Venezuela since 1999, which has become known as the "Bolivarian Process."[77] When the anti-neoliberal candidate Hugo Chávez won the presidential election in 1998 and took office in February 1999, he called for elections for a constituent assembly, which developed the new "Bolivarian Constitution" over the course of the year in an extensive procedure with the population being activated and participating. With this, Chávez set two parallel processes in motion: on the one hand, a grassroots social revolution was to be impelled, on the other the institutions of the state were to be made functional again within the framework of a process of re-institutionalization. The content of the new Constitution was

not only widely discussed, in some points it even goes beyond conventional Constitution texts in its emancipatory potential. The Constitution introduced "participative democracy" and the "protagonist role" of the people, included a complex version of human rights and the rights of women and Indígena, and generally followed an anti-neoliberal course.

Nevertheless, it is not entirely coherent when Negri's concept of constituent power is so frequently cited in this context.[78] As radical and potentially oriented to overcoming representative democracy as the twofold movement of the introduction of participative democracy and the support of the grassroots movements in Venezuela may be, the Constitution does not correspond to the concept of constituent power, neither as a process nor as a product, in the way that Negri developed it. Instead it stands more for a consistent radicalization of the ideas of constitutional law at the end of the 19th century between Sieyes and Jefferson. The copied print version of the Bolivarian Constitution, which was excessively distributed and sold and has now almost attained the status of a cult object, is far more a ubiquitous testimony to the incommensurability of ideas of state constitution and constituent power.

Antonio Negri logically pursues the question of how a constituent power is to be imagined, which does not engender constitutions separated from itself, but rather constitutes itself. Here the idea of constituent power leads to the necessary dissolution of every form of constitution: The "repubblica costituente" is a "Republic which comes before the State, which comes outside of the state. The constitutional paradox of the constituent Republic consists in the fact that the constituent process never closes, that the revolution never comes to an end."[79] Constituent power in this most developed meaning—and here the concept also fits into the

triad of the revolutionary machine—means establishing possibilities and procedures outside of constituted power, outside state apparatuses, experimenting with models of organization, collective forms and modes of becoming, which resist—at least for a time—reterritorialization and structuralization.

3

Out of Sync:

The Paris Commune as Revolutionary Machine

"In the present movement we all stand on the shoulders of the Commune."

— V.I. Lenin[1]

"Nor did it break with the tradition of the state, of representative government."

— Peter Kropotkin[2]

MICHAEL HARDT AND ANTONIO NEGRI maintain that the Paris Communards in March 1871 provided the model for all modern communist *revolts*, thus limiting the Commune to the single component of insurrection.[3] They claim that the strategy of the Commune, which was initially victorious and hence later copied, consisted of using the preconditions of an *international* war, which was turned into a *civil* war, a war between the classes. In this narration the German-French war, which brought Bismarck's armies deep into France in 1870 and left Paris under siege for months, as an international war served as a condition of possibility for the revolt. The Prussians before the gates of Paris—according to Hardt/Negri—not only overthrew the Second Empire of Napoleon III (on September 4, 1870 Napoleon was deposed without resistance and a bourgeois republic was installed), but also enabled the

Paris insurrection of the Commune against the National Assembly that fled to Versailles in March 1871.

Yet, still according to Hardt/Negri, the tragedy of the modern revolts is that national civil war is immediately and inevitably transformed back into *inter*national war. This means that a national victory would always only invoke a new and permanent war. Even the victory of the Bolsheviks in the Russian Revolution, as Hardt/Negri maintain, was merely the beginning of a (hot and cold) war that lasted over seventy years and finally ended with the implosion of Socialism.

In both its generalization and in the specific case of the Paris Commune, this chain of causes seems to be an inadequate reduction of the historical context. Aside from the strangely revisionist and linear-causal sequence of communism and fascism in hot and cold wars, aside from the dubiousness of a generic impossibility of insurrection in the limited space of a nation-state, a region or a metropolis, it is wrong to describe the Commune as a *revolt*, as an exemplary case for the reduction of Negri's own concept of the triad of insurrection, permanent resistance and constituent power to the one-dimensional revolt, the civil war.[4] In contrast to Hardt/Negri, who argue that the non-linear, simultaneous emergence of the three components first became possible in the development from the modern to the postmodern concept of revolution, I support the thesis that the Commune was primarily not a civil war, but that the concept of the intertwinedness of resistance, insurrection and constituent power is actually best instantiated by the Commune. In other words, the Commune actuated all the components of the revolutionary machine.

Let us begin with the most expressive narrative of the Commune, that of the women of Paris, who opposed the Versailles government troops on March 18, 1871 together with the men of the Paris National Guard, defending the cannons of the National Guard

and thus introducing the section of the revolutionary process that is generally called the insurrection of the Paris Commune. When the Versailles troops attempted to remove the remaining cannons stored in the district of Montmartre in the early morning hours on March 18th, it was primarily the women, according to the account by the contemporary Commune historiographer Lissagaray, who were up early to organize food, who sounded the alarm and confronted the troops. "As in our great days, the women were the first to act. Those of the 18th March, hardened by the siege—they had had a double ration of misery—did not wait for the men. They surrounded the machine guns, apostrophized the sergeant in command of the gun, saying, 'This is shameful; what are you doing there?' Suddenly a large number of National Guards, the butt-end of their muskets up, women and children, appeared on the other flank from the Rue des Rosiers. Lecomte, surrounded, three times gave the order to fire. His men stood still, their arms ordered. The crowd, advancing, fraternized with them, and Lecomte and his officers were arrested."[5]

This story of the heroic defense of the cannons of the National Guard by the women of Paris, of the convincing strategy of non-violent resistance and the refusal of the government soldiers to take action against the women and the Paris National Guard, differs fundamentally from conventional narratives of revolution and creates more congenial images than the martial narratives celebrating the success of the storm of the Bastille, for instance, or the storm of the Winter Palace. Nevertheless, this—like the other descriptions of the 18th of March that foreground the heroism of the National Guard—is simply a more congenial version of constructing a founding myth that is produced *ex post* through historification and political interpretation and neatly detached from the larger context. This foundational narrative constricts the setting of the revolution

to a single point and decontextualizes both the scene and the specific functions of the women in the Commune. Rather than elucidating these functions more precisely and in the context of the social and political developments in the years before, an emotional cliché is produced that has been picked up not only by Marx in his remarks about the "real women of Paris" as being "heroic, noble, and devoted, like the women of antiquity."[6] This cliché, the flip-side of which was the denunciation and persecution of women as "pétroleuses"[7] in the weeks and months following the defeat of the Commune, is also a repeatedly cited instrument for the shut-down of movement in various art genres and thus also an instrument for reducing the revolutionary machine to the one-dimensional revolt.[8]

The reduction to March 1871, or even to the two explosive months of the "revolt" from March to May 1871, in other words to seventy-two days and between twenty and thirty thousand people dead in the end,[9] is hardly suitable to grasp the historical Parisian context. Nor was the end of the Commune in the so-called "Bloody Week" a civil war, but rather the revanchist massacre of the mostly proletarian population of Paris on the part of the reactionary government army. It is only when we look beyond these two months into the last third of the 19th century that we see more clearly the long movement, the social transformations that resulted in the overlapping of all three components of the revolutionary machine.

With the defeat of the June Revolution of 1848 and the coup of Napoleon III, by 1851 the revolutionary processes in Paris were almost entirely disrupted, and Napoleon's populistically vacillating reform policies succeeded in neutralizing new attempts of formation and organization for over a decade. With the crisis of the regime in the late 1860s, though, social unrest gradually began to grow, leading to a strengthening of oppositional movements. Freedom of the

press and freedom of assembly in 1868 were formal prerequisites for a developing continuum of resistance. The important precondition for the Commune was the crystallization of a rapidly growing field of publication, manifold newspapers that stood for the most diverse oppositional positions, and the protagonists writing for them. An abundance of newspapers, pamphlets, gazettes, propaganda brochures, tracts, manifestos and caricatures flooded public space, augmented by the growing diversity of posters, wall newspapers and proclamations. Parallel to this, the freedom of assembly led to two bursts of expansion (1868 and 1870) of the oppositional public spheres. In his study *Insurgent Identities* Roger V. Gould describes how a "meeting movement" arose directly following the sanctioning of the freedom of assembly in 1868. In public debates every evening, this movement soon addressed issues of property, the influence of monopolies on production or the question of women's rights. From June 1868 to April 1870 a total of 776 assemblies took place. In larger assembly halls, theaters and public ballrooms, sometimes over 1000 people were present. The assemblies that were initially strongly male dominated and influenced by the moderate bourgeoisie quickly expanded in terms of gender and class composition, especially through expansion into less central districts such as Montmartre, Belleville, La Villette or Charonne. It was particularly here in sometimes less orderly settings that attacks on the state and the bourgeoisie became important components of the more radical speeches, but sometimes also an element of spectacle and ritualized collisions. Over the course of the year 1869 the conflict between the increasingly provocative speakers and the spies and police commissioners, who were also present and disbanded the assemblies as often as not, led on several occasions to tumults.[10]

In May 1870 the right to assembly was annulled. Just four months later, however, as the Second Empire had collapsed in a military debacle, the assembly halls filled again immediately. Gould calls this second discursive opening the "club movement," because the term club spread in the last months of 1870. Clubs were set up in school halls, university faculties, theaters, and finally during the Commune even in churches, and in some cases they even conducted daily (nightly) assemblies. Even though the presence of police commissioners and restrictions of discussion topics were abolished with the Proclamation of the Republic on 4 September 1870, accompanied by the increasing importance of military topics due to the siege by the Prussian army, anti-state polemics remained in the foreground. In opposition to the conservative "government of national defense" under General Trochu, its military failures and the bottleneck of supplies to the capital, in opposition to social inequalities in the face of the increasing intensity of cold and hunger, calls for decentralization and self-government were raised more and more often. In the anti-etatist continuity against the Second Empire and against the "government of national defense," the demands especially for local autonomy became increasingly radical, initially calling for municipal elections and then—with even greater vehemence—as a call for the Commune.

"The clubs and associations caused all that was foul ... I ascribe all the occurrences that took place to the clubs and associations," this was the extent of the impact attributed to the clubs by Claude, the Chief of the Security Police[11] in the phase of the criminalization of the Commune at the end of 1871. Due to their position far from representation and the exercise of power, during the period of the Commune from March to May 1871, the clubs were able to go much further in their criticism than the official organs of the Commune,

so that they were also able to articulate more radical ideas. The density and intensity of the club assembly resulted in the collective understanding of those present that they were part of an urban public, or more precisely, a social context in the quarter.[12] Whereas the class composition seems to have been relatively heterogeneous, the constant was mutual acquaintance from the neighborhood. During the Commune, the main function of the clubs was to discuss specific local interests and economic problems, such as the costs of rent, the soup kitchens or establishing community abattoirs,[13] and all these questions were also taken up by the Council of the Commune.

Whereas the movements of the meetings and the clubs were characterized by heterogeneous class composition and marked by the social relation to the neighborhood in the respective Paris arrondissements, the class-specific networking endeavors of the workers movement also intensified. In 1869 and 1870 there was an increasing number of candidates in the elections from among the workers.[14] Parallel to this, more and more French sections were formed of the International Workers Association, which had been founded in 1864 in London. Beginning in 1864, but more significantly in 1868, there was an increase in the participation in strikes: 20,304 strikers in 1868, then 40,625 in 1869. Beginning in January 1870 the number of strikes and demonstrations throughout the country rose dramatically. Despite the war, there were 88,232 strikers in 116 strikes.[15] At the same time, the differentiation into bourgeois-liberal republican currents and a growing social revolutionary left with many facets became increasingly evident in this period.[16]

"Thus set right for the future, the working men continue the struggle single-handed. Since the re-opening of the public meetings they fill the halls, and, in spite of persecution and imprisonment, harass, undermine the Empire, taking advantage of every accident

to inflict a blow. On October 26, 1869 they threaten to march on the Corps Législatif; in November they insult the Tuileries by the election of Rochefort; in December they goad the Government by the *Marseillaise*; in January, 1870, they go 200,000 strong to the funeral of Victor Noir, and, well directed, would have swept away the throne."[17]

In early 1870 Napoleon was not deposed by the people of Paris, but was instead captured in early September in the Battle of Sedan by the Prussian army, and the Republic was proclaimed on September 4, 1870. Alongside the "government of national defense" the people of Paris consequently created unofficial administration organizations, the "comités républicains de vigilance" (vigilance committees) in the individual districts of Paris. Each of these bodies delegated four representatives to the "comité central des 20 arrondissements." The municipal authorities installed from above were thus to be countered with a control body organized from below, which exercised "vigilance" with regard to the external military threat and the internal monarchist threat at the same time. The concrete tasks of the committees involved the distribution of food rations, the election of the district chairman and arming the battalions of the National Guard in the respective district.[18] The formation of the battalions of the National Guard from each district and the necessity of creating a network among them finally (in February 1871) led to the formation of the "Féderation de la garde nationale" and its central committee delegated from below in the realm of the National Guard as well.[19]

Whereas Marx and later the Marxist-Leninist tradition bemoaned the immaturity of the socialist ideas of the time, the weak organization and the influence of Proudhonists, Bakunists, Blanquists and Jacobins, it was exactly this myriad of political currents that

shaped a new quality of the movement around 1870. The most contradictory revolutionary ideologies and programs ran through not only the clubs and assemblies, but also the concepts of their protagonists. Although the new urban publics had already existed for some time, before the liberalization of the right of assembly they were harmless or clandestine discussion circles that now became hotbeds of revolutionary propaganda. The movement developed so rapidly and so widely, specifically because there was *no* unified party apparatus, *no* unified ideological line. Instead, revolutionary micropolitics developed spontaneously, local committees and council-like systems were founded, and expanding grassroots movements arose everywhere. Specifically this element of domestic politics was also crucial for the situation, from which Napoleon III sought to save himself with the war against Germany: resistance and constituent practice were already there in the 1860s *before* the concatenation of international war, national civil war and again international war.

Insurrection as the mass component of the revolutionary machine is indeed also a component of the Commune, but before March 18, 1871. A situation of insurrection can already be noted on September 4, 1870, following the capture of Napoleon.[20] In Paris this led to the proclamation of the bourgeois Republic, and in Lyon, Marseilles and Toulouse even to the proclamation of communes, which were quickly suppressed, however, by the "government of national defense." Major demonstrations took place in Paris on September 22nd, October 5th and October 8th propagating the Commune.[21] On September 28th the Bakunists occupied the Hôtel-de-Ville, but were driven out by a bourgeois battalion of the National Guard. Subsequently there were several uprisings that were violently suppressed by government troops. On October 31st worker battalions of the National Guard occupied the Hôtel-de-Ville and set up a

Comité de salut public under Blanqui;[22] on November 1st/2nd revolutionaries in Marseilles and other cities proclaimed the Commune,[23] and on January 21st/22nd a large-scale demonstration was violently dispersed by National Guardists in front of the Hôtel-de-Ville in Paris.[24] There were a number of smaller uprisings in between, which are to be seen in conjunction with the course of the German-French war on the one hand, but which also placed the call for the Commune more and more clearly at the center of their demands.

In comparison with these ongoing and bloody conflicts (more than fifty people were killed on January 22nd,. for instance), the date of the Proclamation of the Commune was a more unspectacular event and less of a rupture. Following general elections on February 8th, resulting in a monarchist-bourgeois majority and a government under Adolphe Thiers, and following the exodus of the army and administration apparatus of Thiers' government to Versailles, the Commune was almost inevitable. "All contemporaries noticed the special character of March 18th. On the one hand, in the Paris of March 1871 there was nothing of that which had marked the previous uprisings: parades and marches, bloody conflicts, battles over barricades, acts of violence.... On the other hand there was no preparation on the part of the people, no appearance of well-known personalities."[25]

In the days before March 18th there had been repeated provocations against Paris on the part of the National Assembly that had relocated to Versailles. Support payments for the National Guard were halted, the compulsory moratorium on rents, which had been introduced during the war, was annulled, the most important daily newspapers were prohibited, and finally, the revolutionary protagonists Blanqui and Flourens were condemned to death in absentia. Nevertheless, no mass uprisings followed these affronts from the departed government; the founding of the Commune is not to be

regarded as an insurgency, but rather as an almost non-violent, constituent act with a relatively contingent date: the 18th of March was an act of disobedience, a rebellion against the—renewed[26]—attempt of the Versailles army to confiscate and remove the cannons of the Paris National Guard. This last provocation finally triggered the occupation of public buildings—which had already been abandoned by the government, the National Assembly and the administration.

The insurrection of the people of Paris corresponds to filling a double lacuna: the concretely evacuated public buildings in Paris matched the political vacuum left by the exodus of the state personnel. Rosa Luxemburg described this vacuum as an exceptional case: only in the case of the Commune "the proletariat did not obtain power after a conscious struggle for its goal but power fell into its hands like a good thing abandoned by everybody else."[27] This statement is both true and false at the same time: it is true that the exodus of the government first resulted in the possibility of an uprising without violence, but the formulation "power fell into its hands" is false. Here Luxemburg also echoes of the tendency to constrict the long duration and the components of the revolutionary machine to the one-dimensional revolt. Hannah Arendt reversed Luxemburg's argument (the Commune as exception) and used the same formulation to introduce the contrary generalization that "power virtually falls into the hands" of all real revolutions, that they "only pick up the power of a regime in plain disintegration."[28] The revolutionary machine flows specifically where the authority of those in power is completely discredited, where the offices and streets are literally abandoned, into the vacuums that it fills with something new. The image of filling lacunae is appropriate, as long as it does not impute heteronomy or pure coincidence to the movement: the conditions for this vacuum were first created during the months of demands for

self-government and the Commune between September 1870 and March 1871, specifically through a constant intensification of all three components of the revolutionary machine.

Civil war and revolt are the wrong categories for March 18, 1871 in any case: no bloody confrontations, no acts of violence, no barricade battles. The Commune was not the quick result of a purposeful battle of the proletariat. The Situationist interpretation seems more apt, according to which the Commune is described as an anarchic, militant festival spreading through the everyday life of the people of Paris.[29] This Situationist conceptualization of the Commune as the "biggest festival of the nineteenth century" implies neither its trivialization as a spectacle nor its glorification as a transgressive act. "The vital importance of the general arming of the people was manifested practically and symbolically from the beginning to the end of the movement."[30] Militancy here is not the act of transgression on the part of a few, but rather the result of the widespread arming of the Paris National Guard, in part also of the women, with guns and cannons, specifically *in addition to* the regular troops. While the populace was armed against the siege by German troops, it turned against the French government troops.

Henri Lefebvre's flowery interpretation of the Commune as festival[31] had some influence on the further reception of the Commune around and after 1968[32] and it exemplifies a problem that applies not only to representations of the Commune. From Bakunin's enthusiastic report of the 1848 February Revolution in Paris as a celebration with no beginning and no end to Hardt/Negri's interpretation of the counter-globalization protests as carnivalesque street festivals,[33] the more or less poetic attempts to evoke the movement of the revolutionary event mimetically in the representation tend more to indicate a lacuna—if not in reference to

the lack of concrete reports and experiences, then more fundamentally to a structural impossibility of representation. They remain impossible representations of the unrepresentable and regularly tend to cover up the paradox in this with metaphors and topoi of movement and transgression. The revolutionary machine of the Paris Commune was less a case of transgression or a large step from one world to another, than a *militant* festival and a continuous movement articulating constituent power. Insisting on the quality of the Commune as festival especially indicates the development of its "own terrain," radically experimenting with forms of social organization.

When Kristin Ross attributes a "semi-anarchistic culture"[34] to the Commune, behind this rather dark term there is perhaps the double structure of what constituent practice or constituent power meant in the Commune. On the one hand, Ross's remark underscores the tendency to reduce political representation radically to a minimum in every context; the constitutional process and the work of the Council of the Commune, for instance, stand for this as a form of organization of a radical democratic and collective government without a chief. At the same time, however, it also refers to the manifold attempts to develop non-representationist practices in the activist and discursive work of political clubs, collectives and assemblies of the people, in spontaneous gatherings, on the street, and finally in the defense of the Commune on the barricades. In the specific case of the Commune these two aspects of constituent power do not necessarily need to be understood as an antagonism (of radical democracy and something which lies beyond), as a break between communism and anarchism or as a dialectic of spontaneity and organization. Instead, specifically in the maximum extension of both poles, they have the impact of radically opening the state apparatus *and* organizing the war machine.

THE ORGIASTIC STATE APPARATUS:
SHATTERING REPRESENTATION

TO THE EXTENT THAT it attempted not only to prevent the restoration of the monarchy, but also to go beyond the concept of representative democracy and to radically reduce the aspects of representation to a minimum, the Commune can be understood as an experiment of working on the form of the state apparatus. Deleuze explained this movement using the distinction between "organic" and "orgiastic" representation: organic representation means the subordinating of difference to identity, establishing a harmonious organism and a hierarchical organization; orgiastic representation means subjecting the principle of representation to permanent unrest, allowing no place of peace and order, extending representation all the way to the greatest difference and the smallest difference.[35]

The time that the Council of the Commune had for its measures was extremely brief. These measures, which Lenin called the "minimum program" of socialism,[36] were by no means minimal, however. They refer to the attempt to extend representation into the orgiastic, on the basis of the aforementioned political vacuum, without an overall ideological model, without a finished program, not merely to *reform* the state apparatus, but to *form it anew*.

"But the working class cannot simply lay hold of the ready-made state machinery, and wield it for its own purposes."[37] In his text in defense of the Commune, written during the time of the Commune and published in June 1871 as an address to the General Council of the International Workers Association in London, Marx condemned the idea of simply taking over the bourgeois state, particularly in light of the concrete experiences of the Commune; centralized state power with all its organs ordered according

to function (standing army, police, bureaucracy, clergy, and judicature) was the organizational form of the bourgeoisie, first used as a powerful weapon against feudalism, but after the deployment of the "gigantic broom of the French Revolution of the 18th century" more and more as an instrument against the working class: "At the same pace at which the progress of modern industry developed, widened, intensified the class antagonism between capital and labor, the state power assumed more and more the character of the national power of capital over labor, of a public force organized for social enslavement, of an engine of class despotism."[38] How should this "engine," developed by the state apparatus of the Second Empire, be dealt with in a revolutionary situation? In his text on the Commune Marx speaks of the "destruction of the state power" and of the quality of the "new Commune, which breaks with the modern state power."[39]

The radical imperative of necessarily breaking with the state turns primarily against those who think that the state apparatus is something neutral that only needs to be operated well and democratically. The formulation of Marx's Commune interpretation, however, does *not* revolve around exchanging the personnel, in other words a simple takeover of power, nor of feeding the state apparatus with other contents. It revolves around the radical reinvention of the *form* of political organization. In this sense and contrary to later interpretations of the Commune as a dictatorship of the proletariat by Engels, Lenin and other theoreticians,[40] the focus of interpretation should be on the Marx passages stressing that "the old centralized government would...have to give way to the self-government of the producers."[41] Marx sought to learn from the Commune how self-government replaces the state apparatus. "The very existence of the Commune involved, as a matter of

course, local municipal liberty, but no longer as a check upon the now superseded state power."[42]

In the two-month practice of the Paris Commune, it becomes clear how the state apparatus was specifically not simply taken over, the actors not merely exchanged, but how structural interventions were undertaken in the vacuum of the evacuated and orphaned state apparatus. In a probing motion of trial and error (which probably resulted in the undoing of the Commune at the military level), the conditions of this vacuum were used to press forward into the new territory of a different political organization. The Central Committee of the National Guard had already been constituted (definitively constituted on March 15th; from March 18th until the official invocation of the Commune on March 28th it was effectively the transitional government) through a precondition that was crucial in this context: by the election of delegates from below, which was highly unusual for military conditions. Marx was not the only one to criticize how quickly the Central Committee turned over power to the Council of the Commune elected on March 26th,[43] but it was a necessary step in the direction of a radical democratization, because the Central Committee had not been elected as an organ of government, but rather to coordinate the National Guard. "We say to you the revolution is made; but we are not usurpers. We wish to call upon Paris to name her representatives," as one member of the Central Committee is quoted,[44] thus affirming the passage to the Commune as a practice of orgiastic representation permanently working on its organizational transformation. "What indeed could be said against this new-born power whose first word was its own abdication?" asks Lissagaray.[45]

The implicit program of the Council of the Commune, which took office on March 28th, aimed to push back the logic

of representation to the smallest degree, to contrast the abstract hierarchical system of the bourgeois state with a practice of exchange, in which representation was understood as a constant oscillation between representatives and those represented. How did they attempt to implement this constant minimizing of the logic of representation in reality? First of all, the constitution of the Council of the Commune was based on the possibility of divestiture at any time, on direct responsibility and on the imperative mandate of the delegates. "The Commune was to be a working, not a parliamentary body, executive and legislative at the same time,"[46] wrote Marx, disassociating it from parliamentarism and from the decoupling, autonomization and segmentation of the administrative apparatus at the same time. The "social republic"[47] of the Commune, unlike parliamentary democracy, should not need a "separation of powers," but instead ensure the execution of the resolved measures with the help of its commissions and delegates.

In addition, the consistent necessity of election, the possibility of divestiture, and accountability were introduced for all officials. Not only the delegates of the Commune, but also the functionaries from the National Guard, the police, and altogether all the officials were to be elected from below. To prevent the formation of new elites, resolutions were passed on the salaries of the delegates and officials allowing them only average wages.

Historiographers with a favorable view of the Commune lamented the fact that the majority of the officials left their posts when the government departed for Versailles; some of them regarded this as a mistake on the part of the Commune that not only the army but also the officials were allowed to escape. Lissagaray, for instance, objects that in the course of earlier revolutions, the revolutionaries found the administrative apparatus intact, "in readiness

for the victor. On March 20th the Central Committee found it taken to pieces."[48] Presumably, however, it is precisely this aspect of the ghostly parallel evacuation that is a main reason for the model-like character of the Commune as an example of orgiastic representation: both the political representatives and the executives of the bureaucratic administration apparatus left the city, leaving behind them a ghostly emptiness in the assembly rooms and offices. Along with the competencies of the personnel, to a certain extent the form of the apparatus left the city too: reinventing the apparatus became a necessity. It was the exodus of the officials that first cleared the way so thoroughly for the first steps toward an alternative approach to administration, which was necessarily pushed forward in a time of growing military threat: "Taxes, street inspection, lighting, markets, public charity, telegraphs, all the respiratory and digestive apparatus of the town of 1,600,000 souls, everything had to be extemporized."[49] *Extemporize*, this term corresponds to the point of intersection in the Marxian concept of the shattering and non-takeover of the state apparatus and that of orgiastic representation. And the "marvellous elasticity" of "our Paris" proved to be an amenable field of experimentation for this: "[T]he most important services were set to rights in no time by men of common sense and energy, which soon proved superior to routine,"[50] wrote the same Lissagaray, who then proceeded to criticize the numerous defects and the limited extent of the measures implemented by the Commune a hundred pages later.

In terms of economic affairs a process took place that was essentially analogous to the reorganization of administration and government: what was left was occupied and filled not only with new ownership, but also with new forms of organization. Instead of authoritarian revolutionary measures in the question of the

ownership of means of production, in other words instead of a rigorous policy of dispossession, the Commune limited itself to transferring the businesses that had been abandoned by their owners to the workers and their cooperatives. The analogy between economic and political procedures falters, though, where it is clear that the state apparatus was abandoned as a whole and could therefore be fundamentally reorganized, whereas this was not the case in the question of ownership structures. It was obviously not as simple to take hold of the infrastructure of capital as of that of the state apparatus. In this sense, the criticism of the Marxist interpreters of the Commune is right: the scope for workers to try out self-management was relatively limited. The Commune's abstemiousness in only hesitatingly appropriating economic resources reached its negative climax in the vacillating behavior of the appointed commissioner of the Commune, Charles Deslay, in dealing with the assets of the National Bank.[51]

Finally, the movement of newly filling and newly forming in the wake of an exodus of old contents and old forms was also similar, to a certain extent, in military affairs. The very first measure of the Commune consisted of doing away with the standing army. "Paris could resist only because, in consequence of the siege, it had got rid of the army, and replaced it by a National Guard, the bulk of which consisted of working men. This fact was now to be transformed into an institution. The first decree of the Commune, therefore, was the suppression of the standing army, and the substitution for it of the armed people."[52] However, this undertaking was not quite as radical as Marx describes it here, but rather the abolition of the standing army was more of a legislative confirmation of the status quo. Indeed, the National Guard was not first founded because of the withdrawal of the government troops, but

instead had a long history—including the suppression of uprisings and strikes by the government troops since the 1850s—that also substantially influenced the course of the political developments in the year of the Commune.

Accordingly, the conflicts were inevitable that weakened the dual and principally incommensurate decision-making system of the Council of the Commune and the Central Committee of the National Guard in military issues in the face of increasing pressure from Versailles.

At the same time, the tendency for military issues to become predominant set the boundaries of the Commune as an orgiastic state apparatus. The Council of the Commune attempted to conjoin dissent and transparency with public meetings, but this question soon became a point of contention between the majority and the minority in the Council and reached its pinnacle with the appointment of a *Comité de salut public* (Committee of Public Safety). What Marx wrote about the publicizing practice of the Commune really only applied to the first weeks. "But indeed the Commune did not pretend to infallibility, the invariable attribute of all governments of the old stamp. It published its doings and sayings, it initiated the public into all its shortcomings."[53] In fact, an internal battle broke out within the Council within only a short period of time, between the centralist Jacobini/Blanquists (the "majority," who finally insisted on the introduction of the *Comité de salut public*) and the anti-authoritarian wing (the "minority," comprising mostly—essentially Proudhonist—members of the International), over just this question of transparency, specifically over the meetings of the Commune being open to the public and the publication of dissent. In addition, the relationship between the representatives and those represented developed more

and more into a separation toward the end of the Commune and the incipient attempts of orgiastic representation were lost in the chaos of the barricade battles.

However, Marx's formulations of breaking with the state power and the Commune as a local self-government of producers clearly indicate the advanced development of an "orgiastic state apparatus." At the same time, these terms indicate an astonishing approximation of two ideological directions that had already been battling for years for predominance in the workers movement, the communist and the anarchist camps. While Marx was interested in the revolutionary development in France from the beginning (although he initially took a very critical view, it turned into vehement support when the Commune was proclaimed), Michail Bakunin also attempted to intervene in the course of the French uprisings in 1870/71 with his activist-discursive means. This overlapping of sympathy with the Paris struggles on the part of the—otherwise antagonistic—positions within the First International also corresponds to the way that the ideological positions of Marx and Bakunin briefly moved closer to one another. The brief congruence that was untypical of both adversaries was probably due primarily to the situation that necessitated an affirmative interpretation of the Commune beyond all ideological differences for the International. What it also demonstrates, though, is the situation that was as yet undecided at that time between communist and anarchist positions, in other words a point of reference, in a sense, that conjoined the problems of opening the state apparatus with those of organizing the war machine.

The members of the socialist "minority" in the Council of the Commune were mostly Proudhonists, in other words societary-anarchistically influenced, and it was probably also this reality of

the Commune that led Marx to emphasize the significance of what was later to be called direct council democracy, declaring that it was less a case of the state in transition dying out, but rather a break-up of the state and naming a "separate power" that takes the place of the state. "The *Commune*—the reabsorption of the State power by society as its own living forces instead of as forces controlling and subduing it, by the popular masses themselves, forming their own force instead of the organized force of their suppression—the political form of their social emancipation, instead of the artificial force…of society wielded for their oppression by their enemies. The form was simple like all great things."[54] What is important about this formulation is the consequence that something *different* follows the break-up of the state, something that—as Engels added—"was no longer a state in the proper sense of the word."[55]

"The administrative and government machinery of the state has become powerless and is to be abolished," declared Article 1 of the Proclamation of the Revolutionary Federation of the Communes from 26 September 1870. This formulation is based on Bakunin in association with the failed revolt in Lyon. And similar to the way Marx finished "Civil War in France" as early as June 1871, Bakunin wrote "The Paris Commune and the Idea of the State" from his diary notes at about the same time. "I am its supporter, above all, because it was a bold, clearly formulated negation of the State."[56] The negative foundation that Bakunin had in common with Marx in "Civil War in France:" the social revolution aims to break with the state, which was for the one "a vast slaughterhouse or an enormous cemetery"[57] and for the other a "huge governmental machinery, entoiling like a boa constrictor the real social body in the ubiquitous meshes of a standing army,

hierarchical bureaucracy, an obedient police, clergy and a servile magistrature."[58]

Unlike the clear picture that Bakunin draws, specifically in his Commune text, of the difference between "revolutionary socialists" / "collectivists" and their strategy of developing and organizing not political, but rather social power on the one hand, and the "authoritarian communists" as supporters of the absolute initiative of the state on the other, the concrete evidence of the revolutionary machine in the case of the Commune seems to leave the various interpreters of the Commune relatively little scope for distinctions.[59] "The Commune sprang up spontaneously. No one consciously prepared it in an organised way,"[60] as even Lenin said forty years later, not entirely in keeping with Bakunin's picture of authoritarian communists either. As such, he would have to have seen the social revolution of the Commune—like later Marxist-Leninist historians—as being consistently decreed and organized by a dictatorship, not as being made by the "spontaneous and continued action of the masses, the groups and the associations of the people...it is exactly this old system of organization by force that the Social Revolution should end by granting full liberty to the masses, the groups, the communes, the associations and to the individuals as well; by destroying once and for all the historic cause of all violence, which is the power and indeed the mere existence of the State..."[61] Bakunin, for his part, moved closer to the positions of Marx and Engels in 1871, when he stressed the necessity of a long-term process of organizing the workers movement in several passages. This relates to Bakunin's experience with the revolts in other French cities, which even from his anarchist perspective failed due to a lack of organization.

WAR MACHINES:
ORGANIZING BEYOND REPRESENTATION

> "This [the Commune] was, therefore, a revolution not against this or
> that, legitimate, constitutional, republican or imperialist form of
> State power. It was a revolution against the State itself, of this super-
> naturalist abortion of society, a resumption by the people for the
> people of its own social life." — Karl Marx [62]

SOCIETARY ANARCHIST CURRENTS and social revolutionary actors
did not foreground merely spontaneous chaos and confusion around
1870, but instead attempted to address the question of organization
from a perspective of revolutionary politics that tended to be non-
representationist and oriented to action. In the everyday life of the
Commune there were numerous examples of these kinds of attempts
to go beyond the principle of representation and yet not dispense with
organization. Alongside the attempted movement of opening up the
state apparatus, a second line beyond representation emerged in the
non-structure of the everyday meetings of the quarter committees, the
neighborhood assemblies, the political clubs, the women's clubs, the
sections of the International, the people's societies, but also the wild
forms of public dispute in urban Paris with its site-specific aspects
ranging from the proclamation to the barricades.

In relation to the implacable course of history, according to
Kristin Ross the Communards were "out of sync:" "Like adolescents
they are moving at once too fast in their unplanned seizure of power
and too slowly." [63] However, this image of adolescents tumbling
through a window in time should not be too hastily interpreted in
terms of chaos, confusion and disinformation. [64] It was because of

being out of sync, or rather not being bound to the synchronization line of linear time, that they succeeded in inventing new networks and communication systems in the midst of the disintegration of everyday life due to the siege of Paris. It was not least of all the women of the Commune who played a role in this context, which goes far beyond the clichés of the "red virgin," the "pétroleuses," the "wild women" and the allegorization of woman as "Revolution," "Commune" or "Freedom."

"A helpmeet in labor, she will also be an associate in the death-struggle;"[65] however, she was not allowed to vote. One of the blind spots of the French revolutions was the exclusion of women from universal suffrage.[66] Despite Olympe de Gouges' "Declaration of the Rights of Woman and the Female Citizen" that was published as early as 1791, despite the revolutionary women's clubs and attempts to organize around 1848, despite Jeanne Deroin's candidacy for the constitutional assembly in 1849, women were not yet permitted to take part in elections in the 19th century—in fact, not until 1944 in France. In the long lethargy of the Second Empire, the struggle for women's rights, especially for women's suffrage, seemed largely to have suffocated. Louise Michel wrote about this period in her memoirs: "Political rights are already dead. The same level of education, commensurate wages in women's professions, so that prostitution is not the only profitable business that was what was real in our program."[67] The main thrust of organized women's groups in the Commune was to reform the educational system and to improve the working conditions of women, while forgoing the demand for women's suffrage.

The women of the Commune had not forgotten the demands of their revolutionary predecessors nor dismissed them as being reformist and thus irrelevant. In the context of the Commune, though, the impossibility of political participation seems to have

given greater weight to the battles *beyond* the sphere of their exclusion, in other words beyond the sphere of politics of representation, in which they were denied active and passive suffrage. From their involvement in the mobilization against the bourgeois republic to their interventions on March 18th to the final days on the barricades, specifically as those excluded from directly influencing the state apparatus in any way, the women impelled the Commune on the side of the war machine, the spontaneous actions, the grassroots assemblies, and finally the barricade battles. This means that the importance of the women in the context of the Commune is not limited to the most famous protagonists, whose names have been passed on to posterity, such as Louise Michel, Sophie Poirier, André Léo, Paule Minck or Elisabeth Dmitrieff, nor to the purely quantitatively strong participation of women in the battles, but is instead due most of all to the specific type of their resistance and the forms of organization that resulted from the status of exclusion from the representative forms of politics.

On the one hand, because of the economic and military circumstances women appropriated public spheres, from which they had previously been excluded.[68] From September 1870 to February 1871 the city was besieged by Prussian troops and under an extensive blockade. Consequently the men were fixed on shoring up defenses, while at the same time there was an extreme scarcity of supplies in the coldest period of the year. The women were constantly moving in the public space of the city to organize the procurement of heating material and food. In addition, the state of emergency cancelled out gender-specific stereotypes, which would otherwise have hindered the women's activities in the public sphere: where every hand is needed, essentialist speculations about the "natural" limitation of women to certain roles become superfluous. The concrete link between questions

of the survival of families and the political events, the immediately tangible interplay between war, internal politics and everyday life left no room for women to retreat into the "private sphere."

As a result of economic constraints and necessities, countless cooperatives and neighborhood groups formed in the arrondissements and quarters, in which women played an important role. At the same time, these cooperatives were also the foundation for the work of politically oriented women's organizations. The settings of the soup kitchens and infirmaries traditionally dominated by women were ideally suited for conducting agitation for revolutionary ideas and organizing workers, even during the period of the siege.

While the clear exclusion from suffrage was maintained, there was a reorientation in the 1860s on the part of the organized French workers' movement away from a strictly anti-feminist or even sexist Proudhonism[69] in the direction of a somewhat more open attitude toward politically active women. After the assembly prohibition was annulled in 1868, numerous conferences, lectures and discussions were organized, mostly in Paris, on the question of women's rights.[70] The politicization of women as a process of becoming visible in the form of a public presence of women went hand in hand—although somewhat laboriously[71]—with the thematization of discrimination. This resulted in a greater sensitivity on the part of previously male-dominated groups and publics, including the Paris sections of the International Workers Association, which otherwise carefully avoided the question of women's rights. Here and there women even infiltrated men's clubs and workers organizations. The majority of the politically active women did not take a dogmatically socialist stance. They preferred molecular variants of revolution, were decentrally organized in numerous political clubs, vigilance committees and informal women's groups, which ultimately

assumed a mediating role between the Council of the Commune and the concerns of those not represented.[72]

In a way, these non-representationist activities can also be seen as a pragmatic feminist version of deflecting the fixation on the state apparatus and its takeover. Louise Michel, who became an anarchist propagandist following the Commune and banishment to New Caledonia, affirmed this in her memoirs: "Again: calm down, gentlemen, we need no legal grounds to take over your offices when it suits us! Your privileges? You don't say! We don't want old trinkets; do with it what you will; for us it is too patched and constraining. What we want is knowledge and freedom."[73] The feminist practice of the Commune countered the desire of taking over state power by testing alternative forms of organization. Marian Leighton even suggests an "unofficial and unrecognized revolution in the revolution" in this context, which often deviated from the structures of representation solely occupied by men.[74] Women were thus able to take increasingly radical positions at the end of the Commune, also in military matters. In a manifesto written and signed by the women associated with Louise Michel, war was declared against all endeavors to end the battles with the government troops through reconciliation: "…we, the women of Paris, will show France and the world that like our brothers we will give our blood and our lives on the barricades, on the walls of Paris, when the reaction breaks open the doors, in the moment of greatest danger for the defense and the triumph of the Commune, of the people!"[75]

Most relevant to the public presence and increasing visibility of the women was the successive liberalization of the right of assembly in the years before the Commune. Beyond this, the liberalization of press laws was additionally significant for the emergence of public spheres. The liberalization of the press laws had already begun in

1868, but in September 1870 the entire system of censorship collapsed, resulting in a period of testing all possible media. Most of all, countless newspapers were founded, which were less interested in influencing broad public opinion than in respectively being a mouthpiece for diverse political positions. Marxist historians were even tempted to say that there were *too many* newspapers; it was notable, however, that even the explicitly bourgeois press did not have to cease publishing with March 18th. No newspaper was the organ of a party. The more important papers, such as *Le Mot d'Odre*, *Le Cri du Peuple*, *Le Vengeur*, *Le Père Duchêne*, were published primarily by intellectuals, who had developed revolutionary positions from the tradition of the Second Empire. In addition to considerable space for letters to the editor, which had substantially more of the character of information from correspondents at that time and related the most recent developments from the Paris battles, there was also room for reports and demands from the clubs, sections and unions.[76]

However, newspapers represented only *one* important form of media in the public spheres of the Commune. Political posters, notices and announcements marked the face of the city; roughly 4000 lithographs were created in the period from September 4, 1870 to the suppression of the Commune at the end of May 1871.[77] The publicly posted caricature was a medium that especially accompanied the process on the way to the Commune, as a "form of intercourse tied to the organization process and the political struggles."[78] Kristin Ross has pointed out the connection here between illiteracy and the spread of caricatures and posters throughout the area of Paris, the significance of the politics of "instant information" for a population of illiterate people and those who could not afford to buy newspapers.[79] The speed of the revolutionary development was sometimes so fast that newspapers could

hardly keep up with it; this was another reason for the huge number of "murailles politiques," announcements, denunciations, political posters and proclamations that were often read out loud when people gathered in the street.[80] The announcement of decrees through posters and the commentaries on political events through caricatures were not only suited to ensure rapid dissemination, they also marked the displays of everyday life, especially the public space of the city. In this way they were also part of non-representationist public spheres, which consisted less and less of the classical parades and marches of the National Guard (and thus the occupation of central public spaces as successor to the Greek agora), but were instead constructed through the appropriation of various specific, sometimes ephemeral locations in the city, which were temporarily occupied.

Kristin Ross' image is apt here too: the Communards were, in fact, "out of sync," not to be contained in a single grid of time. Sometimes they moved at high speed, as in the dérive-type practices of distribution in the city, everywhere that people gathered briefly, listened to announcements, read posters and discussed the situation; sometimes, though, they were slowed down to an extreme degree by the long disputes and working through conflicts in the more or less grassroots assemblies. The Commune took place in the streets and in the places of assembly and naturally on the barricades. And even in the final days, this discursive and activist distribution in space was still carried out alongside the military battles. In this sense, the revolutionary machine of the Commune was, contrary to Marx's words, less "the glorious harbinger of a new society,"[81] but rather it was this "new society" already: as ongoing resistance, as recurrent insurrection, and finally as constituent power, through which the state apparatus is extended into the orgiastic and the war machine organizes itself.

4

The Courbet Model.

Sequential Concatenation: Artist, Revolutionary, Artist

"... A TIME WHEN ART AND POLITICS could not escape one another,"[1] this is how the ex-Situationist and social historian of art Timothy J. Clark begins his monograph on Gustave Courbet, and at first glance it seems apt for establishing the connection between the revolutionary machine of the Commune and Courbet's artistic /art-political practice. Yet there are two things that do not fit here. For one, Clark is not writing about the older Courbet as Communard, but about the young Courbet around 1848 (who did not actively take part in the Revolution, but at least drew the cover picture *La Barricade* for the short-lived paper of his friends Baudelaire and Champfleury, *Le salut public*),[2] and for the other, in our context—almost contrary to Clark's introductory statement—Courbet is to exemplify the conditions, under which art and revolutionary politics tend to be mutually exclusive, to follow one another in a sequential logic. In the Courbet model, art and revolution are obviously not only able to escape one another, but each actually conditions the exclusion of the other.

In her Rimbaud book, Kristin Ross also takes over Clark's romanticizing formula of the wild marriage of art and politics, of the disappearance of the separation between political and aesthetic discourses.[3] This kind of dissolution of the boundaries (including

the less spectacular art-immanent boundaries of art genres and the distinction between art and crafts, high art and reportage, etc.)[4] would be an over-interpretation after the fact, however, constructed from the shifted perspective of art practices and art policies of the 20th century.

When Clark describes the "artist as opponent" as Courbet's intention with regard to his profession,[5] Courbet's biographical reality at the time of the Commune does not correspond to this aim as an overlapping of the aesthetic and the political, but rather precisely as an incommensurable transformation of the one into the other (and vice versa), as a strict succession of being artist, then political activist and then artist again. Courbet as an exemplary artist-revolutionary thus does not exemplify the overlapping of art and revolution, but rather the rapid succession of the roles of artist and revolutionary politician. Art was suspended in the Commune. The specific tools of art were not employed and further developed in the concrete revolutionary situation, but packed away for the duration of the Commune.[6]

Two fundamentally different strategies led to this silence of art in the Commune: for one, many artists such as Pissarro, Cezanne, Manet or Monet withdrew from Paris to the countryside, to England or into various forms of inner emigration for political or personal reasons. For the other, those who chose to stay in Paris and fight on the side of the Commune devoted themselves, with few exceptions, entirely to political tasks. Between September 1870 and March 1871 Courbet advanced successively to become a committed cultural functionary and art politician; in April he even became a member of the Council of the Commune. Then, after the defeat of the Commune, in the period of the political persecution of the Communards, he took up his artistic work again.

Clark's emphatic description of Courbet transgressing the fields of art and politics in the Commune correlates, to a certain extent, with its complementary negative: in the popular art history writing of Marie Luise Kaschnitz, for instance, the account of Courbet's *artistic* quality withering away complements the denunciation of his subsequent *political* role as "pitiful and unfortunate," resulting in an "artistic and personal decline and downfall,"[7] and it is notable that this downfall is not located in the period of Courbet's persecution by Thiers' administration, but already before 1870. Even in the most progressive art studies discourse, this figure persists, at least in being conspicuously left out: in his Courbet monograph T. J. Clark neglects the *Communard* Courbet, as "Courbet's decline"[8] purportedly began as early as 1856. Clark affirms and in fact even constrains the dominant art historical image of the Second Empire as being Courbet's "period of real creativity."[9] This omission of Courbet's time in the Commune is strangely in harmony with Clark's art studies antipode Michael Fried, who forced Courbet, the inventor of "realism," against the grain into his depoliticizing aesthetic concept.[10]

Gustave Courbet's development was ruptured and erratic in many ways, from early engaged art to radically subjective pictorial provocations, from the early self-portraits through the initial scandals of socio-political and later socialist influenced pictures, such as *The Stone Breakers, Funeral in Ornans, Return from the Conference,* or *A Beggar at Ornans,* through the representation of nudity and lesbian sexuality widely perceived as offensive in the pictures *The Bathers, Venus and Psyche* and *Sleep,* to the hunting and sea pictures and the self-portrait in the prison of Saint-Pélagie. This development that took several turns and was significantly influenced by the two revolutionary events of 1848 and 1871, is not the subject here, however. In any case, it can hardly be interpreted as linear in any

way, in terms of rise and decline or in especially remarkable "phases of creativity." As simple as it would be to focus on the central invention and trademark of "realism," Courbet had more than one card in the game at all times.

Courbet's political stance would also be falsely described as a linear process of politicization from the naïve youth from Ornans to the revolutionary Communard. Courbet's friendship with Max Buchon and Jules Champfleury and—initially conveyed through Buchon and Champfleury—Proudhon's political ideas successively affected Courbet's artistic production and reinforced the development of realism as a project. Conversely, Courbet's request for a catalogue preface also led to Proudhon's tract "Du principe de l'art et de sa destination sociale," which was published several months after Proudhon's death in 1865 and ultimately led to greater recognition for the painter in political revolutionary circles. However, just as Proudhon's interpretation of Courbet's works did not unreservedly suit Courbet's taste, Courbet's reading of Proudhon was also somewhat superficial, his political attitude an individual mixture of vulgar socialism and anti-statism. Nevertheless, as a non-conformist, oppositional figure, Courbet's personality certainly marked the art-political wasteland of the Second Empire through idiosyncratic acts with respect to the cultural administration, through spectacular performances and media presence, the technique of scandal in picture production and presentation, and not least of all through his stance of rejecting Napoleonic (cultural) politics.[11]

Against the backdrop of the increasingly populist masquerade of Napoleon III as a "liberal," in 1869/1870 it was possible to impel the culture-political discourse from the non-governmental side: Courbet stepped up both his anti-Napoleonic and his anti-military efforts, organized an exhibition for the benefit of the wives of the

striking workers in the munitions factory of Creuzot, and refused to accept the Cross of the Legion of Honor from Napoleon III, even though he had accepted Belgian and Bavarian medals shortly before that. He justified his refusal with the words: "I do not recognize the right of the state to interfere in art, and I will not ally myself with this state in any way. I am a free artist."[12] Courbet's reservations about the function of the state in deciding on the visibility of new art (not only individual works, but also entire currents) had begun with the rejection of his works by the juries of the Salon, which acted as the main element of official cultural policies in Paris. As his reservations grew even stronger, the result was more intense art-political activity on his part. The painter, who had already conducted offensive art policies with his two counter-exhibitions to the world exhibitions of 1855 and 1867, finally instigated the organization of visual artists in Paris, primarily around the common point of reference of a criticism of state art policies under Napoleon III.

In early September 1870 Courbet was appointed president of the museums and art treasures of Paris by an artist association arising from these contexts. For a "civil society" formation of this kind it was—wholly unlike the early attempts to proclaim communes—possible to receive official sanction very quickly from the bourgeois "Government of National Defense." On September 4th Courbet was confirmed by the government as chairman of the artist association and appointed president of the Art Commission for the Protection of Monuments. Shortly thereafter he moved into the Louvre and worked on preserving the art treasures of Paris from bombardment,[13] as it was especially emphasized in his later defense before the Versailles court, probably for tactical reasons.

In the period from September 1870 to May 1871 Courbet was mainly involved with art policies. Although this tendency certainly

had a revolutionary potential as an exemplary act of gradual politi-cization that starts in one's own field of competence, in the context of the increasingly more radical, anti-statist and anti-capitalist politics of the Commune, it seemed strangely particular and focused on clientele. The limitation of the Paris artists association under Courbet's direction to the improvement of framework condi-tions for art production, a prelude of today's lobby politics on the part of unions and special interest groups,[14] may be explained by Courbet's distance, despite his relationships with Proudhon et al., to revolutionary practice on the barricades and in the assemblies in the quarters. Nevertheless, after his political engagement continued to intensify, he finally became a member of the Council of the Commune[15] following two unsuccessful election candidacies (on February 8, 1871 in the elections for the National Assembly and on March 26th in the regular election of the Commune: here he reached sixth place in his arrondissement, which only had five seats in the Council of the Commune).

Courbet was elected to the Council of the Commune in the supplementary elections on April 16, 1871 and took office on April 23, so that he was a Council member for about a month until the end of the Commune. Not much is known about his activities during this month. The most important aspect of the cultural policies of the Commune probably related to educational policies, with which Courbet was in no way involved. Edouard Vaillant, the delegate for educational affairs, mostly pushed for a radical secu-larization of education. In this context the abolition of the church budget as an aspect of the separation of church and state, the reduction of religious influence on the schools, the removal of crucifixes, madonnas and other symbols, and the opening of secu-lar schools were decreed. In contrast to an idea of cultural policies

that was this broad, Courbet's art policies remained limited to a small frame: to organizing artists and to taking over and reorganizing cultural administration. Courbet did not implement large-scale structural innovations during his time as president of the art commission, nor during his brief period of office as a member of the Council of the Commune, but instead concentrated on smaller reform ideas such as the abolition of the state subsidy for the Ecole des beaux arts or of state exhibitions and acquisitions, which he probably regarded as a source of corruption based on his own experience. Whereas the "Fédération des Artistes du Théâtre" immediately demanded that private theater must be turned over to free artist collectives, propounding the socialist policy of "dispossessing the dispossessors" more radically than the economic policies of the Commune, the federation of visual artists seemed to be satisfied with a defensively corporatist policy primarily concerned with the preservation of cultural heritage.[16]

The assertive side of art policies, in which context Courbet's role is not really quite clear, consisted of the symbolic-political phenomenon of iconoclasm. Since September 4th street names had been assiduously changed and imperial mascots and emblems removed. With the Commune the measures became somewhat rougher. On April 6th the guillotine in the Place Voltaire was burned, before that a small statue of Napoleon was thrown into the Seine from Pont Neuf.[17] However, the debate with the most drastic consequences was the overthrow of the Vendôme Column. The impact of the consequences affected mostly Courbet himself: for "his participation in the destruction of the Vendôme Column" Courbet was initially sentenced by the Versailles court on September 2, 1871 to six months imprisonment and a fine of 500 Francs.[18] In comparison with the sentences of other members of the Commune in the same trial (two

death sentences, two life sentences, seven sentences of deportation), initially Courbet's sentence was relatively light. In June 1873, however, all his property was impounded without waiting for a court order, to be used to reproduce the bronze column.[19] In 1874 the court subsequently sentenced Courbet to a fine of 323.091 Francs and 68 Centimes, ordered the impounding of Courbet's property, and began with the public sale of works and property in late November 1877, one month before Courbet's death in Swiss exile.[20]

How did this come about? Setting up a column in the Place Vendôme had been ordered by Bonaparte in 1803, from 1806 to 1810 it was cast from the metal from 1200 captured Russian and Austrian cannons. According to the initial plans, a small statue of Charlemagne was to be placed at its pinnacle, but then the decision was made for an over-sized statue of Napoleon, who had meanwhile been crowned, as Caesar with an orb and a wreath of victory. The statue was melted down by the Bourbons in 1814; in 1831 Louis-Philippe had a statue of Napoleon as soldier placed on the column, and under Napoleon III the Caesar Napoleon finally returned in 1863 in an even more monumental version to the pinnacle of the column. This meant that it was simultaneously a provocative embodiment of both empires and a sign of colonialist-militarist ideology, and it was the object of—initially—journalistic attacks again and again. As early as 1848 the philosopher Auguste Comte suggested the overthrow of the column, demanding the elimination of "this insult to humanity" or at least the replacement of the Napoleon statue with the originally intended figure of Charlemagne.[21] The war memorial paradoxically in the immediate proximity of the Rue de la Paix was thus part of all oppositional discourses[22] and regarded almost automatically as a provocation, especially in revolutionary times, and an object likely to be toppled.

In allusion to the manifesto of the Paris members of the International addressed to the workers of all nations, but especially to the Germans, who were supposed to join in helping to prevent the German-French war, in October 1870 Courbet published a "Letter to the German Artists." In it he expressed the internationalist-pacifist idea, in reference to Comte, of the "last cannon:" "…Leave us your cannons from Krupp, and we will melt them down together with ours; the last cannon, its muzzle in the air, the Phrygian cap on top, the whole thing set on a postament resting, for its part, on three cannon balls, and this colossal monument that we will erect together in the Place Vendôme, this will be your column, yours and ours, the column of the peoples, the column of Germany and France, which will then be forever united."[23] Courbet proposed countering Napoleon's imperialist gesture of integrating the cannons of conquered armies in his own monument, thus triumphing once again over those conquered with a symbolic act of ingestion, with the vision of a non-violent internationalism in the future United States of Europe. And instead of the emperor, the goddess of freedom was to crown the new pillar.

In Paris the artists association, over which Courbet presided, concretely discussed the idea of moving the Vendôme Column and agreed on this finally for the reason that the column was said to have no artistic value whatsoever, that it made the place where it was standing ridiculous and was an offense to modern civilization.[24] The neologism "déboulonner" (literally to take a bolt out of the machine to make it stop working), which was coined during the Commune, bears witness to Courbet's cautious deliberations about the column. What Courbet wanted was not to topple and smash the column, but rather to take it apart and move it, for which he soon became known as a *déboulonneur*. Along with several other ideas, he suggested

the forecourt of the Invalides as a place to move it to. "There at least the invalids could see where they got their wooden legs."[25] These kinds of proposals and their published communication served to spread and intensify the discussions, which ultimately led to a decision by the Council of the Commune. Whereas more cautious positions were taken in the discussions among the artists about what to do with the column, the decision in the Council of the Commune was one that was both popular and essentially determined by symbolic political considerations. It may be that the decision itself was actually more tumultuous[26] than the overthrow of the column, which has been erroneously handed down as a tumult.

On April 12th, *before* Courbet became a member of the Council of the Commune, the Council came to the decision to topple the column. "In consideration of the fact that the imperial column in the Place Vendôme is a monument to barbarity, a symbol of brutal violence and false glory, a hymn to militarism, a rejection of international law, a permanent insult to those conquered by the victor, a perpetual attack against one of the three great principles of the French Republic, namely fraternity, the column in the Place Vendôme is to be destroyed."[27] The anti-militarist and internationalist argument for destroying the column is actually in keeping with Courbet's idea of the anti-war monument, except that a realization of this monument was out of the question following the execution of the decision of the Council on May 16th. Later, after the fall of the Commune, Courbet reported that he had done everything within his power to prevent the execution of this decision.[28]

On May 16th huge crowds gathered at the Place Vendôme that was blocked off by National Guardists, and in the neighboring streets. Lissagaray recounts technical problems (the "lukewarmness of the engineer," who had already been commissioned with coordi-

nating demolition work and protecting the surrounding buildings on May 1st) in carrying out the expensive ("almost 15,000 francs") undertaking.[29] Following two unsuccessful attempts, the gigantic column was finally toppled,[30] the people cheered and tried "to divide among themselves the fragments of the column."[31] It seems that the event had altogether the character of a spectacle and public celebration with marching music, speeches, the Marseillaise and red flags.

The demolition of the column was subsequently interpreted as a collective, heroic anti-hierarchical act, as a spontaneous and self-organized reappropriation of space.[32] However, the overthrow of the Vendôme Column was an "attack on verticality" in a completely unmetaphorical way: namely in the sense of a literally toppled pillar. It was not a spontaneous performative gesture emerging from the productive force of a constituent power, but a well organized, symbolical mass event of an already constituted power continuing a long tradition of vandalism of the column with a grand gesture: the demolition of the column had been broadly and popularly discussed in the months previous to that, was then decided per decree in the Council of the Commune, meticulously prepared technically, and carried out according to plans over a month later on May 16th, more or less according to protocol and under supervision by official organs.

Iconoclastic symbolic policies cannot be anti-hierarchical, because they take place within the framework of a game of above and below, of build-up and break-down. Here one molar mass engenders another, the structuring mass of the National Guard engenders the stagnating mass of the audience. Unlike the frequent emergence of molecular, non-conforming masses in the time of the Commune, the destruction of the column evinces all the moments of molarity and can therefore not be interpreted, as Kristin Ross

does, as an act of "complete re-appropriation"[33]—even though a reference to the (re-) appropriation of space is certainly apt in many other situations of the Commune, when a "reversal of values"[34] flares up in productive confusion and in the doctrinal chaos of the Commune. Yet whereas the events of March 18th that led to the proclamation of the Commune can be understood as a spontaneous, uncontrolled insurrection resulting from chaos, the "success" of the overthrown column is that of a procedure planned by a constituted power.

The destruction of the Vendôme Column in the final phase of the Paris Commune is a highly questionable example of hypostatizing the "social space" as a territory of political practice and a confrontation with history.[35] This kind of pseudo-deterritorialization steered and regulated from above, a final officious show of power in the days before the storm of the government troops, may have produced a brief and temporary play of transgression, but one that was actually intended to support reterritorialization and reinforce structuralization and segmentation—and which also promoted a logic of continued construction and demolition. The construction and demolition of monuments are part of the same play. Both operations organize the space around the monument, thus also serving to hierarchically organize the public. A sequence of solemn unveilings and equally solemn demolitions that tends to be endless. On the day after the destruction of the column, the Commune organ "Journal officiel" noted: "The Paris Commune held it as a duty to tear down this symbol of despotism: it has done its duty. The Commune thus proves that it places the law above violence and that it gives preference to justice over murder, even if the latter should triumph. The world should be convinced: the memorial pillars that it erects will never again celebrate any villain of world

history, but should instead carry on the memory of some glorious deeds of science, labor and freedom."[36] And Lissagaray, who knew better from the perspective of the *ex post* historian following the counter-revolution and the persecution of the Communards, stated, "One of the first acts of the victorious bourgeoisie was to again raise this enormous block, the symbol of their sovereignty. To lift up Caesar on his pedestal they needed a scaffolding of 30,000 corpses."[37]

Thus it only made a difference to Courbet's contemporaries whether he was attributed with the responsibility for the vandalist act of razing a historical column and condemned for that, or whether, conversely, he was attributed with being a dodger betraying the Commune and condemned for that. In his self-representation as an accused Communard, his role is reduced to that of the objective, reserved mediator: in his "Authentic Account" against the accusations, Courbet styles himself as a peace-maker and preserver of art treasures, who used his role to ensure the safety of these art treasures. In the end, the art treasures were the only thing not touched, thanks to him.[38] Against this background, the role that Courbet actually played in the execution of the Commune's decision to destroy the column, which was formally made without him,[39] is just as secondary as the question of whether Courbet is the bearded man in the famous photo showing a group of soldiers and civilians gathered behind the overthrown statue of Napoleon in the Place Vendôme.

What seems significant to me at this point, however, is the aspect of the particularity of the art-political activities of Courbet and the artists in the Commune as a whole, especially against the background of the false options of choosing between a controlled, molar version of symbol-political iconoclasm on the one hand and a militant "protection of culture" on the other. Contrary to the collective attempts of the commune to impel the dissolution of the

segmenting state apparatus of the Second Empire and replace it with an orgiastic form of (self) management and (self) organization, the reduction of Courbet's politics to matters of administering art seemed to affirm the cliché of the autonomous field of art hermetically preoccupied with itself and resisting every kind of transversalization. This is not a coincidence, but is, not least of all, a result of the blossoming of the autonomization of art in the 19th century, in which Courbet had also developed his non-conformist gesture of independence from the state. As a prototype of the "autonomous artist" operating against the authoritarian state of the Second Empire, Courbet must have necessarily had great difficulty in finding a constructive position in the new setting of the Commune when applying the contemporary models of subjectivation as the universal intellectual and the autonomous artist.

If a position of this kind was not to be found with and in the revolutionary practice of the Commune, then perhaps counter to it. A last pointed example of the antinomies that arise in the collision of art-political particularism (which is nevertheless argued here and elsewhere with the universal quality of culture) and revolutionary universalism: In the last days of the Commune, while the bloody offensive of the government troops was in full swing, the entire Commune on the barricades and the Tuileries burning, artists were purported to have placed themselves protectively before Notre Dame to prevent the excited crowd of Communards from spontaneously setting fire to it, defending the cathedral in the name of protecting a cultural heritage. The artists, who limited themselves and their activities in the Commune to particular art policies, allegedly finally found their universalism in the gesture of the defense of Notre Dame. Whereas the Communards saw the Commune threatened as a "universal republic," especially in the days before the "bloody

week," by the impending violence of the government troops and the looming restoration of church and bourgeois culture and hindered the progress of the government troops with arson,[40] the abstract universalism of the artists placed itself protectively in front of "culture:" a construct of culture as simultaneously neutral and all-transcendent, eternal and universally accepted, a symbol of history and yet separated from its concrete history.

The Situationist Theses on the Paris Commune intensify the contradictory universalism conflict between the increasingly defensive machine in the barricade battles and the artist who has become part of the state apparatus in the inherently biased question: "Were those artists right to defend a cathedral in the name of eternal aesthetic values—and in the final analysis, in the name of museum culture—while other people wanted to express themselves then and there by making this destruction symbolize their absolute defiance of a society that, in its moment of triumph, was about to consign their entire lives to silence and oblivion?"[41]

The story of the defense of Notre Dame, which may have served the later defense of the Commune artists before the tribunal[42] as well as providing the later avant-garde with a negative foil in their spectacular pamphlets and actions against "culture," sounds extremely constructed in any case. Beyond the question of whether iconoclasm is good or bad in general or in particular, the anecdote at least illustrates the problematic figure of the specialization of artists as—militant—art-politicians, who, "acting as specialists, already found themselves in conflict with an extremist form of struggle against alienation."[43] If we take the defense of Notre Dame as an invented parable and as the complementary narrative to the real destruction of the Vendôme Column at the same time, then the pivotal point here is the two sides of the figure of over-

throwing/preserving culture as a pseudo-universal value, of which the particularity vanishes behind its twofold and only seemingly contradictory function. For one side, bourgeois culture must be destroyed by the Commune in analogy to the destruction of the state apparatus, for the other side, in the misunderstanding of "the innocence of a monument,"[44] Notre Dame has to be saved. The logic remains the same: the destruction and the fanatical protection of cultural heritage refer to the same conjunction of the politics of symbols and the selective universalism of culture, as well as to the clear separation of particular art/art politics and universal revolutionary politics in the Commune.

On March 2, 1872 Gustave Courbet's release from prison was celebrated with an exhibition at the Durand-Ruel Gallery. Frédérique Desbuissons formulates the clearly separated sequence: Courbet returned to painting, which he had given up for his political functions.[45] And the painter himself wrote in his "Authentic Account" on his time in the prison of Saint-Pélagie: "After he made Europe talk about his art throughout twenty years, *after he lost his work for one year*, it is not even granted to him in this hour to take it up again in prison."[46] In our investigation of the interdependencies, relations of exchange and overlappings of art and revolution, the Courbet model embodies the model, in which there can be no systematic overlapping of the revolutionary machine and the art machine. On the contrary: for the period in the Commune, the artist Courbet becomes a politician who attempts to adapt the rules of his particular field, then afterward he becomes an artist again. Coupling Courbet's roles as an art-political expert in a "cultural" universalism and as a proponent of artistic autonomy turns out to be a dead end, where further attempts of the concatenation and transversalization of art and revolution remain obscured.

Spirit and Betrayal:

German "Activism" in the 1910s

"Leave your post.

The victories are won. The defeats are

Won:

Leave your post now....

Pull in your voice now, speaker.

Your name will be erased from the boards. Your orders

Will not be carried out. Allow

New names to appear on the board and

New orders to be carried out."

 — Bert Brecht, Fatzer-Fragment[1]

"Reliability is essential—reliability even in the most minor issues and seemingly cold administrative matters. Most of all, of course: reliability in terms of character; solidarity; I mean the opposite of betrayal."

 — Kurt Hiller[2]

"It is difficult to be a traitor, it is to create. One has to lose one's identity, one's face in it. One has to disappear, to become unknown."

 — Gilles Deleuze/Claire Parnet[3]

IN HIS ESSAY "THE AUTHOR AS PRODUCER" Walter Benjamin draws a clear line of distinction between the question of how a work relates *to* the production conditions of its era,[4] a question motivated by content, and the variation of this question that shifts technique, function and production apparatus into the foreground, namely the question of how a work is positioned *in* the production conditions of its era. Benjamin outlines a distinction here that becomes central wherever the stance, positioning and attitude of intellectuals[5] in political struggles are examined. In reference to his own context in Germany under the Weimar Republic he writes: "It has been one of the decisive processes of the last ten years in Germany that a considerable proportion of its productive minds, under the pressure of economic conditions, have passed through a revolutionary development in their attitudes, without being able simultaneously to rethink their own work, their relation to the means of production, their technique, in a really revolutionary way."[6]

"The Author as Producer" is an attack on the "leftist bourgeois intelligentsia" in Germany of the 1920s and early 30s. Its primary targets were the *Neue Sachlichkeit*[7] and a movement from the 1910s that has been largely forgotten even in German-speaking countries, but whose name sounds surprisingly up-to-date today: the name "Activism" was applied to a discourse in the shadow of Expressionism[8] marked by literature and literary criticism and a loose association of mostly literary men affiliated with it. This included, for certain periods of their work, such diverse authors as Heinrich Mann, Gustav Landauer, Max Brod and Ernst Bloch. The circle, increasingly labeled "Activism" after 1914, was affiliated with the publicist Kurt Hiller. Although Hiller and his circle are hardly remembered today, in 1934 Benjamin could be certain that the figure of Hiller and the associated positions would still be familiar

to his audience. In particular, the wild diatribes and mockery on the part of the Berlin Dadaists against the "Activists" around 1920 were characterized by a remarkable vehemence and probably still remembered in the mid-1930s due to their verbal brutality.[9]

In "The Author as Producer" Benjamin presents Hiller as the "theoretician of activism," as a classic example of a purportedly leftist intellectual tendency that was actually counter-revolutionary. According to Benjamin, it was revolutionary only in its attitude, but not in its production.[10] This difference between tendency and technique and the neglect of the latter was only *one* of the problems of "Activism," their misleading naming was another. What was peddled during World War I and the years following it as "Activism" was, according to Hiller's self-definition, "religious socialism"[11] or— in my interpretation—*vitalist spiritism [vitalistischer Geistismus]*.[12] In addition to eloquent appeals to, and invocations of, the "young breed" ["das junge Geschlecht," Heinrich Mann], of the "New Demotic" ["Neue Volkstümlichkeit," Kurt Hiller], or the people as "sacred mass" ["heilige Masse," Ludwig Rubiner], the "Activists" focused primarily on the hypostasization of the spirit and the "spiritual" [die *Geistigen*]. The term "geistig," initially a tactical substitute for "intellectual," was gradually substantiated by Hiller and others and eventually understood as a "characterological type."[13] From Heinrich Mann's seminal text "Geist und Tat" ["Spirit and Action"] to Hiller's manifesto-like "Philosophie des Ziels" ["Philosophy of the Goal"] to Ludwig Rubiner's "Der Dichter greift in die Politik" ["The Poet Intervenes in Politics"], the Activism texts[14] wrestle conspicuously often with themes of religion, mysticism and the church. It seems that the spirit that haunts the spiritual here is more of a holy one than Hegel's *Weltgeist*. Hiller himself tends to posit paradise more than revolution and

socialism as a utopian goal. "Consecrate yourselves, you spiritual ones, finally—to the service of the spirit; the holy spirit, the active spirit."[15] The two main aspects of Benjamin's question about the "place of the intellectual" are its position with respect to the proletariat on the one hand, and the manner of organization on the other. Benjamin's criticism of "Activism" thus consists primarily in its self-positioning "between the classes." This position *beside* the proletariat, the position of benefactors, ideological patrons, is an impossible one.[16] The principle of the formation of this kind of collective, which assembles men of letters around the concept of "the spiritual" beyond any incipient organizing, is in fact, a wholly reactionary one, and not only for Benjamin.[17] This criticism is even more evident, if we include not only Benjamin's insistence on changing the production apparatus, but also the *attitude* of the "Activists" that was not at all revolutionary: sometimes their texts are marked by nationalism, are often even anti-democratic, and in Hiller's circle, anti-democratic tendencies could not be interpreted as radically democratic or radically leftist. Hiller's principle of spirit-aristocracy propagates a dominion of the spirit. This dominion belongs to those who are of the spirit, of the best, finally even of the "new German master house."[18] In this way Hiller also inverts the one-sided cliché of action and activism, and the hierarchy conventionally associated with it, between thought and action. Instead of subordinating action to the intellect—as called for by the cliché—Hiller writes in his "Philosophy of the Goal:" "The intellect sets the goals, practice realizes them.... Practice: the troops; intellect: the commander." Sentiments like these were naturally not addressed to the revolutionary proletariat. Their audience was to be found more among the Berlin bohemians, who probably enjoyed basking occasionally in the role of intellectuals that Hiller attributed to them. "In

the end it will be the man of letters…. Tomorrow's man of letters will be the one to take great responsibility; the purebred intellectual; thinking, yet non-theoretical; deep, yet worldly… He is the initiator, the executor, the prophet, the leader [*der Führer*]."[19]

Such an unequivocal attitude inevitably leads to the question of why Benjamin was even willing and able to sell the authors of "Activism" as *left-wing* bourgeoisie at all. I suspect that has to do not only with Benjamin's text-immanent intention, which I will come back to later, but also and especially with the broader activities of a second branch of "Activism." This branch rarely referred to itself as "Activism," yet its organ, the weekly paper *Die Aktion*, with a clearly anti-militarist tendency, substantially influenced leftist intellectual and radical leftist movements in the German-speaking region of the 1910s.[20] Although *Die Aktion* and its protagonists were not activists in today's sense either, they were certainly more politically and pointedly active than Kurt Hiller's circle. In its early years until the start of the war, *Die Aktion*, alongside the *Sturm*, was the leading Expressionist periodical with a clearly anti-militarist tendency. During the war it was the only oppositional literature and art periodical, avoiding censorship with astonishing mastery, using veiled writing and other means, and after the end of the war it increasingly became an organ of the radical leftist opposition with a close relationship to Rosa Luxemburg and Karl Liebknecht. Its publisher and editor-in-chief, Franz Pfemfert, radicalized himself and the paper in several surges from its founding in 1911 into the revolutionary war and post-war period, through the Spartacist uprising and the Council Republic.

Whereas the literary activism associated with Hiller was otherwise marked by a relatively diffuse will to change, from the start Pfemfert linked Expressionist literature and contemporary cultural

politics in *Die Aktion* with (historical) social-revolutionary texts to form a singular combination. The focal point of the paper was its anti-militarist critique, which particularly examined the war-mongering function of the liberal press and the Social Democrats and the affirmative stance of writer-colleagues within the framework of events leading up to the war. It also published early social-revolutionary texts, anarchist texts from Russia, essays by Lassalle and Reclus. Texts by the later Dadaists Hugo Ball, Hans Richter and Raoul Hausmann were also circulated by *Die Aktion*.

As people involved in earlier associations (the newspaper *Demokrat* and the Democratic Association) gradually left for ideological reasons, in the early years, *Die Aktion* drew more and more authors and subscribers; at least until Pfemfert distanced himself from Hiller in 1913,[21] *Die Aktion* was something of a gathering point for the literati who were later to assemble under the label "Activism" with Hiller. Hiller's spiritist ideas were reason enough for Pfemfert to put an end to the cooperation in the paper's third year. Contrary to Hiller's reactionary rejection of democracy, Pfemfert's anti-authoritarianism saw itself as propagating council democracy; the absolute pacifism of Hiller's logocracy (the revolution of words) was countered by Pfemfert with an anti-militarism that became increasingly revolutionary and concretely council-communist during the course of the war; contrary to Hiller's German nationalism, Pfemfert's position was anti-national(ist) and anti-antisemitic.

In the first months of its publication *Die Aktion* was published with the programmatic subtitle "Publication Organ for the Intelligentsia of Germany." Even though this subtitle quickly disappeared again, the paper increasingly assumed organizing functions for an arrangement of artists and intellectuals throughout the decade. Whereas the literary-activist circle around Hiller comprised—as

Benjamin correctly describes it—"any number of private individuals without offering the slightest basis for organizing them,"[22] Franz Pfemfert was the pivotal point not only for *Die Aktion*, but also for a number of other attempts at an "organization of the intelligentsia." Following the start of *Die Aktion* as a weekly paper on 20 February 1911, a publishing company was founded in 1912. To begin with, Pfemfert published Expressionist literature; this was expanded beginning from 1916 on with the "Political Action Library," including revolutionary texts by Lenin, Marx, Liebknecht and others. Finally, Pfemfert also recognized the necessity of a concrete location, a public place in addition to printed material, and opened, together with his wife Alexandra Pfemfert and her sister, the Berlin "Action Book Shop" in 1917, which was open for exhibitions and events.

One of the anti-militarist agitation actions against conscription in 1913[23] even turned into an early instance of communication guerrilla: to create a broader base for protests against an extension of the powers of the Wehrmacht in Berlin, Pfemfert faked the declaration of a bourgeois anti-national association, "To the German Reichstag," against the new military laws. This declaration was propagated not only through *Die Aktion*, but also with flyers, which ultimately led to an actual demonstration through the aspect of media counter-information. Since conscription was being debated in France at the same time, the action was extended there to a parallel French declaration under the direction of the later Nobel Prize winner for literature, Anatole France.[24] This may be regarded as an attempt to internationalize anti-militarist resistance, which also used media guerrilla means to struggle for an expansion and international organization of anti-national structures; with little success, however, as history shows.

Whereas Hiller's "Activists" increasingly invoked the party of the spirit, the German spirit or the spiritual,[25] Pfemfert founded the Anti-Nationalist Socialist Party Group of Germany (ASP) as early as 1915. The tiny anti-capitalist, anti-nationalist, socialist party was "covertly active" until the end of the war, entering the public sphere on 16 November 1918 with a manifesto in *Die Aktion*. The party never grew beyond the status of a special interest group of a few dedicated artists, yet the reversal of the conventional relationship between party and newspaper appears to be an interesting constellation: instead of a party founding its publicizing organ, the newspaper started organizing a party in an ongoing process. Although the collectivity and the quantity of the endeavors revolving around *Die Aktion* may be debated, Benjamin's question about organizing must certainly be answered positively in Pfemfert's case as the process of organizing leftist intellectuals in the second half of the 1910s, especially because of the aforementioned attempts to work on organizational concatenation and articulation in association with *Die Aktion* and going beyond the paper.

Beginning in 1917 the activism of *Die Aktion* was increasingly impelled by council-communist and anarcho-syndicalist ideas. Texts were published in 1917 by Bakunin, in 1918 by and about Marx; in addition, there was an accumulation of writings on activist principles and social-revolutionary texts, including some from the women's movement and from the youth movement before that.[26] With the November Revolution *Die Aktion* completely outgrew the Expressionist movement to become an organ for political agitation, especially in conjunction with political work for the council movement. There are a number of analogies here to the paradigmatic development of the Situationist International forty years later: just as Guy Debord on his long passage

from art to revolution distanced himself with growing vehemence from any kind of art production, for Pfemfert the separation from his own Expressionist-activist involvement was final by early 1920—and this separation was quite a forceful one, in which he dismissed the spiritists as "ignorants." The second similarity between *Die Aktion* and the S.I. consisted in the increasing crassness of the practice of exclusion. From the time *Die Aktion* was founded, Hiller, who was ousted for obvious reasons, was not the only one to be dismissed. Pfemfert conducted a rigorous practice of discipline toward other co-workers, who had to leave the editorial board of *Die Aktion* and its association of authors not only because of their own statements or texts, but also because of their contexts. Like Debord in the context of the Lettrist and Situationist International, in the early years of the successful expansion of *Die Aktion* Pfemfert was the influential and determining pivotal point of communication. Also analogously to Debord's increasing isolation in the 1970s, after the war *Die Aktion* became more and more of a one-man operation. The further development of *Die Aktion* could accordingly be understood as an analogy between Activist and Situationist history. Although they pursued different strategies of involvement in political contexts, over time they both seemed to acquire a similarly bad reputation: in the socialist contexts of the Spartacus League, the KPD (Communist Party of Germany), the KAPD (Communist Workers Party of Germany), the AAUE (General Workers Union Unity Organization), and other groups with which Pfemfert organized for a time or was at least in solidarity with, and especially later in Marxist-Leninist research, Pfemfert was accused with growing frequency of having a "disintegrating function in the process of the decomposition of radical leftist organizations."[27]

Thus the whole spectrum of German "Activism" appears to be quite a disparate network that was fed—roughly outlined—from two sources: a right-wing activism of the spirit, which sometimes slipped into the margins of anti-semitism, racism and proto-fascism,[28] and from a left-wing activism of *Die Aktion*, which from its basis as a literary magazine became increasingly radical, until it turned into an agitation platform for radical leftist politics. Especially in the first half of the 1910s, the actors frequently alternated between the unraveling camps, and naturally there were "activisms" of all kinds to the right of Hiller as well.

Returning now to Benjamin's essay, which was based on the draft that was prepared for a lecture in Paris in April 1934,[29] the reason for this late attention devoted to Hiller in particular may be found in the context of this lecture.

Benjamin uses the foil of "Activism" mainly to criticize recognized leftist, but purely content-focused, agitational strategies in art, i.e. Socialist Realism, in a communist context. At the Paris Institute for the Study of Fascism, a sham organization controlled by the Comintern, he would have found himself on thin ice with this, as he was well aware. Even before Stalin's cultural politics, such diverse positions as Lenin's, Bogdanov's and Lunacharsky's were all, despite their very disparate ideas of proletarian culture, oriented to the artistic production and presentation of proletarian *contents*. In Germany, in the socialist circles of the 1920s and 30s, there was also a tendency to give precedence to revolutionary contents over *form*. Benjamin's attitude, which focused primarily on the technique and organizing function of art practice, was the exception. For Benjamin's assumed audience, presumably an audience that was similarly skeptical about formal considerations, Hiller's reactionary position may have seemed excellently suited as

a negative point of approach to and substitute for an attack on Socialist Realism. Although Hiller represented something completely different from the position of Socialist Realism, in Benjamin's lecture he was to represent that content-fixed position indicated in sentences such as these: "But in truth, all truly great artworks…were great not because of the perfection of what was specifically artistic about them, but rather…because of the sublimeness of their What, their Idea, their Goal, their Ethos…. If one takes away from one of them its content, its idea, its morality, so that only what is 'designed' remains, what remains is worthless!"[30] The old sterile opposition between content and form permeates Hiller's writing; with all the pathos of intervention, the "*What* of wanting" remains his highest criterion: "Form, though, as such, is empty," "what remains essential is *what* is designed."[31] In the position of the German "Activist" there is an allusion to a discourse that was also prevalent in Soviet cultural policies, but because of its idealistic orientation, Hiller's position could not really be linked to materialist positions. This is how the discourse associated with Hiller could become a suitable backdrop for Benjamin to highlight the practices of Bertold Brecht and Sergei Tretyakov as positive counter-examples of attempts at also changing the production apparatus.

Let's stay with this negative juxtaposition for a little longer and examine the question that was central for Benjamin: the position of the "author as producer" or, more broadly, the position of intellectuals and artists. In the distinction between "universal" and "specific intellectuals" developed by Foucault, Hiller's position would be that of representing the universal. The spiritual thus corresponds to a universal truth, the carriers of which, the spiritists, represent a universality denoting the conscious and developed

form of the unconscious universality of the proletariat. Here, the spiritists would be the widely visible role models, exemplary and illuminating, rising out of the dark form of the proletariat. Foucault describes the universal intellectual—and the example of Hiller's literary "Activism" also corresponds to this—using the figure of the *writer* and the threshold of writing as the sacralizing feature of the intellectual.

This figure, which implies a speaker articulating the mute truth of others, must necessarily come under fire in emancipatory, egalitarian contexts. According to Benjamin, contents and political tendency retain a counter-revolutionary function, as long as the instruments, forms and apparatuses of production, i.e., the relationship between the spiritist (as universal intellectual) and the proletariat remains unchanged. Benjamin refers not only to the example of "Activism," but also to that of *Neue Sachlichkeit* to describe how even photographs of misery can become an object of enjoyment, how the artistic processing of a political situation is able "to achieve ever new effects for entertaining the audience;" in other words, how the bourgeois apparatus of production itself and its publications are able to assimilate and even propagate revolutionary themes using the figure of the artist/intellectual beside/above the proletariat.[32]

The work of writing *for* the proletariat from the position of a bearer of the law and a fighter *for* justice is a presumption; the status of the universal intellectual is an untenable one. If the intellectual's solidarity with the proletariat can always only be a mediated solidarity, then the intellectual, who has become a *bourgeois* intellectual due to social and educational privilege, must become, according to Benjamin, a "betrayer of his [bourgeois] class of origin." This necessary betrayal consists in the transformation

of his position, from someone who *supplies* the production apparatus with contents, as revolutionary as they may be, to an engineer who *changes* the production apparatus; as Benjamin formulates it, someone who "sees as his task to adapt this apparatus to the purposes of the proletarian revolution."[33]

For a renewal of this demand that Benjamin poses, that of adapting the production apparatus rather than supplying it, it seems to me that both aspects are equally important. The first part of the demand, not to supply the production apparatus, could be updated with the help of Deleuze's criticism of representation, namely the criticism of the framework of media representation and the function that intellectuals and artists carry out within this framework. The second part of the demand, that of adapting the production apparatus, is also found in an expanded form in Foucault's exhortation to specific intellectuals to constitute a new politics of truth. There are echoes of Benjamin's figures and terminology in both Deleuze and Foucault: with Deleuze it is the topos of betrayal, with which the intelligentsia leave their class; with Foucault it is the specific intellectual as "specialist," which Benjamin in turn took over from the terminological toolbox of the Russian productivists.

Contrary to Foucault's assumption of the disappearance of the great writer, or the universal intellectual, ever new metamorphoses of this type have emerged, still assuming the pose of the autonomous artist and thinker, but in fact, caught in a heteronomous subordination to structures in which their figures fulfill certain functions. Contrary to this pseudo-revival of the classical bourgeois, the universal intellectual, who always gets questioned about everything and also has always something to say about everything, especially on the surface stage of the media and

instrumental think-tanks, today's point would be not to continue supplying these media and politics with ever new contents, but rather to refuse to supply, to vanish from the machinery of the spectacle, to betray the spectacle.

To a certain degree, to the extent that intellectuals are involved in this spectacle, this also implies a betrayal of oneself. With *Die Aktion* Franz Pfemfert remained true to this path. His disappearance was not only the effect of the persecution of his marginal council-communist position, the bitterness and the mechanisms of increasing exclusion, but also the consequence of his radical criticism and refusal of the media spectacle, his betrayal of the bourgeois production apparatus. Going beyond Benjamin's classical Marxist formulation, the movement of the "betrayal of the bourgeois class" could be rephrased, following Deleuze/Parnet, as the position of a "traitor to one's own reign, to one's sex, to one's class, to one's majority."[34] Betraying one's bourgeois class of origin and adapting the production apparatus to the proletarian revolution today would primarily mean dropping out of the framework of representation. If only that which is a priori acceptable can be aligned to the grid of possible permitted images and statements, and what is acceptable is susceptible to recuperation a priori, then a contemporary form of betrayal seeks ways of breaking through this grid. To counter the mechanism of the media spotlight, which is capable of assimilating contents today much more radically than the reportage of the *Neue Sachlichkeit* was able to do, it is necessary to vanish from the picture, remain unrecognized, blur the traces of prominence.[35] Anonymity, multiple names, collective authorship, masks could be tools for this kind of betrayal. The key to change lies not in the struggle of intellectuals for hegemony in the mainstream media, but rather in refusing to take part in this

show battle, rejecting the role of commentators and suppliers of keywords in the framework of the media spectacle. Disrupting this relationship, and preferably developing a form of disturbance through these kinds of disruptions in order to toss the wooden shoes of sabotage into the apparatus of communication, this is how Deleuze adapts the demand *not to supply* the production apparatus: "Creating has always been something different from communicating. The key thing may be to create vacuoles of non-communication, circuit breakers, so we can elude control."[36]

This brings us now to the second part of Benjamin's demand: the intellectuals' betrayal must also go beyond simply rejecting their role as universal consultants and spectacular suppliers of key words. An update of the second part of Benjamin's demand must therefore also ask what it means today not only to not supply the production apparatus, but also how it can be changed. Benjamin states that in the debate on the stance of the Russian intellectuals after the October Revolution, a crucial clarification was achieved through the concept of the "specialist." The concept initially remains obscure; at first glance it even seems to contradict organizing a revolutionary alliance between the proletariat and intellectuals. Here Benjamin is referring to Sergei Tretyakov's figure of the "Bolshevik specialist," and this figure confounds the dualism of universality and particularity. The task of intellectuals as specialists initially consists in calling to mind their own position in the production process, so as not to be tempted to present oneself as a spiritist, as a universal intellectual. Instead of appealing to universality and autonomy as "catalysts" or "transmission belts," the point is to abandon central positions and become a "betrayer to one's class of origin" as a specialist, as a *specific* intellectual, with specific competences, from a specific position.

The specific intellectual, for Foucault something like the politicized flip-side of the scientific expert, no longer presumes to be the bearer of universal values. By fighting local and specific struggles and contributing her or his specific knowledge there, the specific intellectual fights for a new politics of truth.[37] Here Foucault makes a suggestion that can be linked to Benjamin's call to change the production apparatus and takes this call further. "The essential political problem for the intellectual is not to criticize the ideological contents supposedly linked to science, or to ensure that his own scientific practice is accompanied by a correct ideology, but that of ascertaining the possibility of constituting a new politics of truth. The problem is not changing people's consciousness—or what's in their heads—but the political, economic, institutional regime of the production of truth."[38]

It is not a matter of communicating the (right) revolutionary contents to "the masses," a point upon which Benjamin and Foucault agree, for the kind of truth does not exist that would be the privilege of a certain class. What does exist, however, are power relations, which permeate the regime of the production of truth just as much as the production apparatuses of art. In the search for possibilities for changing the regime of the production of truth today, the practices of the media guerrilla are especially conspicuous: using counterfeits, fakes and hoaxes, their attacks explode the framework of mass media representation. Benjamin's question about changing the production apparatus and Foucault's question about changing the political, economic and institutional regime of the production of truth could be formulated even more extensively with Deleuze. "If power is constitutive of truth, how can we conceive of a 'power of truth' which would no longer be the truth of power, a truth that would release transversal lines of resistance and

not integral lines of power?"[39] To answer this question, it is no longer sufficient solely to pursue Benjamin's proposals of abandoning the distinctions between the different genres of art, between author and audience, converting the functions of the novel, the drama, the poem; the crux is changing the relationship to the production of truth more fundamentally, in a way that goes beyond the static figure of the artist, the intellectual, even if it is the specific intellectual.

"The intellectuals to come will not be individuals, not a caste, but rather a collective concatenation, in which people are involved, who do manual work, intellectual work, artistic work,"[40] said Guattari as early as the late 1970s. In the post-fordist setting of cognitive capitalism there is evidence that knowledge production as the privilege of intellectuals is dissolving, while there is an increasing diffusion of "the power of truth" in society at the same time. What Marx once alluded to with the term of the "general intellect" was taken up again in the Italian tradition of the Operaism of the 1960s and 70s as "mass intellectuality" generalized by social struggles. In the meantime, immaterial and cognitive labor have become the dominant paradigms not only of post-fordist theory, and this causes both the increasing precarization and exploitation of all forms of immaterial labor and the process of the "autonomist self-organization of cognitive labor,"[41] the possibility of a "cognitariat" (Bifo Berardi).[42] However, this kind of distribution of self-organized knowledge beyond classical intellectual, academic, artistic formations does not at all imply that *adapting* the production apparatus and the concatenation of self-organization against the exploitation of cognitive labor is a self-actuating process. On the contrary: in the age of cognitive capitalism it becomes possible and necessary

that not only intellectuals, be they universal spiritists or special-ists, but *many* change the regime of the production of truth; that many refuse to supply the production apparatus without changing it. "There is no specific truth work at the intellectual level. However, there are truths in the framework of precise practical concatena-tions, of exactly defined social relations, of struggles, of particular relationships of semiosis."[43]

Disruptive Monsters:

From Representing to Constructing Situations

"Up till now philosophers and artists have only interpreted situations; the point now is to transform them." — Situationist International [1]

Moments constructed into "situations" might be thought of as moments of rupture, of acceleration, *revolutions in individual everyday life*.
— Situationist International [2]

GUY DEBORD AND THE SITUATIONIST INTERNATIONAL were not the first to introduce the concept of the situation into the debate on art and politics. At that time, in the context of the French variation of the wild 1950s, as the coming avant-garde of Paris May 1968 was about to expand the gesture of artistic radicalism as a means of passage into the political, the term was opposed not only to everyday language and several—more or less bizarre—social sciences or theological "situationisms;" its prehistory ranges from the vocabulary of military sciences through its use as a philosophical auxiliary term by Sartre, Heidegger and Kierkegaard all the way back to its function as one of the central terms in Hegel's aesthetics.

G.W.F. Hegel had taken the situation concept from the theater discourse of the 18th century and introduced it in his *Lectures on*

Aesthetics (held for the first time in 1818 in Heidelberg, then further developed in Berlin over the course of the 1820s) as a generalized key term applying to all art forms. What was specific about Hegel's use of the situation concept was that he opened it up, initiating a movement with enough verve that the situation, based on its quality as an aesthetic category in his own use, can be developped beyond Hegel and beyond the framework of conventional aesthetics. The questions that Hegel raised on the relationship between representation and action led in the heterogenesis of concrete art practices in the 20th century from representing situations through various stations of expanding representation into the orgiastic to the postulate of constructing situations. This primarily involves understanding the construction of situations as present becoming happening here and now, exactly in the plane of immanence of globalized capitalism, in the center of the society of the spectacle, in the midst of the territory of that which it seeks to overthrow.

REPRESENTING THE SITUATION:
THE DISSOLUTION OF DIFFERENCE IN HEGEL'S AESTHETICS

"Stability is provisional. It is the conflicts that are eternal because there is pleasure in conflict. The individual, in this return to him or herself, experiences division, conflict, pleasure and jouissance in this fragmentation." — Julia Kristeva[3]

IN HEGEL'S *LECTURES ON AESTHETICS*, the situation is a crucial category of the idea of artistic beauty [das Kunstschöne].[4] Following the exclusion of the "imperfect" natural beauty [das mangelhafte

Naturschöne] from the realm of aesthetic questions, with major consequences for the further development of aesthetics as a philosophical discipline, Hegel proceeds to take a closer look at artistic beauty and its determinacy as artwork. According to Hegel, the most important part of art has always been "the discovery of interesting situations."[5] With the help of a plethora of material using examples from every section of art and with an equally abundant wealth of graded categories, Hegel attempts to establish a complex system of representing situations intended to apply equally to Egyptian sculpture and Dutch genre painting, to Euripides and Sophocles as well as to Shakespeare and Goethe. In the familiar dialectical movement, he develops the situation as the crucial step of the "inherently differentiated and progressive determinacy of the Ideal, which we may formulate in general terms as Action."[6] The situation functions as an intermediary stage between the general state of the world on the one hand and action on the other, in which "the struggle involved in difference and the dissolution of difference appear."[7] The situation itself also appears as a three-part movement, which leads from the absence of situation through the specific situation as a harmless determinacy without opposition and ultimately to collision, which for Hegel forms the starting-point as well as the transition to action proper.

This third stage of the situation, the collision of opposites against the backdrop of the situation, is what is to be made productive as the difference-theory turn of Hegel's situation theory. Contrary to Hegel, however, the movement is not to be understood as a temporary process of progressively particularizing the ideal into differences, which—as a mere passage—are intended to be sublated in a higher identity. Here the "Zweispaltung" is intended to be more than the "Fundemaintalish of Wiederherstellung"[8] so aptly formulated by Joyce in his jumbled artificial language in *Finnegans Wake*. The

dialectic of the Hegelian train of thought that so obstinately resists being thwarted is to be opened up; the situation is not meant to be an intermediary stage, a dynamizing passage between two stages of uniformity, but rather a suspension, a precondition for the potentially unbounded collision of differences. The general state of the world that Hegel *pre-supposes*, the general manner in which the substantial is imagined as the moment conjoining all appearances, is not needed for this; and the dissolution of differences is equally unnecessary as the distant, but yearned for *goal* of a return to uniformity. It is not the dissection of a prior substance into its individual components that is predominant, not the temporary, passing disunion of the unified state of the world, not the change of a state that was harmonious before that disunion and is to be transformed in order to return to harmony again. The Hegelian intermediary state of the situation, the collision and its components—conflicts, differences and tensions—are the focus of my deliberations. Hegel's *Ungeheuer der Entzweiung* [monster of disunion, disruption][9] slumbering in the general state of the world and dozing off again in the subsequent sublation of differences is to be treated here only in a waking state, or rather: as though it had never gone to sleep at all.

Disruptive monsters do not emerge from the sleep of reason, they do not know the sleep of reason nor its dominion. On the contrary, the monsters permanently move in the concatenations of all possible experiences in between desire and reason. They do not stop moving and do not come from dreaming. Disruptive monsters—as Hegel recognizes with his choice of terms—are monstrous precisely because there is danger in permanent disruption, in the moving relation of different to different, something explosive that eludes determination, description, representation. The corresponding passage in the theory of the situation is then, contrary to the general

tendency of the dialectical movement, one that is productive for poststructuralist difference theory as well: where determinacy founds a collision in opposition to something else, "the situation in its specific character is differentiated into oppositions, hindrances, complications and *transgressions [Verletzungen]*, so that the heart, moved by circumstances, feels itself induced to react of necessity against what disturbs it and what is a barrier against its aims and passions. In this sense the action proper only begins when the opposition contained in the situation appears on the scene. But since the colliding action *transgresses* an opposing aspect, in this difference it calls up against itself the power lying over against it which has been assailed, and therefore with the action, reaction is immediately linked."[10] Here we have arrived at the pivotal point of the theory of the situation: in its determinacy difference incites movement, the relation of different to different. At this moment, when the differences have started to flow, we divert Hegel's dialectical movement and ask: What would happen if we specifically do *not* take this incited movement as an instrument for establishing peace and quiet, but rather as one that is potentially impossible to conclude, infinite? What if the differences, in constant exchange, refuse to be subordinated to the rule of identity and representation? What if all identities were only simulated, generated through a deeper game, specifically the one that Gilles Deleuze called "the game of difference and repetition?"

"We propose to think difference in itself independently of the forms of representation which reduce it to the Same, and the relation of different to different independently of those forms which make them pass through the negative."[11] In the place of the identical and the negative, of identity and contradiction, Deleuze posits a concept of difference without negation, which can never be driven

to opposition and to contradiction: not a mediated difference in other words, which can be subordinated to the fourfold root of mediation (identity, opposition, analogy, similarity), which wants to be rescued from its cave. The difference may remain a monster, it is more than just a differentiation of an essence that sooner or later returns to uniformity. If the same is thought starting from the different, then identity loses the aura of a foundation. It may exist as a principle, but only as a secondary principle revolving around the different, ultimately as a repetition.[12]

Hegel, however, does not remain at the plane of colliding action, where the differences have started to dance, where "the ideal has entered into full determinacy and movement. For now there stand in battle against one another two interests, wrested from their harmony, and in reciprocal contradiction they necessarily demand a resolution of their discord."[13] Conclusion. End. Curtain. Hegel insists on the irrevocable necessity that the collision needs a resolution, that transgression cannot remain transgression, but must be annulled. He meticulously delineates the limit to which dissonance may be driven in the diverse sections of art between the poles of "inner ideas" and "immediate intuition."[14] Thus poetry may even proceed to ugly forms, to the extreme torment of despair, but in sculpture and painting the external shape stands too fixed and permanent to represent ugliness that cannot be resolved. Ambivalence requires reconciliation; the conditions arising from transgression must not be allowed to continue. Disruption and strife must be sublated, so that harmony arises again as a result.

This norm could be concretely falsified specifically with contemporaneous art practice, with concrete art works of Hegel's day that go beyond his numerous examples from antiquity and German Idealism. Géricault's *Raft of Medusa* or the first works by Delacroix

and Stendhal, for instance, were created at about the same time that Hegel held his lectures on aesthetics. Yet E.T.A. Hoffmann's representations of the "inner unstable distraction which runs through all the most repugnant dissonances" strongly upset Hegel, and even Shakespeare had gone too far with his *King Lear*. The negative as reason for the collision "should not find its place," only the "inherently affirmative and substantive powers" should supply the content of the action.[15] Due to this limitation of the content in the age *before* an "aesthetic of the ugly," in the framework of what Deleuze calls "organic representation," the potentials of the situation for difference theory remain limited. However, the fluctuation range of possible contents of representation is a secondary problem in comparison with the identitarian determination of the situation in Hegelian aesthetics. The formal principle of the necessary dissolution of differences has an impact beyond Hegel's examples on later art practices as well, even on those approaching the modi of representation that Deleuze calls "orgiastic representation."

Such orgiastic representation tends toward the endless, to extend to the greatest and the smallest of difference, encompassing the beautiful as well as the ugly. "When representation discovers the infinite within itself, it no longer appears as *organic* representation but as *orgiastic* representation: it discovers within itself the limits of the organised; tumult, restlessness and passion underneath apparent calm. It rediscovers monstrosity."[16] In his treatment of the "difference in itself"—as the relevant chapter is entitled in *Difference and Repetition*—it seems as though Deleuze had the passage from Hegel's theory of situation in front of him, disruptive monsters before his eyes, especially the paragraphs in which Hegel endeavors to imagine the movement into infinity. "It is a question of causing a little of Dionysus's blood to flow in the organic veins of Apollo."[17]

Yet, in Hegel's theory of the situation, movement is consistently described as a reterritorializing movement of identity, in which difference remains cursed and deficient. Even where darkness is to be conquered, reterritorialization shows itself in a ground that insists that it has always already been there. The endeavors of the organic to become orgiastic, to imagine representation as being infinite, bear little fruit in the case of the *Lectures on Aesthetics*. Representation maintains its claims in the theory, even more so in the realm of bourgeois art practice. Hegel's dialectical methods and the evidence of art works explicitly or implicitly taken into consideration, especially Greek tragedy and the theater of the 18th and early 19th century perfectly complement one another: the beauty of art, and in particular the situation, becomes the container that not only holds the differences together but also captures them. Subjecting the different to the identical is passed off as the salvation of difference, but "difference must leave its cave and cease to be a monster."[18]

EXCURSUS ON MACHINES

"In the history of philosophy the problem of the machine is generally considered a secondary component of a more general question, that of the *techne*, the techniques. Here I would like to propose a reversal of the view in which the problem of technique is a part of a much more extensive machine issue. This 'machine' is open to the outside and its machinic environment and maintains all kinds of relationships to social components and individual subjectivities. It is hence a matter of expanding the concept of the technological machine into one of the machinic assemblage…"

— Félix Guattari[19]

FÉLIX GUATTARI DESCRIBES HERE in a few words the extent of one of the main and frequently misunderstood concepts of his heterogeneous theory production. Like many terms from the Guattarian concept forge, the machine is quite intentionally far removed from everyday language. In theory reception, this practice of bending and inventing terms led to widespread, polemic attacks on Guattari and Deleuze as "hippies."[20] Yet the reinterpretation of the machine concept is not so new and radical as to be attributed solely to the French poststructuralists. Even at the time of the final expansion of the industrial revolution throughout Europe, a clear movement in the direction of Guattari's extended machine concepts can be found in Karl Marx's *Grundrisse der Kritik der politischen Ökonomie*, drafted in 1857/58, in the "Fragment on Machines."[21]

In this section of the *Grundrisse* Marx developed his ideas on the transformation of the means of labor from a simple tool (which Guattari later called a proto-machine) into a form corresponding to *capital fixe*, in other words into technical machines and "machinery." In addition to the central concept of the machine, to which Marx was later to devote considerably more attention in *Capital*, here a second concept is treated on the side, which had a greater impact on further post-Marxist theory currents. The concept of the General Intellect, which Marx introduced in the Fragment on Machines as a secondary concept, was the explicit starting point for the Italian (post-) operaists' ideas on mass intellectuality and immaterial labor. The mutual references between French poststructuralism and Italian post-operaism are generally just as manifold as the ways both currents refer to Marx *and* distance themselves from him, but the concrete relation between the two aspects of the small Marx fragment (machine—General Intellect) got lost on both sides.[22]

In general, Marx sees the machine succinctly as a "means for producing surplus-value,"[23] in other words certainly not intended to reduce the labor effort of the workers, but rather to optimize their exploitation. Marx describes this function of "machinery" in Chapter 13 of *Das Kapital* with the three aspects of extending human labor power (especially women's and child labor), prolonging the working day and intensifying labor. Yet the machine also appears as an ever new effect of ever new workers' strikes and protests, as capital confronts them not only with direct repression, but especially with new machines.[24]

In the "Fragment on Machines" Marx especially addresses the negative aspects of a historical development, at the end of which the machine, unlike the tool, is not at all to be understood as a means of labor for the individual worker: instead it encloses the knowledge and skill of workers and scholars as objectified knowledge and skill, opposing the scattered workers as a dominant power. According to Marx, the division of labor is specifically the precondition for the rise of machines. It was only after human labor became increasingly mechanical, mechanized, that the condition was created for these mechanical tasks of the workers to be taken over in a further step by machines: "But, once adopted into the production process of capital, the means of labor passes through different metamorphoses, whose culmination is the *machine*, or rather, *an automatic system of machinery* (system of machinery: the *automatic* one is merely its most complete, most adequate form, and alone transforms machinery into a system), set in motion by an automaton, a moving power that moves itself; this automaton consisting of numerous mechanical and intellectual organs, so that the workers themselves are cast merely as its conscious linkages."[25]

This passage from Marx indicates that the machine itself, in the final stage of the development of the means of labor, not only structuralizes, striates and stratifies the workers as automaton, as apparatus, as structure, but it is also simultaneously permeated by mechanical and intellectual organs, through which it is successively further developed and renewed.

On the one hand Marx here formulates the workers' alienation from their means of labor, how they are (externally) determined by the machines, the domination of living labor by objectified labor, and he introduces the figure of the inverted relationship of man and machine: "The worker's activity, reduced to a mere abstraction of activity, is determined and regulated on all sides by the movement of the machinery, and not the opposite. The science which compels the inanimate limbs of the machinery, by their construction, to act purposefully, as an automaton, does not exist in the worker's consciousness, but rather acts upon him through the machine as an alien power, as the power of the machine itself."[26] The inversion of the relationship between workers and means of work in the direction of the domination of the machine over the human being is defined here not only by the hierarchy of the labor process, but is also understood as an inversion of the disposal of knowledge. Through the process of the objectification of knowledge forms in the machine, the producers of this knowledge lose undivided competence and power over the labor process. Labor itself appears as separated, scattered among many points of the mechanical system in single, living workers. "In machinery, knowledge appears as alien, external to him [the worker]; and living labor [as] subsumed under self-activating objectified labor."[27]

Even for Marx in the Fragment on Machines, however, the huge, self-active machine is more than a technical mechanism. The machine

does not appear here limited to its technical aspects, but rather as a mechanical-intellectual-social assemblage: although technology and knowledge (as machine) have a one-sided effect on the workers, the machine is not only a concatenation of technology and knowledge, of mechanical and intellectual organs, but additionally also of social organs, to the extent that it coordinates the scattered workers.

Hence the collectivity of the human intellect is ultimately also evident in the machine. Machines "are *organs of the human brain, created by the human hand*; the power of knowledge, objectified. The development of fixed capital indicates to what degree general social knowledge has become a *direct force of production*, and to what degree, hence, the conditions of the process of social life itself have come under the control of the general intellect and been transformed in accordance with it. To what degree the powers of social production have been produced, not only in the form of knowledge, but also as immediate organs of social practice, of the real life process."[28] I will come back to the significance of the General Intellect later, but at this point the aspect should be emphasized that productive force not only corresponds to new technical machines, not even only to the concatenation of "mechanical and intellectual organs," but also and especially to the relationship of the producers to one another and to the production process. Not only the inside of the technical machine is permeated by mechanical and intellectual lines, but social linkages and relationships are also evident on the outside, which become components of the machine. The Fragment on Machines not only points to the fact that knowledge and skill are accumulated and absorbed in fixed capital as "general productive forces of the social brain"[29] and that the process of turning production into knowledge is a tendency of capital, but also indicates the inversion of this tendency: the concatenation of knowledge and technology is not exhausted in fixed

capital, but also refers beyond the technical machine and the knowledge objectified in it to social cooperation and communication.

In the "Appendix" to *Anti-Oedipus* Gilles Deleuze and Félix Guattari not only develop a "Balance-Sheet Program for Desiring Machines,"[30] but also write, in contrast to Marx's ideas on machinery,[31] their own machine concept. What this involves is an expansion or renewal of the concept, but not at all a metaphorizing of the machine. Deleuze and Guattari do not establish a "figurative sense" of the machine, but instead attempt to newly invent the term at a critical distance from both the everyday sense and Marxist scholars. "We do not presuppose the metaphorical use of the word machine, but rather an (indistinct) hypothesis about its origins: the way in which arbitrary elements are made to be machines *through recursion and communication.*"[32]

Marx's machine theory is introduced here with the cipher "that classical schema" and only explicitly named in the third and final part of the appendix.[33] Whereas Marx, in the thirteenth chapter of *Das Kapital*, addresses the question at some length of "how the instruments of labor are converted from tools into machines, or what is the difference between a machine and the implements of a handicraft,"[34] Deleuze/Guattari find particularly the linear conception of the first question insufficient in many respects. What they question here is less the immanent logic of the transformation of the machine as described by Marx, but rather the framework that Marx presupposes as the basis of this logic: a dimension of man and nature that all social forms have in common. The linear development from tool (as an extension of the human being to relieve strain) toward an upheaval, in the course of which the machine ultimately becomes independent of the human being, so to speak, simultaneously determines the machine as one aspect in a mechanical series. This kind of schema, "stemming from

the humanist spirit and abstract," especially isolates the productive forces from the social conditions of their application.

Imagined beyond this evolutive schema, the machine is no longer only a function in a series imagined as starting from the tool, which occurs at a certain point. Similar to the way the techne concept of antiquity already meant both material object and practice, the machine is also not solely an instrument of work, in which social knowledge is absorbed and enclosed. Instead it opens up in respectively different social contexts to different concatenations, connections and couplings: "There is no such thing as either man or nature now, only a process that produces the one within the other and couples the machines together."[35]

Instead of placing tool and machine in a series, Deleuze and Guattari seek a more subtle differentiation, and in this way their query corresponds to Marx's second question about the distinction between machine and tool. Indeed, this distinction could be explained in the form of a different genealogy than the one followed by Marx, such as one that refers to the pre-modern understanding of the "machina," in which the separation between the organic and the mechanical was irrelevant. In *Anti-Oedipus*, however, this difference is treated conceptually/theoretically: the machine is a communication factor, whereas the tool—at least in its non-machinic form—is a communication-less extension or prosthesis. Conversely, the concrete tool in its use for exchange/connection with the human being is always more machine than the technical machine imagined in isolation. "Becoming a piece with something else means something fundamentally different from extending oneself, projecting oneself or being replaced."[36]

By distinguishing the machine from something that simply extends or replaces the human being Deleuze and Guattari not only

refuse to affirm the conventional figure of the machine's domination over the human being. They also posit a difference from an all too simplistic and optimistic celebration of a certain form of machine, which from Futurism to cyber-fans is in danger of overlooking the social aspect in ever new combinations of "man-machine."[37] The narrative of the human being's adaptation to the machine, the replacement of the human by the machine misses the machinic, according to Deleuze/Guattari, not only in its critical, Marxist articulation, but also in its euphoric tendency. "It is no longer a matter of confronting man and machine to estimate possible or impossible correspondences, extensions and substitutions of the one or the other, but rather of conjoining the two and showing how man becomes a piece with the machine or with other things in order to constitute a machine."[38] The "other things" may be animals, tools, other people, statements, signs or wishes, but they only become machine in a process of exchange, not in the paradigm of substitution.

Consider the fable from *The Third Policeman* by Flann O'Brien, in which the Irish author presents precise calculations of the point in time when, due to the flowing of molecules, people on bicycles turn into bicycles and bicycles into people and in which percentage—with all the problems resulting from this, such as people falling over if they are not leaning against a wall and bicycles assuming human features. For an investigation of the machine here, it is specifically not a question of changing quantities of identity on both parts (20% bicycle, 80% human or—even more alarming—60% bicycle, 40% human), but rather of the exchange and the flux of machinic singularities and their concatenation with other social machines: "On the contrary, we think that the machine must be grasped in an immediate relation to a social body and not at all to a human biological organism. Given this, it is no longer appropriate to

judge the machine as a new segment that, with its starting point in the abstract human being in keeping with this development, follows the tool. For human being and tool are already machine parts on the full body of the respective society. The machine is initially a social machine, constituted by the machine-generating instance of a full body and by human being and tools, which are, to the extent that they are distributed on this body, machinized."[39] Deleuze and Guattari thus shift the perspective from the question of the form in which the machine follows the simpler tool, how human beings and tools are machinized, to that of which social machines make the emergence of specific, technical, affective, cognitive, semiotic machines and their concatenations possible and simultaneously necessary.

The main feature of the machine is the flowing of its components: every extension or substitution would be communication-lessness, and the quality of the machine is exactly the opposite, namely that of communication, of exchange, of openness. Contrary to the structure, to the state apparatus,[40] which tend toward closure, the machinic tends toward permanent opening. From the text "Machine and Structure,"[41] written in 1969, to "Machinic Heterogenesis," published in 1992, Guattari repeatedly pointed out the different quality of machine and structure, machine and state apparatus: "The machine has something more than the structure" It is not limited to managing and striating entities closed off to one another, but opens up to other machines and moves with their machinic assemblages. It consists of machines and pervades several structures simultaneously. It depends on external elements in order to be able to exist at all. It implies a complementarity not only with the human being that fabricates it, allows it to function or destroys it, but also by itself in a relationship of alterity with other virtual or actual machines.[42]

In addition to this theoretical approach to a simultaneously indifferent and ambivalent machine concept in *Anti-Oedipus* and several older and more recent texts by Guattari, however, it is important not to omit the historical context of a normative turn to the machinic. Guattari had already started to develop his machine concept in the late 1960s, specifically against the political background of leftist experiments in organizing. These endeavors were initially directed against the hard segmentarity of Real-Socialist and Euro-communist state left-wings, were further explored on the basis of the experiences of diverse subcultural and micropolitical practices, in Guattari's case especially on the basis of anti-psychiatric practice, and ultimately flowed, even after 1968, into efforts to resist and reflect on the structuralization and closure of the 1968 generation in cadres, factions and circles.

The problem that Guattari deals with in his first machine text, written briefly after the experience of 1968, is the problem of a lasting revolutionary organization: an institutional machine that does not transform itself into a state or party structure; a machinic institution that does not reproduce the forms of the state apparatus, those provided by the paradigm of representation, but produce new forms of "instituent practices:"[43] "The revolutionary project as the machinization of an institutional subversion would have to uncover these kinds of subjective possibilities and ensure them ahead of time in every stage of the struggle against being 'structuralized.' Yet this kind of permanent check of the machine effects that affect the structures could never be satisfied with a 'theoretical practice.' It requires the development of a specific analytical practice, which immediately applies to every step of organizing the struggle."[44]

In his texts on the theme of this section, especially in the *Grammar of the Multitude*, Paolo Virno picks up directly from the

Fragment on Machines and the concept, casually introduced there by Marx, of the General Intellect. Even if social knowledge was really ever fully absorbed in the technical machines in the era of industrialization, this would be completely unthinkable in the postfordist context: "Obviously, this aspect of the 'general intellect' matters, but it is not everything. We should consider the dimension where the general intellect, instead of being incarnated (or rather, *cast in iron*) into the system of machines, exists as attribute of living labor."[45]

As post-operaist theory formulates, following Guattari, due to the logic of economic development itself, it is necessary that the machine is not understood merely as a structure that striates the workers and encloses social knowledge in itself. Going beyond Marx's idea of knowledge absorbed in fixed capital, Virno thus posits his thesis of the simultaneously pre-individual and trans-individual social quality of the intellect. "Living labor in postfordism has as raw material and means of production: thinking that is expressed through language, the ability to learn and communicate, the imagination, in other words the capacity that distinguishes human consciousness. Living labor accordingly incarnates the *General Intellect* (the 'social brain'), which Marx called the 'pillar of production and wealth.' Today the *General Intellect* is no longer absorbed in fixed capital, it no longer represents only the knowledge contained in the system of the machines, but rather the verbal cooperation of a multitude of living subjects."[46]

By taking up Marx's term Virno indicates that "intellect" is not to be understood here as the exclusive competence of an individual, but rather as a common tie and a constantly developing foundation of individuation, as a social quality of the intellect. Here *pre*-individual human "nature," which lies in speaking, thinking, communicating, is augmented by the *trans*-individual aspect of the General Intellect: it is not only the entirety of all knowledge accumulated by the

human species, not only what all prior shared capability has in common, it is also the in-between of cognitive workers, the communicative interaction, abstraction and self-reflexion of living subjects, the cooperation, the coordinated action of living labor.

Finally, on the basis of Virno's writings we are able to connect General Intellect as a collective capability and a machine concept in Guattari's sense. Knowledge as collective intellectuality is complementary to the machinic quality of production and social movement. General Intellect, or the "public intellect," as Virno further develops the concept, is another name for Guattari's expansion of the machine concept beyond the technical machine and outside its realm. "Within the contemporary labor process, constellations of concepts exist, which function as productive 'machines' themselves, without needing a mechanical body or a little electronic soul."[47]

THEATER MACHINES AGAINST REPRESENTATION:
EISENSTEIN AND TRETYAKOV IN THE GASWORKS

"Theater did not succeed in going into the street and dissolving its aesthetic, emotionalizing essence in action. The confrontation between 'life' and 'art' was over." — Sergei Tretyakov[48]

THE PROBLEM OF AESTHETIC REPRESENTATION is so closely linked with the dialectical framework of identity that breaking out of this limitation seems completely unthinkable, particularly in the context of classical art theories. Art must be imagined in the rule of identity as pure representation, as an image of something, a description of something, an appearance of general forces; in other words, as a

representation of situations. In the setting of the bourgeois theater evening, it can only be a matter of representing situations, of a temporary, at best orgiastic representation of the collision that is not only dissolved as an action when the curtain falls, but also becomes irrelevant as soon as one leaves the theater.[49] In the words of Hegel again: "The situation in general is...the stimulus for the specific expression of the content which has to be revealed in existence by means of artistic representation."[50] Yes, but which "existence" is meant here, which "action," when Hegel discusses action specifically in the theory of the situation? It is undoubtedly an existence represented on the stage, the action of the play. Differentiating the situation into oppositions, complexities, transgressions remains part of the plot. The interests intentionally torn out of a presupposed harmony remain performed on the stage, unable to do anything but anticipate their end in two hours.

Against this backdrop of the fixation of art production to aesthetic representation, in the early 20th century a continuous stream of artistic strategies emerged, which opposed this one-sided fixation due not only to Hegelian aesthetics. What Marcuse was later to describe as the "affirmative character of culture" was repeatedly subjected to new fundamental criticisms by the new avant-garde as early as the 1910s and 1920s to an even greater extent than on the part of Marxist theory, later also as a "radical leftist deviation" *against* Marxist-Leninist cultural policies. Along with the biting criticism of bourgeois cultural enterprises, Futurism, Dadaism and Productivism strove for performative, provocative and subversive strategies to thwart the logic of representation both in the aesthetic and in the political sense. In this way they also carried out a tendential turn from the 19th century model of artistic autonomy toward an avant-gardist collective and self-defined heteronomy,

whereby their transgressions "toward life" implied a limited subordination to political practice.

Yet it is especially in these aspects of self-instrumentalization that a differentiation between the strategies and historical developments of the Soviet avant-garde and the Western European avant-garde is evident. Although there were exchanges and overlaps between the avant-gardes in socialist and capitalist contexts in the early 20th century, they developed different strategies of transgression and provocation in keeping with the completely different social developments. In the post-revolutionary Soviet Union the extensive plans of the Proletkult—contrary to the intentional self-marginalization of Dadaist positions, for instance—were to contrast bourgeois culture with an entirely new, proletarian culture. As weakly as these plans were theoretically and politically positioned, they formed a solid foundation for testing these kinds of strategies. Even though the struggles for the autonomous development of educational and cultural policies on the part of the Proletkult organizations in Bogdanov's sense were soon lost, as the party and Lenin no longer left much scope open after 1920 at this general political level, a relatively broad scope was still present within the smaller framework of art production. The debates about appropriate art for the socialist society and the transition into this society opened up a post-revolutionary battlefield between very different positions, between the bourgeois art concept of Bogdanov, who sought to preserve the cultural heritage from Gogol to Tolstoy, through the predecessors of Socialist Realism all the way to the leftist positions of Futurism, agitation art and production art.

Based on Marx's statement that in a communist society there would be no painters, but at best people who *also* paint, this field also included the first programs of an art which takes to the streets,

dramaticizing everyday life, dramaticizing life in general. In the phase of the widespread emergence of these ideas directly after the October Revolution, the "objective conditions" for this were also the optimum conditions. The Revolution had created the preconditions for an increasingly differentiated and experimental development of what Tretyakov called the maximum program of Russian Futurism, the "dissolution of art in life:"[51] from the extensive, but also naïve ideas of "art for everyone" through the work of the dramatic circles in the workers clubs to the exodus of the "writers to the kolkhoz."

Against the negative background of ongoing factional fights and disputes between the party, the unions and the Proletkult along with Lenin's omnipresent criticism, in the first years after the October Revolution, at least the left wing of the Proletkult and after 1921 the Leftist Front of the Arts (LEF) were able to establish their practice on the sparse areas of contact between revolutionary Russian workers and radical bourgeois intellectuals.

The Soviet revolutionary theater with its mass productions left the theaters and went into the street. The "Theater October" brought a wave of theatrically produced mass celebrations, amateur actors and agitation evenings. Gigantic productions extending to half the cities were to create a mass celebration type of framework for a "dramaticization of life," in which the masses of the audience become actors. The legendary re-staging of the storm of the Winter Palace was the most far-reaching rehearsal of this extension of the theater to urban space. In 1920, on the third anniversary of the October Revolution, 15,000 players, mostly recruited from the Red Army, and a total of 100,000 participants in the whole city of Petrograd repeated the events of November 7, 1917 under the direction of Nikolai Evreinov. Following separate depictions of the

pre-revolutionary Provisional Government on the "white stage" and the proletariat preparing for battle on the "red stage" along with several scuffles on the bridge in between the two stages, the white government took flight into the Winter Palace, which was stormed with heavy gunfire and the deployment of vehicles and the cannons of the battle cruiser Aurora.[52]

Yet, with the introduction of the New Economic Policy (NEP) in 1921, the Proletkult also changes its official strategy. In general, the NEP was conceived as a policy of the massive integration of petit bourgeois and peasant contexts into socialist society and was thus also a step back into capitalist conditions, resulting in a strong reduction of funding for the Proletkult in particular. Theater was re-privatized and tickets became more expensive again, leading to an increase in a new audience, the NEP audience: small-scale capitalists, business people, new large-scale farmers and their families. Although hopes for a "genuinely proletarian art" thus sank and the general tendency toward a uniformity of socialist cultural policies started here, the left wing of the Proletkult was able to constructively turn around cultural political impositions in a last tour de force. The mass development of a proletarian culture gave way to the orientation to a directly effective agitation and production art.

Building upon early attempts at mass staging, biomechanics and constructivist stage mechanization by Vsevolod Meyerhold, in the Moscow First Workers Theater Sergei Eisenstein, Boris Arvatov and Sergei Tretyakov developed the "eccentric theater" and the "montage of attractions" between 1921 and 1924, from which separate versions of production art strategies later emerged in film, theory and operative literature. The first attempts of agit-theater were undertaken to counter the effects of the organic representation of situations in the theater and to counter depictive illusion and passive contemplation/

empathy. The politically and theoretically formulated goal was the complete elimination of the stage, tearing down the boundary between viewer and actor, between theater and everyday life, between reality in life and reality in art. In the practice of Soviet theater around 1920, however, it was evident that the hierarchy of the spatial and social architecture of the theater thwarted the realization of these far-ranging goals, while at the same time the goal of the dissolution of difference between art and life itself held a counter-productive aspect: with the de-differentiation of art and life the specific strengths of the institutions of the art field and the specific competencies of its actors are made to disappear.

One consequence of this problematization of the relations of art and life in the practice of the Moscow Workers Theater consisted of turning away from earlier mass stagings toward the development of more detailed strategies for a consistent and precisely calculated agitation of the audience in the theater. This strategic reorientation also meant promoting increasingly specific audiences.[53] This reached both its climax and, to a certain extent, its conclusion in 1924 in the third and final theater cooperation between Eisenstein and Tretyakov. Tretyakov's play *Protivogazy* ["Gas-Masks"] responded as a radicalization of Proletkult theater work to both the aforementioned problems: In order to break the molar structure of the theater, in February 1924 the theater people left the theater again, but this time not to go "into the streets," into the equally unbounded and anonymous "urban space" of the city, but instead into the gigantic hall of the Moscow gas works at the Kursk train station, where they agitated a specific audience, that of the workers in this plant. Not only the content, but also the location of this performance aimed at the everyday life of production. This practice was consciously limited to a particular

public that was not intended or willing to correspond to abstract notions of the dissolution of art and life. Here the different location—unlike the current romanticization of post-industrial ruins as cultural centers—did not function as decoration, artistic means of distinction or just stage for artistic representation, but was instead intended to guarantee an audience of workers and their specific agitation. In the midst of the workers' customary working environment the actors operated alongside the gigantic apparatuses of the plant on the scaffolding of the stage in workers' uniforms to blur the difference from the watching workers—not, however, with complete success, as is apparent in a later account from one of the protagonists. "But it already became clear after the first performance that we were disrupting their work....They put up with us for four performances and then politely showed us the door."[54] Nevertheless, in 1925 Mayakovsky wrote about the play: "Every performance of Tretyakov's helpless little play that was put on by the Proletkult in the gas factory contains more new culture and revolutionary achievements than can be generated by any large stage, achieved by any major and, in the sense of the Futurists' finesse, sophisticated work."[55] The consequence of Tretyakov and Eisenstein's view that their final theater cooperation did not work was that Eisenstein rigorously turned away from theater and began working straight away with the same core of Proletkult actors from the *Protivogazy* production on his first film *Strike*.

In the three years prior to that, the Moscow Proletkult theater around Eisenstein and Tretyakov had already withdrawn to specific publics—in the Proletkult studios, which were regarded as laboratories of proletarian culture. At the same time they had undertaken extensive experiments in the space of the theater itself—under the motto of "eliminating the theater per se"[56]—relating to performance

practice, beginning with an increasingly eclectic mixing of genres. In the Soviet Union in the early 1920s the inclusion of elements from circus, revue and film[57] still signaled an attack on the pure practice of bourgeois theater, carried out especially by means of the "attraction." The "Theater of Attractions" practiced and theoretized by Eisenstein and Tretyakov around 1923 involved aggressive and physical moments of theater, the effects of which were intended to disrupt the mechanism of illusion and empathy. The montage of attractions did not mean accumulating tricks and artifices designed for effect, but rather developing circus and vaudeville elements for a materialist, "natural science" theater. What the Proletkult theater took over from the circus was the approach of the artiste, but also the fragmentation of its structure of numbers, the sequencing of "single attractions not conjoined by a subject matter:"[58] with Eisenstein and Tretyakov, this seemingly deficient disconnectedness became a weapon against empathy. To counter the totality of the subject matter they mounted and molecularized the piece as a piecework of single attractions. Eisenstein wrote: "I define an attraction in the formal sense as an independent and primary element of the construction of a performance—as the molecular (i.e. constitutive) unity of the *impact* of theater and of the *theater in general.*"[59] The attraction is thus more than just a circus number, it is a situation that, as a "molecular unit," contains conflicts. Contrary to the Hegelian treatment of the collision, however, it was not Eisenstein and Tretyakov's intention to present *conflicts*, but rather to create a collision *with the audience*.

The theater of attractions did not conceal this assault on the audience as the "main material of the theater."[60] In this context the function of the situation was not to present the emergence and dissolution of oppositions, but rather to "evoke a maximum psychical effect."[61] This effect consisted of establishing a process of fragmented

excitement contrary to the situation as illusion inviting the audience to take part in an experience in a pseudo-participatory manner. The aspect of montage did not determine the macrostructure of the piecework here, but was instead applied to the composition of the individual attractions. "The actors, the things, the sounds are nothing other than elements, from which an attraction is constructed:"[62] an assemblage of actors, who do not portray, but work—and things, constructive frameworks and objects that the actors work with instead of decorations and props.

"The illusory action of the theater is regarded as an inherently coherent manifestation; what we have here, however, is a conscious expectation of incompleteness and of major activity on the part of the viewer, who must be able to orient himself to the most diverse manifestations that are played out before him."[63] The concatenation of events and of actors, things, sounds and viewers, as described here, comes surprisingly close to Guattari's machine concept. In *Anti-Oedipus* Deleuze and Guattari, however, remark that in Russian Futurism and Constructivism certain production conditions remain, despite collective appropriation, "external to the machine,"[64] yet the practice of the theater of attractions seems to contradict this.

In his concept of theater Tretyakov indicates the direction that the relationship of human-machines, technical machines and social machines should take. "The work on the scenic material, the transformation of the stage into a machine that helps to develop the work of the actor as broadly and diversely as possible, is socially justified if this machine not only moves its pistons and holds up to a certain workload, but also begins to carry out certain useful work and serve the ongoing tasks of our revolutionary era."[65] Above and beyond the aestheticizing use of technical machines and constructions as decoration, attempts were undertaken to make the stage

machinery of the theater transparent as a model for technicization and to create flowing transitions between technical machines and the constructive scaffolding and stage sets. Beyond Meyerhold's biomechanics, which trained rigid self-discipline of the human body as a machine, but easily dwindled into danced sculpture, the actors and actresses became elements of the attraction. And finally, Gastev's Taylorist ideas of the scientific administration of work and the reversal of the human-machine relationship[66] led to the development of a concatenation of technical machines (the things), the bodies of the performers and the social organization of all participants, including the audience. These ideas of the interlocking of technical and social structures in the theater of attractions only remain superficially bound to a "theater of the scientific age." The attempt to also "calculate" machines this complex, as proposed by Eisenstein and Tretyakov, goes beyond a relationship of the exteriority of technical machines and social collectives and far beyond purely mathematical, technical considerations.

Eisenstein described the attraction as being based solely on something relative, on the reaction of the viewers. The representation of a given situation, due to the subject matter, and its development and resolution through collisions that are logically connected with this situation, subordinated to the psychologism of the subject matter, is replaced by the free montage of attractions, which are mounted to achieve a certain final effect and thus carry out a work on the audience. Eisenstein and Tretyakov wanted to change the order of emotions, to organize them differently. The audience was to become part of the machine that they called the theater of attractions. Through "experimental testing" and "mathematical calculation," they wanted to produce "certain emotional shocks" among the audience.[67]

The emphasis here is on *certain* emotional shocks: contrary to the total management of emotions in bourgeois theater, this meant an excitement determined by utility and precisely demarcated by exactly mounted impulses. This attempt to "exactly calculate" emotions had less to do with the Pavlovian stimulus model than with the attempt to steer and test the cited reality of signs, with body work of the performers and the bodies of the audience in the interplay, contrary to the bourgeois strategy of aesthetic fiction. A clear distinction must be made between the means of the old theater model and that of the new. Although the theater performance was not explicitly defined as a "process of working on the audience with the means of the theater effect"[68] in bourgeois theater jargon, the intention of "aesthetic education" implicitly had a similar effect. The theater of attractions, however, sought to *calculate* its audience. This also meant that "the attractions are calculated *depending on the audience*."[69] In other words, every performance required new considerations, in fact that the performance found its purpose in the audience, its material in the context of the life of the audience. It is not known how far Eisenstein and Tretyakov took their calculation experiments; surveys were taken among the viewers, their reactions meticulously observed and the results carefully evaluated. The fact that their calculations had to/were intended to take a considerable difference between aims and consequences into consideration (certainly a far greater uncontrollability than the performance practices of the 19th century) was due not only to the audience classes newly won for the theater, but also to the experimental format of the attraction.

The performances of Tretyakov's *Slyshish', Moskva?!* [Can You Hear, Moscow?!] must be called a pinnacle in this context, resulting in partly tumultuous situations in the theater.[70] Written, organized and produced extremely quickly as a mobilization and agitation play

for a possible German revolution following the Hamburg revolt in late October 1923, it premiered on the sixth anniversary of the October Revolution on November 7, 1923. Its plot according to Karla Hielscher: "The provincial governor Count Stahl wants to forestall the expected workers demonstrations on the anniversary of the October Revolution with a patriotic mass celebration, where a historical play is to be performed and the bronze statue of some minor noble ancestor is to be unveiled. An action committee of communist workers risk their lives to convert the mass celebration. The actors go along with it and perform the historical play with more and more obvious allusions to the history of oppression and class struggle, and instead of the 'Iron Count,' a gigantic portrait of Lenin appears when the monument is unveiled. This becomes the signal for the armed revolt."[71]

From a superficial perspective Eisenstein and Tretyakov's play failed at two levels: at one level, it failed on account of the occasion, since the revolution, as we know, did not take place. At another level, its self-reflexive theme, inciting a revolution through art, also holds the entire problematic issue of overestimating the effects of artistic practice. The revolution was to be set off not solely by representing revolutionary situations, but by converting the situation through intervention and by abruptly transforming the bourgeois theater into a revolutionary theater. Just in the specific performance context of the socialist society in Moscow, however, this representation of revolution was to have a different impact than in a revolutionary situation. Tretyakov and Eisenstein made use of the increasingly mounted attractions with an accentuation such that more and more excitement spread through the audience: more and more frequent heckling, viewers reaching for weapons and fist fights with extras getting involved in play fights must have resulted in an

impressive chaos. And the inflamed viewers were reported to have reacted heatedly not only in the theater, but also in the streets of Moscow afterward: "…after that they moved through the streets, wildly beating against shop windows and singing songs."[72]

Four years after the performance Tretyakov regarded this effect of triggering spontaneous actions as a negative one.[73] It seems that when theater in Moscow finally went "into the streets," it proved to be quite problematic. However, the author's late self-criticism could also be due to the development of official Soviet cultural policies, which took a clear position in June 1925 against the Proletkult and especially against its leftist currents.[74] At that time Tretyakov had already distanced himself again from the eccentric theater of attractions.

In the discussion of *Slyshish', Moskva?!* in the LEF newspaper, the organ of the left front of the Proletkult, it was said quite differently in 1924 that the procedure of the montage of attractions had "successfully proven itself" in the performances of *Slyshish', Moskva?!*[75] The question can probably not be answered as to what extent the theater of attractions intended to "calculate" with the spontaneity described above outside the space of the theater as well. The *calculation* of the audience may well have gone so far as to seek to plan for, calculate and evaluate even chaos and tumult. With their demands for exact definitions of social tasks and scientific methods Eisenstein and Tretyakov certainly succeeded in shifting the theater machine to a terrain that was so unstable that no other artistic practice would soon be able to achieve.

The two theater workers succeeded in disrupting the idealistic patterns of thinking and emotional automatisms of the theater of illusion with the fragmentation and aggression of the attractions.[76] Along the way from representing to constructing the situation, however, the experiments of the Proletkult theater appear contradictory,

entangled in complex contradictions with both their theoretical aims and the instructions of official cultural politics, so that they are oddly blocked, stuck in an in-between phase. Trapped in the framework of the—still bourgeois—theater field, it is as little possible for the strategies of attraction, of interruption and distancing to *construct* situations as it was for the strategies of the extension of representation into the orgiastic in the 19th century. The gap between representing social processes and intervening in them proves to be just as resistant as the foundations of the bourgeois theater apparatus (in the socialist as well as in the capitalist context).

However, the successes of the Proletkult have also been marginalized due to the distorted and neglected inscription of Agit-Theater in the histories of theater and art. There are two reasons for this: first of all, there were the increasingly restrictive cultural policies, which interrupted the work of the left-wing Proletkult in the mid-1920s as a deviation from the party line and strengthened the right-wing, so that further experiments of radicalization became impossible. In the decades after that and as a consequence of the Soviet cultural policies drastically coming to a crisis, a kind of *damnatio memoriae* for the left-wing Proletkult emerged as a secondary development in socialist countries, along with a clean break between the later works of its protagonists and the early experiments. Finally, the self-historicization of the protagonists, seeking to describe their further developments in other art practices as progress, led to a devaluation of the earlier experiments. For Eisenstein this was the acclaimed history of his cinematic works, as from this perspective the theater works of the early 1920s had led to a boundary that could only be productively transformed through its logical continuation in film. Tretyakov, following his greatest success with *Rychi, Kitai* ["Roar, China!"], turned to an experiment of a completely different kind.

WRITERS TO THE KOLKHOZ!:
TRETYAKOV AND THE "COMMUNIST BEACON"

"And transversal connections from knowledge to knowledge, from
one point of politicization to another can be established…"
— Michel Foucault[77]

"OUR CONSTANT MISFORTUNE in LEF was that we represented a river
on the map of literature, which sank into the sand without ever reach-
ing the sea. In 1919 the 'Art of the Commune' broke off, in 1924 the
old 'LEF' dried out, in 1928 the 'New LEF' ended abruptly. But our
work is not worth a cent, if we do not flow into the sea—into the sea
of the masses."[78] This was how Sergei Tretyakov described the situa-
tion in the last issue of *Novi LEF*, following the break with his
colleague and editor in chief Mayakovsky in 1928, four years after the
first LEF with Arvatov, Kusner, Tarabukin, Eisenstein, Brik and
Mayakovsky had broken up. The radical left sections of the Soviet
cultural left-wing also split several times, particularly in conjunction
with the increasingly rigid cultural policies of the 1920s under Stalin,
desiring less and less to flow into the "sea of the masses." In this con-
text, Tretyakov's unbroken zeal is all the more remarkable, as it echoes
in the concluding sentences of his last article in Novi LEF: "If our
enemies cry happily: LEF is dead! Your happiness will be short-lived!
It will be continued—through LEF to the factographs."[79]

The "factographs" were, for Tretyakov, the mass of worker corre-
spondents, the reporters and amateur photographers, the newspaper
and radio-makers, in whom he saw the future of Soviet production
art, but he himself was also among them. In 1928 it seemed fortu-
itous to him to interpret and channel a widespread call from state

cultural policies in this, his own sense. "Writers to the Kolkhoz!" was the call that sounded odd even in the Soviet context: as supplementary measures to accompany the first five-year plan, art workers were also to contribute to the collectivization, mechanization and efficiency of the agricultural production. Tretyakov describes the ambiguity and vagueness of the call and his own confusion along with divergent advice from all sides in his book *Feld-Herren*: Some thought that the task of the writers called on to leave their urban surroundings was to closely observe the way the kolkhoz was managed and to describe the expediency and profitability of the collective farms. Others maintained to the contrary that the writers knew too little about it and should instead limit themselves to describing everyday life and the "living human being." Still others whispered, "Check whether they are building silos, you must check that."[80]

On the whole, it seemed that the campaign was not strategically well planned. Those responsible in Moscow were more conspicuous for the tone of emotional invocation, which was used to mask the lack of clear instructions, but the protagonists on both sides did not seem overly pleased: the majority of the writers were still not interested in production art, much less in spending a longer period of time in the countryside; the agronomists and workers in the kolkhoz were not at all happy about the "tourists," "holiday-makers" and "guests of honor."[81] Tretyakov was the only one who described the work as a further stage along the long and often interrupted flow that never carried him and the Soviet Union into the sea of the masses. Against the background of his insights from the prior first decade of the Proletkult, however, this stage did not involve art "going among the people" as suggested by the title of the call. It involved a further facet and refinement of experiences with specific public spheres and collectivity. Concretely, it involved an organizational process in the limited space of a rural collective.

Tretyakov thus responded to the call and went to the North Caucasian kolkhoz commune "Communist Watchtower" for the first time in July 1928. Walter Benjamin summarized sections of Tretyakov's catalogue of competencies in "The Author as Producer,"[82] which he used, along with Brecht's epic theater, to illustrate his theses on changing the production apparatus and on the "organizing function" of art.[83] The following is the extensive version of Tretyakov's self-portrayal in *Feld-Herren*:

"What did I do in the kolkhoz?

I took part in the directors' meetings, where all the vital questions of the kolkhoz were raised: starting from the purchase of spark plugs for the tractors and mending the tarpaulins and ending with setting up the threshing machines and help for single farms.

I held mass assemblies in the kolkhozes and collected money to pay for the tractors and for the state fund. Explained Yakovlev's theses (the People's Commissioner for Agriculture). Provided the collectivists with an account of the work done by the combine. Persuaded single farmers to join the kolkhoz. Made peace among fighting mothers in the children's nurseries. Took part in consultations about how to distribute the harvest. Argued with overly zealous economists, who didn't want to give the education functionaries any horses. Wrung material for the newspaper from intellectuals. Helped participants in radio courses to figure out passages of the lectures that were hard to understand. Investigated farmers' complaints in all directions for their justification. I spoke at assemblies, where the cleansing of the kolkhoz from kulaks and anti-collectivist elements was conducted.

I was a member of the commission for military physical examinations and had to check the readiness of the kolkhoz for cultivating in spring. This I found difficult, because in the beginning I could not

tell which horse collar was good and which was bad or if parts of the plow were missing. There are people who find this trivial. They think smiths are there for the plows, it is not necessary to trouble the writer with that. This is wrong: without exact knowledge of the plow, one could attain no clarity about the moods of the collectivists, consequently one could not step forth with a speech, a sketch, a purely authorial work, in other words.

I inspected reading huts, clubs and kept an eye on the children that I wanted to set up a nursery for in the coming summer. I introduced delegations, visitors and brigades to the operations. I initiated wall newspapers and helped to produce them. I worked on methods for a clear and generally intelligible control over socialist competition in the steppes. I drafted a plan for the cultural offerings for the combine with booth cinemas and temporary clubs. For this I assembled the right people, apparatuses, aids and money. Obtained portable radios and a sufficient library from Moscow, a traveling cinema from Georgievsk. This became the foundation for our educational work, in which Comrade Schimann from the brigade of the 'twenty-five thousand' assisted me.

I led congresses of the education functionaries, conferences of the village correspondents and organized an exhibition of wall newspapers. I continuously reported to the Moscow newspapers from the kolkhoz front, mostly to the *Pravda* and the *Socialist Agriculturalist*, and to magazines.

I organized and led the kolkhoz newspaper. Originally it was only a supplement to the newspaper *Terek*, which provided information for preparing to cultivate the fields.

Later I fought, yes fought and achieved, after many meetings, telephone discussions, letters, telegrams, reminders, depressions and promises, that Moscow newspapers (*The Farmworker* and the *Farmer's Newspaper*) assumed patronage. Moscow provided the

typesetter, the paper and the setting material. And our newspaper *The Challenge*, of which more than sixty editions had already been published, proved to be a highly tangible lever of collectivization, without which we could hardly have done it. I provided the typesetter with an apprentice, a former shepherd, an artist by his own power. Aside from notes, minutes, documents and sketches, I have been documenting life in the kolkhoz with the camera. I currently have about two thousand negatives. To more completely and impressively capture the profound change in the countryside, unique throughout the course of history, I have suggested a system of permanent filming, such that a cinema troop would record the changes taking place in a kolkhoz over a long period of time. A cinema troop of this kind was provided for me by the film company 'Meschrabpom.' Although it turned out that there were substantial gaps in their work, they nevertheless collected a certain amount of valuable material."[84]

Tretyakov's seemingly endless activity report may at first look more like the bureaucracy of an organizer and controller from Moscow with an inclination to be more of a universal intellectual and intervening administrator than a transversal specialist. The gesture of a full statement of accounts is probably also due to his function. As cautious accounts of his first period in the kolkhoz suggest, Tretyakov saw himself as a careful participant in a collective process. As he became increasingly critical of his own term of the "specialist Bolshevik" (which Walter Benjamin was to take over some years later), seeing it as culminating in a savior figure and as a completely excessive demand in reality, as much too complex and exceptional to go into mass production, in the kolkhoz he realized that it was not necessary for one person to unite these characteristics alone. His experiences in the "active" of the kolkhoz even led him to see that "conventionally rejected attitudes like

specialized narrow-mindedness, a mania for innovation or conservative hesitancy become useful, when they criticize one another;" here a change of positions fosters "the necessary flexibility of the active."[85] Tretyakov had abstractly developed the theoretical figure of the specialist Bolshevik from work in the production and reception structures of the institutions of theater and film, which were still classically hierarchical despite the Proletkult. In the practice of the organizational work in the kolkhoz this concept evolved into the "flexible socialist active of very different personalities,"[86] in which the different specific competencies of the individual participants in the collective had a productive impact. Linking these competencies meant linking one specific knowledge with another specific knowledge in a patchwork that did not have wholeness as its goal, but rather a transversal relationship of exchange.

Parallel to this a radicalized turn was evident again on Tretyakov's part, away from the traditional media and genres of the bourgeois concept of art. Instead of the experimental expansion of the concept of theater or literature, he was interested in the media of an organizing production art: club, demonstration, film, photo, radio and especially newspaper. The art worker's competency turns away from the famous attempts to transform the bourgeois theater toward an actuation of newer media or media still to be invented and the new forms of these media, and toward organizing activities that pick up from Tretyakov's earlier Proletkult experiences in the experimental organization of collectives. With Eisenstein and Arvatov he had also worked on the "Experimental Laboratory of Kinetic Constructions" of the Moscow Proletkult. All possible forms of social assembly were to be experimentally tested in the workshops in the course of training: "Conference, banquet, tribunal, assembly, meeting, audience space, sport events and competitions, club evenings, foyers, public cantines, mass celebrations, processions, carnival, funerals, parades,

demonstrations, flying assemblies, company work, election campaigns, etc. etc."[87] It almost seems as though Tretyakov seized a long sought after opportunity almost a decade later with his work in the kolkhoz to try out the same work on the forms of organization that he had conducted in the meanwhile closed laboratory of the Proletkult, but now decidedly outside the realm of art institutions. In the jargon of socialist art theory, "he made his literary theme the site of his social activity."

The sketches by the operating writer Tretyakov in his book *Feld-Herren*, published in the early 1930s in Germany, are traces of a retreat from the organizing function of art back to the old apparatus of the subjectively literary and they dispense with a structuring portrayal of working on the forms of organization; something like "Instructions by the Production Artist Tretyakov for the Collective Organization of the Kolkhoz"[88] would have proved more useful in terms of content and more logical in terms of form. However, the documentation and compilation of Tretyakov's reflections and reports in book form is only the surplus; with Benjamin, the art practice consists in continuously changing the production apparatus, but also in changing the concept of art: following the paring of the grand ideas of art being absorbed in life, after the first specifications of theater work with Eisenstein in the factory, after turning away from theater again, Tretyakov arrived at his most radical strategy, almost outside the realm of art. In the setting of a broad campaign in socialist society, in which potentially thousands of experiments of this kind could have taken place in parallel, Tretyakov's micro-politics functioned as a laboratory still waiting for concatenation. Then the mechanisms of Stalin's molar apparatus caught up with him and increasingly prevented him from working. In 1937 he was arrested, in 1939 he was shot, in 1956 he was rehabilitated, as it is euphemistically called in the historiography of the Soviet Union.

CONSTRUCTING THE SITUATION:
THE SITUATIONIST INTERNATIONAL AND THE PASSAGE OF A FEW PEOPLE FROM ART TO REVOLUTION

"To purposely construct life is what the LEF wanted to achieve. The LEF is against, not for a theatricalization of life."
— Boris Arvatov, 1924[89]

"The S.I. is still far from having created situations."
— Situationist International, 1963[90]

"Previously the most lucid artists had wanted to break the separation between art and life: the S.I. raised this demand to a higher level in their desire to abolish the distance between life and revolution."
— Gilles Dauvé[91]

AT THE BEGINNING OF GUY DEBORD'S pre-Situationist practice there were experimental film attempts and performative expansions of the cinematic space. Influenced by the Lettrist experiments associated with Isidore Isou, Debord set out in the early 1950s to further develop the techniques of montage and distortion, to productively invert them. It was no longer to be the interventions of the author that would violently pull the audience out of empathy in the stream of the plot, but rather the audience itself should intervene in the form of the film, so that the final montage took place in the cinema. In a continuation of the avant-gardist methods of Futurism, Dada, Agit-Theater and the Theater of Attractions, Debord's filmic strategy was designed not only to trigger conflicts, but to actually drive the provocation as far as possible. More than a decade before the corresponding

experiments by Kaprow, Schneemann, EXPORT, Weibel and others with Fluxus, Happenings and Expanded Cinema, this strategy calculated with the interruption of the film evening by a protesting, howling audience, planned the tumult. Debord's first film, *Hurlements en faveur de Sade*, does without images, consisting of a white illuminated screen corresponding with a few text fragments and—most of all—black sequences without sound that become longer and longer, ending with 24 minutes of silence and darkness. In 1952, at the first screening at the Paris Musée de l'Homme, the audience already rebelled against the first prescribed pause for reflection, and the film was stopped.[92] Tumults, a rebellion of the audience, uproar, that was Debord's ambition, not only in the cinema.

Although he was probably not aware of Tretyakov and Eisenstein's experience of agitation with *Slyshish', Moskva?!*, in his early works he implicitly referred to the tradition ranging from Eisenstein and Tretyakov to Benjamin and Brecht,[93] for instance when he repeated that "the most pertinent revolutionary experiments in culture have sought to break the spectators' psychological identification with the hero so as to draw them into activity by provoking their capacities to revolutionize their own lives."[94] It was not separated work on the art space that was to determine the Situationists' concept of art, but rather anti-art interventions in concrete social spaces. While Debord therefore increasingly broke with the classical forms of art, trading the closed art space for the tendentially open surroundings of urban space, during the 1950s there were more and more indications of a concept that became most prominent in the cluster of Situationist terms such as dérive, détournement and psychogeography, and which gave the International its name. More and more often they discussed *créer une situation*, creating a situation: "Our central idea is the construction

of situations, that is to say, the concrete construction of momentary ambiances of life and their transformation into a superior passional quality."[95]

As early as 1953 the then 19-year-old Lettrist Ivan Chtcheglov (Gilles Ivain) presented his "Formulary for a New Urbanism,"[96] in which he introduced the need to construct situations "as being one of the fundamental desires on which the next civilization will be founded."[97] And a few years later Debord stated that this need in no way applies to the space of art: "Situations are conceived as the opposite of works of art, which are attempts at absolute valorization and preservation of the present moment."[98] Whereas the artwork, according to Hegel, suspends the situation in harmony and standstill, the construction of the situation is to be imagined as an attempt to newly experience, newly organize a certain space for a certain time in the midst of the "society of dissolution." Instead of the *representation*, the *construction* of situations "will be the continuous realization of a great game, a game the players have chosen to play: a shifting of settings and conflicts to kill off the characters in a tragedy in twenty-four hours."[99] In the terrain of what Debord would later call the "Society of the Spectacle," what distinguished the pre-Situationist attempts to construct the situation is that they were temporary, provisional constructions of situations: "passageways" "without a future."[100] This is where the present becoming is to be tested, a bit of "life" even on the ground of the "society of the spectacle," in which you usually only care about surviving. Nevertheless, testing the situation best corresponds to what is imaginable in the "prehistory of everyday life."[101]

As a number of things generally remain obscure when (Pre-) Situationists negotiate the situation, starting with Chtcheglov's first text there is only a vague association of what could specifically be

meant by the construction of the situation beyond the theoretical conception. Yet Chtcheglov clearly presents his urbanist-architectural ideas by intertwining the need for "total creation" with the need to *play* with architecture, with time and space. The situation does not exclude coincidence, but tries to regain it. The participants in the situation and dérive carry out active détournement on the spectacular image of the city.

There is little to be found in the extensive texts of the bulletin of the Situationist International (S.I., founded in 1957) about the way in which the construction of situations and the constructed situation itself may actually have occurred. Only a few vague reports describe these early experiments;[102] they decided to necessarily reject products that could be exploited in the art field and combined a few undocumented concretizations of creating situations with an abundant production of reflexive and political texts. From the beginning, however, Debord left no doubt that situations are not to be taken as romantic ideals, but rather as the active formation of environments, a free play with urban space as playing field. In the midst of space permeated by spectacle, the Situationists sought to find—or rather *invent*—disruptions of the familiar. Instead of the situation being depicted on the stage in the Aristotelian theater, being interrupted on the stage in epic theater, in the Situationist theater of everyday life the situation is shifted to the everyday space of the city. In conjunction with the practice of dérive, drifting through the city, the experience of the city oscillates between the two poles of concentration and distraction, between precisely coordinated movements —controlled by walkie-talkie, for instance—and spontaneous explorations of urban space. Aimlessly roaming through the suburbs, sometimes at dawn following a night of drinking, presumably alternated with calculated interventions in the urban centers.

Graffiti, détournement of inscriptions on monuments, the removal of street signs, psychogeographical cartographies. Here the potential of experiencing the city is developed as the production of desire and the possibility of directly, "situatively" resisting the objectively posited "situations" of capitalist societization. Situation and dérive serve the exploration of an urban landscape for entirely different purposes, from a students' drinking tour to determining potential sites for building barricades. In noise, in the provisional, in the breakdown of events, the situation is condensed and intensified. In Paris of the late 1950s, the emphasis on experiencing new possibilities and introducing unforeseeable actions already anticipated the situations of the Parisian May and the uprising in the Quartier Latin ten years later.

What is clearly evident in the existing documents: the construction of situations was certainly not to revolve around passively drifting in quasi natural situations, but was instead a matter of more or less intentional, artificial interventions. These were carried out, however, between the poles of a discreet détournement within the framework of reinterpreting familiar city streets on the one hand and the style of maciste provocations from Lettrist rowdies on the other. When talking about the intentional *construction* of situations, however, a question arises that the S.I. itself raised: "What admixture, what interactions ought to occur between the flux (and resurgence) of the 'natural moment,' in Henri Lefebvre's sense, and certain artificially *constructed* elements, introduced into this flux, perturbing it, quantitatively and, above all, qualitatively?"[103] That a conscious and direct intervention is required beyond "natural moments" to construct a situation is already evident in the terms *créer* and *construire*, which are used in conjunction with the Situationist situation, as well as in several passages in the S.I. bulletin,

which refer to these kinds of direct interventions. The Situationist definition accordingly conveys the constructed situation as "a moment of life concretely and deliberately constructed by the collective organization of a unitary ambiance and a game of events."[104] Although Debord's ideas later led more and more beyond questions of participation and of the gap between production and reception—Debord anticipated the problems of participation and activation in the post-fordist paradigm as early as 1963[105]—one aspect of the construction of situations was an endeavor to thwart the fixation of the relationships between the stage and the audience space, between actors and observers. The situation is constructed "to be lived by its constructors. The role played by a passive or merely bit-part playing 'public' must constantly diminish, while that played by those who cannot be called actors, but rather, in a new sense of the term, 'livers,' must steadily increase."[106] Instead of "audience" and "acteurs," it is thus the "livers," "viveurs" that characterize the situation, at least in the ideal case.

The ambivalence of the Situationist International as an a-hierarchical network and record-breaking operation of exclusion has already been widely discussed.[107] What is interesting in our context, though, is less the self-mythologizing organization of the S.I. itself than the organization of the situation. Yet a temporary functional division must be considered even in the concrete cases of constructed situations. In other writings Debord limited the collective practice of the *viveurs* to a three-stage hierarchy. In this hierarchy a certain predominance is attributed to the director as leading coordinator, who is also permitted to intervene in events, whereas at the second level we find "the direct agents living the situation, who have taken part in creating the collective project and worked on the practical composition of the ambiance," and finally at the third level "a few

passive spectators who have not participated in the constructive work, who should be *forced into action*."[108] Indeed Debord continues that this involves merely a temporary subordination of the situationist collective under a person responsible for the experiment as a whole. What remains, however, is the impossible position of the third level, that of the audience. It is not necessary to go as far as Roberto Ohrt, who imputes that Debord uses the audience as a punching bag.[109] The problem is a more general one, which—if we are not to take recourse to molar structures—can be treated, if not solved, in two ways: either by permanently specifying and delimiting the audiences (which become "active") *or* through opening up to the complexity of political processes.

Brecht took the first course with a gesture of radical *closure* by developing the strict form of the *Lehrstück* ("learning play") from the various experiments with epic theater in the 1920s. "The Lehrstück teaches by being played, not by being seen. In principal no viewer is needed for the Lehrstück…"[110] By giving up the theater as a site of presentation, the audience as a receptive figure, the text as a finished form, Brecht conceived of a theater that is intended not only for those conducting it, that involves communication exclusively among the active participants; specialists as recipients that—being relieved of reception—*take action*. The teaching of the learning play consists of playing (out) various—even all possible—positions and roles in a constant change of perspective. For this reason Brecht repeatedly refused performances of his Lehrstück *Die Maßnahme* before an audience, calling it a "means of pedagogical work with students of Marxist schools and proletarian collectives."[111] "We take these important events out of all dependencies and let those carry them out, for whom they were intended, the only ones who have a use for them: workers choirs, amateur theater

groups, choirs and orchestras of school children; in other words those who neither pay for art nor are paid for art, but who want to make art."[112] However, it is not only the purely receptive audience that is set in motion, but also the text itself. From the beginning, suggestions from the actors as well as Marxist criticism resulted in more and more versions. At the same time, *Die Maßnahme* was virtually always in danger of being censored: it was prohibited in 1933 just before the Fascists took power; in the USA it was the reason why Brecht was called before the US anti-communist authorities for questioning; it became problematic in the GDR because it could be interpreted as a criticism of Stalin. As a result, the Lehrstück was not only not played as an event for an audience, but no longer played at all.

Debord was to take the other path: with its politicization until May 1968 in Paris the S.I. as a discursive assemblage achieved— even with all the internal practices of exclusion—an *opening* into the complex and unpredictable space of the revolutionary machine. Starting from performatively processing the situation and its necessary hierarchy the S.I. developed a practice of a pre-productive opening of the situation and its "viveurs," igniting a spark that suspended its organizers.

Revolutionary ignitions of this kind, however, have been more or less omitted in the reception history of the S.I.: whereas political histories practically obliterated the role of the S.I. before and during May 1968 in Paris, not least of all because of the many enemies that Debord made, Roberto Ohrt's *Phantom Avantgarde*, which inscribes the S.I. in art history, foregrounds the artistic orientation of the S.I. in comparison with their effect in the political movements. For this reason, Ohrt focuses on a separation and categorization into *either* art history *or* revolutionary action: every "dissolution of the situation

into the moment of action" would be contrary to the interest of the situation, writes Ohrt.[113] By taking the action as the *dissolution* of the situation, along with Hegel, he thus affirms the old dichotomy between artistic representation and political action, personified in the case of the Situationists by the opposition between the (ex-) painters Constant and especially Asger Jorn on the one hand and the activist filmmaker and political theoretician Debord on the other. The art historian Ohrt impunes that Debord "found no access to modern art, to its work on aesthetic experience"[114] and therefore eliminated the artwork and the classical field of art from his considerations.[115] Jorn, on the other hand, functions as a positive foil of the artist in comparison with the S.I.'s "obsolete political notions" disseminated "under the protection of their subtle humor."[116] According to Ohrt, Jorn refused to "follow violence into an abstract extremism,"[117] pointed out "the Situationist ideas' potential for violence,"[118] and—most of all—recognized the "danger of anti-artistic tendencies in art."[119]

This kind of traditional separation between art and politics, however, corresponds less to the practice of the protagonists and not at all to the theory of the S.I. Even in the early "Contribution to a Situationist Definition of Play," published in the first edition of the S.I., there is an unmistakable expression of this twofold and indivisible stake of action and representation in the situation. It is a matter of "struggle" *and* "representation:" "the struggle for a life in step with desire, and the concrete representation of such a life."[120] The explosive mixture of raving cultural criticism, revolutionary theory and contemporary political texts culminating in Debord's *La Société du Spectacle* and Vaneigem's *Traité de savoir-vivre à l'usage des jeunes générations* (both published in 1967) was one of the most important theoretical antecedents of May 1968 in Paris. Their

pointed concepts spread far beyond the walls of Paris, inspiring several generations of not only French activists *and* intellectuals before and after 1968. The ongoing politicization of the S.I. later led to the participation of the Situationists in political actions, to the development from playing with the components of a political party in the art field to becoming an anti-party component of the social movement. The specific Situationist combination of brutal attacks on the society of the spectacle and on the reformist left-wing, together with the older experiments with situation and dérive, provided tangible impulses for critique and forms of action in 1968.

Whereas the political historiography of 1968 tends to slip more and more into glorifying and/or reactionary terrain, the role of the S.I. before and after 1968 has still been too little researched to allow for clear statements about its transformation from an art machine to a revolutionary machine. Even insiders like the two ex-Situationists T.J. Clark and Donald Nicholson-Smith expounded on the difficulties of this endeavor in 1997: "We were members of the Situationist International in 1966-67. This gives us no special vantage point with respect to the really interesting questions about the S.I. in its final, extraordinary years. In particular the key issue, of how and why the Situationist came to have a preponderant role in May 1968—that is, how and why their brand of politics participated in, and to an extent fueled, a crisis of the late-capitalist State— is still wide open to interpretation."[121]

During the 1960s the S.I.'s text production shifted from still art-immanent anti-art propaganda to more political and political theory themes, and Debord completely abandoned filmmaking until the end of the S.I., becoming temporarily affiliated with the theoretical circle around Claude Lefort and Cornelius Castoriadis and their Marxist-council revolutionary periodical *Socialisme ou*

Barbarie. Closer to 1968, however, the practice of the S.I. developed more and more in the direction of an intersection of theoretical impulses for the movement on the one hand and affiliation with the newest forms of political action on the other. Even though the S.I. remained true to its nonchalant gesture and superficially maintained the appearance of a traditional avant-garde (including its outmoded relationship to the masses), the combination of refusing to adapt to the form of the political party and the radicalness of their ideas resulted in spreading Situationist theories beyond the International itself.

Félix Guattari, for instance, without explicitly naming Situationist influences, found a prototype for his theorem of the "subject group" in the movement of March 22nd, which was triggered in early 1968 by the Situationist *enragés* [the enraged ones] of Nanterre. Unlike "subjugated groups," the subject groups are defined "by coefficients of transversality that banish all totalities and hierarchies."[122] It was particularly the aversion to the form of the political party, to union discipline, to subordination to the hierarchies of molar forms of organization, which was a reference point for many different groups between Strasbourg and Nanterre. "The exemplary action of this avant-gardist group paved the way, cleared up prohibitions, uncovered an understanding, a new logical order, but without suffocating it with a new dogma at the same time."[123] Situationist positions, signs and strategies were diffused not only throughout the movement of March 22nd, but also in a broad field of subversion and action culminating in the revolts of May 1968. The influence of the S.I. is evident especially in the specific Situationist genre of comics and subverted advertising, but also in the unusually differentiated slogans on posters and graffiti.

The first concrete case of testing these strategies in the milieu of the student movement took place, however, as early as 1966. Instead

of carrying out détournement based on signs and images, the student organization UNEF was converted as a whole. Several people affiliated with the S.I. took over student representation at the University of Strasbourg only to drive the unionized student organization into a fundamental crisis. They used UNEF funding to publish a Situationist tract by Mustapha Kayati entitled *On the Misery of the Student Milieu, Considered under its Economic, Political, Psychological, Sexual and Especially its Intellectual Aspects, and on Several Means of Relief* in a high quality printed edition of ten thousand copies. Although it had become involved in the formulation and the distribution of the brochure rather indirectly,[124] the S.I. contributed to expanding and radicalizing the protests. The production and wide-spread posting of a comic in Situationist style ("The Return of the Durutti Column"), smaller disruptive actions during the academic opening ceremony of the study year 1966/1967 and during lectures, throwing tomatoes at teachers, closing the psychological counseling office and disputes in the student organizations went on from October 1966 to January 1967 and spread to Lyon and Nantes during 1967.[125] The resultant controversies that led to trials and the closing of the student representation, and the scandalization through the media helped the S.I. to achieve unexpected fame. This relatively permanent link with the concerns of the student movement and the publication of *On Misery in the Student Milieu* in an edition of 300,000 copies a year after the Strasbourg scandal effected a further spread of Situationist ideas and the involvement of the S.I. in the Parisian May 1968.[126]

In a way similar to Strasbourg, from November 1967 to March 1968 the *enragés* developed methods of sabotaging lectures and exams at the Nanterre branch of the Paris Sorbonne (founded in 1964), which were based on Situationist theories. With these

they opposed not only the politics of the university establishment (and hence the educational policies of the government), but also the student representatives (and hence also the unions and the leftist parties, especially the French Communist Party). The threefold strategy of May 1968 was already developed in Nanterre: it consisted of disturbing lectures with disruptions and the distribution of flyers, of fixing slogans and signs on the walls, and finally of occupying more and more buildings of educational and cultural institutions, later also of factories. The special background of the protests in Nanterre was the isolated situation of the new university at the edge of Paris and its architecture, which René Viénet has described as a "microcosm of the general conditions of oppression."[127] As Guattari wrote: "The architecture is a sign of this: just viewing these places causes one to break out in a cold sweat. This campus itself is the symbol of a student world that is cut off from the rest of society, detached from the world of work…"[128] Perhaps it was exactly this complete lack of urban and social environments that was especially favorable for the spread of the protests.

Aside from lectures by Henri Lefebvre, Edgar Morin and Alain Touraine, which were popular objects of disruptions, it was primarily the endless cement walls that were apparently best suited for the eruption of a "critical vandalism."[129] S.I. quotations were inscribed on the surfaces of the repellent university architecture, unfolding their full quality of catchword-like clarity while simultaneously transporting complexity, openness and ambiguity: "Never work!," "Regard your desires as reality," "Boredom is counterrevolutionary," "The unions are brothels!," "Consume more, then you live less!," "Live without killing time, enjoy without inhibitions!" Successively expanded interventions in the scenery of alienation

perfected the practical critique of urbanism that the S.I. had already proposed in their reflections on constructing situations.

The paradoxically double-sided face of the S.I.—their practice of exclusion (whether this is to be understood as a "cleansing process" or a "rescinding of the organization") on the one hand and the Situationist process of opening up toward the movement[130] on the other—led into participation in action committees, yet without therefore permanently interacting with "the masses." The S.I.'s isolation was not a practical one, they did not withdraw to a rural commune or an urban communal space, but rather it was only their theoretical rigidity that isolated them while simultaneously enabling them to open up. With the escalations in the early days of May, with the spread of the protests to the Sorbonne and to the streets of the Quartier Latin, the concepts of situation and dérive underwent a final stage of radicalization. After the general strike on May 13th, wild strikes and occupations of factories spread throughout France. On May 14th the committee "Enragés-Situationistes" was founded.[131] The walls of the Sorbonne were covered with posters. For the first time since the founding of the S.I., a series of their bulletins called for taking action—specifically occupying factories and forming workers councils. On May 16th and 17th the committee "Enragés-Situationistes" even took over the leading role in the occupation committee of the Sorbonne for two days.[132] Under the waves of repression that regularly seem to follow barricades and street fighting, however, the S.I.'s political poetry was drowned out: "under the pavement" activists were looking for "the beach" ("Sous les pavés, la plage"), but they only found beatings, persecution and criminalization.

In the end, after the climax of the Parisian May, members of the S.I. also took part in attempts to maintain and expand the occupations, especially of the factories. In the latter part of May

and the first half of June until their (futile) disintegration, they attempted to mobilize French workers and internationalize the movement.[133] Along with forty other people, ten of the Enragés and Situationists, including Debord, Khayati, Riesel, Vaneigem and Viénet,[134] instituted the "Council for the Sustainment of Occupations," and until June 15th they distributed several hundred thousand copies of their flyers, posters, manifestos, comics and songs all over France and then, translated into English, German, Spanish, Italian, Danish and Arabic, all over the world.[135]

The history of the S.I. is that of a development from an avant-gardist art collective to a political agitation troop. Through continuing to intensify text work, through continuity in the form of publishing a central organ of the S.I., and through increasingly linking discursive and activist strands, the S.I. ended up becoming—parallel to the movement of disintegration and orgies of exclusion in the core group—a relevant component of the Parisian May. It was questions emerging from the art field that led to an increasing politicization of the S.I. Questions of the practice, the function and the potential of the situation transported the Situationists almost inevitably from a pure art practice into the broader context of revolutionary theory and political action.

Debord's increasingly vehement anti-art propaganda and the friction between art and revolution are constants in a long passage, a transition, a successive development from the art machine to the revolutionary machine. Experiences, strategies and competences that emerged in the 1950s in the art field, in confrontation and friction with art traditions such as Dadaism, Surrealism and Lettrism, underwent a transformation along this passage. In the 1960s the S.I. increasingly left its original field and began cultivating the field of political theory and revolutionary action.

In the preface to the fourth Italian edition of "The Society of the Spectacle," Debord describes this path: "...in 1952, four or five scarcely recommendable people from Paris decided to search for the supersession of art. It appeared then, by a fortunate consequence of a daring advance on this path, that the old defense lines that had smashed the previous offenses of the social revolution found themselves outflanked and overturned... The previous attempts, where so many exploiters had got lost, had never directly emerged onto such a perspective. This is probably because there still remained something in the old artistic realm for them to ravage and, above all, because the flag of revolution seemed to be brandished previously by other, more expert hands."[136]

If vestiges of a sentimental view of the art avant-garde still echo in the Situationist writings here and elsewhere, then this is due, not least of all, to the concept of a linear idea of development beginning with art and ending in revolution. In the concept of a dialectical movement of sublating art in/into revolution, however, a remainder of the hierarchical fixation of the relationship between art and revolution is still retained. And finally, when the revolutionary situation is teleologically determined, it is reduced to the Hegelian immobilization of movement stopping the dance of differences and, at the same time, to the postponement of the dance until after the great rupture, after which the dance of conditions can finally begin, for the S.I. as well as in Marx's famous passage from the "18th Brumaire of Louis Bonaparte:" "Proletarian revolutions, like those of the nineteenth century, constantly criticize themselves, constantly interrupt themselves in their own course, return to the apparently accomplished, in order to begin anew; they deride with cruel thoroughness the half-measures, weaknesses, and paltriness of their first attempts, seem to throw down their opponents only so the latter

may draw new strength from the earth and rise before them again more gigantic than ever, recoil constantly from the indefinite colossalness of their own goals — until a situation is created which makes all turning back impossible, and the conditions themselves call out: Hic Rhodus, hic salta! [Here is the rose, here dance!]"[137]

Yet what distinguishes the Situationist situation is that it is less created (as perfect) than it is becoming, an assemblage of (revolutionary) situations newly initiated again and again. In the Situationist passage, in this transition which seems to have unequivocal end points in the suppression of the insurrections of 1968 on the one hand and the disintegration of the Situationist International in 1972 on the other, Hegel's monster of disruption certainly did not fall asleep.

"Art and Revolution," 1968:

Viennese Actionism and the Negative Concatenation

"The actionists saw the left-wingers more as idiots, the right-wingers too." — Ferdinand Schmatz[1]

"who says that revolutionaries even want to destroy the society of coercion at all?" — Otto Muehl[2]

THERE IS A VIENNESE INTERPRETATION of the events of 1968 that says the artists in Vienna very quickly wrapped up their version of 1968 "the Austrian way." Leading up to May 1968 in Paris, the S.I. set off discursive explosions in Strasbourg and Nanterre, the ex-painter and happening artist Jean-Jacques Lebel and the Living Theatre founders Julian Beck and Judith Malina were substantially involved in the occupation and restructuring of the Théâtre Odéon, and in Germany the "Subversive Aktion," which emerged from the Situationist group SPUR in Munich, partially infiltrated the Social-ist German Students Association (Sozialistischer StudentenBund— SDS) in the mid-1960s. In Austria, however, not only was there allegedly no lasting radicalization of the cultural left-wing, but a determined and ongoing interest on the part of artists to become massively involved in political struggles seemed equally absent; the

Austrian 1968 movement is said to have distinguished itself alto-
gether "by a lack of theory and by a low level of militancy."[3]

Another interpretation says that in the period before and
around 1968 the art scene exploded in Austria, that the Viennese
Actionists and their actions up to "Art and Revolution" in June
1968 played a key role within the '68 movement—whether as
avant-garde of the movement[4] or conversely as compensation for the
lack of a movement[5]—and that the connection between the cultural
and the political left-wing was stronger than, for instance, in Ger-
many: whereas in Germany the fronts between art and politics
clashed more and more rigidly, in the smaller Viennese context there
was purportedly no strict separation between the artistic and the
political avant-garde.

Finally, there is yet a third interpretation that agrees equally
with both sides, but shifts the date and the protagonists. According
to the writer and subculture theorist Rolf Schwendter, 1968 did not
take place in Austria until 1976: the Arena movement, the occupa-
tion of the slaughterhouse in the Viennese district of St. Marx, in
the framework of which the most diverse transversal initiatives were
tried out, mark the caesura that made up for the missed develop-
ment of an extra-parliamentary opposition in the 1960s and had a
subsequent impact on the social movements of the late 1970s and
the 1980s as the occurrence of lasting organization.[6]

In the context of authoritarian post-war Austria, the artists'
endeavors concentrated more on minimal free spaces for new art
practices and thus on marginal public spheres in an otherwise
rigidly conservative art field until into the late 1960s. When mem-
bers of the Viennese Action Group[7] were arrested on several
occasions in the 1960s, this was less the result of their revolution-
ary activities. Alongside wholly invented projections on the part of

the repressive state apparatus,[8] it was most of all the growing effrontery from Actionist art provocations that drew the attacks from the authorities as soon as they dared to move even slightly out of the realm of art.[9] Through the artists' pleasure in arranging their own history, through their interventions in later publications and exhibitions, through the interventions of gallerists, art historians and museums, however, a myth emerged, which often glorified both the artistic practice and the political significance of the Actionists—where they were not conversely depoliticized—and established via state and media repression measures (especially those *after* 1968) a legend of their radical politicization.

In terms of both social composition and impact, 1968 in Austria was almost only a "cultural revolution:" as the artistic avant-garde was not lastingly politicized, the student "political left-wing" conversely seemed permeated by the aesthetic. The social connections between the "Vienna Commune," SÖS and the literary activism of the later "Hundsblume" ("dogflower") associated with the poet Robert Schindel or the "Informelle Gruppe" ("informal group") associated with Rolf Schwendter[10] were among the most active constellations before the Austrian May 1968. If the writer and cofounder of "Wiener Gruppe," Oswald Wiener, is referred to as head of the action "Art and Revolution"—as suggested in some art or literature histories—the Viennese version of 1968 could be constructed as the work of three literary men: Wiener, Schwendter, Schindel as the librettists and simultaneously the protagonists of a revolution opera. And at the climax of the "hot quarter-hour" of the Austrian 1968, the fronts of the Actionist cultural left-wing and the also-artistic political left-wing collided in the action "Art and Revolution" with such force that both parts completely lost their already precarious organizational cohesion.

The SÖS (Sozialistischer Österreichischer Studentenbund—Socialist Austrian Students Union),[11] the short-lived Austrian counterpart to the German SDS, arose from the context of the "Commune Vienna."[12] The commune had formed in late 1967 around the writer Robert Schindel and the SDS member Günther Maschke:[13] beginning in October 1967—thus three years before Otto Muehl's "Praterstrasse Commune" and six years before his AA Commune in Friedrichshof—the Commune Vienna was less an experiment in holistic communal living than a pivotal point for organizing love-ins, sit-ins, street theater and working groups devoted to Marx, Freud, the bible and Hegel. At its peak it consisted of up to fifty activists who attempted to conjoin radical politics and "aesthetic self-realization" (as it was really called at that time) relatively undogmatically. They fought for the university reform, for solidarity with Vietnam, against the Opera Ball, and for a red May 1st.

"Outside we gather for a 'love-in' in the auditorium of the Vienna university. We sing Solomon's Song of Songs. See, my beloved, how beautiful you are! See, you are beautiful! Your eyes are like the eyes of a dove between your plaits. Your hair is like a herd of goats grazing on Mount Gilead. And we wrap the Vienna police in paper with black flowers. We found the Commune Vienna. The popular press discovers student protest. Comrade Maschke is arrested. We gather for unapproved demonstrations and face the police. Meetings take place permanently in coffee houses and flats. We write flyers, paint posters, have discussions at the university."[14] Although the practice of the Vienna Commune was not entirely free from the usual patriarchal ideology discussions, from unquestioned hierarchies and incipient structuralization, their forms of action led to a movement of opening

that no longer made it necessary for political work to be integrated in political party organizations.

At a first Opera Ball demonstration on February 22, 1968 ("motto passive resistance. let yourself be carried away")[15]—unlike the militant Vienna Opera Ball demonstrations of the 1980s and 1990s—in addition to sit-ins in front of the opera house, there was also an action *in* the opera house: "katja showed us all, in a patent leather coat and a little hat, her bag full of flyers, she went into the opera, quite matter-of-factly, let the flyers rain down from the balcony, went right out the door again just as matter-of-factly…"[16] This was followed by initial experiments with dérive strategies in the framework of small demos: streets and squares were blocked by small groups to create a traffic jam. When the traffic jam was big enough and before the police arrived, the activists had already dispersed and occupied the next corner in the first district in small groups.[17] These kinds of tactics of "limited infractions" held a certain attraction for left-wing students, but also for the media, which accompanied the actions in Winter 1967/1968 with growing approval (which was to result in an even deeper fall in June 1968). "Love-ins," "go-ins," wild demonstrations and "walking discussions" also drew sympathizers affiliated with the SPÖ (Socialist Party of Austria), whose youth organizations in revolt were repeatedly confronted with the nervous irritation of the chairman and later Austrian Chancellor Bruno Kreisky, who was still in opposition with the SPÖ then.

From early May to mid-June 1968 the quality of the protests condensed and the quantity of the protesters grew. On May 1st the Vienna communards did not disrupt the traditional SPÖ parade, but only a brass band concert afterward. Yet the gesture of subversive affirmation (a round dance to the music of the brass band) was

enough to have the square in front of City Hall brutally cleared by the police. The police violence reached a quality that in turn resulted in another wave of resignations from the socialist student organizations. Then on May 16, 1968 the newly formed SÖS presented itself at a press conference in Vienna. Contrary to the customs of the parliamentary fractions of the student union, which were tied to political parties, the SÖS functionaries were only to hold office for four months and then pass on their mandates. This point was not to be reached, however. Two weeks later, the SÖS began its activities with a teach-in on the theme of "world revolution and counter-revolution" and with the occupation of Lecture Hall 1 in the New Institute Building with 200 people—n.b. two *hundred* and not two thousand, as the newspaper *Süddeutsche Zeitung* wrote, thinking that masses would be required to occupy a university. And on June 4, 1968 the Ministry for the Interior prohibited the activities of the SÖS, however not for political reasons, but rather with the intelligent argument that it could be confused with other student organisations. Since the decree of dissolution was not yet legally in force, on June 7th the teach-in "Art and Revolution" could take place as a joint action by the SÖS and the Viennese Actionists in Lecture Hall 1 of the New Institute Building.

Viennese Actionism and its protagonists have often been attacked, for very contradictory reasons, though. Whereas not only large portions of the popular press but also the art-art scenes long insisted that Actionism belonged to the realm of non-art, from the left there were accusations of fascism—even long before the founding of the Muehl Commune. Contrary both to early statements from Muehl, in which he spoke against political revolutions from the stance of the artist in permanent revolt in all directions,[18] *and* to later extreme structuralizations and hierarchizations and

probably also fascist outgrowths in the "structure" of the Muehl Commune,[19] the development of the actions by Brus, Muehl and others in the years between 1966 and 1968 is to be understood as a temporary wild process of politicization. In this process chaos and the destruction of the bourgeois society (in Muehl's terminology at that time, "the society of gnomes") were propagated, partly as a fundamentally critical attack on the state, society *and* revolutionary groups, but partly also with the means of the over-affirmation, radical escalation and exaggeration of reactionary positions.

In the beginnings of more open collaboration with other artists (especially the literary scene associated with Oswald Wiener), the Viennese action group succeeded in opening itself up somewhat, beyond individually anarchist eruptions and thus also beyond the audiences of a circle of friends and the marginal art scene in Vienna. At the same time, cultural institutions and the notion of the artist were also increasingly subject to attacks in the tradition of avant-gardes ranging from the Dadaists to the Situationists ("Zock has no art and no artists!").[20] In 1966 the "total actions" emerged as syntheses of Muehl's material actions and Brus' self-mutilation, thereafter the "Vienna Institute for Direct Art" was founded. This was the foundation for usually short-lived cooperations that were started again and again. Together with Oswald Wiener, Muehl invented an action-political "program" under the label "Zock."[21] With Zock the ironic and vague figure of the material action developed in the direction of a sharper verbally and pictorially propagandist fundamental criticism of the state and ideology, simultaneously counter to the figure of the revolutionary subject and to reform ideas.[22] The actions also took on a more strongly agitatory character, were organized in alternating groups as chaotically mounted collective works and accompanied by the

production of manifestos in conjunction with the "aesthetically poor" publication series *Zock Press*. What distinguished the anti-program of Zock were the multiple fractures between destructive criticism and affirmation of destruction that sought to hinder any closure or coherence.

As the high point of the Zock phase, in April 1967, the Zock Fest (with Muehl, Nitsch, Wiener, Attersee and others) in a Viennese restaurant ended with a large-scale police raid and a rowdy conflict among the participants of the action carried out live. Aside from the incompatibility of the artistic positions and the artists' embarrassing mania for self-expression, what was also evident here was the strong side of the Actionist setting: creating a chaos that calls forth the authorities from inside and outside at the same time. Organized as a coincidental cooperation with the Catholic League, the event soon turned into a dispute among the actors and between actors and audience; a fist-fight with people from a student association ensued, later followed by a police raid with helmets and dogs, and then the festivities were broken up. Otmar Bauer, at that time one of "Muehl's students" or "Muehl's men," who took part in arranging most of the actions in this phase as "models" or actors, described the high points of the tumults:

"ossi wiener in a chrome crash helmet from his harley-davidson days ordered two trays of bread dumplings, agitated through the megaphone, which was also chrome, to the audience *hülsenbeck's dada speech*, except that he inserted zock instead of dada: zock is everything—throws the first dumpling into the audience—zock doesn't want anything—the next dumpling comes flying—zock does not smell—dumpling—the first dumplings are hurled back—dumpling fight. the antiques dealer kurt ochs stumbles onto the stage, fights

with the announcer over the microphone with a half-empty bottle of vodka, tears it off the stand and hurls it into the audience—ouch.

it doesn't hit anyone, that would be dangerous, this heavy iron thing. the publican wants to close: if they can't quiet things down again, then the party has to close!

bertram, michl's friend, farts, sweats. nitsch hisses at me: the lamb, the lamb. the cadaver squeaks on the rope coil from the balcony, doesn't hang, though, plops onto the roll of packing paper in the middle aisle. choir, he calls. choir, us with five voices singing to the twang of the guitar in the seething hall: waaahhah—cotton pad on the guitar—wound—orchestra: rattle—rattle—bucket of red paint poured on the lamb—and then from another world there are a few couples dressed for a ball, all decked out in tuxedos, fraternity cap, fraternity sash across the chest: catholic leaguers, stopped by on their way to the concordia ball for a *poetry reading* by their fellow student bertram—red splashes of paint on snow-white décolleté—the lady's escort, a student rooster, grabs a bucket, hits nitsch full in the back as he's running away, nitsch hits the ceiling, grabs another bucket, swings as he's running, slips on the runway of packing paper, the bucket goes up, everything in it comes down right on nitsch. mühl insists on performing his furniture smashing action, gets cupboard, table, bed filled with duvets onto the stage, o.k., we chop up the furniture—mühl sprinking powdered dye, dust clouds, feather bed feathers fogging up the scene. police—po*lice* comes in, off the stage, i stand there in my performance costume, long underwear and undershirt covered with powdered dye, ochs, the antiques dealer, lying in the corner with the empty vodka bottle—the double door flies open—a german shepherd pulls in a steel-helmeted beer-bellied pig, whose gaze wanders around—it's all over—they're taking us in.

good that you're here, inspector! pronounces ossi next to me: rioting elements have disrupted the event, thrown powdered dye all around, just look at my colleague here, his suit is ruined, he had to take it off, please reestablish peace and quiet here!

the pig salutes—exit, the steel helmets clear the hall and the five of us clear up the remains of the chaos in the quiet of the drifting smoke, sit around dazed, everyone has left, no helping artist hands."[23]

Particularly where strategies of representing all kinds of tabooed processes mobilize the forces of order both from the right and from the revolutionaries, thereby activating not only the media scandalization of the right, but also tumultuous protests from the left, this is where the practice of the Actionists appears in its most important political function, as a productive attack on the weaknesses of the (radical) left-wing as well: lack of humor and pleasure, closure, structuralization, reterritorialization. What is total in Muehl's "Total Revolution" between 1966 and 1968—unlike the later commune experiments—does not consist in closure into a totality, but rather in that it aims for *more* than the destruction of the totality of the state; it is directed not only against a certain state apparatus, but also and "equally against the bourgeois society, the left revolt, and itself."[24]

The SÖS poster announced a lecture on June 7, 1968 by Brus, Muehl, Weibel and Wiener and a discussion with Jirak, Šubik and Stumpfl. The title: "Art and Revolution;" the accompanying text by Oswald Wiener on the invitation stated: "assimilation democracy keeps art as a safety valve for enemies of the state. the schizoids it creates use art to keep their balance—they remain on this side of the norm. art is different from 'art'. the state of consumers pushes a bow wave of 'art' before itself; it seeks to bribe the 'artist' and thus

turn his revolting 'art' into state-supporting art. But 'art' is not art. 'art' is politics, which has created new styles of communication."[25] These new styles of communication were to fulfill the promise that art would become politics. Yet Wiener's image of the bow wave already anticipates the negative impacts of "Art and Revolution," the violence with which the "state of consumers"—now no longer "assimilation democracy"—was to roll over the Actionists in a combination of spectacular media machine and repressive state apparatus.

The event started with Peter Jirak, Christof Šubik and Christian Beirer with a short introductory lecture about the "Position, Possibilities and Functions of Art in the Late Capitalist Society." The subsequent simultaneous actions by Otto Muehl, Günter Brus, Oswald Wiener, Peter Weibel, Franz Kaltenbäck, Malte Olschewski, Otmar Bauer, Herbert Stumpfl, Anastas and Hermann Simböck[26]—all of them male, although at least Valie EXPORT was allowed to hold a spotlight[27]—were conducted according to Peter Weibel's account thus:

"Otto Muehl opened 'the lecture,' as it was harmlessly promised by the poster, with insulting the recently murdered Robert Kennedy and his clan. Peter Weibel continued in the same style with a speech targeting the Minister of Finance Stephan Koren with black polemics, the volume of which could be controlled by the audience and its volume. In the midst of this noise, Günter Brus placed himself naked on the lecture table, cut his chest with a razor blade, urinated and drank his urine, defecated on the floor, sang the national anthem, smeared feces on his body, stuck his finger in his throat, vomited. While he was lying flat on the lectern making masturbating motions, Oswald Wiener was holding a lecture about language and consciousness in reference to

cybernetic models that he was drawing on the blackboard, unde-terred by Brus or the subsequent action by Otto Muehl, although his lecture was inaudible, despite the wireless microphone, due to the noise. In the meantime Muehl was whipping a masochist named Laurids, who had volunteered and later read an erotic text out loud. Then Muehl's men simulated an ejaculation with over-flowing beer bottles and competed to see who could urinate the farthest. In between, Franz Kaltenbäck held an obsessive speech about information and language, and Weibel held a literally inflammatory speech—his outstretched right arm was prepared and set on fire—on Lenin's question, 'What is to be done?'"[28]

The action "Art and Revolution," whose protagonists became popularly known as "Uni-Pigs," did not last much longer than half an hour. Contrary to Peter Weibel's later description, those present found it relatively dull, and the audience was more bored than shocked, even though Weibel accidentally burned himself. This also led to the later famous objection from the audience, which was attributed to Oswald Wiener and resulted in him spending several weeks in jail, even though he never said it: "What is the point of doing this at the university, you should do it in St. Stephen's Cathedral!"

In any case, the space of the university was probably ill-chosen for two reasons. On the one hand, the Actionists were unable to break through the hierarchical architecture of the lecture hall, so that the polar and molar relationship of performers and audience intensified; on the other, particularly this setting resulted in an unproductive collision between the positions of the two organizing "parties." The SÖS activists wanted to win over the "unpolitical artists" for the revolution, whereas the Actionists wanted to prove to the "political revolutionaries" how Catholic or Victorian or

bourgeois they were. The SÖS people discussed up until the last minute whether they should cancel or postpone the event, because they were skeptical about the form of the action. In the view of the artists, on the other hand, the majority of the students were "timid and uncertain, the leaders were against the event and only the best of them were in favor of it."[29]

This rigidly antagonistic situation, the irrational collision of the two positions, or rather of their respective attributions and projections, was to be continued into the structure of the action. "Art and Revolution" was more of a spontaneous montage of individual performances following the pattern of the Dadaist simultaneous lectures than the concentrated performance of a group. As a platform for diverse, fragmented and partially contradictory elements, it was supposed to attack and caricaturize the function of language and communication in conventional political contexts on the one hand, and on the other it was to gain a tumultuous quality through the body actions. Yet just as the fragments of the actions remained closed to any involvements on the part of the audience, a tumultuous overflowing of bodies, as in conjunction with the Zock Fest, did not occur. The fragments were left indeterminately suspended and unlinked.

Even though anarchic molecular performance forms may also subvert individualistic artist concepts, the mere addition of individual or collective positions (whether at the level of the addition of action fragments or at the level of the addition of the actionist and the student activist positions) does not produce an *articulation*. On the contrary, it remains a *negative* form of concatenation.[30] And the collision pre-programmed by the Actionists certainly becomes a *negative concatenation*, when the weak form of artistic collectivity in the case of "Art and Revolution" additionally runs into the SÖS's

weak form of political collectivity. Barely established and already confronted with dissolution ordered by the Ministry of the Interior, SÖS interpreted the Actionist criticism more as a hermetic gesture of patriarchal elucidation than a serious intention of cooperation. The action thus functioned as a static caricature of political action and communication without shifting or negotiating the boundary between the two camps in any way. Instead of an overlap, the confrontation consisted in a sudden takeover of the event by the Actionists and in the irrational clash of two (as yet) non-collectives.

In June 1968 the period of Actionist politicization could be taken to have arrived at the end of the previously productive travesty of art and revolution, where the spiral of agit-prop and pop could not have been turned any further.[31] Another interpretation would conversely suggest that the critical proximity to and confrontation with political action had never been a particular goal, that the spiral bringing art and revolution together had been turned for too *short* a period and not far enough. Particularly in conjunction with the highly charged international political situation of 1968 and the development of anti-dogmatic and anti-hierarchical forms of politics and organization, it may be that the conditions were principally given for moving from a purely additive or confrontational to an articulative practice. Nevertheless, in June 1968 the attempt to link artistic actionism and student activism failed as an unproductive clash, as an antagonism and as a negative form of concatenation. Concatenation as a "political practice of organizing collectivity," as constituent power and as a necessary component of the revolutionary machine thus remained an unnamed, covert desideratum. And yet, even in its negative form, the potentiality of concatenation is apparent, even

if only in the persons of the auxiliary protagonists Otmar Bauer and Herbert Stumpfl, who were active in both contexts at the same time and played secondary roles next to those of Schindel, Wiener and Muehl.[32]

In any case, the action was both the pinnacle and the turning point for Viennese Actionism, for which Ernst Schmidt's description as the "best happening in the world"[33] is to be taken literally: seen through the eyes of the international art world, the action was the culmination of an art-immanent wave of escalation in the 1960s,[34] whereas it became a welcome object of spectacle for the populist Austrian media. The sensational scandalization of the action matched Muehl's story of the society of gnomes: "we became the victims of garden gnomes."[35] The parallel persecution of the Actionists by the popular press and by the reactionary Austrian courts resulted in a wave of criminalization in both the media and the legal system simultaneously. Consequently, the loose group previously operating only in the tiny progressive segment of the art field was transported into the mechanism of media representation, labeled with the collective identity "Uni-Pigs" (and later "Viennese Actionists"), segmented and finally sent back along isolated career paths (partly in exile in Germany) into the art field. From this point on, the protagonists pursued their respective practices in a self-referential way, so that the traces were lost of the breaking test that failed in the overlapping of the aesthetic and the political. Schwarzkogler committed suicide in 1969, Brus radicalized his actions alone until the "Zerreißprobe" (1970) and then returned to drawing and poetry. Nitsch became immersed in the pomp of the Orgy Mystery Theater all the way to the marketing of its relics, constantly building his church and finally landing in the international sales charts. Muehl radicalized his political experiments in

the AA commune, building his state within a state with increasingly fascistic structuralization and finally landing in prison following a charge of sexual abuse in the 1990s.

What was less scandalized and not taken into art history were the media and legal persecution, inner divisions and dissolution of the SÖS. A substantial number of its members, if not indeed the majority, had rejected the action from the start.[36] Immediately following "Art and Revolution" there was a wave of resignations and the SÖS subsequently fell apart.[37] There was no longer any need to appeal against the ministerial decree to disband.

8

The Transversal Concatenation of the PublixTheatreCaravan:

Temporary Overlaps of Art and Revolution

"Cultural and political revolution are inseparable, so theater can contribute substantially to revolutionary changes."[1]
— Volxtheater Favoriten

ART THAT TENDS TO LOSE ITSELF in life usually ends up being a bit too grand. In the relevant main currents in the 1910s/20s and in the 1960s/70s it is evident that the general "vitalization" of art came to no good end: de-politicized drifting into hermetic pseudo-autonomies and the total heteronomization of art are only two sides of the same coin. In cultural political endeavors that have ended up being too large and too abstract, the ideals of the inseparability of art and life, instead of questioning rigid boundaries between aesthetic and political practice, absolutized these boundaries or made them reoccur somewhere else.

Yet, beyond these kinds of tendencies toward dedifferentiation and overloading art with pathos, questions can still be raised about the appropriate form of the concatenation of art machines and revolutionary machines as such, which focus on more limited and more modest overlaps of art and revolution. How can this kind of overlapping be understood as a temporary alliance and exchange,

and yet constantly and conflictually impel attacks on social power relations and internal structuralization at the same time? Instead of seeking to abolish representation in pure action and in abundant life, how can a critique of representation and an expansion of orgiastic representation be developed? Instead of the promises of salvation from an art that saves life, how can revolutionary becoming occur in a situation of the mutual overlapping of art and revolution that is limited in space and time?

After 1968 there initially seemed to be an answer to this complex of questions in the self-determined strengthening of marginal, minoritarian approaches. In the art field it was primarily a continuously growing feminist movement that broke open the purely patriarchal setting of art institutions in the 1970s, but also used the art field as a base for launching feminist themes in general.[2] Faith Wilding, Judy Chicago, Miriam Schapiro, Valie EXPORT, Erika Mis, Carolee Schneemann, Mary Kelly, Laura Mulvey, Martha Rosler, Suzanne Lacy, Laurie Anderson, Adrian Piper, Eleanor Antin, Mierle Laderman Ukeles, Marina Abramovic, Chantal Akerman, Yvonne Rainer and many others attacked the sexist structures of the art world, the art history canon and the conventional constructions of femininity with strategies of activism and institutional critique. This was, first of all, a matter of thwarting the dominant constants of masculinity (later more precisely: white, heterosexual masculinity) and concretely creating separate and self-determined women's spaces. Nevertheless—and this applies not only to the feminist movement, but to all emerging components of the New Social Movements—their politics often remained limited to essentialist and identity-political approaches, or they increasingly got lost in processes of structuralization and closure. Even in contexts in

which the beginnings of transversality were evident after 1968, a retreat back into the boxes of closing units soon took place.

The term transversality had already been introduced into the critical psychiatry discussion by Félix Guattari in 1964[3] and seeped into the French politics and theory scenes around 1968, primarily through smaller articles by Guattari and Foucault. Transversality—as Guattari explained in 1964—is intended to overcome both dead ends: both the verticality of the hierarchical pyramid and the horizontality of compulsory communication and adaptation.[4] Both the old command structure in top-down mode and the logic of horizontal control networks that prevails in post-fordist frameworks are thus to be thwarted by the transversal line. According to Guattari, the new dimension of transversality moves and accelerates the spatial regulation of the geometrical concepts of horizontal and vertical. Unlike centralist forms of organization *and* polycentric networks, transversal lines develop constellations that are *a-centric*, which do not move on the basis of predetermined strands and channels from one point to another, but right through the points in new directions. In other words, transversals are not at all intended to be connections between multiple centers or points, but rather lines that do not necessarily even cross, lines of flight, ruptures, which continuously elude the systems of points and their coordinates.

Although these kinds of transversal concatenations occurred occasionally and incipiently in the revolutionary machines of 1968, in the early 1970s the theory of transversality remained quite abstract and was mainly used as a defensive argument against structuralization, against the bureaucratic self-mutilation of subject groups. The closure process of political groups in the 1970s, however, proved to be quite obstinately anti-transversal. It was not

until the 1980s that the first wave of transversal projects emerged, which countered the particularity and segmentation of the movements with transsectoral and successively also transnational projects. Among others, with participation of actors from the art field as well, these were platforms such as the anti-AIDS platform ACT-UP, founded in New York in 1987, the Third Wave Feminism platform Women's Action Coalition (WAC), which was active from 1991 to 1997, or the "Wohlfahrtsausschüsse" ("Committees of Public Safety") that formed in 1992/93 in several cities in Germany and organized actions and events against racist and nationalist policies and against the interplay of neo-nazis, mainstream press and official migration and asylum policies.

THEATER OF THE WILD HORDES OF TODAY

SOMEWHAT SMALLER, MICROPOLITICAL approaches of transversality and the convergence of art and revolution marked the beginnings of the Volxtheater Favoriten,[5] which overlapped the traditions of the workers theater and the autonomist movement in the 10th district of Vienna. Their motto: "living revolutionary subjectivity in the here and now instead of saving up wishes for change in the party funds—for the some-fine-day of the revolution."[6] In the squatted Ernst-Kirchweger-Haus (EKH) in the Viennese workers district Favoriten, amateur theater in the anarchistic sense and in the Brechtian tradition was started in 1994. The house, which had been used in the 1930s as a varieté theater, was squatted in 1990 by autonomist political groups, anarchists and Kurds.[7] In addition to the autonomist and Kurdish-Turkish groups, in the mid-90s there were also Roma families and refugees living in the EKH, which was

repeatedly the focal point of political disputes; sometimes with the KPÖ (Communist Party of Austria) as the owner of the house, which did not entirely accept the squatters without resistance, sometimes with the police, whose raids were apparently aimed at combating the specific combination of autonomist and migrant squatters (also some without papers). "Culturally" the EKH was primarily used as a venue for concerts. The autonomist production genres were (and are) primarily punk/hardcore and working with industrial-postindustrial aesthetics: performances with fire, material demolition and welding actions.

The theater practice in the EKH arose on the one hand from the idea of switching from event organization (in other words, from setting up the PA all the way to cleaning toilets) to the production side, and on the other from the fun in expanding the mostly musical event experiences with more performative and verbal elements, finally developing so-called operas (from the opera of "Beggars for Beggars" to the dog-opera to the trip-hop opera): "Opera as the place where the fighting proletarians debate their strategic plans, where the wild hordes of today can enjoy themselves in the performance,"[8] as the Volxtheater describes its genre. Instead of just attacking the Vienna State Opera symbolically once a year in anarchist Opera Ball demos, the EKH as an appropriated place was now also to be instituted as a place of production. "We no longer dream *exclusively* of demolishing and burning down opera houses, like young Richard Wagner, who was supposed to have been an accomplice himself in burning down the Dresden Opera in the revolutionary year 1849; no, we share the dreams of Brecht and Weill, who demand 'turning over the grand machinery of the opera to a new social use, radically conquering this form and abusing it for our own, new and exciting purposes.'"[9]

Counter to the class-specific function of the bourgeois theater, counter to spectacular cultural industry formats, but also counter to the structuralized forms of the independent theater of the 1990s, alternative processes of working and rehearsing were developed, which the Volxtheater activist Gini Müller later summarized: "Interests, conflicts, living conditions continuously changed the group composition, but the principles defined in the beginning remained: no director, collective work and decisions, no personal fees, open to interested people."[10] From 1994 to 1997, in addition to smaller projects, Brecht/Weill's *Three-Penny Opera*, a free interpretation of Kleist's *Penthesilea*, and Heiner Müller's *Der Auftrag* were developed and performed with considerable success as opera with band and DJ participation and finally including the use of electronic music. The treatment of the plays became increasingly free, the power of names was entirely dispensed with in the collective production process, the performances evolved in Volxtheater plena and experimental rehearsals. "We all know that life is much easier with a boss and a hierarchy, with carrots and sticks, but none of us give a damn about that knowledge."[11]

Following the successful first production, the *Three-Penny-Opera*, the theater collective decided to update Kleist's *Penthesilea* as a play about wild women, going beyond the classic identitary cliches of femininity and women's struggles, experimenting with queer, transversal concepts. What was raging and resistive about Kleist's Amazon drama, written in 1806/07 and condemned as unplayable after its premiere seventy years later, was to be used to develop a contemporary aesthetic of women's resistance. In this way, a feminist furioso was to be created, in which women "naturally" appear militant, yet without simply assuming macho-martial poses. "Fighting. Nothing easier than that. Every female

memory stores enough wounds inflicted by society as a structure or as a man. A little autonomist screaming or dance exercise releases memories of long repressed offenses from the cramps and posture damage. Our bodies and voices, necks and stomachs are marked by the—fortunately failed—education to be good, pretty, pleasant little girls. A few warm-up exercises and our fists start pounding by themselves."[12]

Going beyond Kleist's position of abstracting gender aspects, the EKH *Penthesilea* was used to invent a non-particular offensive from gender-specific experiences of oppression. To begin with, the queen and the main heroine had to be abolished, priestesses and princesses turned into comrades, and the heroine's monologues distributed among many women. Lesbian love relationships, Achilles' becoming woman, the idea of a world with any number of gender variations, but also the attempt to link anti-sexist and anti-racist strands (an autonomist Amazon group kidnaps the Minister of the Interior, whereby the Amazon army meets the reality of the year 1996, which in the EKH is one of more and more police raids and associated racist assaults) expand the strategies of breaking out of identitary models.

Even though self-critical voices complained that "a little Kleist plus women's struggles resulted in a rather superficial operetta with hot sound,"[13] the collective discussions and rehearsals in the months before the performances provoked crucial conflicts and an exchange of experiences, which were to decisively influence the further development of the Volxtheater all the way to the VolxTheaterKarawane (PublixTheatreCaravan). Especially the disputes over classic cadre obedience, rationality, self-discipline and subordination under the flag of a primary contradiction were played through excessively here. "Vehement discussions. Should

we show Amazons as they are supposed to be? Those that place the collective struggle above their own ego trips? Those that listen calmly to one another, not interrupting, always considerate of the weakest members in their group? Or should our Amazons' Kleistian conflicts, the love of a man, the madness, the megalomania, the passion for war lead them into disarray? Vehement discussions. Shouldn't the courageous women resistance fighters in the male-dominated liberation movements fight twice as much? Against armies. And against the patriarchal structures in their own organization. Haven't they been barred often enough from fighting against patriarchal structures within the organization because of the need for unity against the class enemy?"[14]

According to Deleuze/Guattari, Kleist succeeded in combining catatonic fits, swoons, suspenses with the utmost speeds of a war machine, the becoming-affect of the passionate element with the becoming-weapon of the technical element.[15] The Volxtheater Favoriten attempted to update this *Penthesilea* equation, drawing lines of flight beyond the takeover and reversal of traditional conditions of violence in war and love—and thus also beyond the figure of the Kleistian Penthesilea. Against the twofold background of punk heroines like Poly Styrene and an anti-identitary, queer program, the Volxtheater developed its concept of militancy: "Fighting women—wonderful. But fighting women that are not to be misunderstood as propagandists for 'women in the army,' but rather as comrades of the fighting women in the exploited countries of Africa, Asia, Latin America. As nomadic war machines against the institutions of the states. As everyday fighters gathering in the impoverished quarters of southern big cities to organize daily survival and political battles."[16]

THE PRACTICE OF PARRHESIA

VOLXTHEATER FAVORITEN AIMED to break through processes of structuralization and closure in the political project of the squatted house and to initiate a lasting movement of opening. Later this opening process increasingly expanded: from performances in the EKH itself to guest performances in other squatted houses to performances on the street and finally various forms of caravans. In controversies revolving around organizational forms and contents, however, the Volxtheater kept coming back to its implicit function, to the most important aspect of the pre-caravan Volxtheater Favoriten as a transversal concatenation of art machines and revolutionary machines: even with the first performances in the EKH, it was not solely a matter of criticizing capitalist society, but also of using the means of collective art production to criticize aspects of structuralization and reterritorialization in political work, *and simultaneously* to reflect on their own structuralization and exercise relevant self-criticism. All three forms of criticism, which we could call for the sake of clarity social criticism, institutional criticism and self-criticism, converge in both the practice of the Volxtheater and in the concept of *parrhesia* that Michel Foucault introduced in 1983 in his Berkeley Lectures.

In *Discourse and Truth* Foucault sets forth a genealogy of criticism, focusing on the term *parrhesia*, which played a central role in ancient philosophy: *parrhesia* means in Greek roughly the activity of a person (the *parrhesiastes*) "saying everything," freely speaking truth without rhetorical games and without ambiguity, even and especially when this is hazardous. The *parrhesiastes* speaks the truth, not because he[17] is in possession of the truth, which he makes public in a certain situation, but because he is taking a risk. The clearest indication

for the truth of the *parrhesia* consists in the "fact that a speaker says something dangerous—different from what the majority believes."[18] According to Foucault's interpretation, though, it is never a matter of revealing a secret that must be pulled out of the depths of the soul. Here truth consists less in opposition to the lie or to something "false," but rather in the verbal activity of speaking truth: "the function of *parrhesia* is not to demonstrate the truth to someone else, but has the function of criticism: criticism of the interlocutor or of the speaker himself."[19]

Foucault describes the practice of *parrhesia* using numerous examples from ancient Greek literature as a movement from a *political* to a *personal* technique. The older, *political* form of *parrhesia* corresponds to publicly speaking truth as an institutional right. Depending on the form of the state, the subject addressed by the *parrhesiastes* is the assembly in the democratic agora, the tyrant in the monarchical court. *Parrhesia* is generally understood as coming from below and directed upward, whether it is the philosopher's criticism of the tyrant or the citizen's criticism of the majority of the assembly. "*Parrhesia* is a form of criticism…always in a situation where the speaker or confessor is in a position of inferiority with respect to the interlocutor."[20] The specific potentiality of *parrhesia* is found in the unequivocal gap between the one who takes a risk to express everything and the criticized sovereign who is impugned by this truth. Through his criticism the *parrhesiastes* enters into exposed situations threatened by the sanction of exclusion.

The most famous example, which Foucault also analyzes in great detail,[21] is the figure of Diogenes, who commands Alexander from the precariousness of his barrel to move out of his light. Dio Chrysostom's description of this meeting is followed by a long parrhesiastic dialogue, in which Diogenes probes the boundaries of the parrhesiastic

contract between the sovereign and the philosopher, constantly seeking to shift the boundaries of this contract in a game of provocation and retreat. Like the citizen expressing a minority opinion in the democratic setting of the agora, the Cynic philosopher also practices a form of *parrhesia* with respect to the monarch in public.

There is some evidence for assuming a transformation of this kind of public criticism of society and government in the liberal democracies of the second half of the 20th century: artists have increasingly taken over the role of the political *parrhesiastes*, not only in the obvious context of philosophical, social and cultural problems, but even ranging into the leading disciplines of the natural sciences as an effect of the utilization of scientific think tanks for the policies of transnational corporations and the concomitant shifting of the function of the sciences. It appears, however, that this role, which updates artist images between jester's license and dissidence and generally has to grapple with forms of soft censorship through the withdrawal of resources, is newly at risk at a time and in a setting of the intensified totalization of the control society and the persecution of parrhesiastic techniques.

Examples of these increasingly acute developments are the prosecution and arrest of the PublixTheatreCaravan by the Italian authorities in Genoa 2001,[22] but also the legal prosecution of Caravan activists in various smaller cases (primarily in art contexts) in Austria.[23] Similarly, the events surrounding the arrest of the US media artist Steve Kurtz by US secret services[24] suggest that a new quality of attacks against practices of criticism is beginning to prevail. In the growing confluence of war and police measures and the decreasing differentiation between external and internal enemies, criticism and critical art are losing their relative autonomy and ending up in the cross-hairs of the state apparatuses.

To return to the development of *parrhesia* in ancient Greece and Foucault's interpretation of this development: Over the course of time, a change takes place in the game of truth "which—in the classical Greek conception of *parrhesia*—was constituted by the fact that someone was courageous enough to tell the truth to *other people*...there is a shift from that kind of *parrhesiastic* game to another truth game which now consists in being courageous enough to disclose the truth about *oneself.*"[25] This process from public criticism to personal (self-) criticism develops parallel to the decrease in the significance of the democratic public sphere of the agora. At the same time, *parrhesia* comes up increasingly in conjunction with education. One of Foucault's relevant examples here is Plato's dialogue *Laches*, in which the question of the best teacher for the interlocutor's sons represents the starting point and foil. The answer is naturally that Socrates is the best teacher; what is more interesting here is the development of the argumentation. Socrates no longer assumes the function of the *parrhesiastes* in the sense of exercising dangerous contradiction in a political sense, but rather by moving his listeners to give account of themselves and leading them to a self-questioning that queries the relationship between their statements (*logos*) and their way of living (*bios*). However, this technique does not serve as an autobiographical confession or examination of conscience, but rather to establish a relationship between rational discourse and the lifestyle of the interlocutor or the self-questioning person.

The function of the *parrhesiastes* undergoes a similar change analogous to the transition from the political to the personal *parrhesia*. In the first meaning there is a presuppositional condition that the *parrhesiastes* is the subordinate person who "says everything" to the superordinate person. In the second meaning, it only seems that

the "truth-speaker" is the sole authority, the one who motivates the other to self-criticism and thus to changing his practice. In fact, *parrhesia* takes place in this second meaning in the transition and exchange between the positions. *Parrhesia* is thus not a characteristic / competency / strategy of a single person, but rather a concatenation of positions within the framework of the relationship between the *parrhesiastes'* criticism and the self-criticism thereby evoked. In *Laches* Foucault sees "a movement visible throughout this dialogue from the *parrhesiastic* figure of Socrates to the problem of the care of the self."[26] Contrary to any individualistic interpretation, especially of later Foucault texts (imputing a "return to subject philosophy," etc.), here *parrhesia* is not the competency of a subject, but rather a movement between the position that queries the concordance of *logos* and *bios*, and the position that exercises self-criticism in light of this query.[27]

It would be too simple an analogy to posit a recurrence of the development of *parrhesia* in today's setting or even interpret it in the sense that in control society conditions that repress political *parrhesia* as dangerous objection, all that is left is a retreat into "private" self-questioning. Not only does personal *parrhesia* specifically *not* mean this, but my aim here is to link and combine the two concepts of *parrhesia* described by Foucault as a genealogical development, to understand dangerous objection in its relation to self-revelation.[28] Criticism, and especially the form of institutional criticism that is relevant here, namely the criticism of the structuralization of a political movement, is not exhausted in denouncing abuses nor in withdrawing into more or less radical self-questioning. Just as the constellation of the Volxtheater and the EKH overlap, mutually permeate one another, here it is not a case of a dichotomy between art activism and political activism; just as

the individual actors are also crossed by both lines, that of the art machine and that of the revolutionary machine, their form of *parrhesia* also proves to be a double and linked strategy: as an involvement in a process of dangerous objection *and* as a critical movement of (self-) questioning in relation to the structuralization processes of the political project EKH. In the tradition of political *parrhesia*, the theater works of the Volxtheater and the later caravan projects involve radical social criticism, the criticism of (hetero-) sexist, racist and nationalist conditions. Along with this and at the same time, the theater activists also assume the role of the *parrhesiastes* in the personal sense: especially through debates on key terminology and specific unresolvable contradictions of the squatters' setting, but also in discursive openings, they cause the "institution" EKH to question the concordance between *logos* and *bios*, between program and institutional reality.[29]

In the case of the Volxtheater, this complex arrangement of a multiple *parrhesia* led to a process of expansion and an increasing positioning toward the outside, as an attack against the state apparatus and—counter to leftist forms of organization closing in on themselves—to a way of tying into specific public spheres outside the EKH as well. Parallel to the Volxtheater Favoriten's theater performances and political song evenings, beginning in 1995 a practice of performative political street actions also developed from the same context, essentially from the EKH plena. This practice seems to correspond even more to the principle of *parrhesia*, also in terms of risk (all the way to temporary arrest) than the conventional form of performance. In the course of "Flight from Transdanubia" in May 1995, the second district of Vienna was closed off, and "refugees from Transdanubia" attempted to swim across the Wien Donaukanal to call attention to deportation

practices, especially of the Austrian Social Democracy. In the same year, the military parade along the Vienna Ring was disrupted in "Dying on the Ring:" "While the Austrian soldiers proudly rolled past in their tanks and the Draken [fighter planes] flew over the university, there was a sudden loud bang. Crowds of people fell bleeding to the ground, screaming, writhing, limbs flying around. One of the Draken had obviously dropped a bomb, one of the tank drivers reacted as though he were a few hundred kilometers further south, where people were playing more seriously with war toys at that time. Fortunately, rescue workers quickly appeared, who provisionally took care of those seriously wounded and carried them away. The state and other police, whose job it was to prevent the unseemly disruption of the military show, were perplexed and shocked in the face of thousands of convincingly realistic casualties."[30]

Beginning in 1996, the activist theater group began to focus more and more on European migration policies: with actions against the Fortress Europe, against "racist purity checks" (call for voluntary stool samples using a stool sample portable toilet in front of the Hofburg in Vienna) and with a "Great Border Protection Day," when over-affirmation was used to promote the expansion of controls and borders in Europe in St. Stephen's Square in Vienna in 1998. These situative interventions increasingly overcame the genre-specific limitations of theatrical practice, providing the foundation for a competence in collective spontaneity and quick adaptation, which was continuously expanded in the later caravan projects. Specifically because there were no clearly delimited, reasonably ordered and predictable settings in these actions, unlike the agora or the theater space, so that the contours of the addressees blur, what developed here was a new and precarious form of dangerous objection.

Closely interlocked with this expansion of performative attacks, there was also a personal *parrhesia* that occurred, the movement from *parrhesiastes*, who questions the concordance of *logos* and *bios* in the institution, toward self-questioning actors: even more than in the example of Socrates as teacher and the movement of *parrhesia* in the direction of self-criticism, in the context of Volxtheater and the EKH an overlapping of institutional criticism and self-criticism was established. The figure of the *parrhesiastes* was thus detached from any identification with a certain person, and the movement of personal *parrhesia* became the institution's collective self-critical practice, in which there was also no predominance of art machine and war machine. At the same time, discussions arose about the appropriate form and function of theater in the political process, which de-stratifies its space, shifts its boundaries, as well as about the (self-) exclusion of migrants, about sexisms and machoisms in autonomist contexts. A productive play emerged in the relationship between art machine and revolutionary machine, but one that required a great deal of energy, incited many conflicts and could only be maintained by most of the actors for a certain period of time. "Volxtheater always works and plays at the verge of self-destruction over the meaning and purpose of their own political agency. The (pretended) flirtation with art leads all too often to the suspicion of political betrayal. Sitting between the two chairs of art and politics wears down the soul and the limbs with performative violence."[31] And yet, specifically the complex setting of being sustainably rooted in a political project reduces the dangers of spectacularization and cooptation, which otherwise influence the relationship between art work and political movements in conjunction with distinction effects, the production of symbolic capital and various small markets.

The link between social criticism and institutional criticism/ self-criticism is simultaneously the link between political and personal *parrhesia*. Combining the two *parrhesia* techniques prevents a one-sided instrumentalization, preserves the institutional machine from closure, maintains the flow between movement and institution. In the intersection of the two forms of *parrhesia*, the Foucaultian idea of ethical self-criticism is shifted and expanded into a third form, namely that of an institutional-critical self-criticism, which develops alongside political and personal *parrhesia*. In the terminology alluded to above, *parrhesia* is thus updated as social criticism, institutional criticism and self-criticism. The political context of the Volxtheater in the squatted centre (in this case the "institution") was a productive precondition for the overlap, the exchange and the temporary blurring of art machine and revolutionary machine.

CARAVANS: PRECARIOUS OFFENSIVES

IN CONJUNCTION WITH the Austrian parliamentary elections in Fall 1999 and the formation of the reactionary coalition government of the ÖVP (conservative Austrian People's Party) under Chancellor Wolfgang Schüssel and the FPÖ (radical right-wing Freedom Party of Austria) under Jörg Haider in February 2000, resistance and art-activist endeavors spread throughout Austria, but especially in Vienna. In late 1999, combining anti-national with anti-racist strategies, the Volxtheater Favoriten performed the collaged action-operetta "Schluss mit lustig" ["No more joking"] at the Vienna Schauspielhaus: "Österreich—ein Land dreht durch …und der Fremdling ist Schuld daran" ["Austria—A country goes

haywire…and the foreigner is to blame"].[32] Thrown out of the prestigious theater and deemed "arrogant, humorless, dilettantish" by the director after only one performance, the action revue, which included fencing in the audience with grates and garden fencing and was not really all that scandalous, was shown at the EKH as usual. Presented in the context of widespread outrage at the election success of the FPÖ and the founding of anti-racist platforms by intellectuals and artists, such as the "Democratic Offensive" or "gettoattack," and using a filmed documentation of the exclusionary policies of the EU external borders, the performance demonstrated that the FPÖ's racism was only the tip of an iceberg of more widespread phenomena, which were substantiated in the effects of European migration policies originating with conservative and social-democratic politicians and parties.

A multitude of art actions arose in the months of the activist-anti-racist boom in Vienna, which induced temporary projects in every art sector to leave their respective spaces.[33] In this context the idea of the caravans also developed, which was realized for the first time soon after the "black-blue"[34] government took office: in May 2000 the "EKH Tour" confronted larger towns in the Austrian provinces with the actions and aesthetics of the autonomist activists. With about fifteen partly very conspicuous vehicles, as many as forty people from the EKH and the Volxtheater Favoriten set out on tour, testing the basic constants of the caravan for the first time: the precarious quality of actions in a new terrain and constantly moving, the aesthetics of the convoy (including protection from the state police who rarely left their post at the end of the caravan), the mixed use of performative, musical, art and media strategies, but especially the offensive appropriation of public places. "For us the street is not merely the stretch from H to A,

but a place where we celebrate, rebel, make music, meet people, discuss and carry on all kinds of shenanigans."[35] The nine-day street celebration in nine different places in Austria brought the tour to Wels, Linz, Salzburg, Leoben, Graz, Klagenfurt, Lienz, Innsbruck and Bregenz. The increasingly well rehearsed program was characterized by overtaxed police organs and by activists experienced in dealing with authorities and legal aid: occupy the square, quickly set up the equipment, operate a book table with current political information and the publix-kitchen, live radio, DJing, public pie fights, juggling and varieté, situation-specific performances and street theater, and in the evening songs, sketches and excerpts from the Volxtheater programs.

The term "organized caravans" was also used for the first time in the course of the EKH Tour. In conjunction with anti-racist activism and migrant self-organization, the caravan as a form of movement had been used more and more often in the years before. In the summer of 1998, for instance, prior to the German parliamentary elections, an alliance of migrant groups and anti-racist organizations organized the "Caravan for the Rights of Refugees and Migrants"[36] that traveled through Germany with the slogan "Wir haben keine Wahl, aber eine Stimme" ["We have no choice (election), but a voice (vote)"], stopping in forty-five towns in one and a half months. In the following year, 500 farmers from India traveled through Europe together with 100 representatives from other Tricont countries under the banner "Intercontinental Caravan for Solidarity and Resistance," seeking to start discussions about the disastrous effects of the global economy and especially the practices of multinational bio-tech corporations on their living conditions.[37] However, these caravans' forms of action were largely limited to traditional demonstrations and rallies and, in the first

case, "visits" to political parties' election campaign events. In the context of the autonomist squatters movement, other caravan forms of action became possible, due to fewer legal problems than in the case of asylum seekers, for instance. These forms of action had to be prepared and organized in less detail and were able to develop their micropolitics processually. Against the background of travel experiences in the course of "squatter internationalism" and that of bands touring in the autonomist spectrum, a new, moving format of action was to develop.

The success of the EKH Tour brought a continuation of the caravan genre. The first explicit caravan in the context of the Volxtheater followed as early as fall 2000: the "Culture Caravan Against the Right-Wing" set out to the Southern Austrian province of Carinthia around October 10th to intervene in the annual Carinthian meetings of the international exteme right and German nationalists. The caravan travelled through Carinthia for a week to generate a paradoxical colonization effect in the province governed by the radical populist leader of the FPÖ, Jörg Haider. Under the motto "Art is a She-Bear, and She Bites Whoever She Wants,"[38] the caravan was intended to link oppositional cultural events together through its travels, which were taking place during this period in various towns in Carinthia. The trip was also intended to promote the political events of the Klagenfurt Days of Resistance and the concluding major demonstration against Haider and the post-fascist gatherings in Carinthia.[39]

In contrast to the success of the urban EKH Tour, however, the village squares of Lower Carinthia remained empty, the masses to be agitated were hardly to be found: few responses, no confrontations, heckling everywhere, with the result that the caravan failed its goal of agitating the rural masses and simply undertook

a peaceful drive through the Carinthian landscape, even though it was a drive with highly scurrilous and conspicuous vehicles.[40] However, the caravan did not achieve much more than this aesthetic of tractors, trucks and buses. Even at the otherwise well attended concerts with well known DJs and musicians, the Carinthian public stayed away this time, even though and because it was "against the right-wing." "Only people from the Slovenian minority with the anti-fascist tradition of partisan fighting occasionally wandered in among the caravan's camels and sometimes got kicked for their trouble. Thus the attempt to make people at cultural events stumble over the migration policy discourses had to fail: due to the lack of an audience."[41] Whereas many local cultural initiatives failed to take part because they feared that their financial support would be cut, the charm of the paradoxical colonization and agit-prop with aesthetic means was lost on the Carinthian public: a further experience for the orientation of future caravan projects and for dealing with the question of which contexts the nomadic practice of the caravans can be made productive in, and which not.

After asylum-seeker Marcus Omofuma was killed in the course of a forced deportation by the aliens police, the "Platform for a World without Racism"[42] was founded in Vienna in 1999. The platform plena for political anti-racist groups and self-organized migrants became a further pivotal point for the Volxtheater activities in addition to the EKH. The international noborder network[43] formed at about the same time, and the Volxtheater activists garnered concrete impulses for a first transnational caravan at the second noborder meeting in Paris in December 2000. The idea of the VolxTheaterKarawane (PublixTheatreCaravan/PTC)[44] grew out of the emergence of the international context of an anti-national,

anti-racist network that explicitly undertook a criticism of the concept of the "border" in the complex interweaving between nation-state and globalization. Developed in early 2001, a transversal and transnational caravan project was to be started in the summer of 2001 under the slogan *no border, no nation*. Transnationality had a twofold meaning in this case: on the one hand, the caravan participants came from ten different countries. On the other, the caravan's path was to link various European highlights of the noborder network and the counter-globalization movement in the summer of 2001: smaller actions at the borders of Burgenland and Carinthia, bordercamps in Lendava and Frankfurt, and the manifestations against the major summits in Salzburg (WEF) and Genoa (G8).

With an open and very widespread mobilization and an initial plenum in late March 2001, the caravan was initiated, a-hierar-chically prepared in working groups on specific issues such as theatrical actions, theory, press and vehicles, with ongoing attempts for greater openness, and finally started on June 26th with a party at Heldenplatz in Vienna. On June 27th the hetero-geneous and fluctuatingly staffed caravan set out for the WEF summit in Salzburg, organized a park party two days before the big anti-WEF demonstration, was accused by the right-wing newspaper *Kronenzeitung* of carrying a weapons depot,[45] played with a globalization monster made of inner tubes[46] at the demon-stration, subsequently extended an invitation to a "public presentation of the weapons depot," then moved on to the bor-dercamp in Lendava on July 4th, organized an action against the deportation prison in Ljubljana, spent several days in lower Carinthia, and then moved on in the direction of Italy. The con-cluding destination of the tour was to be the bordercamp in Frankfurt from July 27th to August 5th.

Reports on the "noborder tour" were provided by a tour log-book[47] alternately maintained by ten to fifteen people, which was broadcast daily via mobile phone and the Viennese independent Radio Orange. Although the broadcasts were not very sophisticated technically and required much effort due to the many different caravan languages (German, English, Spanish, Slovakian), they were an important aspect of the strategy of self-determined representation and offensive visibility. The wish to sovereignly create the images of the caravan, in contrast to images from spectacular media machines *and* in contrast to clandestine political strategies, led to a gesture of radical, intentionally insistent transparency. In addition to the mediated image in the web documentation, the image of the colorful, punk convoy left its traces both as it moved and at the stops of the tour.

The centerpiece of the caravan was an 11-meter long overland bus, which was joined at different stages of the noborder tour by varying numbers of cars and minivans. Unlike the effective images of the "Carinthian Cultural Caravan Against Right-Wing," however, the aesthetic of the closed convoy was necessarily frequently interrupted in the summer of 2001. Whereas the earlier caravan passed through Carinthian villages sometimes at only 10 mph, the PublixTheatreCaravan had to cover far greater distances at different speeds, which could not always be accomplished in a convoy. Nevertheless, possibilities arose here too—for instance in the context of the Slovenian bordercamp or along the journey to Genoa—for setting self-determined images of difference in rural spaces. Alongside the images of the caravan as a convoy, the Publix-TheatreCaravan especially derived its nomadic quality from specific interventions in concrete locations and through linking different locations of resistance.

At the edge of the bordercamp in Lendava, for instance, the Caravan used the means of invisible theater and of irritation to investigate the no-man's-land between the border stations. On the bridge in the border zone between the Hungarian and Croatian border posts, activists in orange overalls and UN uniforms set up an additional border station, stopped cars there and distributed noborder passports and flyers to the drivers. These kinds of performative actions by the PublixTheatre aimed not to abolish borders, but to achieve the apparent opposite: to establish *new* border posts in order to append additional borders to the absolute borders of the nation-state in the no-man's-land as a subversive affirmation.

Nomadic practice, borderspaces and caravan concepts refer to a repoliticizing revival of concepts from *Anti-Oedipus* and *A Thousand Plateaus*. Toward the end of the 1980s various groups such as surfers, techno musicians and media artists had misunderstood Deleuze/Guattari's concept of the nomadic as a flowery metaphor, happily identifying themselves and their activities with it. The Caravan countered the associated naïve hymns to freedom and flux, or later to the ultimate democratization through the Internet, with a political concept of the nomadic.

Since the end of the 1990s there had been a new renaissance of the nomadic, which also served Michael Hardt and Antonio Negri as a key concept in *Empire*.[48] When the figure of the nomad reappears here in this explicitly political context (in contrast with the surfer romanticism of the 1980s) with reference to Deleuze/ Guattari, it undoubtedly has a different quality than in the context of earlier evident misunderstandings. However, as the movements of traveling intellectuals and political refugees are mixed under the concept of nomadism in *Empire*, the result is a conceptual merging of self-chosen and forced migration. This almost inevitably leads

to a disproportionate overestimation of the subjects of migration, which are simultaneously glorified as the most important opponents of the all-powerful "Empire."

With Deleuze/Guattari the molar sedentary line of power is directly contrasted with two lines: the molecular line or migrant line and the line of flight, the rupture, the nomad line.[49] This corresponds to the necessary differentiation between forced migration, fleeing from one place to another, where there is hope of a new sedentariness, on the one hand, and every offensive nomadic practice on the other. The migrant line connects two points, leads from one to another, from deterritorialization to reterritorialization. The nomad line is a line of flight that accelerates the movements of deterritorialization into a stream between the points and passing through them. This is a rushing movement that has nothing to do with flight in the conventional sense, but rather with fleeing to look for a weapon.

In the context of the Caravan, at first the concrete movement from one node of the noborder network and the counter-globalization movement to the next seems to correspond more to a migrant line, which returns to its starting point in the end (or at least intends to). Yet at the same time, with all the focus of the noborder tour on the right to freedom of movement, on resistance against the isolationist policies of the Fortress Europe and on the old slogan *no one is illegal,* the conditions of the transnational Caravan specifically made it impossible for people conventionally called migrants to take part. "…in terms of real politics, for people with an insecure residency status in Austria, it is hardly possible to travel even to other EU countries. As a result of this, only people with an Austrian, German, US American, Australian or Slovakian passport took part in the projects."[50] For asylum-

seekers in Austria, it is not only dangerous to cross any border, they are also prohibited from becoming politically active. If it was already sometimes difficult for the Caravan activists to move across internal EU borders (over the course of time it became evident that black-lists of counter-globalization activists were circulating in Italy, barring certain people from entering the country during the time of the G8 summit in Genoa, although not all of the affected activists even knew about it), for people without papers it was entirely impossible. From these experiences the Caravan then self-critically drew the consequence that taking migrant reality into consideration would require more time and continuous examination.[51]

The quality of the nomadic, as it is actualized in the practice of the PublixTheatreCaravan, is not found in the invocation of migrants as revolutionary subjects and in the movement of the caravan from one place to another, but rather—somewhat further away from the term—in a primary effect of this movement, name-ly the precarious movement into the offensive.

Offensive action in precarious contexts is the condition of the nomadic. With the PublixTheatreCaravan, nomadic precarity can be described in three ways. First of all in the struggle for the appropriate, or better yet: with the *only possible* form of organiza-tion, the a-hierarchical collective. In the size of the Caravan, consisting of between ten and thirty people, it is only just still pos-sible to test radical grassroots democracy and plenary forms of organization over certain periods of time. Discussions going on for hours and lengthy negotiation processes in plena, discrepancies between formal equality and informal hierarchies, misunderstand-ings in spontaneous collective actions, all of these can wear down these kinds of collectives in the long run, even ruin them, but at the same time they are necessary in relation to the form of

organization in order to hold the activist context together. The ambition of not limiting the noborder tour participants only to Viennese or Austrian associates, of mobilizing as transnationally as possible, led to a second difficulty for the PublixTheatreCaravan: an almost Babylonian confusion of languages sometimes used all at once, which sounds good, but can easily lead to an accumulation of misunderstandings.

The third and most relevant element of precarity consisted in the nature of the Caravan itself: the nomadic movement engenders precarity, because the collective—here contrary to Deleuze's notion of the nomadic[52]—travels unknown paths, ends up in completely unfamiliar places. Creating situations in new places, rather than in familiar, well explored territories, means being forced to make quick decisions, often reducing complexity to a minimum, constantly having to readjust the goals of actions. Within this deterritorialization movement that tears a certain territory out of its familiar context, temporary nomadic terrains emerge, zones of experimentation for a smooth space without delimitations and striations.

As a moving collective, the PublixTheatreCaravan was constantly involved in dealing with all these levels of precarity. It was clear from the start that the limited time period of this project would be a condition for the success of the multilingual and flexible collectivity. This combination of transversal openness and temporal limitation seems to have been largely successful and to have developed into a specific competence of the Caravan as a war machine intervening in uncertain territories with its offensives. Yet, it was precisely because of its nomadic and non-representationist quality, among other things, that the Caravan became a target for the state-apparatus.

GENOA: STRIATING THE WAR MACHINE

OPERATING ON A NOMADIC LINE, a line of flight, the PublixThe-
atreCaravan becomes a war machine. This does not at all mean
attributing a certain form of violence to it. On the contrary, the war
machine points beyond the discourse of violence and terror; it is the
machine that competes against the violence of state apparatuses,
against their order of representation *and* against the order of macho
rituals of violence in movement contexts. At the abrupt end of their
tour, however, the PublixTheatreCaravan was forced to experience
how the state apparatus, for its part, succeeds in forcing the non-
representable into the logic of representation. Because the war
machine, with its infinitely small quantities, invents "the abolitionist
dream and reality,"[53] the state apparatuses work on domesticating
the nomadic and controlling movement, hence on striating the
space against everything that threatens to go beyond the state. In
this specific case in July 2001, it was the Italian police and judicial
system, supported by Berlusconi's new government, which placed
Genoa in a kind of state of emergency at the time of the G8 Sum-
mit and ultimately constructed a "Black Block" out of the Caravan.

Among the first groups that arrived for activities against the G8
Summit in Genoa, some of the Caravan activists had been able to
watch how Genoa was put into a state of siege, but paradoxically a
siege from within, a siege against the residents—although many of
them were away on holiday—by the police from the center of the
Red Zone, where the G8 heads of government were to hold their
conference in the Genoa harbor.[54] Both on the eve of the demon-
strations, on July 18th at the Manu Chao concert of the Genoa
Social Forum, and at the migrant demo on July 19th, the Caravan
operated with the usual means of a combination of counter-infor-

mation and theatrical strategies, also against the structuralization of the movement. On July 18th the PublixTheatreCaravan protested with performances against the high admission prices, the obtrusive security and the commercialized surroundings of the major events organized by the Genoa Social Forum. On July 19th, together with many other more colorful than black blocks, they took part in a demonstration marked by many costumes and little structure, which was successfully carried out by migrants demanding "equal rights for all" and "open borders."

On July 20th/21st, the Caravan did not appear as a group. The activists were under way singly and without props, attempting to do media work to supply the media center with images and audio. They not only noticed that on Friday the police gave wide berth to individual rampaging groups in the center and far from the Red Zone,[55] but also and especially that the non-violent Catholic grassroots organizations and other pacifist groups were attacked by the police during their sit-ins, but most brutally at the demonstration march of "civil disobedience" initiated by the Tute Bianche. Some of the demonstrators were sprayed with tear gas and brutally beaten. At the end of the day the activist Carlo Giuliani was shot by a policeman.

On the 21st the masses flowed into Genoa in even greater numbers to protect the demonstrations and take part in them, and they experienced the continuation of the brutal attacks by the police from the day before: "Z. didn't think about not going on Saturday. She thought, 'It can't get any worse.' Big demo with unions, a mass demonstration. It will be very different... None of the PTC activists got hurt. Some decided to go to the demonstration as 'medics'... Saturday: Z. came to the starting point relatively late. Black clouds could already be seen in the distance. View of below from the hilly landscape. A sea of people... The police started breaking up the

demo. Demolished benches. Units attacked the demo from behind with tear gas. Chases. Running, running, running…CS gas is shot into the crowd. Nerve gas. Sharp. Z. 'learned' the difference between tear gas and CS gas here…Barricades are set up to protect people from the 'police mob,' which worked for a while…Massive phases of the police attacks, brief pauses. Z. runs. Horde of police from the sides. Everyone running. Z. runs into a cement block, falls, thinks for a minute that her knee is broken. She is beaten, kicked in the stomach and the shins. Bruises on her upper arm. She is put on the side with others, but not arrested, driven away instead. 'Go! Go! Go!' …Escape over a bridge. Z. meets a German demonstrator with head wounds. Both shaking. Both have lost their friends in the confusion …Z. searches for hours. She can hardly walk, everything hurts. She thinks, 'it's over, I've had enough.' Shaking. Rage. Close to tears …"[56]

The demonstrations came to an end on July 21st, but the police attacks did not. Shortly before midnight a special unit of the Italian police stormed the Scuola Diaz, in which G8 protesters and journalists were sleeping, beating most of them so severely that they could hardly walk. Many lost consciousness, some suffered life-threatening injuries.[57] In the Scuola Pertini opposite, which served as media center and headquarters of the Genoa Social Forum, all that the media workers, including some of the Caravan activists, could do was to watch stunned as unconscious people were carried away and to document the strategy of the uniformed police, who blocked off a large area and did not at all intervene in the special unit's orgies of violence, not even allowing members of parliament to pass. Afterward the police also invaded the media center and destroyed/confiscated hard disks, photo and film material.

"The night from Saturday to Sunday after the concluding major demonstration: those who had stayed in the camp heard via

radio about a raid in the Diaz school. Rumors of dead people carried away in black sacks. B. thought, 'Now they will come for us too.' Sleeplessness… And the last day in Genoa: on Sunday B. and a few others were almost alone in the camp. Fear. B. thought, 'As soon as we are out of Genoa, nothing more can happen'… The PTC bus set off around noon, B. following with the car… A mountain road, a beautiful landscape. B. felt relieved. Everyone met up again in a parking area, single vehicles and bus, coffee break. After 30 to 60 minutes they were joined by plainclothes police. Then a carabinieri jeep. More and more police. B. thought at first it was another control, as so often before, about ten times already. Then he saw machine guns… The PTC activists had to wait standing in the sun for hours. Props and black clothing were taken out of the bus and confiscated… As a convoy, now with 'police escort,' back again. To Genoa. For a long time B. thought it was just another harassment on the part of the police… Then to the police station: mistreatment, long waiting in the hall, verbal abuse: 'Black Block!, Pigs.' Another sleepless night. Beatings. Strip-search, beatings. K.'s screams could be heard from an interrogation room. T. was deathly pale, marks from slaps on his face… When it was light again, the men were chained together in groups of five and driven to Alessandria. The transport drove in a rush for hours. Duce songs. The prisoners were forced to stay awake. When they arrived at the prison, B. thought, 'now we have to run the gauntlet.' He had only been kicked, otherwise the authorities there acted 'correctly.' He was 'relatively little mistreated,' 'got off relatively lightly'… B. says that at the police station before, his head was knocked against the table and the wall in the course of the strip-search, naked, and he was kicked in the back. He did not resist being fingerprinted. He knew they were allowed to do that,

resistance would only lead to coercion. He was extremely frightened. The police were wound up, aggressive, 'like on speed.'"[58]

One person dead, hundreds wounded in Genoa, followed by three weeks in custody for the Caravan activists, reflex-like defensiveness on the part of the black-blue Austrian government, not even a glint of dismay, but instead precipitated incrimination through alleged "registrations" in the Ministry of the Interior; no official support whatsoever, until the pressure from the media, especially on the Foreign Ministry, became too great. After the activists were released there was a brief rustling among the Austrian media, but by the end of August the media hype about the Caravan was over. "The media's image production manifested and pulverized the Caravan. In the course of the arrests after the G8 protests in Genoa, the project became more famous than previously even imaginable. In this way, the image of the PTC was grabbed away from the image producers. The question of whether the line of flight is transversal or terrorist is something the molar tribunal will have to decide."[59]

The double violence of organic representation, which consists in the distortion and shutdown of images by mass media communication *and* in the subjugation and striation of the war machine by the state apparatus and its traditional organs of the police and justice, this combination of rigid spectacularization and criminalization overtook the Caravan in Genoa with full force (just as it has the counter-globalization movement as a whole). In terms of the symbolic occupation of media and political space, and a self-determined use of the stage of representation and its expansion into the orgiastic, in the summer of 2001 after the experience of lasting repression from Göteborg[60] and Genoa,[61] a crisis of the entire movement must be noted.

Based specifically on the gesture of insistent transparency, the Caravan repeatedly produced images, audio and texts, both in the landscape with the picturesque caravan aesthetics and with interventions in urban centers, and also in media form, especially through radio and the internet. There is no trace of a practice of clandestinity, which is an important component of the construct of the Black Block; yet the Caravan activists were singled out for criminalization by the police, as were the explicitly pacifist groups and Catholic grassroots organizations.

Instead of having an exonerating effect, the Caravan's self-chosen conspicuousness actually backfired at the moment of attack by the state apparatus: nothing was easier for the police than to isolate a group setting out from Genoa so visibly and so slowly. "Before Genoa the PTC was on the road for weeks and able to autonomously decide on their actions... After the arrests, on the other hand, it often felt like being part of someone else's production. Charge: criminal association. Wrong film."[62]

9

After 9/11:

Postscript on an Immeasurable Border Space

"AND is neither one thing nor the other, it's always in-between, between two things; it's the borderline, there's always a border, a line of flight or flow, only we don't see it, because it's the least perceptible of things. And yet it's along this line of flight that things come to pass, becomings evolve, revolutions take shape."[1]
— Gilles Deleuze

IN THE SUMMER OF 2001, not only the various lines of the concatenation of 20th century art machines and revolutionary machines experienced a significant rupture, but also the series of struggles whose forms of articulation had emerged in the period between the Zapatista revolts beginning in 1994 and the Anti-WTO protest in Seattle 1999, and which grouped themselves under various concepts revolving around the theme of globalization. The common point of reference for these struggles has consisted less of its forms of action peddled in the media as the revolution of the 21st century, but more in the recognition of the "affinities" that the Zapatistas spoke of: groups marginalized by the effects of economic globalization insist that their marginal positions are not accidental or even natural deviations, but are instead immanent to the postfordist capitalist

conditions. Parallel to recognizing this kind of "affinity" between diverse struggles, very different stances with respect to this point of reference have become differentiated. In distinguishing between anti-globalization or anti-globalism, counter-globalization, globalization critique, "another" globalization and "globalization from below,"[2] various ideological positions have emerged, leading to new types of direct actions, association-like clusters such as ATTAC or forms of assembly like the Social Forums.

However, the globalization, intensification and differentiation of the movement against economic globalization has also led to a strange tendency to standardization and homogenization. With the abridged interpretation of the "Battle of Seattle" as the origin and overhastily reproduced model for a new cycle of struggles, a dominant paradigm of revolt became established, placing mass dissidence and protest in the foreground of the movement, especially in the urban centers of Europe and North America, as a means of problematizing "undemocratic outgrowths" of globalization. This constricting standardization to an image of urban mass demonstrations with differently tumultuous qualities went hand in hand with overlooking struggles in other parts of the world, especially those— less one-dimensional—in Central and South America. At the same time, other components of the revolutionary machine that could not be as spectacularly integrated were ousted. Images of mass demonstrations and street fighting conveyed and distributed around the world by the media finally also led to the impression of *one* movement. Its forms of expression were perceived as being melded in a uniform "protest culture" independent of the specific social structures and regional differences between the Americas and the various zones of Europe—"a form of expression that can be employed in front of the scenery of North American Seattle, the old central Euro-

pean city of Prague and southern Genoa equally well."[3] Regardless of the ideological discrepancies, whose impact ranged far beyond the question of naming and self-definition into the various articulations, the potently effective image of *one* movement developed, and it is difficult to tell whether this was simply picked up again and again by the media, or whether the activists themselves repeatedly reproduced this mediated image as a unifying backdrop for their actions.

This also became a point for internal critique and self-criticism: contrary to the hope that mass insurrection in the inner cities would pave the way out of the marginalization and isolation of protests to put pressure—multiplied through the mass media—on the actors of economic globalization, the main point of criticism was that the political contents were in danger of being pushed into the background or becoming trivial generalities in these forms of mass mobilization. David and Goliath or the Black Block vs. the Robocops, these were the kinds of dual images that dominated not only the popular media, but also, to an increasing extent, the debates within the movement.

On the one hand, the various counter-summits and Social Forums led to relatively broad debates on the contemporary relations of power and domination, yet these debates were mostly conducted without reflecting on the movement's own structures and patterns. "What would have been needed was an equally in-depth reflection on how to deal with the religious moments of the anti-neoliberal resistance movement. The extent to which the zealousness was possibly also a kind of religious service."[4] Tina Leisch describes the protests in Genoa in 2001 especially as a bipolar ritualization of resistance with a human sacrifice as its low point. In this ritual, the "red zone" embodied the holy sanctuary that both sides turned into a sacral space.

By again imagining the red zone and the state apparatus as the *one* "bait," as the sole object of desire, the false image of a monolithic power was reproduced. Feasible affirmative and subversive strategies of resistance would engender less homogeneous images of power, resulting instead in conceptual assemblages like "omnipresent micromachines for maintaining power."[5] Most of all, though, this kind of fixation on the "red zone" as the center of desire ultimately corresponds to a subordination to the state apparatus' politics of space. This means a subordination on the one hand to the precondition of a space that is a priori striated and a city rigidly segmented into different zones with different access thresholds, on the other to the permanent striation of the war machines by the state apparatus, as exemplified between July 20 and 22, 2001.

Beyond this fixation on the bait of state power, the lack of self-examination on the part of the movements also has a problematic effect in relation to their own social composition. This problem arises especially when the political positions within the movements are arbitrarily juxtaposed and even to be read counter to one another. In this way they hardly produce concatenations, but increasingly mutual delegitimization instead: whereas Hardt/Negri still focused on the "convergence in Seattle" in their book *Multitude*, published in 2004, maintaining that "old oppositions between protest groups seemed suddenly to melt away"[6] in Seattle, others specifically take the example of Seattle to analyze the emergence of strange parallel appearances of political articulations, whose contradictions are wholly unresolvable.

In her essay on the "Articulation of Protest," Hito Steyerl questions the strange "convergence" of contradictory contents, the addition of voices, which "sometimes radically contradict one another, such as those from environmentalists and unions, different

minorities, feminist groups, etc."[7] The articulation of these voices, an in-depth discussion of their claims and demands, is certainly to be desired; where they are simply strung together arbitrarily, though, the Deleuzian AND[8] turns into a blind addition/inclusion with no becoming, instead of emerging in the in-between space between the links of the chain. "What is added together, edited together, and which differences and opposites are leveled for the sake of establishing a chain of equivalences? What if this 'and' of political montage is functionalized, specifically for the sake of a populist mobilization? And what does this question mean for the articulation of protest today, if nationalists, protectionists, anti-Semites, conspiracy theorists, Nazis, religious groups and reactionaries all line up in the chain of equivalences with no problem at anti-globalization demos?"[9]

The phenomena that evoke these kinds of critical questions have been engendered primarily through the dimensions of the insurrection components in the framework of the counter-globalization movement, dimensions that have sometimes pushed micropolitical endeavors of resistance and constituent power into the background. The mobilization of thousands of demonstrators could only be realized with the organizational forms of *constituted* power. These kinds of quantitative dimensions seem to be the precondition for the structuralization and establishment of dichotomous patterns, both within the movements and in the relationship between the inside of the movement and the outside of the state apparatus.[10]

Beyond these (self-) criticisms, it is primarily external factors that indicate a rupture, an "end" to talking about this concrete form of articulation of mass insurrection, an "end" that is transitorily taking place as a transformation in different directions. Indeed the

"end" in summer 2001 is less to be regarded as a single break than as a chain of events that are not entirely mutually conditional, but which produce an ensemble of effects against the background of governmental developments, consisting most of all in an intensification of the control regime and in the overflowing of police logic at a local and at a global scale.

Even before Genoa and 9/11 there was an increase in police cooperation all across Europe with regard to the surveillance of counter-globalization activists, including blacklists, denial of entry, etc. With Göteborg and Genoa repression and police violence against the counter-globalization movement reached the highest stage of escalation. This meant a culmination of the phenomenon that could be called "summit battle," which was also a turning point in the counter-globalization movement's mode of organizing at the same time. "Following the escalation in Italy, strategies of political activism need to be re-thought. The reactions of the state in Genoa took on such excess of violence that they could certainly be regarded as a successful warning or set-back."[11] In Genoa, at the latest, it became clear that if the practice of confrontational and insurrective mass demonstrations were to be continued, the brutality of the police apparatus together with the spectacle production of the media machine would generate a spiral of increasingly repressive scenarios.

The situation proved to be even more difficult a few weeks after Genoa: following the attacks on the World Trade Center and the Pentagon on 11 September 2001, the state threat scenarios intensified and became generally predominant. On the basis of this, repression was intensified and refined many times over. The ensuing "war against terrorism" makes it impossible to protest openly at all in many countries. Even in countries without armed conflicts, the

war regulations of anti-terrorist measures have given the organs of the state apparatus a license that means a limitation to the rights of liberty and a further stage in the repeal of democracy. A tendency to a permanent state of war, no longer between sovereign nation-states, but in the global context and permeating the nation-states, replaces the procedure of the declaration of war with transnational police measures. This results in the increasing confusion of internal affairs and foreign policy targets of war. Where the "enemy" was previously perceived as an external one, now there is a blending of this external "enemy" and a new "dangerous class" within the nation-state. The process of the blurring of the enemy and the targets of war results in an ominous progress in the development of the erosion of democracy: since 9/11 all forms of dissidence are subject to an explosive increase in denunciations and repression.

Against this background of the intimidating effect of police terror in Göteborg and Genoa and the comprehensive re-ordering of the global policies of police action, not only through and in the USA, the forms of insurrection as component of the revolutionary machine were transformed. On the one hand, the summits of economic globalization and the counter-summits of the counter-globalization movement were succeeded by another paradigm that is just as dualistic: the "war against terror" and the widespread and less confrontational anti-war demonstrations that grew in size over the course of 2002 and culminated on February 15, 2003. As surprising and impressive as the huge participation was in all corners of the world on that day, in a way it also meant an eruptive discharge of the crowd, after which the masses dispersed again. In this overflowing movement with quantities of demonstrators that had not been reached since the anti-Vietnam demonstrations (amounting to several million around the world on a single weekend), every kind

of differentiated debate was drowned out by the drums of the single demand "No War!" on the one side and the noise of US propaganda against Iraq on the other.

The other pole was—and continues to be—a contrary movement: instead of planning bigger and bigger manifestations and thus retreating to the lowest common denominator, smaller forms of the revolutionary machine are being set in motion. Especially the component of the insurrective mass demonstration is necessarily subjected to changes, specifically not only in light of the various aspects of self-criticism as delineated above, but also conditioned by the concrete trauma of the participating activists due to their experiences in Genoa and elsewhere.

One form of action that has sought to offensively posit openness countering closure and clandestinity was the form of the border camp, especially as it has been developed as an anti-racist noborder camp in the process of the emergence of the noborder network.[12] In comparison with the 300,000 demonstrators in July 2001 in Genoa or the million just in the London anti-war demonstration on 15 February 2003, the largest international border camp in Strasbourg brought together less than 3000 activists. Yet it is not a question of numbers, but above all of different forms of organization and especially of a possible way of problematizing themes that are less unequivocal and not necessarily capable of majority agreement. Whereas the anti-war demonstrations had a clearly formulated goal that was negatively defined and not achieved (as was subsequently evident), the noborder network and the various border camps developed into diverse assemblages of discursive and activist components that offensively addressed the drastic migration policies and—as the name suggests—attacked the border regime.[13]

NO BORDER, NO NATION

"… é all' interno *di questo mondo* che si trova lo spazio della nostra differenza, è dentro che si trova l'unica nostra possibilità di sfuggire al miraggio del limite, il solo terreno dove tentare di tracciare un giorno delle linee di fuga che non incrocino alcuna frontiera."[14]

— Judith Revel

JUDITH REVEL CONCLUDES her essay on the limits of the concept of the border with a vision of a borderless world. In a similar way, the activist noborder network insists on the exuberant desire to abolish all borders with the slogan *no border, no nation*. In fact, as Judith Revel writes, the spaces of difference are only found on the plane of immanence, inside this world. It is less probable, however, that the border is a kind of mirage that will one day prove to be an illusion. In the control society setting, external borders may be becoming increasingly invisible or they may seem to be dissolving— but only to simultaneously engender a whole landscape full of internal borders. Etienne Balibar writes about these manifold forms of borders: "The geographical and geopolitical borders, the 'external' and 'internal' borders, but also the social borders that separate groups of people from one another, are precisely the point in today's world where democracy comes to a halt, beyond which it is, like a ticket, 'no longer valid.'"[15]

In this situation of the neoliberal fantasy of the dissolution and actual multiplication of borders, the old state border does not disappear either. It becomes diffused in space, multiplies, and sometimes it emerges again in an old garb, e.g. in the times of international major demonstrations, when the activists registered in the

EU internal affairs databases are suddenly not allowed to leave a country that actually no longer has a border to the country of their destination according to the Schengen Agreement. Yet independent of specific suspicions, people are increasingly stopped and controlled not only at the actual border lines and zones around them, but also in train stations, at airports, in trains and elsewhere. The EU technocracy divides all of Europe into zones with a varying density of controls to stop or steer migration movements at an early stage, but also to condense the control regime as a whole. In its cartographic fantasy it also proliferates beyond the EUropean borders.

Beyond Balibar's reflections on questions of exclusion due to internal borders, especially in relation to (limited and expanded) citizenship, the phenomenon of internal borders has partly developed extreme forms in the restructuring of urban centers due to economic and "security policy" considerations. These forms are related to various aspects of the privatization of public space, from the all-encompassing commercialization of urban shopping zones to the establishment of gated communities. The increasing privatization of previously "public" (at least in the sense of non-private) spaces and their permanent economization lead to a radical segmentation of territories and a smooth transition to the surveillance of these territories by private *and* state organs. The rigidity of these segmented spaces and thus also of the social conditions within these spaces corresponds to the crystallization of clearly delimited special interest groups of consumers, who claim different locations of consumption and self-representation, which in turn engenders new internal borders and exclusions. For this reason, the media activist Shuddhabrata Sengupta from India speaks of a "'frontierization' of all urban spaces in Europe"[16]—and beyond, we must add.

To this extent, the demand *no border, no nation* must remain a utopia that is constantly at odds with the increasingly rigid logic of enclosing controls, consumption and surveillance on the one hand and that of excluding enclosure in the various forms of deportation camps, exterritorial prisons, etc. on the other. Despite the slogan *no border, no nation*, however, the concrete practices of the noborder network do not aim so much at an elimination of borders, but at strategies of thematizing, making visible, performatively opening borders. Following Balibar among others, the border is not to be imagined solely as an ominously multiplying instrument of exclusion, but also as the "point from which the expansion of democracy begins, where new spaces open up, which are to be explored by taking risks."[17] The following therefore revolves less around developing theoretical ideas about a world *without* borders, but is instead intended to examine, on the basis of a brief discussion of the linguistic history of the terminology, the potentials of strategies that seek to offensively and productively negotiate and change borders.

FINIS, FRONS, LIMES: SPACING THE BORDERLINE

"Here, limit [*peras*] no longer refers to what maintains the thing under a law, nor to what delimits or separates it from other things. On the contrary, it refers to that on the basis of which it is deployed and deploys all its power [...]" — Gilles Deleuze[18]

THE GERMAN LANGUAGE has only one word, *Grenze*,—derived from the Slavic languages (Polish, Russian: *granica*)—for that which can be differentiated in Latin-Romance languages with at least three

different terms. Although these terms are often blurred in everyday usage, they indicate fundamental differences that go beyond the difference between geographical-geopolitical and abstract terms for borders. The three different components of the terms for border developed in the Romance languages from the three Latin terms *(con-) finis*, *frons* and *limes*.

The linguistic surroundings of the Latin terms *finis* (border, barrier, goal, end) and *confinis* (adjacent, neighboring) indicate the significance of what is adjacent, the common border between what is neighboring, the two-dimensional phenomenon of an overlapping zone. In antiquity dense zones of settlement were often found surrounded by isolating zones, sometimes of natural origins like forests, steppes or swamps, sometimes man-made. In Caesar's *De bello gallico* there is a passage, in which the greatest praise is given to the city that has laid waste to the broadest strip of land surrounding it.[19] As great an expanse of no-man's-land as possible was the desire of these kinds of communalities, which simultaneously conveyed an image of magnanimously dealing with space. An idea of the border is suggested in this context, which comprises a more or less broad strip of land, a border zone, but sometimes also—beyond the idea of a border as a no-man's-land—an inhabited border region and entire (borderland) provinces. Indeed, with this understanding of *(con)fines* as common border regions, it was possible to designate the marginal zones of two territories and their inhabitants as separate but covered by the same term. Hence the border here assumes the meaning of an indeterminately broad margin; *finis*, the Latin word for "end," refers not only to something final, but also a spatial, spatialized end, a seam.

The concept of the border as seam, as a border region extended as far as possible, was succeeded by a different kind of borders,

specifically those that had to accommodate a denser settlement as well as larger and more complicated states. The opposite of *(con)fines* is the frontier *(frontiera/frontière)* for the figure of the abrupt, spaceless borderline. In the Romance language terms derived from the Latin *frons*, there is an echo not only of the forehead as the outermost surface of the body and the facade as the surface of an architectonic structure, but also and especially of the military front. In other words, the frontier is where the enemy is confronted, a spaceless, abrupt borderline, where opposites part, or rather where they are violently separated. Changing this border can mean its dissolution in the course of a complete conquest over one side. At the same time, the front line of a troop opposing the enemy also implies the possibility of *moving* this front in battle and shifting it.[20] However, the border still remains the same in this shifting movement, abrupt and spaceless as a *borderline*.

It was only from the 15th to the 17th century that the meaning of *frontiera/frontière* as a military front developed through a movement of abstraction up to the present day into the most widely held meaning of a more or less secured national border. In this development, nation and border are inseparably linked; the border as a precisely drawn line of demarcation becomes the "outline of a nation conscious of itself."[21] With this development the character of the territorial frontier was transformed into a moral boundary protecting the interior of the nation. What once served as a measurement of military power relations now becomes a highly charged instrument of the construction of national identity and the setting for confrontations with fundamentally different identities, and thus its quality is all the more abrupt. To protect the homogeneity of the national territory, every force is used to prevent external powers from violating the border. In this logic the border remains a borderline

without spatiality, and establishing an identitary separation from others. At the same time, this scene of power conflicts is one that clearly distinguishes between inside and outside. The border has proven to be not only an abrupt figure of defense, but also one of protecting the interior.

Today this form of the simultaneously protective and abrupt border finds itself in the midst of a process of being replaced by boundaries that are increasingly oriented to the interior or by constellations of internal and external boundaries.[22] Instead of the national border regime with the characteristics of territorial definition, of the clear demarcation of the domestic and the foreign, of different currencies, visible walls, fences and passport controls, there is a third concept of the border emerging, which promotes an economization of the border contrary to the national border. In Latin the *limes* was the border wall that was to secure Roman expansion and prevent attacks from outside the Roman Empire's sphere of influence; in French *limite* meant as early as the 15th and 16th century the line of demarcation between lands in different hands, an economic border marked with stones and posts, unlike the national/colonial meanings of borders that later became dominant.

In conjunction with neoliberal globalization, the economic connotation of border and migration is increasingly growing in significance. The process of the privatization of public space and the restructuring of urban zones of consumption creates model cases of the border regime under postfordist conditions. The re-economicized border is substantiated here in various forms, depending on the status of the subject confronted with it. For some, the limit represents an insurmountable obstacle, for others it implies a fluid movement from one point to another, from one center to the next. The border either remains closed like a bullet-proof glass door, or it

is passed through like a revolving door of glass panes; depending on the circumstances, the movement of crossing it can be one that is confining or one that is always open.

For those who are disadvantaged the limit as a confining border[23] means being enclosed in a place, where those enclosed are not only confined to a certain space, but also where there is no free disposition available to them *inside* the space. Instead, their position in the space is assigned to them.[24] This includes the general figures of exile and banishment, the establishment of exterritorial prison camps such as the US American camps in Guantanamo and Afghanistan, but also current legal restrictions such as the German district residency obligation law, which drastically limits the movements of asylum-seekers.

In a mixed discipline/control society context the focus is less and less on classical forms of confinement, which seek to prevent movement through incarceration, but rather an absolute command over the distribution of space, which is here imagined as tending toward unlimited totality. Confining exclusion and excluding confinement supplement one another in a zone of the increasing indistinguishability of inside and outside.

Talk of the dissolution of borders thus proves today to be primarily an ideological instrument of neoliberal globalization, which corresponds less to the emphasis of the slogan *no border, no nation* or the realization of "spaces without borders," but seems instead to indicate that for some people some borders are becoming increasingly invisible. The multiplication of internal borders is progressing more and more rapidly, and external borders such as the EU Schengen border are becoming more rigid at the same time and only permeable for those who are privileged. Rather than enthusiasm for the dissolution of the principle of the border, there is an increasing urgency to

the question of how to address and articulate the evident and constantly newly emerging borders, how to negotiate and spatialize them as the precondition for a self-determined distribution in space.

In picking up and overcoming the old image of *(con)fines* as border seams and neighboring zones, this question leads to reintroducing the idea of the spatial border; here, however, it is not to be taken as a defensive or restrictive figure of the desert and the no-man's-land, the wasteland whose existence is intended to exclude the conflict of two identities from the start. In an offensive turn of these figures, it is contrarily a matter of conceptualizing a *dilation* of the border. This means, in other words, spacing the borderlines, turning borderlines into border spaces, within which differences can be made to oscillate—instead of absolute differences/identities on both sides of the border.[25] In expanding and extending the borderline, in spatializing the border wall, in breaking open the postfordist forms of the *limite*, the border is no longer intended to keep two sides apart, but rather to enable the permanent constitution and confrontation of different with different as a space and condition of possibility for the revolutionary machine.[26]

In this context, the idea of transgressing borders is also no longer to be understood as a movement from one identity to an essentially different one, both separated from one another by a border tending to be absolute. Transgression does not overcome the border to make it disappear, but as Michel Foucault wrote in his early "Preface to Transgression," it is the gesture that changes the border *inside it*.[27] Transgression concerns the border exactly in the space of the borderline, no matter how narrow it is: not by taking a step beyond it, stepping over, but by changing it on the way through it. The line spatialized in the transgression is, at the same time, already the "entire space of transgression."

Foucault's definition of the border as the whole space of transgression especially illustrates the fact that there is no beyond in this movement, that transgressing the border seeks to change the border as the only possible plane of immanence. In the context of a discussion of the dilation of the border, we are primarily interested in the process and character of this change: a change that does not consist in the absolute division of identities, but in enabling a flowing space, in which differences oscillate, collide, process. Contrary to the conventional use of the term, the border would thus be less linked with the gesture of rigorous separation than with a fluid form in which difference floats.[28]

The specific form of transgression that is the issue here does not oppose one side to the other, does not enter into the dialectical mockery, in which the border is regarded as a towering and yet incomprehensible in-between. It does not shake the stability of foundations on both sides of the border by temporarily negating the border, allowing the other side of the mirror to shine, while the line in between remains invisible and impassable. Because this transgression is neither violence in a divided world, nor does it seek to triumph over the border by extinguishing it, "it takes the immeasurable measure of distance at the heart of the border."[29] Exactly on and in the border, the immeasurableness of the space is opened up, in which differences move without necessarily being sublated in a higher identity.

Foucault's notion of an immeasurable border space is also picked up by Antonio Negri, when he describes constituent power as expansive, unlimited and unfinalized.[30] Negri regards this limitlessness as spatial and temporal, a quality of dangerous and unpredictable expansiveness in time and space, in which the border represents nothing other than a necessary and, to a certain extent,

productive obstacle, on which confrontation and constitution are constructed. Constituent power means here the permanent conflictual exchange of differences and, at the same time, the potentiality of a radical reformulation of social organization, which conjoins the rupture in the event with an uninterrupted formation process.[31]

Spacing the borderline means opening a space, which makes up not only the becoming of the border, but also of differences; nor is the border space that emerges in dilation to be understood as a static container, but instead it is in motion and its form is constantly changing, its impact expanding successively and in all directions. In these transformations there is no passive acceptance of the distribution, of the segmentation *of* space, no lining up and submitting to hierarchical conditions, but only a transversal distribution *in* space. Gilles Deleuze explored this conjunction, this simultaneity of the metamorphosis of the borderline and the decision for a certain quality of the resultant space (instead of a molar *distribution of* space, a nomadic *distribution in* space) in *Difference and Repetition*: "We must first of all distinguish a type of distribution which implies a dividing up of that which is distributed: it is a matter of dividing up the distributed as such.... A distribution of this type proceeds by fixed and proportional determinations which may be assimilated to 'properties' or limited territories within representation.... Then there is a completely other distribution which must be called nomadic, a nomad *nomos*, without property, enclosure or measure. Here, there is no longer a division of that which is distributed but rather a division among those who distribute *themselves* in an open space—a space which is unlimited, or at least without precise limits."[32]

This kind of "space which is unlimited," according to Deleuze a smooth space, according to Foucault an immeasurable space—if

it is not bogged down in romantic glorification and transgression pathos—means the recomposition of social assemblages, in which there are persistent struggles not to acknowledge exclusions and border regimes as they exist, and it means the emergence of machines, in which the logic of distribution and division, the striation of space, is pierced again and again. Precisely here, in the "unsettling difficulties that nomadic distributions introduce into the sedentary structures of representation,"[33] is where the abstract concept of spacing the border and the constituent practice of the noborder network meet.

THE BORDER CAMP AS REVOLUTIONARY MACHINE

"Within ten days they build a state and a wall around it."
— border camp activist

"After the ten days of the camp, the camp could have started."
— another border camp activist

"If anything, this microcosmic model of a 'functioning anarchy' was an instance of how the actions and energies of the 'multitudes' might translate into concrete realities on a day to day basis in a possible future away from capitalism." — Shuddhabrata Sengupta[34]

FROM JULY 19 TO 28, 2002 roughly 3000 activists met for an international anti-racist border camp in Strasbourg.[35] Even though the Rhine border between Germany and France is more historically charged than representing a highly contested Schengen border,

Strasbourg was chosen by the noborder network as the location for its largest and most ambitious border camp experiment; not only because it was geographically well placed for a mobilization throughout Europe, but also and especially because this city is the location of, among other major European institutions, the Schengen Information System (SIS). Data is collected in the SIS databases on migrants, which has a central function in the approval of visa applications and asylum processes. Since the rise of mass protests against economic globalization, data on demonstrators and "troublemakers" is also integrated in this system.[36] This makes the SIS a virtual instrument that indicates the rigidity of exclusions in the European legal system and the internal borders that are drawn right through the middle of EUrope. The legal, economic and political shifting of the nation-state borders, as described above, to supranational and manifold internal borders is illustrated by the fact that with the help of data from the SIS, the external borders are virtualized beyond their real actuality and multiplied into the interior, as authorities all over Europe can make use of the SIS for methods of pursuit and exclusion. The noborder camp was intended to make this function of the relatively unknown networked database public and to try out counter-strategies at the real/physical and the virtual level.

The practice of the border camp is not to be hypostasized here as the ultimate pattern of revolutionary micropolitics, nor to be trivialized as a summer camp for young revolutionary romantics. In the context of aggravated conditions following 9/11, it was even more important to the noborder activists to consciously work on new forms of organization, which would include (self-) criticism of the large-scale counter-summits described above. The possibilities of technological networking were also to be more strongly

integrated in the experiments in constituent power. Especially the international preparation of the camp through several meetings in Strasbourg and intensive online discussions beginning in December 2001 marked a high point of the noborder network in up to fifteen countries. The months of preparation for this transnational discussion and action framework was to lead into an experiment in organization that would conjoin constituent practice on site with the technical possibilities of virtual networking.

By avoiding a mobilization to a summit of "the adversary," both complexes of the negative effects of counter-summits, that of spectacularization and that of criminalization, were to be forestalled. "The adversary" was concretely located in an inconspicuous building at the edge of a Strasbourg suburb, stored on a few hard disks that are frequently and regularly secured with backup copies. The SIS was definitively not a classical bait, not an object of physical dichotomization or major opposition in urban space. However, the border camp in Strasbourg was intended to provide good conditions for small interventions in everyday life, situative micropolitics, exchange with local groups.

Just outside the city there is an elongated meadow along the Rhine with a view of the German-French border and the Europa Bridge between the Alsatian Strasbourg and the Baden city of Kehl. Beginning in mid-July the camp tents of different sizes and types gradually started spreading out over this meadow. Daily life in the camp was organized in different "barrios" that were each arranged around a kitchen, a toilet block, a garbage collection point, and a discussion area. The distribution of the participants among the barrios was free and changeable and was by no means intended to reproduce a distribution according to countries. For the various levels of everyday problems, the coordination among the barrios

and mutual information, a complex organizational proposal had been prepared.[37] However, what was planned to be a "ten-day laboratory for creative resistance and civil disobedience" was also sometimes described by the participating noborder activists as "completely over-dimensional," "clumsy," "incapable of action" and "self-laming."

The noborder network had obviously mobilized too well. Instead of being able to realize a lively discursive exchange on practices of resistance and the experimental testing of small actions, due to the surprisingly large dimension and the participation of many groups not involved in the preparation, the camp became entangled in a procedure that tended more to prevent micropolitical progress. Instead of discussions about the effects of the SIS and concrete actions (to link inside the camp and outside), at the plena and barrio meetings in the camp there were more and more and finally only vehement discussions about such burning issues as vegan food and the dimensions of the bio-toilets; media work and journalists were excluded, and the guarding of the camp was organized. The consequence of self-administration in the succinct sense as closure and turning to the inside was that there was no room left for discussions or preparing actions on these formal platforms of self-organization. Debates in the usually over-filled workshops in the camp, on the other hand, were at least the starting point for continuing the discussion informally.

The presence of media and the use of technology remained a central theme of debate throughout the entire period of the camp. Right at the entrance to the camp, the media barrio was made up of the ACSII Public Internet Café, the Indymedia tent, two radio buses, everyone is an expert, the video groups from AK Kraak and Organic Chaos, and the PublixTheatreCaravan bus.[38] From the

beginning, however, in addition to this concentration of techies and media activists, there was also an anti-technology café and vehement debates about (im-) possible distinctions and demarcations between mainstream media and alternative media, as well as the self-organized Indymedia area. Although the PublixTheatreCaravan activists were misunderstood as computer freaks who like to play with cars (or vice versa), they were otherwise generally well regarded even by fundamentally critical activists due to the "Genoa bonus," but the media barrio as a whole was regarded as both the physical and the political transition or border to the "bourgeois" outside. For some it was not even clear whether the media barrio even belonged to the camp or not.

Attempts to develop the beginnings of an orgiastic state apparatus in Strasbourg can easily be judged as a failure. Despite the early manifestations of structuralization, it was primarily the informal arrangements beyond the organizational structures of the camp that prevented the formation of constituted power. Although relatively scurrilous "laws" such as a prohibition of alcohol and drugs were discussed and sometimes "decreed," they nevertheless had little effect and were not executed. What worked much better was the chaotic spatial and social spread of the camp, which was first structured around kitchens and by instituting a women/lesbians' area, although this did not hamper the movement of an anarchic distribution in space. Since the central organization attempts were regarded by many participants as failed at a relatively early stage, the temporary village increasingly became a do-it-yourself camp with a completely incomprehensible abundance of small meetings, workshops and informal meetings.[39] It was precisely at this level that what Shuddhabrata Sengupta called the "microcosmic model of a functioning anarchy" took place, a concrete actualization of the concept of constituent power.

Many of those who had not taken part in preparing the camp, however, saw no change of paradigms following 9/11 at all and had come to Strasbourg to experience, along with the charm of alternative camping, more or less confrontational demonstrations. Here we see the problem of the insurrective mass demonstration in the tendency to rigidify into a ritual: many people could simply not imagine a border camp without the classical large-scale demonstration. For this reason, a considerable amount of energy was invested in three larger demonstrations, which followed the familiar logic of anti-globalization tourism: consuming or playing along in the ordered setting of the large-scale demonstration, from which— sometimes glass-breaking—eruptions emerge. It was not by chance that it was from a large demo like this that the Strasbourg synagogue was sprayed with the slogan "Smash Capitalism!" as an exemplary anti-Semitic effect of mass demonstrations as they occured more and more frequently on both sides of the border, in the German and the French context.

Offenses like this did not arise in the performative actions of some of the theater groups and in the many smaller spontaneous demos that were mainly devoted to spraying and painting the inner city: streets, buildings and walls were decorated with slogans and signs that soon marked the small center of the city. Street art occurred in a somewhat more general form and less clandestinely than in the nighttime practice of the graffiti sprayers and taggers, but in the course of events the separation between bodies and signs seemed to vanish. The reappropriation of the streets and public spaces took place as a rearrangement of the mixed conglomeration of bodies and signs in an area where action and representation also seem to blur.

In the face of the lasting distribution of signs in the space of the city, until toward the end of the camp there were two more

"conservative" than repressive patterns of reaction on the part of the authorities, whose actions where purposely unobtrusive during the first days: first of all, the spraying and performing activists were not arrested, but simply returned again and again to the camp, apparently in the hope that they would not find their way back into the city center again so quickly. Secondly, the city administration devoted considerable energy and resources to painting over the tags, graffiti and slogans, and these spots of fresh paint increasingly marked the city as an aesthetic of patchwork tapestries. Houses, statues and other architectonic environments displayed the fresh signs from the activists next to the cover-up attempts from the previous night. The arbitrary colors on different backgrounds were almost as easily recognizable and identifiable as the sprayers' slogans. In a way, this duplication of the creative painting process extended the activist practice of distribution in space into a practice of the city administration.

Where resistance makes such a fluid transition into insurrection, possibilities emerge for not allowing the practice of insurrective demonstration to turn into spectacle. Of the three components of the revolutionary machine, in Strasbourg the component of resistance was clearly the most successful: in the diverse theatrical actions in the inner city, in the communication guerrilla actions and counter-information caravans with discussions and film screenings in the banlieues, but also in exchange with the migrant population of the peripheries, local political activists, groups affected by the border regime and racism, and noborder activists from elsewhere were able to network and collaborate. In the following, the concluding action is to be described as exemplary not only in being oriented to the outside as an intervention, but also for its repercussions within the camp.

Right at the start of the camp, a plenum reached the agreement not to allow any media and press work at all, due to bad experiences with mainstream media. However, an undercover press group arose from this defensive precondition, which even organized a press conference at the end of the camp. For this the PublixTheatreCaravan's white double-decker bus was positioned lengthwise in the media barrio as stage for the event and to block the view of the camp. Representatives from Kanak Attack, The Voice, noborder network, kein mensch ist illegal and other groups gave statements to journalists from alternative media all the way to the Strasbourg regional television broadcaster and *Le Monde*. At the end of the press conference the journalists were invited to document an action, in which the SIS data was to be made available to the public.[40]

The SIS hack had already been rehearsed the day before. After the demonstration to the SIS building was canceled, four experts from "Noborder Silicon Valley" had gone to the inconspicuous building in a small middle-class suburb of Strasbourg, where the SIS databases were administered. Dressed in orange and white overalls and equipped with portable technical paraphernalia, they began digging at the fence around the building, fiddled with a laptop and a cable that suddenly seemed to come out of the ground, and were promptly driven away by the police.

The next day the small troop of activists set out after the press conference with a television team and journalists to return to the same place, which was now more widely blocked off than before. Before the eyes of the police and the media people, they dug up a bit of ground, connected ominous cables and purportedly transferred data with the laptop. The police ended the action after ten minutes. Nevertheless, various newspapers and online forums

reported that the SIS had been successfully tapped into. And finally the rumor came up in the camp. As a subversive affirmation of the freedom of information with respect to the mainstream media as well as to the media-hostile campers and as an attack on the closure strategy of the border camp, the media activists once again made use of the hype about "new" media and the myths of hacking and data liberation. Thus the media work returned even to the "media-free" space of the camp as a rumor.

In a small framework and for a brief period of time, the border camp is not only a contemporary, highly unsentimental example of the problems and possibilities of a revolutionary machine in Europe, in which the three components of the revolutionary machine continuously overlap. In the same way, neighboring zones of art and revolution open up from both sides. This opening corresponds to a more general tendency of increasingly emerging transversal concatenations. Here the quality of the transversal also means that this is no longer a one-sided relationship: it is not only activist art that docks into a political movement, but political activism also increasingly makes use of specific methods, skills and techniques that have been conceived and tested in art production and media work. In many cases it is not even possible to distinguish this movement from one side to the other, just as the actors reject identifications and fixed definitions altogether.

As the suffragettes of the 19th and early 20th centuries developed specific combinations of direct action, hunger strikes and blue stockings, as the Zapatistas invented the non-representationist staging and discursivization of the revolutionary machine as a weapon in the 1990s, as the communication guerrilla came up with semiotic attacks on the interior of the spectacle society (and still persist in refusing to be designated as art), as the pink and silver

blocks have brought queer movement and color into the bellicose dualisms of power and insurrective counter-power in recent years, the methods of political action and artistic practice permeate and temporarily overlap one another.

This leads us back to the starting point of the relationship between art and revolution problematized with the figures of Lunacharski and Wagner in the introduction to this book: behind the application of art techniques in activist practice just as in the participation of art activists in practices like the noborder network, there is neither a logic of exploitive subordination and heterono-mization, nor one of a dedifferentiation and totalization of the concatenation. The figure of instrumentalizing the concatenation to derive all kinds of capital from it principally belongs to the cur-rent trend of fashionable border-crossings: When media intellectuals today, much more than Lunacharsky and Wagner in the 19th and 20th century, avail themselves of the symbolic capital and scandal of revolution, or when actors in the art field instru-mentalize social transformations as spectacular conditions just to finance their art, this is part of what has become a familiar arsenal of aggressive publicity work and self-presentation. In the exchange between art activism and political activism, however, a different practice of the concatenation of art and revolution emerges, one that dispenses, as far as possible, with the logic of the spectacle and the scandal, yet without losing its insurrective components. Instead of dramatizing and scandalizing resistance, insurrection and constituent power, this practice makes the concatenation of art machines and revolutionary machines permanent and transversal.[41] As a counter-figure to confusing and diffusing art and revolution, transversal concatenation does not lead to totalizing and aestheti-cizing the political, nor to dissolving or suspending the elements of

the concatenation, but rather to an ongoing relationship of exchange among the elements as singularities. In all the various historical and actual forms of the subsequence and juxtaposition, the subordination and superordination of art and revolution, over-laps emerge in which the neighboring zones of art machines and revolutionary machines intertwine, extend into one another. In these overlaps, the transversal concatenation of art and revolution develops in permanence *and* in the specific temporality of the event, thwarting continuums of time and structuralizations of space. The manifold endeavors in between art activism and polit-ical activism do not aim to institutionalize the concatenation, nor to continue its progress in teleological linearity, nor to trigger the one major rupture leading to a new world; they attempt to insti-tute an ongoing series of singular events, to actuate contemporary becoming revolutionary in the concatenations of revolutionary machines and art machines.

Notes

1. INTRODUCTION

1. Deleuze/Guattari, *What is Philosophy?*, 100.

2. Lunacharsky, "Revolution and Art," 195.

3. Wagner, "Die Kunst und die Revolution," published in July 1849.

4. The first section was printed in 1920 in the magazine *Kommunisticheskoe prosveshenie* [Communist Enlightenment], the second section followed in 1922 as an interview published in *Krasnaya gazeta* [Red Newspaper] on the occasion of the fifth anniversary of the October Revolution.

5. cf. Krohn, "Richard Wagner und die Revolution von 1848/49." Whereas the revolts in Berlin and Vienna had already been crushed by the end of 1848, the rebels in Dresden were still fighting on the barricades in May 1849. Wagner took part in the Dresden Revolt alongside his friend August Röckel, the politically involved musical director of Dresden, and Mikhail Bakunin. He took the side of the revolution as a writer, participated in conspirative meetings, acquired weapons for the rebels, produced and distributed flyers, worked as a delegate, ombudsman and scout for the provisional government. In the final phase of the revolt, he was even accused—falsely—of having set fire to the Old Opera House. Unlike Röckel and Bakunin, Wagner succeeded in escaping to Weimar and then later to Zurich.

6. Wagner, "Die Kunst und die Revolution," 145–169.

7. Lunacharsky, "Revolution and Art," 191.

8. Wagner, "Die Kunst und die Revolution," 164.

9. ibid., 174.

10. Lunacharsky, "Revolution and Art," 191 f.

11. Wagner, "Die Kunst und die Revolution," 172–177.

12. Lunacharsky, "Revolution and Art," 194 f.

13. Wagner, "Die Kunst und die Revolution," 176.

14. Lunacharsky, "Revolution and Art," 195.

15. Wagner, "Die Kunst und die Revolution," 171.

16. Lunacharsky, "Revolution and Art," 193.

17. cf. the section "Theater Machines Against Representation. Eisenstein and Tretyakov in the Gas Works."

18. cf. Benjamin, "The Work of Art in the Age of Mechanical Reproduction," 234 and 243.

19. Lunacharsky, "Revolution and Art," 192.

20. cf. Benjamin, "The Work of Art in the Age of Mechanical Reproduction," 234.

21. Wagner, "Die Kunst und die Revolution," 171.

22. The development of my concept of machines is essentially based on Deleuze/Guattari. Here machine means neither a purely technical mechanism (a mechanized tool) in contrast to the human, nor a mere metaphor. Machines are thus complex constellations that pervade and conjoin several structures simultaneously, permeating collectives and individuals, people and things. In this kind of conception of machinization, the relationship between human and machine can no longer be covered in terms of replacement or adaptation, in other words the replacement of the human *by* the machine or the adaptation of the human *to* the machine, but only in terms of connection and exchange. Most of all, though, according to Deleuze/ Guattari the concept of the machine also designates social arrangements, which do not function, contrary to the "(state) apparatuses," on the basis of mechanisms of structuralization, hierarchization and segmentation. Cf. my "Excursus on Machines" in chapter 6.

23. cf. Benjamin, "Theses on the Philosophy of History," 253; cf. also Deleuze/Guattari, *What is Philosophy?*, 95–97.

24. Periodizations of this kind are not new and may be found among a number of theorists from various disciplines: Fernand Braudel and Eric Hobsbawn respectively called the 16th and the 19th centuries "long," Giovanni Arrighi in his economic history study *The Long Twentieth Century. Money, Power, and the Origins of Our Times* also deals with aspects of the extension of the 20th century.

25. cf. the relevant works by Eric Hobsbawn, but also outside the science of history Jürgen Habermas or Okwui Enwezor's ideas.

26. Deleuze/Guattari, *L'Anti-Oedipe*, 487.

27. Günther Maschke, before 1968 activist in the student movement in Germany (SDS) and Vienna, arrested and banished in 1968, emigrated to Cuba and returned to Germany following an attempted putsch against Castro as a right-wing theorist and philologist, co-founder of the radical right-wing magazine "Etappe" in 1988, also writes for other extreme right-wing journals such as "Elemente," published by the nationalist, anti-semitic Thule Seminar, and is co-editor of the "Bibliothek der Reaktion" for the right-wing Viennese Karolinger Verlag. The RAF co-founder Horst Mahler has developed into an anti-semitic right-wing extremist and "nationalist revival preacher" (*Die Zeit*). Rainer Langhans, co-founder of the commune K1, is "meanwhile one of the most prominent figures of the esoteric scene with a close affinity to eco-fascist thinking" (Jutta Ditfurth). Bernd Rabehl, SDS activist in Berlin and the closest associate of Rudi Dutschke at the time, seeks to redefine "non-parliamentary opposition" (APO—Außerparlamentarische Opposition) as a national-revolutionary movement. SDS activist Frank Böckelmann, co-founder of the

situationist Subversive Action in the early 1960s, published the book *Die Gelben, die Schwarzen, die Weißen* ("The Yellow People, the Black People, the White People") in 1998, a defense of the ethnically homogeneous Germanness described as "ethnopluralist." Together with Böckelmann, the Viennese Foucault translator Walter Seitter publishes the magazine "Tumult," in which he complained about "violently smelly Turks" at Brandenburg Tor (No. 17, 121) and publishes essays that were previously written for the radical right-wing journal "Etappe." Seitter makes use of his renown as Lacan and Foucault expert to reinterpret and give a right-wing turn to the French post-structuralists, just as he teaches the "right use of the French." On Maschke, Seitter and Böckelmann, see Diederichsen, "Spirituelle Reaktionäre und völkische Vernunftkritiker;" on Mahler and Rabehl: Gretchen Dutschke, "Was Rudi Dutschke zu den Irrwegen der abgefallenen Achtunsechziger sagen würde," and the Internet lexicon of right-wing extremism http://lexikon.idgr.de; an exemplary summary of the entanglements of former leftists in the network of the "New Right-Wing" is found in the article "Zwei links—zwei rechts: Ex-Linke verstricken sich im rechten Netz."

28. This appendix is found in the original French version as "appendice. bilan-programme pour machines désirantes," but it is not included in the English version of *Anti-Oedipus*. The quotations and translation follow the French version here.

29. cf. for instance not only Mussolini's interest in Italian Futurism, but also Gramsci's.

30. cf. Walter Benjamin's essay "The Author as Producer," which includes his criticism of *Neue Sachlichkeit* and Kurt Hiller's "Activism;" also the chapter "Spirit and Betrayal. German 'Activism' in the 1910s."

31. On this, see the section "Theater Machines Against Representation. Eisenstein and Tretyakov in the Gas Works."

32. Deleuze/Guattari, *L'Anti-Oedipe*, 487.

33. ibid.

2. THE THREE COMPONENTS OF THE REVOLUTIONARY MACHINE

1. Negri, "Constituent Republic," 251.

2. Marx, "First Draft of 'The Civil War in France,'" MEW 17, 539 [http://www.marxists.org/archive/marx/works/1871/civil-war-france/ drafts/ch01.htm#D1s1].

3. Luxemburg, "The Mass Strike," http://www.marxists.org/archive/luxemburg/1906/mass-strike/ch04.htm.

4. Arendt, *On Revolution*, 42–44, even describes the first political use of the term with the example, among others, of England in the 17th century as a "movement of revolving back to some pre-established point and, by implication, of swinging back into a preordained order." In certain cases revolution can thus paradoxically mean counter-revolution, or at least the restoration of an earlier state. However, Arendt's philological-etymological conclusion (42 f.) goes too far, when she claims that the Latin word *re-volvere* essentially means re-turning a historical process. This is not the case, as the prefix re- in Latin means a movement in the right place rather than a movement backward. Cf. also Kristeva, *Revolt, She Said*, 85 and 100.

5. Marx, "The Eighteenth Brumaire of Louis Bonaparte," MEW 8, 197 [http://www.bookrags.com/ebooks/1346/75.html].

6. Deleuze, "Préface. Trois problèmes de groupe," VII ["The theory of phases damages every revolutionary movement."]

7. Already in 1891 Engels wrote in his introduction to the revised edition of Marx' "Civil War in France" (MEW 17, 625), that the final destruction of the state apparatus is conceived of as being postponed to an indeterminate period, "until such time as a new generation, reared in new and free social conditions, will be able to throw the entire lumber of the state on the scrap-heap." [http://www.marxists.org/archive/ marx/works/ 1871/civil-war-france/postscript.htm]

8. Deleuze, *Foucault*, 30.

9. Guattari, "Machine et structure," 247; *miroir aux alouettes* is a "lark baffle," a device to attract small birds using a mirror that glitters in the sun.

10. ibid., 248.

11. On the criticism of this premature dismissal of the nation-state, cf. Arrighi, "Lineages of Empire."

12. Deleuze/Guattari, *A Thousand Plateaus*, 351–423.

13. ibid., 418.

14. Deleuze/Guattari themselves pointed out this ambivalence of the war machine in several places, cf. for instance *A Thousand Plateaus*, 222 and 420–422.

15. Deleuze/Guattari, *A Thousand Plateaus*, 421.

16. ibid.

17. ibid.

18. Žižek, *Revolution at the Gates*, 5.

19. ibid., 310: "[…] to repeat Lenin is to accept that 'Lenin is dead,' that his particular solution failed, even failed monstrously, but that there was a utopian spark in it worth saving. […] To repeat Lenin is to repeat not what Lenin *did* but what he *failed to do*, his missed opportunities."

20. cf. ibid., 7.

21. Guattari, "La causalité, la subjectivité et l'histoire," 186.

22. Deleuze, "Préface. Trois problèmes de groupe," V.

23. Guattari, "La causalité, la subjectivité et l'histoire," 186.

24. Žižek, *Revolution at the Gates*, 7.

25. Guattari, *Wunsch und Revolution*, 69.

26. Holloway, *Change the World Without Taking Power*, 6.

27. Hardt/Negri, *Empire*, 369.

28. Holloway, *Change the World Without Taking Power*, 153 f.

29. ibid., 213.

30. Deleuze/Guattari, *A Thousand Plateaus*, 423.

31. "Primera Declaracíon de La Realidad," in: La Jornada, 30.1.1996, quoted from: Holloway, *Change the World Without Taking Power*, 20.

32. Marx formulated this criticism in the "Eighteenth Brumaire of Louis Bonaparte" at the point (MEW 8, 122) where he addressed the relapse of the proletariat following the defeat of the June Insurrection of 1848: "It partly throws itself upon doctrinaire experiments, 'co-operative banking' and 'labor exchange' schemes; in other words, movements, in which it gives up the task of revolutionizing the old world with its own large collective weapons and on the contrary, seeks to bring about its emancipation, behind the back of society, in private ways, within the narrow bounds of its own class conditions, and, consequently, inevitably fails."

33. Holloway, *Change the World Without Taking Power*, 37.

34. Negri, "Constituent Republic," 251.

35. Michael Hardt and Antonio Negri, "Globalization and Democracy," Paper at Documenta 11, Platform 1, Vienna, 20.4.2001, cf. Hardt/Negri, "Globalisierung und Demokratie," 383f.

36. ibid., 380–382.

37. S.I., "Now, the S.I."

38. Foucault, *The Will to Knowledge*, 95.

39. Deleuze, *Foucault*, 24.

40. Foucault, *Discipline and Punish*, 26.

41. Foucault, *The Will to Knowledge*, 96.

42. cf. Raunig, "Walking Down the Dead-End Street and Through to the Other Side. Lines of Flight of (from) Governmentality;" cf. also Deleuze, *Foucault*, 96: "If at the end of it [of *The Will to Knowledge*] Foucault finds himself in an impasse, this is not because of his conception of power but rather because he found the impasse to be where power itself places us, in both our lives and our thoughts […]."

43. Holloway, *Change the World Without Taking Power*, 40.

44. Deleuze, *Foucault*, 95. The original quotation is found in Foucault, "Lives of Infamous Men," 161.

45. Butler, *The Psychic Life of Power. Theories in Subjection*, 98 f.

46. Foucault, *The Will to Knowledge*, 96.

47. Deleuze, *Foucault*, 89 [Translation slightly changed by the author, according to the French orginal], cf. also 94.

48. cf. also Deleuze, "Desire and Pleasure," section F: "the lines of flight are primary (even if 'primary' isn't chronological)." (In this text Deleuze attempts to delineate the theoretical differences and commonalities between his position and Foucault's.)

49. Deleuze, *Foucault*, 90.

50. ibid., 144, footnote 28. In addition to Operaism, this figure comes up in the 1960s in the writings of the Situationist International as well (see the motto of this section).

51. Hardt/Negri, *Empire*, 59–61.

52. ibid., 360.

53. ibid. This figure is repeated in Hardt/Negri, *Multitude*, 64, ("[…] *resistance is primary with respect to power.*") in allusion to Marx's preface to *Capital*: "Whereas Marx's exposition begins with capital, then, his research must begin with labor and constantly recognize that in reality labor is primary. The same is true of *resistance.*"

54. Hardt/Negri, *Empire*, 210–214.

55. Hardt/Negri, *Empire*, 208–210.

56. ibid., 211: "If there is no longer a place that can be recognized as outside, we must be against in every place." Cf. also Raunig, "War Machine Against the Empire," 134–136.

57. Hardt/Negri, *Empire*, 399.

58. ibid.

59. Such as the protests against the War in Iraq, when over ten million people took to the streets on 15 February 2003 all over the world.

60. Such as in the practice of the noborder network or the EuroMayDay parades, cf. Raunig, "La inseguridad vencerá. Anti-Precariousness Activism and Mayday Parades."

61. cf. Hamm, "A *r/c*tivism in Physical and Virtual Spaces."

62. Aside from the wave of manifestations from 1999 to 2001 against WTO, WEF, G8, EU summits and others, current forms of insurrectionist mass demonstrations are Global Street Parties, Carnivals against Capital and EuroMayDay parades, as well as collective actions on a smaller scale. Quantities are less relevant here than the aspects of transnationality and non-conformity described in this chapter.

63. cf. Raunig, *Wien Feber Null*, 46–52.

64. Hegel, *Grundlinien der Philosophie des Rechts*, 389, 473. Mass is described here as "undifferentiated," "formless."

65. Hardt/Negri, *Multitude*, xiv: "The essence of the masses is indifference: all differences are submerged and drowned in the masses. All the colors of the population fade to gray. These masses are able to move in unison only because they form an indistinct, uniform conglomerate." Cf. also Negri, "Towards an Ontological Definition of the Multitude," http://multitudes.samizdat.net/article.php3?id_article=269

66. cf. Canetti, *Masse und Macht*, 49–54

67. cf. Lazzarato, "Struggle, Event, Media."

68. Arendt, *On Revolution*, 163.

69. cf. ibid., 145, 166.

70. cf. Kristeva, *Revolt, She Said*, 13: "[…] the American revolution, far more legalistic and federalist in spirit, which offered better management of the contract that rather well-off freeholders were making amongst themselves."

71. cf. Arendt, *On Revolution*, 279.

72. ibid., 273.

73. cf. ibid., 262.

74. cf. ibid., 249.

75. cf. Negri, *Insurgencies*, 20 f. The original Italian version of the book published in 1992 is entitled "Il potere costituente: saggio sulle alternative del moderno," and it treats the concept of constituent power in consideration of Niccolò Macchiavelli, James Harrington, the (US) American, the French and the Russian Revolution.

76. Negri, "Constituent Republic," 245.

77. cf. Azzellini, "Der Bolivarianische Prozess: Konstituierende Macht, Partizipation und Autonomie."

78. Chávez himself referred to the French theorists of the *pouvoir constituant* as well as to Negri's concept of constituent power explicitly: cf. *Harnecker, Hugo Chávez Frías. Un hombre, un pueblo*, 19, sentence 72.

79. Negri, "Constituent Republic," 252 f.

3. OUT OF SYNC

1. Lenin, "Plan of a Lecture on the Commune."

2. Kropotkin, "The Paris Commune."

3. Hardt/Negri, "Globalisierung und Demokratie," 381. Cf. also the remarks of the two authors on the Commune in *Multitude*, 87.

4. What especially influenced this historical line of constraining the revolutionary approach of the Commune was Marx' "Civil War in France," which was written during the era of the Commune, first published in English in June 1871 directly after the "Bloody Week," and was already decisive for later interpretations of the Commune as a one-dimensional uprising simply because of its title.

5. Lissagaray, *History of the Paris Commune of 1871*, http://www.marxists.org/ history/ france/archive/lissagaray/ch03.htm. Cf. also Michel, *Memoiren*, 127; Leighton, "Der Anarchofeminismus und Louise Michel," 32; Gould, *Insurgent Identities*, 158 f.

6. Marx, "Civil War in France," MEW 17, 349 [http://www.marxists.org/archive/ marx/works/1871/civil-war-france/ch05.htm].

7. The Versailles court accused the Commune of commissioning and paying a large number of women to systematically burn Paris when it was stormed by the Versailles troops. For this reason, the women communards were said to carry petroleum with them to set fire especially to the houses of the bourgeoisie and the cultural buildings of pageantry and representation. Cf. Boime, *Art and the French Commune*, 196–199.

8. Exceptions in the genres of artistic representation include Brecht's *Die Tage der Commune*, in which the image of the defense of the cannons is interwoven with the everyday life of the Commune, and Peter Watkins' excessive six-hour film "La Commune," in which the reality of the actors increasingly merges with the staged production; cf. Pöschl, "beyond the limitations of the rectangular frame."

9. The numbers differ depending on the account, but the most cautious sources list at least 20,000 deaths. Many of these deaths were not directly the result of battle action, but rather of mass executions by the government army. Cf. Gould, *Insurgent Identities*, 165.

10. Gould, *Insurgent Identities*, 122–134.

11. Quoted from: Bruhat/Dautry/Tersen, *Die Pariser Kommune von 1871*, 131.

12. Gould assembled a considerable amount of material to support this thesis.

13. Bruhat/Dautry/Tersen, *Die Pariser Kommune von 1871*, 135.

14. Although both women and men were involved in the workers movement, all the candidates were men, as there was neither active nor passive suffrage for women in 1870.

15. cf. Bruhat, "Die Arbeitswelt der Städte," 279.

16. On the context of this paragraph cf. Lissagaray, *History of the Paris Commune of 1871*, http://www.marxists.org/history/france/archive/lissagaray/prologue.htm; Bruhat/ Dautry/ Tersen, *Die Pariser Kommune von 1871*, 39–48.

17. Lissagaray, *History of the Paris Commune of 1871*, http://www.marxists.org/history/france/archive/lissagaray/prologue.htm.

18. Gould, *Insurgent Identities*, 141.

19. ibid., 155–158.

20. Lissagaray, *History of the Paris Commune of 1871*, http://www.marxists.org/history/france/archive/lissagaray/prologue.htm.

21. Bruhat/Dautry/Tersen, *Die Pariser Kommune von 1871*, 65.

22. Lissagaray, *History of the Paris Commune of 1871*, http://www.marxists.org/history/france/archive/lissagaray/prologue.htm.

23. ibid. At the same time, according to Lissagaray, the people of Toulouse drove out the general, and in St. Etienne the Commune existed "for one hour."

24. ibid.

25. Bruhat/Dautry/Tersen, *Die Pariser Kommune von 1871*, 93.

26. Attempts to remove the cannons in early March were as frequent as they were unsuccessful, cf. ibid., 86.

27. Luxemburg, "Reform or Revolution," http://www.marxists.org/archive/luxemburg/1900/reform-revolution/ch08.htm.

28. Arendt, *On Revolution*, 116.

29. Debord/Kotány/Vaneigem, *Theses on the Paris Commune*.

30. ibid.

31. cf. Lefebvre, *La Proclamation de la Commune*, for example the following passage (21, · translated A.D.): "The collective hero, the popular genius, suddenly emerges in his innate youth and vitality. He has conquered, simply because he has appeared. Surprised by his victory, he transforms it into magnificence. He rejoices, he contemplates his awakening and transforms his potency into beauty. He celebrates his re-found union with the consciousness, with the palaces and monuments of the city, with the power he had so long been missing. And it is truly a festival, a long festival lasting from the 18th of March to the 26th (elections) and the 28th of March (Proclamation of the Commune) and beyond, with a magnificent ceremonial and solemnity." Cf. also Lefebvre's text on the Commune, published in the final issue of *Arguments* and the earlier Situationist text on the Commune in the SI journal: Debord/Kotány/Vaneigem, *Theses on the Paris Commune*, attacking Lefebvre as plagiarist.

32. See, for instance, Ross, *The Emergence of Social Space*, or Starr, "The Uses of Confusion. Lefebvre's Commune."

33. cf. Hardt/Negri, *Multitude*, especially the section on "Carneval and Movement," 208–211.

34. Ross, *The Emergence of Social Space*, 3.

35. cf. Deleuze, *Difference and Repetition*, 48–50.

36. Lenin, "The Paris Commune and the Tasks of the Democratic Dictatorship."

37. Marx, "Civil War in France" MEW 17, 336 [http://www.marxists.org/archive/marx/works/1871/civil-war-france/ch05.htm]: The formulation was also used by Marx and Engels in the new German edition of the Communist Manifesto from June 1872 as an essential corrective and insight from the experiences of the Commune.

38. Marx, "Civil War in France" MEW 17, 336 [http://www.marxists.org/archive/marx/works/1871/civil-war-france/ch05.htm]. See also the quotation from Marx written almost two decades earlier from "The Eighteenth Brumaire of Louis Bonaparte" (above) about the journey of the revolution through the purgatory of the development of the state engine from the means of preparing the class domination of the bourgeoisie (under Napoleon I), then supporting (under Louis-Philippe) and finally becoming an end in itself (under Napoleon III).

39. Marx, "Civil War in France," MEW 17, 340 [http://www.marxists.org/archive/marx/works/1871/civil-war-france/ch05.htm].

40. Engels ends the introduction to the German version of "Civil War in France" with the words: "Look at the Paris Commune. That was the Dictatorship of the Proletariat." (MEW 17, 625 [http://www.marxists.org/archive/marx/works/1871/civil-war-france/postscript.htm]). The argument can also be turned against those who introduced it, as was the case with the Situationist theses "On the Paris Commune." The first thesis describes

the apparent successes of the communist movement as its fundamental failures (reformism, the establishment of a state bureaucracy), its seeming failures like the Paris Commune as its most promising successes. The third thesis turns Lenin's interpretation of Engels' argument around: Engels' remark "should be taken seriously in order to reveal what the dictatorship of the proletariat is not (the various forms of state dictatorship over the proletariat in the name of the proletariat)" (http://www.cddc.vt.edu/sionline/si/commune.html).

41. Marx, "Civil War in France," MEW 17, 339 [http://www.marxists.org/archive/marx/works/1871/civil-war-france/ch05.htm].

42. ibid., 341.

43. cf. Kropotkin, "The Paris Commune."

44. Quoted from Lissagaray, *History of the Commune of 1871*, http://www.marxists.org/history/france/archive/lissagaray/ch04.htm. Also see the text of the Manifesto of the Central Committee from 20th March, quoted ibid.: "Obscure a few days ago, obscure we shall return to your ranks, and show our governors that it is possible to descend the steps of your Hôtel-de-Ville, head erect" (http://www.marxists.org/history/france/archive/lissagaray/ch05.htm).

45. ibid.

46. Marx, "Civil War in France," MEW 17, 339 [http://www.marxists.org/archive/marx/works/1871/civil-war-france/ch05.htm].

47. This is the term that Marx used in the first draft of "Civil War in France" for the organizational form of the Commune (MEW 17, 554 [http://www.marxists.org/archive/marx/works/1871/civil-war-france/drafts/ch01.htm#D1s3]).

48. Lissagaray, *History of the Paris Commune of 1871*, http://www.marxists.org/history/france/archive/lissagaray/ch05.htm.

49. ibid.

50. ibid.

51. cf. Bruhat/Dautry/Tersen, *Die Pariser Kommune von 1871*, 177f.

52. Marx, Civil War in France, MEW17, 338 [http://www.marxists.org/archive/marx/works/1871/civil-war-france/ch05.htm].

53. ibid., 348.

54. Marx, "First Draft of 'Civil War in France,'" MEW 17, 543 [http://www.marxists.org/archive/marx/works/1871/civil-war-france/drafts/ch01.htm#D1s3ii].

55. quoted from Lenin, *The State and Revolution*, http://www.marxists.org/archive/lenin/works/1917/staterev/ch04.htm.

56. Bakunin, "The Paris Commune and the Idea of the State."

57. ibid.

58. Marx, "Second Draft of 'Civil War in France,'" MEW 17, 592 [http://www.marxists.org/archive/marx/works/1871/civil-war-france/drafts/ch02.htm#D2s1].

59. cf. Bakunin, "The Paris Commune and the Idea of the State."

60. Lenin, "In Memory of the Commune."

61. Bakunin, "The Paris Commune and the Idea of the State."

62. Marx, "First Draft of 'Civil War in France,'" MEW 17, 541[http://www.marxists.org/archive/marx/works/1871/civil-war-france/drafts/ ch01.htm#D1s1].

63. Ross, *The Emergence of Social Space*, 25.

64. On the ambivalence of the phenomenon of confusion, cf. also Starr, "The Uses of Confusion. Lefebvre's Commune."

65. Lissagaray, *History of the Paris Commune of 1871*, http://www.marxists.org/ history/france/archive/lissagaray/ch17.htm.

66. Suffrage is to be understood here as one of several necessary steps in the direction of an effective equality, cf. Balibar, *Die Grenzen der Demokratie*, 78 f.: "In fact, women in the 19th century were not only negatively excluded from the 'public sphere:' one could also say that the social roles attributed to them with the relevant ideologies, educational practices and symbolic complexes were an effective *precondition* for the political competency of men (as a collective)."

67. Michel, *Memoiren*, 110.

68. In reference to the following paragraphs cf. especially Schrupp, *Nicht Marxistin und auch nicht Anarchistin*, especially 124–150, the chapter by Jeanne Gaillard, "Die Aktionen der Frauen" in: Bruhat/Dautry/Tersen, *Die Pariser Kommune von 1871*, 143–154, Michel et al., *Louise Michel. Ihr Leben—Ihr Kampf—Ihre Ideen*, 70, and Leighton, "Der Anarchofeminismus und Louise Michel," 32.

69. However, the fact of Proudhon's open sexism probably led to a certain anti-Proudhonist mobilization of women in the years before the Commune; cf. Schrupp, *Nicht Marxistin und auch nicht Anarchistin*, 11.

70. ibid., 163: "Of 993 public assemblies and 110 conferences that took place from 1868 to 1870 in Paris, the question of women's rights was explicitly on the agenda 76 times and was addressed in the course of discussions in numerous other cases."

71. On the dominance of male speakers even on the question of women's rights and the endeavors of the majority of them to denounce political and economic equality between men and women, cf. Gould, *Insurgent Identities*, 132, footnote 17.

72. cf. Schrupp, *Nicht Marxistin und auch nicht Anarchistin*, 127–134; Leighton, "Der Anarchofeminismus und Louise Michel," 35.

73. Michel, *Memoiren*, 83.

74. Leighton, "Der Anarchofeminismus und Louise Michel," 35.

75. quoted from Lohschelder et al., *AnarchaFeminismus*, 42.

76. cf. Bruhat/Dautry/Terson, *Die Pariser Kommune von 1871*, 139–143.

77. cf. *Die politische Lithographie im Kampf um die Pariser Kommune 1871*, 6.

78. ibid., 8.

79. Ross, *The Emergence of Social Space*, 137.

80. ibid.

81. Marx, "The Civil War in France," MEW 17, 362 [http://www.marxists.org/archive/marx/works/1871/civil-war-france/ch06.htm].

4. THE COURBET MODEL

1. Clark, *Image of the People*, 9: "These statements [quotations from Proudhon, Courbet, Baudelaire and Enault, with which Clark prefaces his first chapter "On the Social History of Art"] conjure up an unfamiliar time, a time when art and politics could not escape each other."

2. ibid., 64

3. Ross writes of the "workings of everyday life, that make the Commune a predominantly 'horizontal' moment" and of an "attack on verticality" (Ross, *The Emergence of Social Space*, 5).

4. ibid.: "But the Commune was not just an uprising against the political practices of the Second Empire; it was also, and perhaps above all, a revolt against deep forms of social regimentation. In the realm of cultural production, for instance, divisions solidly in place under the rigid censorship of the Empire and the constraints of the bourgeois market—between genres, between aesthetic and political discourses, between artistic and artisanal work, between high art and reportage—such hierarchical divisions under the Commune were fiercely debated and, in certain instances, simply withered away."

5. Clark, *Image of the People*, 19 f.: "the artist as opponent—Courbet's intention, which also persisted."

6. Ross, *The Emergence of Social Space*, 14 f.: "During the Commune, however, shoemakers—and artists—have laid down their tools. And shoemakers and artists are not in their place."

7. Kaschnitz, *Die Wahrheit nicht der Traum*, 177, 182.

8. Clark, *Image of the people*, 15.

9. Kaschnitz, *Die Wahrheit nicht der Traum*, 174.

10. cf. Fried, *Courbet's Realism*.

11. cf. Scholz, *Pinsel und Dolch*, especially 74–95.

12. Quoted from Aragon, *Das Beispiel Courbet*, 47. Shortly after Courbet, Honoré Daumier also refused the Cross of the Legion of Honor, but without comparable media attention.

13. On Courbet's art political activities cf. especially the study *Organizing Independence*, published in 1997 by Gonzalo J. Sánchez on the history of the Fédération des Artistes, and as source the "Authentic Report" on the "Conduct and Efficacy of the Painter G.

Courbet During the Government of 4th September and Under the Government of 18th March, the So-Called Commune of Paris, With Respect to the Preservation of Art Treasures and the Vendôme Column," published for the first time and quoted in Aragon, *Das Beispiel Courbet*, 58–63.

14. Sánchez (*Organizing Independence*, 1) defines the circle of political tasks of the Fédération des Artistes as "artistic self-government, education, patronage, production, and museum administration." With this limitation, the Fédération also ended up in conflict with more radical endeavors and abstained from any transversal practice, such as was realized, for instance, during the Commune by theater artists (see below) or the Intermittents et Précaires in France today.

15. cf. Desbuisson, "Le citoyen Courbet," 10; Sánchez, *Organizing Independence*, 46 f.

16. cf. also Courbet's reform proposals listed by Sánchez, *Organizing Independence*, 43 f. and described—somewhat exaggeratedly—as a radical break with the art policies of the past.

17. On the official iconoclasms of the "Government of National Defense" and the Commune, cf. Sánchez, *Organizing Independence*, 32 and 36.

18. cf. Desbuissons, "Le citoyen Courbet," 16; Lissagaray, *History of the Paris Commune of 1871*, http://www.marxists.org/history/france/archive/lissagaray/ch34.htm.

19. cf. Aragon, *Das Beispiel Courbet*, 47 f.

20. cf. ibid., 53.

21. On the history of the column, see Hofmann, "Gespräch, Gegensatz and Entfremdung," 149–152.

22. Marx, too, ended his 1852 essay "The 18th Brumaire of Louis Bonaparte" (MEW 8, 207 [http://www.marxists.org/archive/marx/works/1852/18th-brumaire/ch07.htm]) with an allusion to the column and its symbolic character in conjunction with the revolution: "But when the imperial mantle finally falls on the shoulders of Louis Bonaparte, the bronze statue of Napoleon will come crashing down from the top of the Vendôme Column."

23. Reprinted in Hofmann/Herding (Ed.), *Courbet und Deutschland*, 378–380; quoted by Aragon, *Das Beispiel Courbet*, 47, with the note that the letter was published as a brochure for twenty Centimes by Courbet himself. Courbet is said to have read the letter together with another letter, "To the German Army" on 29 October 1870 at the Atheneum Theater. Lissagary (*The History of the Paris Commune of 1871*, 268) also tells of a letter from Courbet calling for the column to be torn down, which was published during the siege by the "Journal officiel" of the Mairie of Paris.

24. cf. the "Authentic Report," quoted by Aragon, *Das Beispiel Courbet*, 59.

25. ibid., 62.

26. Lissagaray, *The History of the Paris Commune of 1871*, http://www.marxists.org/history/france/archive/lissagaray/ch15.htm: "In the middle of a sitting, Félix Pyat bounded from his chair to demand the abolition of the Vendôme column [...]."

27. quoted from Krause, *Pariser Commune 1871*, 51.

28. cf. the "Authentic Report," quoted in Aragon, *Das Beispiel Courbet*, 60.

29. Lissagaray, *The History of the Paris Commune of 1871*, http://www.marxists.org/history/france/archive/lissagaray/ch24.htm.

30. cf. Hofmann/Herding (Ed.), *Courbet und Deutschland*, 535 f.; Lissagaray, *The History of the Paris Commune of 1871*, http://www.marxists.org/history/france/archive/lissagaray/ch24.htm: The engineer affirmed "that the column would break to pieces during its descent. He had sawn it horizontally a little above the pedestal; a slanting groove was to facilitate the fall backwards [...] A rope attached to the summit of the column was twisted round a capstan fixed at the entrance of the street. [...] The bands played the *Marseillaise*, the capstan turned about, the pulley broke, and a man was wounded. Already rumours of treason circulated among the crowd, but a second pulley was soon supplied. [...] At half-past five the capstan again turned, and a few minutes after the extremity of the column slowly displaced itself, the shaft little by little gave way, then, suddenly reeling to and fro, broke and fell with a low moan. The head of Bonaparte rolled on the ground, and his parricidal arm lay detached from the trunk."

31. ibid.; see also the chapter "Courbet und die Vendôme-Säule" in: Hofmann, "Gespräch, Gegensatz und Entfremdung," 149–155, with several vivid photos and lithographs.

32. cf. for instance Ross, *The Emergence of Social Space*, 5.

33. cf. Ross, *The Emergence of Social Space*, 39.

34. Starr, "The Uses of Confusion," describes this principle of the "reversal of values" particularly against the background of an analysis of the Commune contrary to dogmatic constraints.

35. cf. Ross, *The Emergence of Social Space*, 8.

36. quoted from: Duncker, *Pariser Kommune 1871*, 318.

37. Lissagaray, *History of the Paris Commune of 1871*, http://www.marxists.org/history/france/archive/lissagaray/ch24.htm.

38. Aragon, *Das Beispiel Courbet*, 60.

39. In an open letter, in which Courbet requested the new National Assembly in 1876 to annul the confiscation of his property in France, he again denies material participation in the destruction of the column, although he also admits a "moral participation." Cf. Hofmann/Herding (Ed.), *Courbet und Deutschland*, 68 f.

40. Gould, *Insurgent Identities*, 164, describes the destruction of public buildings (the Tuileries, city hall, the police prefect, the palace of justice) beginning 23 May 1871 as 1) a tactical measure in the course of the retreat of the Commune, 2) a final desperate gesture of resistance, and 3) a consequence of the artillery attacks of the government troops.

41. Debord/Kotányi/Vaneigem, "Theses on the Paris Commune."

42. The metaphors of "Paris in flames" and the "ruins of Paris" were, not least of all, also tactical components of the reactionary pamphlets against the Commune that were published between 1871 and 1873, which were intended to justify the overwhelming violence of the government troops against the Commune in the "bloody week." The combination

of images of extreme chaos and the attack on property relations created a narrative that covered up the blood spilled by the government troops. Cf. Gould, *Insurgent Identities*, 164, also footnote 9.

43. Debord/Kotányi/Vaneigem, "Theses on the Paris Commune."

44. ibid.

45. Desbuissons, "Le citoyen Courbet," 17.

46. Quoted from Aragon, *Das Beispiel Courbet*, 60, emphasis G.R.

5. SPIRIT AND BETRAYAL

1. Brecht, *Der Untergang des Egoisten Johann Fatzer*, 116 f.

2. Hiller, *Philosophie des Ziels*, 50.

3. Deleuze/Parnet: *Dialogues*, 45.

4. Walter Benjamin, "The Author as Producer," 222; cf. the affinity to the ideas of Sergei Tretyakov (Woher und wohin, 47): "The distinction between 'form' and 'content' must lead into a theory of the procedure that comprises the processing of material to produce the thing needed, the function and the matter of appropriating this thing."

5. The references here to Benjamin's discussion of "intelligentsia" and "intellectuals" cover a broad range including artists from all fields, journalists and scholars and all the spreading fields of cognitive work.

6. Benjamin, "The Author as Producer," 226. On updating Benjamin's essay in conjunction with political art practices of the 1990s, cf. Raunig, "Grandparents of Interventionist Art, or Intervention in the Form. Rewriting Walter Benjamin's 'Der Autor als Produzent.'"

7. In a segment of his older text from 1931, which Benjamin himself cryptically cites as a quotation from an "understanding critic" in the "Author as Producer," the target for his attacks on "the proletarian mimicry of the decaying bourgeoisie" is the poetry of Kästner, Tucholsky and Mehring. Cf. Benjamin, *Gesammelte Werke, III*, 280 f.

8. Ursula Baumeister (*Die Aktion 1911–1932*, 43) defines "Activism" as an aesthetic program and radical cultural wing of Expressionism.

9. Raoul Hausmann reviled the "Activists" roughly as "henchmen of the moral idiocy of the constitutional state" and suggested drowning "these snotty-nosed drips" in the "filth of their so horribly serious six-volume works" (quoted from Scholz, *Pinsel und Dolch*, 345).

10. Benjamin, "The Author als Producer," 226.

11. Rothe, *Aktivismus*, 18.

12. Translator's note: The word Geist in German, which is the focal point of Hiller's ideas here, can mean spirit, attitude, mind, intellect, ghost. In this translation, preference is given to the word spirit, although intellect is more frequently used in older, related translations. In this case, spiritism has nothing to do with the esoteric movement of the late 19th century.

13. Benjamin, "The Author as Producer," 226.

14. cf., for instance, the text collection *Der Aktivismus 1915–1920*; in his introduction in 1969 the publisher Wolfgang Rothe called "Activism" an "expression of the German spirit that calls for respect" (21) in contrast with the 1968 movement.

15. Hiller, *Philosophie des Ziels*, 42.

16. Benjamin, "The Author as Producer," 228.

17. ibid., 227.

18. Hiller, *Philosophie des Ziels*, 53.

19. ibid., 46–48.

20. Benjamin was certainly familiar with *Die Aktion*, since he also published articles there. In addition, the publisher of *Die Aktion*, Pfemfert, had already been the publisher of the *Anfang*, the newspaper of the youth movement that Benjamin had been involved with in the early part of the decade.

21. cf. the two Pfemfert articles in the third year of *Die Aktion*: "Die Wir des Doktor Hiller," *Die Aktion* 1913, 637, and "Der Karriere-Revolteur," *Die Aktion* 1913, 1129–1136.

22. Benjamin, "The Author as Producer," 226.

23. Baumeister describes Pfemfert's strategy as the "creation of a counter-public sphere against conscription:" Baumeister, *Die Aktion 1911–1032*, 102.

24. ibid., 103.

25. Hiller, *Philosophie des Ziels*, 39–43.

26. Baumeister, *Die Aktion 1911–1932*, 235–241.

27. cf. Baumeister, *Die Aktion 1911–1932*, especially 269–276, also see the discussion of the attacks on Debord and the S.I. in the following section.

28. Hiller, *Philosophie des Ziels*, 52 f.

29. As explained in the commentary for the Benjamin edition of *Gesammelte Werke*, for unknown reasons, the lecture probably did not take place.

30. Hiller, Philosophie des Ziels, 33.

31. ibid., 33, 45.

32. Benjamin, "The Author as Producer," 229–232.

33. ibid., 237 f.

34. Deleuze/Parnet, *Dialogues*, 44.

35. cf. on the art of escaping, on exodus and flight lines: Raunig, "Instituent Practices."

36. Deleuze, *Negotiations*, 252.

37. On Foucault's concept of truth, see *Discourse and Truth* and my thoughts on the concept of *parrhesia* in the chapter about "The Transversal Concatenation of the PublixTheatreCaravan."

38. Foucault, "Die politische Funktion des Intellektuellen," 151.f.

39. Deleuze, *Foucault*, 95f.

40. Guattari, *Wunsch und Revolution*, 88.

41. cf. the relevant writings by the "(post-) operaist" theoreticians Paolo Virno, Sergio Bologna, Antonio Negri, and especially Maurizio Lazzarato.

42. Berardi, "What is the Meaning of Autonomy Today?."

43. Guattari, *Wunsch und Revolution*, 88.

6. DISRUPTIVE MONSTERS

1. S.I., "Questionnaire."

2. S.I., "The Theory of Moments and the Construction of Situations."

3. Kristeva, *Revolt, She Said*, 100.

4. Hegel, *Aesthetics*, 174–243.

5. ibid., 199.

6. ibid., 177.

7. cf. ibid., 179. Hegel operates with the concept of action at two levels here: the concept of action at the first level means the movement from the general state of the world through the situation to the second concept of action, the action proper. On a higher level, action is in turn the intermediary stage between ideal determinacy as such and the external determinacy of the Ideal.

8. Joyce, *Finnegans Wake*, 296.

9. Hegel, *Aesthetics*, 197.

10. ibid.

11. Deleuze, *Difference and Repetition*, XIX.

12. cf. ibid., 40.

13. Hegel, *Aesthetics*, 217.

14. ibid., 205.

15. ibid., 221–223.

16. Deleuze, *Difference and Repetition*, 42.

17. ibid., 262.

18. ibid., 29.

19. Guattari, "Über Maschinen," 118.

20. cf. for instance Barbrook, "The Holy Fools."

21. Marx, *Grundrisse der Kritik der politischen Ökonomie*, MEW 42, 590–609 [http://www.marxists.org/archive/marx/works/1857/grundrisse/ch13.htm#p690].

22. In Toni Negri's early book "Marx beyond Marx," for instance, which resulted from his Paris seminar on the *Grundrisse* in 1978, there is no discussion of the machine. An exception here is Maurizio Lazzarato, who continued the idea of both aspects in his work on immaterial labor on the one hand and video philosophy on the other.

23. Marx, *Das Kapital*, MEW 23, 391 [http://www.marxists.org/archive/ marx/works/1867-c1/ch15.htm#S1].

24. cf. Marx, *The Poverty of Philosophy/ Das Elend der Philosophie*, MEW 4, 174 [http://www.marxists.org/archive/marx/works/1847/poverty-philosophy/ch02e.htm]: "In England, strikes have regularly given rise to the invention and application of new machines. Machines were, it may be said, the weapon employed by the capitalist to quell the revolt of specialized labor. The *self-acting mule*, the greatest invention of modern industry, put out of action the spinners who were in revolt.;" Marx, *Das Kapital*, MEW 23, 459 [http://www.marxists.org/archive/marx/works/1867-c1/ch15.htm#S5]: "Machinery […]is the most powerful weapon for repressing strikes, those periodical revolts of the working-class against the autocracy of capital."

25. Marx, *Grundrisse*, MEW 42, 592 [http://www.marxists.org/archive/marx/works/1857/ grundrisse/ch13.htm#p692].

26. ibid., 593 [http://www.marxists.org/archive/marx/works/1857/grundrisse/ ch13. htm#p693].

27. ibid., 595 [http://www.marxists.org/archive/marx/works/1857/grundrisse/ ch13. htm#p694].

28. ibid., 602 [http://www.marxists.org/archive/marx/works/1857/grundrisse/ ch14. htm#p706].

29. ibid., 594 [http://www.marxists.org/archive/marx/works/1857/grundrisse/ ch13. htm#p694].

30. Deleuze/Guattari, *L'Anti-Oedipe*, 463–487 (As mentioned above, the Appendix was not published in the English version of *Anti-Oedipus*).

31. In *L'Anti-Oedipe* Deleuze and Guattari seem to consistently refer to Capital; in "*Capital as the Integral of Power Formations*" (205) Guattari also refers to the machine fragment.

32. Deleuze/Guattari, *L'Anti-Oedipe*, 464.

33. ibid., 465 and 481ff.

34. MEW 23, 391 [http://www.marxists.org/archive/marx/works/1867-c1/ch15.htm#S1].

35. Deleuze/Guattari, *Anti-Oedipus*, 2 [*L'Anti-Oedipe*, 8].

36. Deleuze/Guattari, *L'Anti-Oedipe*, 465.

37. At this point it should be noted that Deleuze and Guattari's use of the machine concept is consistently indifferent to ambivalent. At the same time, the dark sides of machinization come up regularly, such as in reflections on fascist and post-fascist forms of

the war machine in *A Thousand Plateaus* (especially 420–421) or Guattari's concept of "machinic enslavement" in "worldwide integrated capitalism," as Guattari called the phenomenon in the early 1980s that is today framed as globalization. Unlike Marx, here "machinic enslavement" (Guattari, "Capital as the Integral of Power Formations," 219–222) does not mean the subordinated relationship of the human being to the technical machine that objectifies social knowledge, but rather a more general form of the collective management of knowledge and the necessity of permanent participation. It is the machinic quality of postfordist capitalism—here Guattari is close to the theories of neoliberal governmentality developed from Foucault—that adds a palette of control mechanisms to the traditional systems of direct repression, which requires the complicity of individuals.

38. Deleuze/Guattari, *L'Anti-Oedipe*, 464.

39. ibid., 516.

40. The relevant concept of the state apparatus goes far beyond conventional concepts of the state; as the opposite of machines state apparatuses are characterized by structures, striated spaces and hard segmentarity.

41. Guattari, "Über Maschinen," 121.

42. cf. Guattari, "Machinic Heterogenesis," 37.

43. cf. Raunig, "Instituent Practices."

44. Guattari, "Machine et structure," 248.

45. Virno, *Grammar of the Multitude*, 65.

46. Virno, "Die Engel und der General Intellect," 174.

47. Virno, "Wenn die Nacht am tiefsten … Anmerkungen zum General Intellect," 154.

48. Tretjakov, "Notizen eines Dramatikers," 99.

49. Even the examples of the "revolutionary" impact of the bourgeois theater that are occasionally brought up as historical exceptions are rarely more than legends. Enthusiastic opera lovers, for instance, like to describe the Brussels Revolution in August 1830 as the effect of a performance of the opera "The Mute Girl of Portici" by Auber. Following the performance in Brussels in 1830 the audience is said to have stormed the Palace of Justice, thus triggering the uprising, with which Belgium separated from Holland. In fact, however, the bourgeois opera lovers simply joined a workers demonstration that was passing the opera. See also the function of the Odéon Theater in Paris May 1968 in Marchart, "Staging the Political."

50. Hegel, *Aesthetics*, 199.

51. Tretyakov, "Woher und wohin?," 51.

52. cf. Goldberg, *Performance Art*, 41–43.

53. Like several other aspects of the Proletkult theater work, these insights also influenced Brecht and Benjamin. In Benjamin's analysis of Brecht's practice of the "epic theater," the transformation of the theater into a political institution was rooted in the corruption of the false, obfuscating totality of the "audience." In comparison, Benjamin focused on

organizing according to the interests of the viewers and the transformation of their reactions into "prompt opinions." Cf. Benjamin, "What is Epic Theatre?," 144.

54. Strauch, "Erinnerungen an Eisenstein," 69.

55. quoted from Gorsen, "Die Ästhetik des Proletkult in der sowjetrussischen Übergangs-gesellschaft 1917–1932," 145.

56. Eisenstein, "Die Montage der Attraktionen," 117: the programmatic article was pub-lished in 1923 in the third edition of the magazine LEF.

57. ibid., 120: "The school of montage is film and especially vaudeville and circus, because making a good performance (from a formal point of view) really means developing a good vaudeville or circus program starting from the situations on which the play is based."

58. "Ein Experiment der Theaterarbeit," 113.

59. Eisenstein, "Die Montage der Attraktionen," 118.

60. ibid.

61. "Ein Experiment der Theaterarbeit," 112.

62. ibid.

63. ibid., 116.

64. Deleuze/Guattari, L'Anti-Oedipe, 486.

65. Tretjakov, "Theater der Attraktionen," 68.

66. "The machine controls living human beings. The machines are no longer objects of control, but its subjects." (Gastev, quoted from Gorsen, "Die Ästhetik des Proletkult in der sowjetrussischen Übergangsgesellschaft 1917–1932," 109).

67. cf. Eisenstein, "Die Montage der Attraktionen," 119.

68. "Ein Experiment der Theaterarbeit," 112.

69. Tretjakow, "Theater der Attraktionen," 69.

70. cf. "Hörst du, Moskau?," 128f.

71. Hielscher, "S.M. Eisensteins Theaterarbeit beim Moskauer Proletkult (1921–1924)," 71.

72. Tretjakov, "Notizen eines Dramatikers," 99.

73. ibid.

74. In the first years of the New Economic Policies the leftist Proletkult organizations belonged to the central core of resistance against the re-introduction of capitalist elements in the Soviet economy and against the newly emerging upper class. However, this position of the cultural left as a radical opposition could only be maintained for a brief period. After 1924 the experiments of the leftist Proletkult had to give way to the theater of illusions again, which retreated to pure representation and traditional aesthetics of empathy.

75. cf. "Hörst du, Moskau?!, 128. Later, in Tretyakov's Piscator essay, a positive interpre-tation of the tumult in the theater prevailed again, cf. Tretjakov, "Sechs Pleiten," 197 f.

76. These insights were picked up in Germany by Piscator and especially by Brecht, who was familiar with the Soviet theater theories through his friendship with Tretyakov and Tretyakov's travels through Germany (on the reception of Tretyakov in Germany, see also: Mierau, *Erfindung und Korrektur*, 21–42). Following first unsystematic attempts, Brecht (who in the beginning used the term *Entfremdung*, following Hegel and Marx, in the sense of active alienation for the purpose of insight) distilled the strategy of *Verfremdung* [distancing] from various anti-idealistic strategies, making this a central term in his theater work. Conceived as a precondition for practical intervention, the strategy of *Verfremdung* breaks with the concept of representing situations, disrupting represented situations instead. Thwarting the cultic ritual, the authority of the stage, the identification with the hero, all the components of the hierarchical theater order, *Verfremdung* does not seek to break down the framework of the theater, but to change the actors in it, the players as well as the audience.

77. Foucault, "Die politische Funktion des Intellektuellen," 146.

78. Tretjakov, "Fortsetzung folgt," 79.

79. ibid., 79.

80. cf. Tretjakov, *Feld-Herren*, 32 f.

81. ibid., 34–36.

82. Benjamin, "The Author as Producer," 223 f.

83. ibid., 233.

84. Tretyakov, *Feld-Herren*, 20–22.

85. On Tretyakov's abandonment of the type of the specialist Bolshevik, cf. the summary in Mierau, *Erfindung und Korrektur*, 110 f.

86. ibid., 112.

87. Arvatov, *Kunst und Produktion*, 92

88. Following the pattern of Mao's "Report on an Investigation of the Peasant Movement in Hunan," which Mao wrote after a longer stay in March 1927, and which pursued the attempt, similar to Tretyakov's approach, of a double operationality of organizing: on the one hand the organizational aspect of concrete discussions and processes of exchange in direct communication, on the other the organizing function of also publishing the insights thus attained.

89. Arvatov, *Kunst und Produktion*, 71.

90. S.I., "The Avant-Garde of Presence."

91. Dauvé, "Critique of the Situationist International."

92. cf. Ohrt, *Phantom Avantgarde*, 41.

93. There are also explicit Situationist references to Brecht, cf. Frankin, "Préface à l'unité scénique 'personne et les autres';" S.I., "Preliminary Problems in Constructing a Situation;" Trocchi, "A Revolutionary Proposal: Invisible Insurrection of a Million Minds," which includes the remark, "Unfortunately, Brecht's theory has had no impact whatsoever on popular entertainment."

94. Debord, "Report on the Construction of Situations and on the International Situationist Tendency's Conditions of Organization and Action."

95. ibid.

96. Ivain, "Formulary for a New Urbanism."

97. ibid.

98. S.I., "The Meaning of Decay in Art."

99. "… A New Idea in Europe."

100. Debord, "Report on the Construction of Situations and on the International Situationist Tendency's Conditions of Organization and Action."

101. S.I., "Situationist Manifesto."

102. In this regard, the S.I. historian Roberto Ohrt from Hamburg especially points out the programmatically conditioned lack of a continuous central and public location like the "Cabaret Voltaire" (cf. *Phantom Avantgarde*, 302); the corresponding Situationist "center" is probably solely the S.I. bulletin.

103. S.I., "The Theory of Moments and the Construction of Situations."

104. S.I., "Definitions."

105. cf. S.I., "The Avant-Garde of Presence."

106. Debord, "Report on the Construction of Situations and on the International Situationist Tendency's Conditions of Organization and Action."

107. cf. Ohrt, *Phantom Avantgarde*; Marcus, *Lipstick Traces*.

108. S.I., "Preliminary Problems in Constructing a Situation."

109. Ohrt, *Phantom Avantgarde*, 304.

110. Brecht, *Die Maßnahme. Kritische Ausgabe*, 251.

111. ibid., 248.

112. ibid., 236.

113. cf. Ohrt, *Phantom Avantgarde*, 218.

114. ibid., 273.

115. cf. ibid., 297, with a completely inappropriate analogy between Debord and the cultural pessimist and conservative German art historian Hans Sedlmayr.

116. ibid., 299.

117. ibid., 298.

118. ibid.

119. ibid., 296.

120. S.I., "Contribution to a Situationist Definition of Play."

121. Clark/Nicholson-Smith, "Why Art Can't Kill the Situationist International."

122. Deleuze, "Préface. Trois problèmes de groupe," VI.

123. Guattari, "L'étudiant, le fou et le katangais," 237.

124. cf. S.I., "Our Goals and Methods in the Strasbourg Scandal."

125. Viénet, *Enragés and Situationists in the Occupations Movement*, http://www.cddc.vt.edu/ sionline/si/enrages02.html.

126. cf. S.I., "The Beginning of an Era."

127. Viénet, *Enragés and Situationists in the Occupations Movement*, http://www.cddc.vt.edu/sionline/si/enrages02.html.

128. Guattari, "L'étudiant, le fou et le katangais," 233.

129. Viénet, *Enragés and Situationists in the Occupations Movement*, http://www.cddc.vt.edu/sionline/si/enrages02.html.

130. cf. also the excerpts of the text on questions of organization, autonomy and fusion, written by Debord, Khayati and Viénet in July 1967, published in Clark/Nicholson-Smith, "Why Art Can't Kill the Situationist International." According to Clark/Nicholson-Smith, they continued to consider, "especially as things heated up in the course of 1967, about how they were to act—to 'expand' […]."

131. cf. S.I., "The Beginning of an Era;" Viénet, *Enragés and Situationists in the Occupations Movement*, http://www.cddc.vt.edu/sionline/si/enrages04.html.

132. S.I., "The Beginning of an Era."

133. cf. ibid.

134. cf. Viénet, *Enragés and Situationists in the Occupations Movement*, http://www.cddc.vt.edu/sionline/si/enrages08.html.

135. ibid.

136. Debord, *Society of the Spectacle*, http://www.notbored.org/debord-preface.html.

137. Marx, "The Eighteenth Brumaire of Louis Bonaparte," MEW 8, 118 [http://www.marxists.org/archive/marx/works/1852/18th-brumaire/ch01.htm].

7. "ART AND REVOLUTION," 1968

1. Quoted from: Roussel, *Der Wiener Aktionismus und die Österreicher*, 91.

2. Muehl, "warum ich aufgehört habe. das ende des aktionismus," 41.

3. Foltin, *Und wir bewegen uns doch*, 74.

4. cf. Roussel, *Der Wiener Aktionismus und die Österreicher*, 19, 86, 91, 93, 102. Roussel, interviewing and affirming the prominent protagonists of that time in her book, seems to support the thesis of the artistic-actionist determination of the Austrian version of 1968 with particular emphasis.

5. ibid., 93, quoting the writer Peter Turrini: "In Germany the students occupied the universities, in Austria Muehl and Brus shat in the university. [...] Political issues were carried out as art issues."

6. Schwendter, "Das Jahr 1968," 167.

7. This was the collective self-designation of the action artists Günter Brus, Otto Muehl, Hermann Nitsch and Rudolf Schwarzkogler in the 1960s in Vienna.

8. cf. for instance the arrest of Otto Muehl, Hermann Nitsch and others in the case of the "opera murder" (the murder of a twelve-year-old ballet dancer in the Vienna Opera on 12 March 1963).

9. cf. the *Wiener Spaziergang* ("Walk in Vienna") by Günter Brus, who walked his body, painted white from head to toe, split by a vertical black line, through the streets of Vienna on 5 July 1965. He did not get far, however, because he was arrested by the police for indecent exposure and sentenced to pay a fine (cf. Schwarz/Loers (Ed.), *Wiener Aktionismus I*, 298 f.).

10. cf. Schwendter, *Subkulturelles Wien. Die informelle Gruppe (1959–1971)*.

11. On the developments of the Austrian students movement and a short history of the SÖS, cf. Keller, "Mailüfterl über Krähwinkel," 59–66; Keller, *Wien, Mai '68*, 76–79; Bauer, *1968*, 24–35. Further insights are from interviews that I conducted with Christof Šubik in summer 2003 and summer 2004.

12. cf. Keller, "Mailüfterl über Krähwinkel," 36–42.

13. Regarding Maschke, cf. above, chapter 1, the footnote about the German leftists that became radical right-wingers after 1968. In 1968 there was a warrant for Maschke's arrest as a "deserter;" he was arrested in Vienna on October 9th and—probably due to the actions of his fellow communards (agit-prop theater and sit-down strike in front of the police prison)—was not deported to the Federal Republic of Germany, but was allowed to emigrate to Cuba.

14. Šubik, "'Ein Vakuum, und da soll man tanzen,'" 120.

15. Bauer, *1968*, 28.

16. ibid.

17. cf. ibid., *1968*, 27f. These kinds of flexible forms of demonstration have been part of the arsenal of leftist forms of action since 1968 and have been used again and again since then. Cf. also Raunig, *Wien Feber Null*, 14.

18. cf. Muehl, *Aspekte einer Totalrevolution*, 19 and (from 1962) 17: "Just look at the revolutions of history, how the wildest revolutionaries, as soon as their enemies were blown away, immediately become proper and put on their comfy slippers. Or just look at the proletarian revolutions: once the resistance is gone, they are already bourgeois-ified. The painter may not take such a route, he must constantly struggle against something ..."

19. cf. especially the detailed history of the structuralization processes of the AA Commune in Bauer, *1968*.

20. Muehl, *Aspekte einer Totalrevolution*, 30.

21. cf. Höller, "Popping Up and Zocking Off," especially 75.

22. cf. Muehl, *Aspekte einer Totalrevolution*, 29: "Zock has no program! Zock doesn't give a shit about workers and employees! Zock doesn't want things to be better for people!"

23. Bauer, *1968*, 18–20.

24. Höller, "Popping Up and Zocking Off," 80; cf. also below, the section on "The Practice of Parrhesia."

25. Quoted from: Fellner, *Kunstskandal!*, 205.

26. Of the four artists who called themselves the Viennese Action Group (i.e. Brus, Muehl, Nitsch, Schwarzkogler) in the mid-sixties and who developed a common discourse, despite all the differences in their artistic means and political positions in art-immanent discussions from 1962 to 1965, only two took part in the action. Aside from Muehl and Brus, however, the "Wiener Gruppe" was also represented by Oswald Wiener, and Peter Weibel, as a master of self-historicization, laid the foundation with his participation for establishing the art-historical construct "Viennese Actionism" a year later and putting himself into this context as a protagonist (cf. also the interview with Weibel in: Roussel, *Der Wiener Aktionismus und die Österreicher*, 131). In addition to the four "Muehl men" (it is interesting here that Otmar Bauer and Herbert Stumpfl, unlike Muehl, Brus, Wiener and Weibel, moved in the context of both the SÖS and Actionism), the journalist Malte Olschewski took part in disguise and was whipped by Muehl in the course of the action (ibid., 168 f.).

27. cf. Hoffmann, *Destruktionskunst*, 177, and the interview with Valie Export in: Roussel, *Der Wiener Aktionismus und die Österreicher*, 122.

28. Weibel, "Kunst: Störung der öffentlichen Ordnung?," 57 f.; on the course of events, see also Bauer, *1968*, 36 f., Hoffmann, *Destruktionskunst*, 177f.

29. Peter Weibel, quoted from: Fellner, *Kunstskandal!*, 205.

30. On the issues of articulation and addition, see also: Steyerl, "The Articulation of Protest" and Raunig, "Here, There AND Anywhere."

31. cf. Höller, "Popping Up and Zocking Off," 81.

32. cf. Bauer, *1968*, 13–41.

33. Quoted from Bilda (Ed.), *Ernst Schmidt Jr. Shoot Films, but No Films!*, 114.

34. The action was originally supposed to have taken place in the Vienna Secession, in other words without student participation in a recognized art space.

35. Muehl, "warum ich aufgehört habe. das ende des aktionismus."

36. cf. Keller, *Wien, Mai '68*, 78.

37. However, the thesis that "Art and Revolution" had been an action by Muehl, Brus and Wiener purposely intended to "shatter the student left-wing" (Josef Dvorak, in: Roussel, *Der Wiener Aktionismus und die Österreicher*, 191) belongs to the strange realm of the paranoia of student splinter groups in the 1970s.

8. THE TRANSVERSAL CONCATENATION OF THE PUBLIXTHEATRECARAVAN

1. Volxtheater Favoriten, *Bezahlt wird nicht! Programmheft*, 2.

2. cf. Reckitt (Ed.), *Art and Feminism;* Cottingham, *Seeing Through the Seventies;* Robinson (Ed.), *Feminism—Art—Theory.*

3. cf. Guattari, "La transversalité;" on a further development of the term, cf. Raunig, "Transversal Multitudes."

4. cf. Guattari, "La transversalité," 79.

5. The following sections on the history of the Volxtheater Favoriten in the 1990s and the first caravans beginning in 2000 are based on interviews conducted in August 2004 with Gini Müller and Gerhard Rauscher and on material from the Volxtheater archive and the web site http://www.no-racism.net/volxtheater. Cf. also Müller, "Transversal or Terror?" and Müller, "10 Jahre Volxtheater."

6. Leisch, "Provokation und Propaganda," 13.

7. The Viennese squatter scene undertook an odyssey in the 1980s, during which they were repeatedly evicted from houses that had been squatted following the example of the Italian Centri Sociali. This was followed—according to Tina Leisch—by a "typically Austrian solution:" "After all the attempts to appropriate private capitalist buildings or at least to negotiate getting a building from the city of Vienna had been thwarted by empty promises or police clubs, finally the easy way out was to requisition the needed space from the communist sister party KPÖ." (Leisch, "Provokation und Propaganda," 13).

8. Volxtheater Favoriten, "Konzept."

9. Volxtheater Favoriten, *Dreigroschenheft*, 2.

10. Müller, "Transversal or Terror?."

11. Volxtheater Favoriten, *Dreigroschenheft*, 2.

12. Volxtheater Favoriten, *Penthesilea. Eine Hundsoper sehr frei nach Kleist.*

13. ibid.

14. ibid.

15. cf. Deleuze/Guattari, *A Thousand Plateaus*, 400 and 355f.

16. Volxtheater Favoriten, "Penthesilea. Eine Hundsoper sehr frei nach Kleist."

17. In ancient Greece *parrhesiastes* was not only grammatically but also actually always masculine.

18. Michel Foucault, *Discourse and Truth*, http://foucault.info/documents/parrhesia/foucault.DT1.wordParrhesia.en.html.

19. ibid.

20. ibid.

21. ibid., http://foucault.info/documents/parrhesia/foucault.DT4.praticeParrhesia.en.html chapter "Parrhesia and Public Life: the Cynics."

22. cf. the section "Genoa. Striating the War Machine" below. More than five years after the G8 summit in Genoa, there is still no decision about a possible trial of the Caravan.

23. cf. for instance the humorous web site on a court case against the Caravan activists, who undertook fake biometric examinations as a project in the course of the Upper Austrian Festival of the Regions 2003 in a school in Lambach, where the director brought charges against them: http://no-racism.net/article/1036/.

24. cf. http://www.caedefensefund.org/.

25. Michel Foucault, *Discourse and Truth*, http://foucault.info/documents/parrhesia/foucault.DT5.techniquesParrhesia.en.html.

26. ibid., http://foucault.info/documents/parrhesia/foucault.DT4.praticeParrhesia.en.html, chapter "Socratic Parrhesia;" and Michel Foucault, *The Care of the Self. The History of Sexuality 3*.

27. This also shows that *parrhesia* cannot be understood here as an aristocratic, philosophical prerogative, and certainly not as a relationship of representation, for instance in being communicated through media. *Parrhesia* requires direct communication and mutual exchange: "Unlike the *parrhesiastes* who addresses the *demos* in the Assembly, for example, here we have a *parrhesiastic* game which requires a personal, face to face relationship." (http://foucault.info/documents/parrhesia/foucault.DT4.praticeParrhesia.en.html, chapter "Socratic Parrhesia").

28. cf. also Foucault's analysis of Ion's and Creusa's *parrhesiastic* discourses in Euripides' tragedy "Ion:" http://foucault.info/documents/parrhesia/foucault.DT2.parrhesia Euripides.en.html.

29. It is almost superfluous to note that the relationship between the Volxtheater and the EKH is not a Socratic teacher-disciple relationship, but rather one that resists the introduction of hierarchies through the permeation of art machine and revolutionary machine, so that it corresponds to a collective-conflictual process.

30. Leisch, "Gescheitheit kommen langsam."

31. Müller, "10 Jahre Volxtheater."

32. Volxtheater Favoriten, "Schluss mit lustig: ein Land dreht durch!."

33. cf. Raunig, *Wien Feber Null*.

34. Translator's note: Black is the symbolic color of the conservative Austrian People's Party (ÖVP), blue of the right-wing Freedom Party of Austria (FPÖ), hence the ÖVP-FPÖ coalition government was referred to as the "black-blue" government.

35. Volxtheater Favoriten, "EKH Tour 2000."

36. cf. the web site of the caravan, which is still active as a network: http://thecaravan.org.

37. The project arose in conjunction with the global network "People's Global Action" (http://www.nadir.org/nadir/initiativ/agp/en), founded in February 1998. A PGA caravan

also traveled with a colorfully painted school bus from New York through Boston and San Diego to the WTO protests in Seattle 1999, organizing actions and teach-ins with local groups along the way.

38. The poetic motto had a twofold background of alluding to Jörg Haider's inherited property in the Carinthian Bärental ("Bear Valley") and to Haider's statement that art should not bite the hand that feeds it.

39. cf. Müller, "Widerstand im Haiderland," with a detailed report of the caravan's stations, and Leisch, "Minimal Thinking," reflecting on the failure of the caravan, also with references to the project successfully conducted in affiliation with the caravan, the "helicopter attack" at the Carinthian Ulrichsberg celebration and the never-ending story of the removed town signs of Krumpendorf.

40. cf. the Volxtheater video "Die Kunst ist eine Bärin und sie beißt, wen sie will."

41. Leisch, "Partizan/Remix. Strategien for Kärnten/Koroska."

42. http://www.no-racism.net.

43. http://www.noborder.org.

44. cf. http://no-racism.net/nobordertour and the video "publiXtheatrecaravan.mov." The following section is based on, among other things, an interview, following the arrest of the PublixTheatreCaravan in early August 2001, with the Caravan activist Christian Hessle, who had taken part in the entire tour, but was fortunate enough to evade arrest.

45. An interpretation of inner tubes, juggling clubs and pocket knives, with which the Italian police were later to agree under far more unpleasant circumstances: the media's perception of the caravan was completely absurd. In Salzburg, for instance, the WEGA (Viennese Deployment Group from the Alarm Department) moved in as a result of the media uproar to uncover an illegal weapons depot and left again just as abruptly when all they found were children playing with tires.

46. On the history of using tires in the theatrical actions of Performing Resistance and the PublixTheatreCaravan and a critique of the action in Salzburg, cf. Raunig, "Für eine Mikropolitik der Grenze. Spacing the Line, revisited."

47. http://no-racism.net/nobordertour/publixtheatre/publixtheatre.html.

48. cf. Hardt/Negri, *Empire*, especially 212–214.

49. cf. Deleuze/Guattari, *A Thousand Plateaus*, 351–423, and Deleuze/Parnet, *Dialogues*, 136 f.

50. Müller, "Transversal or Terror?."

51. cf. ibid.

52. Deleuze/Guattari, *A Thousand Plateaus*, 380; in contrast, Raunig, "A War Machine Against the Empire."

53. Deleuze/Guattari, *A Thousand Plateaus*, 385.

54. The following section draws from the PublixTheatreCaravan's unpublished "Genoa Protocols" and the aforementioned interview with Christian Hessle. On general assessments of the incidents in Genoa, cf. Azzellini (Ed.), *Genua. Italien. Geschichte. Perspektiven* and *On Fire. The battle of Genoa and the anti-capitalist movement.*

55. cf. Azzellini (Ed.), *Genua. Italien. Geschichte. Perspektiven*, 21.

56. Excerpt from the PublixTheatreCaravan's unpublished "Genoa Protocols."

57. cf. Azzelini, *Genua. Italien. Geschichte. Perspektiven*, 15, quoting the Italian daily newspaper *La Reppublica.*

58. Excerpt from the PublixTheatreCaravan's unpublished "Genoa Protocols."

59. cf. Müller, "Transversal or Terror?."

60. At the EU Summit in Göteborg from 14–16 June 2001, the police shot at a demonstrator during a *Reclaim the Streets* party. Subsequently, the demonstrators were met with extremely drastic penalities, but the charges against the police were dropped.

61. Following a wave of arrests in Italy, several Italian activists were sentenced to imprisonment. A number of international activists are still under investigation. Despite widespread mobilization against the brutal proceedings of the Italian police, the court of inquiry only opened criminal proceedings in December 2004 against the 28 police who severely mistreated activists in the Diaz and Pascoli schools.

62. Excerpt from the PublixTheatreCaravan's unpublished "Genoa Protocols."

9. AFTER 9/11

1. Deleuze, *Negotiations*, 45.

2. On questions of differentiating these terms, see Nowotny, "World Wide World. Is There a World of Anti-Globalism?"

3. Hamm, "Reclaim the Streets! Global Protest and Local Space."

4. Leisch, "Gescheitheit kommen langsam."

5. ibid.

6. Hardt/Negri, *Multitude*, 287.

7. Steyerl, "The Articulation of Protest."

8. On the Deleuzian terms of concatenation and the "AND," cf. Raunig, "Here, There AND Everywhere."

9. Steyerl, "The Articulation of Protest."

10. cf. reflections on the "molarization" of the non-conformist mass in the course of protests against the "black-blue" government in Austria: Raunig, *Wien Feber Null*, 118–124. Yet, there is still an urgent need for newly conceptualizing and actualizing the component of post-national insurrection and non-conformist masses.

11. Excerpt from the PublixTheatreCaravan's "Genoa Protocols."

12. For general information on the noborder network and border camps, see http://www.noborder.org/about.php and http://www.noborder.org/camps/campsite.html.

13. The chosen focus on *one* point of reference that follows here (actions against border regimes and migration politics) is certainly not intended to construct a current main contradiction. Numerous other discourses involving the precarization of work and life, new feminisms, queer lifestyles, globalization effects, or a new anti-capitalism enriched by an awareness of anti-colonialism are interweaving and overlapping fields of action and reflection that transgress the Euro-centrist focus of this book.

14. Revel, "Il limite di un pensiero del limite. Necessità di una concettualizzazione della differenza."

15. Balibar, *Die Grenzen der Demokratie*, 13.

16. Sengupta, "No Border Camp Strasbourg: A Report."

17. Balibar, *Die Grenzen der Demokratie*, 13.

18. Deleuze, *Difference and Repetition*, 37.

19. Caesar, *De bello gallico*, VI, 23: "civitatibus maxima laus est quam latissime circum se vastatis finibus solitudinem habere."

20. On the aspect of shifting borders cf. especially the American frontier as a line of colonial appropriation constantly shifted by the settlers.

21. Febvre, "'Frontière'—Wort und Bedeutung," 31.

22. Balibar, *Die Grenzen der Demokratie*, 83.

23. Here the term "confining" no longer refers to the neighboring zones and the border as seam, as described above, but rather to a total form of surrounding, enclosing.

24. cf. Deleuze, *Difference and Repetition*, 36 f., and reflections on the distinction between the distribution of space and distribution in space: below. A similar idea of the coherence of space and social organization was developed 1844 by Max Stirner in his radical-individualist anarchist book *Der Einzige und sein Eigentum [The Ego and his Own]*: individuals arranged in the space of society, the family and the state appear here like statues in a museum—"grouped." It is not we that control the space of society conceived as a closed *Saal* ("hall"), but rather the *Saal* controls us. With Stirner the conceptual opposition to a structuralized, segmented society as a "Saal" consists in the flexible term of *Verkehr* ("traffic"). *Verkehr* "is mutuality, is action, the commercium of the individual" (Stirner, *Der Einzige und sein Eigentum*, 192).

25. On the concept of dilation and my thesis of "spacing the line," cf. the introduction to Raunig, *Charon* and Raunig, "Spacing the Lines. Konflikt statt Harmonie. Differenz statt Identität. Struktur statt Hilfe," and Raunig, "Für eine Micropolitik der Grenzen. Spacing the Line, Revisited."

26. The concepts of border space and constituent power intersect here. This kind of link is also to be found in Negri's conception of constituent power, which establishes the border—albeit as an obstacle here (cf. *Insurgencies*, 317)—as site of conflict.

27. Foucault, "Préface à la Transgression," 264: "La transgression est un geste qui concerne la limite; c'est là, en cette minceur de la ligne, que se manifeste l'eclair de son passage, mais peut-être aussi sa trajectoire en sa totalité, son origine même. Le trait qu'elle croise pourrait bien être tout son espace."

28. Judith Revel ("Il limite di un pensiero del limite") translated Foucault's attempt to evade the dialectic of the border as a line of separation into Deleuze's vocabulary of lines of flight and exodus: "Il passaggio al limite non vale come passaggio da un sistema di riferimento all'altro, da un cerchio all'altro, ma come uscita, come sortita, come linea di fuga. Impone la forza del movimento contro la rassicurante identità delle coordinate. È l'abbandono stesso di tutte le coordinate possibili, il tentativo di giungere a uno spazio altro, il cui nome e la cui geografia non sono mai decisi come tali proprio perché la posta in gioco è tutta presa in un gesto d'uscita che non viene immediatamente recuperato come procedura d'entrata."

29. Foucault, "Préface à la Transgression," 266: "La transgression n'oppose rien à rien, ne fait rien glisser dans le jeu de la dérision, ne cherche pas à ébranler la solidité des fondements; elle ne fait pas resplendir l'autre côté du miroir par-delà la ligne invisible et infranchissable. Parce que, justement, elle n'est pas violence dans un monde partagé (dans un monde éthique) ni triomphe sur des limites qu'elle efface (dans un monde dialectique ou révolutionnaire), elle prend, au coeur de la limite, la mesure démesurée de la distance qui s'ouvre en celle-ci et dessine le trait fulgurant qui la fait être."

30. cf. Negri, *Insurgencies*, 12.

31. cf. ibid., 227.

32. Deleuze, *Difference and Repetition*, 36.

33. ibid., 37.

34. Sengupta, "No Border Camp Strasbourg: A Report." This report by the media activist Shuddhabrata Sengupta provides a good and extensive overview of the events and forms of organization in the context of the border camp.

35. The following section is based on my own observation on site in Strasbourg from 19 to 23 July 2002, on interviews with the Caravan activists Gini Müller, Gerhard Rauscher and Jürgen Schmidt in August and September 2004, Marion Hamm's collection of material ("StrasbourgPlanetActivism") and the contents of the web site http://www.noborder.org/strasbourg/index.php. The camp program can be found at http://www.noborder.org/ strasbourg/program/index.html.

36. cf. Kuemmer, "Border Camp // Strasbourg // July 19 to 28, 2002."

37. cf. the detailed and extensive border camp organization handbook at http://www.noborder.org/ strasbourg/guide_en.html.

38. The PublixTheatreCaravan was both aesthetically and technically well equipped: with an English double-decker bus converted into a media center as its "flag ship," which further impelled the anti-clandestine strategy of the Caravan's visibility. The Caravan set up its noborderZone in the expansive entrance area in front of the Strasbourg train station. The bus was parked in the middle of this zone partially marked off

with red-white-red ribbons and informed not only the people of Strasbourg about the SIS and the border camp, but also gave directions to the camp outside Strasbourg to activists arriving by train. The bus itself was multifunctionally equipped for Internet streaming, video screening and also as a bar; activists enjoyed the sunshine on the top deck and there was a little plastic swimming pool placed in its shade for cooling off. Every evening the Caravan took its bus to the Parc du Rhin to take part in the border camp. The bus was thus the link between the camp and the outside in several respects: between the camp and the noborderZone due to its real daily movements, as a guide and information point for camp activists and the people of Strasbourg, and finally as a pivotal point for media, playing interviews and reports over the local camp radio and connecting with a radio webstream that could also be heard via Radio Orange in Vienna.

39. It was only after Thursday, July 25th, as a prohibition against demonstrations was announced that paranoia and the military logic of guarding prevailed for a certain period—due not least of all too bad experiences in Genoa and the fear that the camp might be stormed.

40. Schmidt, "another war is possible // publiXtheater;" Hamm, "A *r/c* tivism in Physical and Virtual Spaces;" pictures from the action can be found at http://www.noborder.org/strasbourg/display/item_fresh.php?id=125&lang=en.

41. cf. Negri, *Insurgencies*, 333: "We need to reduce the dramatics associated with the concept of revolution by making it, through constituent power, nothing but the desire of the continuous, relentless, and ontologically effective transformation of time."

BIBLIOGRAPHY

Louis ARAGON, *Das Beispiel Courbet*, Dresden: Verlag der Kunst 1956 / *L'Exemple de Courbet*, Paris: Éditions Cercle d'Art 1952.

Hannah ARENDT, *On Revolution*, London: Penguin 1990.

Giovanni ARRIGHI, *The Long Twentieth Century. Money, Power, and the Origins of Our Times*, London/New York: Verso 1994.

Giovanni ARRIGHI, "Lineages of Empire," http://multitudes.samizdat.net/Lineages-of-Empire.html

Boris ARVATOV, *Kunst und Produktion*, Munich: Hanser 1972.

Dario AZZELLINI (Ed.), *Genua. Italien. Geschichte. Perspektiven*, Berlin: Assoziation A 2002.

Dario AZZELLINI, "Der Bolivarianische Prozess: Konstituierende Macht, Partizipation und Autonomie," in: Olaf Kaltmeier, Jens Kastner, Elisabeth Tuider (Ed.), *Neoliberalismus—Autonomie—Widerstand. Soziale Bewegungen in Lateinamerika*, Münster: Westfälisches Dampfboot 2004, 196–215

Michail BAKUNIN, "The Paris Commune and the Idea of the State," http://www.marxists.org/reference/archive/bakunin/works/1871/paris-commune.htm

Etienne BALIBAR, *Die Grenzen der Demokratie*, Hamburg: Argument 1993 / *Les frontières de la démocratie*, Paris: La Découverte 1992

Richard BARBROOK, "The Holy Fools," in: *Mute* 11, London 1998

Otmar BAUER, *1968. Autographische Notizen zu Wiener Aktionismus, Studentenrevolte, Underground, Kommune Friedrichshof, Mühl Ottos Sekte*, Maria Enzersdorf: Roesner 2004

Ursula Walburga BAUMEISTER, *Die Aktion 1911–1932. Publizistische Opposition und literarischer Aktivismus der Zeitschrift im restriktiven Kontext*, Erlangen/Jena: Palm und Enke 1996

Walter BENJAMIN, "The Work of Art in the Age of Mechanical Reproduction," in: ibid., *Illuminations*, Edited and with an Introduction by Hannah Arendt, Translated by Harry Zorn, London: Pimlico1999, 211–244

Walter BENJAMIN, "Theses on the Philosophy of History," in: ibid., *Illuminations*, Edited and with an Introduction by Hannah Arendt, Translated by Harry Zorn, London: Pimlico1999, 245–255

Walter BENJAMIN, "Critique of Violence," in: ibid., *Reflections*, New York: Schocken 1986, 277–300

Walter BENJAMIN, "What is Epic Theatre?," in: ibid., *Illuminations*, Edited and with an Introduction by Hannah Arendt, Translated by Harry Zorn, London: Pimlico1999, 144–151

Walter BENJAMIN, "The Author as Producer," in: ibid., *Reflections*, New York: Schocken 1986, 220–238

Walter BENJAMIN, "Zum gegenwärtigen gesellschaftlichen Standort des französischen Schriftstellers," in: ibid., *Gesammelte Schriften*, Vol. II 2, Frankfurt/Main: Suhrkamp 1991, 776–803

Franco BERARDI Bifo, "What is the Meaning of Autonomy Today?," http://eipcp.net/transversal/1203/bifo/en

Linda BILDA (Ed.), *Ernst Schmidt Jr. Shoot Films, but No Films!*, Vienna: Triton 2001

Rolf von BOCKEL, *Kurt Hiller und die Gruppe Revolutionärer Pazifisten (1926–1933)*, Hamburg: Bormann 1990

Albert BOIME, *Art and the French Commune. Imagining Paris after War and Revolution*, Princeton: Princeton University 1995

John E. BOWLT (Ed.), *Russian Art of the Avant-Garde: Theory and Criticism 1902–1934*, London: Thames & Hudson 1988

Ljubomir BRATIC (Ed.), *Landschaften der Tat. Vermessung, Transformationen und Ambivalenzen des Antirassismus in Europa*, St. Pölten: SozAktiv 2002

Bert BRECHT, *Die Maßnahme. Kritische Ausgabe mit einer Spielanleitung von Reiner Steinweg*, Frankfurt/Main: Suhrkamp 1972

Bert BRECHT, *Die Tage der Commune*, in: ibid., *Gesammelte Werke*, Vol. 5, Frankfurt/Main: Suhrkamp 1982, 2107–2192

Bert BRECHT, *Der Untergang des Egoisten Johann Fatzer*, Frankfurt/Main: Suhrkamp 1994

Jean BRUHAT, Jean DAUTRY, Emile TERSEN, *Die Pariser Kommune von 1871*, Berlin: Deutscher Verlag der Wissenschaften 1971 / *La Commune de 1871*, Paris: Éditions Sociales 1970

Jean BRUHAT, "Die Arbeitswelt der Städte," in: Fernand Braudel, Ernest Labrousse (Ed.), *Wirtschaft und Gesellschaft in Frankreich im Zeitalter der Industrialisierung. 1789–1880*, Vol. 2, Frankfurt/Main: Athenäum 1988, 245–284

Judith BUTLER, *The Psychic Life of Power. Theories in Subjection*, Stanford, California: Stanford University Press 1997

Elias CANETTI, *Masse und Macht*, Frankfurt/Main: Fischer 1980

Manuel CASTELLS, *The City and the Grassroots. A Cross-Cultural Theory of Urban Social Movements*, Berkeley/Los Angeles: University of California Press 1983

Maria DO MAR CASTRO VARELA and Nikita DHAWAN, "Postkolonialer Feminismus und die Kunst der Selbstkritik," in: Hito Steyerl and Encarnación Gutiérrez Rodríguez, *Spricht die Subalterne deutsch? Migration und postkoloniale Kritik*, Münster: Unrast 2003, 270–290

Timothy J. CLARK, *The Absolute Bourgeois. Artists and Politics in France 1848–1851*, London: Thames and Hudson 1973

Timothy J. CLARK, *Image of the People. Gustave Courbet and the 1848 Revolution*, Princeton: University Press 1982

Timothy J. CLARK, Donald NICHOLSON-SMITH, "Why Art Can't Kill the Situationist International," http://www.notbored.org/why-art.html [first published in *October* 79 (Winter 1997)]

Laura COTTINGHAM, *Seeing Through the Seventies. Essays on Feminism and Art*, New York: Gordon and Breach 2000

Bärbel DANNEBERG, Fritz KELLER, Ali MACHALICKY, Julius MENDE (Ed.), *Die 68er. Eine Generation und ihr Erbe*, Vienna: Döcker 1998

Gilles DAUVÉ, "Critique of the Situationist International," http://libcom.org/library/critique-of-situs-dauve

Guy DEBORD, *The Society of the Spectacle*, http://www.cddc.vt.edu/sionline/si/tsots00.html

Guy DEBORD, "Report on the Construction of Situations and on the International Situationist Tendency's Conditions of Organization and Action," http://www.cddc.vt.edu/sionline/si/report.html

Guy DEBORD, "These on Cultural Revolution," http://www.cddc.vt.edu/sionline/si/theses.html

Guy DEBORD, Attila KOTÁNY, Raoul VANEIGEM, "Theses on the Paris Commune," http://www.cddc.vt.edu/sionline/si/commune.html

Gilles DELEUZE, *Difference and Repetition*, translated by Paul Patton, New York: Columbia University Press 1994

Gilles DELEUZE, "Préface. Trois problèmes de groupe," in: Guattari, *Psychanalyse et transversalité*, I–XI

Gilles DELEUZE, *Foucault*, Minneapolis/London: University of Minnesota 1988

Gilles DELEUZE, *Negotiations*, New York: Columbus University Press 1990

Gilles DELEUZE, "Desire and Pleasure," http://slash.autonomedia.org/article.pl?sid=02/11/18/1910227

Gilles DELEUZE, Félix GUATTARI, *Anti-Oedipus. Capitalism and Schizophrenia*, translated by Robert Hurley, Mark Seem, and Helen R. Lane, Minneapolis: University of Minnesota Press 1983

Gilles DELEUZE, Félix GUATTARI, *L'Anti-Oedipe*, Paris: Minuit 1972

Gilles DELEUZE, Félix GUATTARI, *A Thousand Plateaus. Capitalism and Schizophrenia*, translated by Brian Massumi, Minneapolis/London: University of Minnesota Press 1987

Gilles DELEUZE, Félix GUATTARI, *What is Philosophy?*, London/New York: Verso 1994

Gilles DELEUZE, Claire PARNET, *Dialogues II*, New York: Columbia University Press 2002

Der Beginn einer Epoche. Texte der Situationisten, Hamburg: Edition Nautilus 1995

Frédérique DESBUISSONS, "Le citoyen Courbet," in: *Courbet et la Commune*, Paris: Éditions de la Réunion des musées nationaux 2000, 9–27

Die politische Lithographie im Kampf um die Pariser Kommune 1871, Cologne: Gaehme Henke 1976

Diedrich DIEDERICHSEN, "Spirituelle Reaktionäre und völkische Vernunftkritiker," in: ibid., *Freiheit macht arm. Das Leben nach Rock'n' Roll 1990–1993*, Cologne: Kiepenheuer & Witsch 1993

Gretchen DUTSCHKE, "Was Rudi Dutschke zu den Irrwegen der abgefallenen Achtundsechziger sagen würde," http://www.uni-bielefeld.de/stud/linke_liste/sds%20dutschke.html

Terry EAGLETON, "Foreword," in: Kristin Ross, *The Emergence of Social Space. Rimbaud and the Paris Commune*, Minneapolis: University of Minnesota Press 1988, VI–XIV

Sergei EISENSTEIN, "Die Montage der Attraktionen," in: Peter Gorsen, Eberhard Knödler-Bunte, *Proletkult 2. Zur Praxis und Theorie einer proletarischen Kulturrevolution in Sowjetrussland 1917–1925*, Stuttgart: Frommann 1975, 117–121

Friedrich ENGELS, "Einleitung zu 'Der Bürgerkrieg in Frankreich' von Karl Marx," in: Karl Marx, Friedrich Engels, *Werke*, 17, Berlin: Dietz 1976, 613–625 / "Introduction to 'The Civil War in France' by Karl Marx," http://www.marxists.org/archive/marx/works/1871/civil-war-france/postscript.htm

Lisbeth EXNER, "Vergessene Mythen. Franz Pfemfert und 'Die Aktion,'" in: Lisbeth Exner, Herbert Kapfer (Ed.), *Pfemfert. Erinnerungen und Abrechnungen. Texte und Briefe*, Munich: Belleville 2000, 14–60

Lisbeth EXNER, Herbert KAPFER (Ed.), *Pfemfert. Erinnerungen und Abrechnungen. Texte und Briefe*, Munich: Belleville 2000

"Ein Experiment der Theaterarbeit," in: Peter Gorsen, Eberhard Knödler-Bunte, *Proletkult 2. Zur Praxis und Theorie einer proletarischen Kulturrevolution in Sowjetrussland 1917–1925*, Stuttgart: Frommann 1975, 111–116

Lucien FEBVRE, "'Frontière'—Wort und Bedeutung," in: ibid., *Das Gewissen des Historikers*, Berlin: Wagenbach 1988, 27–37 / "Frontière. Le mot et la notion," in: *Revue de synthèse historique* 45 (1928), 31–44

Sabine FELLNER, *Kunstskandal!: die besten Nestbeschmutzer der letzten 150 Jahre*, Vienna: Ueberreuter 1997

Robert FOLTIN, *Und wir bewegen uns doch. Soziale Bewegungen in Österreich*, Vienna: grundrisse 2004

Michel FOUCAULT, *Discipline and Punish. The Birth of the Prison*, translated by Alan Sheridan, London: Penguin 1977

Michel FOUCAULT, *The Will to Knowledge. The History of Sexuality 1*, translated by Robert Hurley, London: Penguin 1978

Michel FOUCAULT, *The Use of Pleasure. The History of Sexuality 2*, translated by Robert Hurley, London: Penguin 1992

Michel FOUCAULT, *The Care of the Self. The History of Sexuality 3*, translated by Robert Hurley, London: Penguin 1990

Michel FOUCAULT, *Discourse and Truth: the Problematization of Parrhesia*, http://foucault.info/documents/parrhesia/

Michel FOUCAULT, "A Preface to Transgression," in: ibid., *Language, Counter-Memory, Practice*, Ithaca, New York: Cornell University 1977, 29–52 / Michel FOUCAULT, "Préface à la Transgression," in: ibid., *Dits et Ecrits 1, 1954–1975*, Paris: Gallimard 2001, 261–278

Michel FOUCAULT, "Die politische Funktion des Intellektuellen," in: ibid., *Dits et Ecrits. Schriften, Band III. 1976–1979*, Frankfurt/Main: Suhrkamp 2003, 145–152 / "The Political Function of the Intellectual," in: *Radical Philosophy*, No. 17, (Summer 1977)

Michel FOUCAULT, "Lives of Infamous Men," in: ibid., *Power*, London: Penguin 2002, 157–175

André FRANKIN, "Vorwort zur szenischen Einheit 'Niemand und die anderen,'" in: *Situationistische Internationale 1958–1969. Gesammelte Ausgaben des Organs der*

Situationistischen Internationale, Vol. I, Hamburg: MaD 1976, 180–182 / "Préface à l'unité scénique 'personne et les autres,'" *Internationale Situationniste* 5 (Dec. 1960)

Michael FRIED, *Courbet's Realism*, Chicago/London: University of Chicago Press 1990

Jeanne GAILLARD, "Die Aktionen der Frauen," in: Jean Bruhat, Jean Dautry, Emile Tersen, *Die Pariser Kommune von 1871*, Berlin: Deutscher Verlag der Wissenschaften 1971, 143–154

RoseLee GOLDBERG, *Performance Art. From Futurism to the Present*, London/New York: Thames & Hudson 2001

Peter GORSEN, "Die Ästhetik des Proletkult in der sowjetrussischen Übergangsgesellschaft 1917–1932," in: ibid., *Transformierte Alltäglichkeit oder Transzendenz der Kunst*, Frankfurt/Main: Europäische Verlagsanstalt 1981, 83–146

Peter GORSEN, Eberhard KNÖDLER-BUNTE, Bion STEINBORN, "Proletkult. Eine Dokumentation zur Proletarischen Kulturrevolution in Russland," in: *Ästhetik und Kommunikation. Beiträge zur politischen Erziehung*, 5–6/1972, 63–203

Peter GORSEN, Eberhard KNÖDLER-BUNTE, *Proletkult 1. System einer proletarischen Kultur*, Stuttgart: Frommann 1975

Peter GORSEN, Eberhard KNÖDLER-BUNTE, *Proletkult 2. Zur Praxis und Theorie einer proletarischen Kulturrevolution in Sowjetrussland 1917–1925*, Stuttgart: Frommann 1975

Roger V. GOULD, *Insurgent Identities. Class, Community, and Protest in Paris from 1848 to the Commune*, Chicago/London: The University of Chicago 1995

Félix GUATTARI, *Psychanalyse et transversalité. Essais d'analyse institutionelle*, Paris: La Découverte 2003

Félix GUATTARI, "La transversalité," in: ibid., *Psychanalyse et transversalité. Essais d'analyse institutionelle*, 72–85

Félix GUATTARI, "La causalité, la subjectivité et l'histoire," in: ibid., *Psychanalyse et transversalité. Essais d'analyse institutionelle*, 173–209

Félix GUATTARI, "L'étudiant, le fou et le katangais," in: ibid., *Psychanalyse et transversalité. Essais d'analyse institutionelle*, 230–239

Félix GUATTARI, "Machine et structure," in: ibid., *Psychanalyse et transversalité. Essais d'analyse institutionelle*, 240–248

Félix GUATTARI, "Machinic Heterogenesis," in: ibid., *Chaosmosis. An Ethico-Aesthetic Paradigm*, Bloomington/Indianapolit: Indiana University 1995, 33–57

Félix GUATTARI, "Capital as the Integral of Power Formations," in: ibid., *Chaosophy, Soft Subversions*, New York: Semiotext(e) 1996, 202–224

Félix GUATTARI, "Über Maschinen," in: Henning SCHMIDGEN (Ed.), *Ästhetik und Maschinismus. Texte zu und von Félix Guattari*, Berlin: Merve 1995, 115–132 / "A Propos des Machines," in: *Chimères* 19 (1993)

Félix GUATTARI, *Wunsch und Revolution. Ein Gespräch mit Franco Berardi (Bifo) und Paolo Bertetto*, Heidelberg: Das Wunderhorn 2000 / *Desiderio e rivoluzione : intervista a Felix Guattari*, Milano: Squilibri 1977

Félix GUATTARI, Toni NEGRI, *Communists Like Us. New Spaces of Liberty, New Lines of Alliance*, New York: Semiotext(e) 1990

Hans GÜNTER, Karla HIELSCHER, "Zur proletarischen Produktionskunst Boris I. Arvatovs," in: Boris Arvatov, *Kunst und Produktion*, Munich: Hanser 1972, 116–133

Marion HAMM, "Reclaim the Streets! Global Protests and Local Space," http://eipcp.net/transversal/0902/hamm/en

Marion HAMM, "StrasbourgPlanetActivism," http://ionnek.strg.at/bin/view/Main/StrasbourgPlanetActivism

Marion HAMM, "Ar/ctivism in Physical and Virtual Spaces," http://eipcp.net/transversal/1203/hamm/en

Michael HARDT, *Gilles Deleuze. An apprenticeship in Philosophy*, London/Minneapolis: University of Minnesota Press 1995

Michael HARDT, Antonio NEGRI, *Empire*, Cambridge, Massachusetts/London: Harvard University Press 2000

Michael HARDT, Antonio NEGRI, "Globalisierung und Demokratie," in: *Demokratie als unvollendeter Prozess. Documenta11_Plattform1*, Ed. Okwui Enwezor, Carlos Basualdo, Ute Meta Bauer, Susanne Ghez, Sarat Maharaj, Mark Nash, Octavio Zaya, Ostfildern-Ruit: Hatje Cantz 2002, 371–386 /"Globalization and Democracy," Paper at Documenta 11, Platform 1, Vienna, 20.4.2001

Michael HARDT, Antonio NEGRI, *Multitude. War and Democracy in the Age of Empire*, New York: Penguin Press 2004

Marta HARNECKER, *Hugo Chávez Frías. Un hombre, un pueblo*, http://www.nodo50.org/cubasigloXXI/politica/harnecker24_310802.pdf

G.W.F. HEGEL, *Enzyklopädie der philosophischen Wissenschaften I*, Frankfurt/Main: Suhrkamp 1986

G.W.F. HEGEL, *Grundlinien der Philosophie des Rechts oder Naturrecht und Staatswissenschaft im Grundrisse*, Frankfurt/Main: Suhrkamp 51996

G.W.F. HEGEL, *Vorlesungen über die Ästhetik*, Frankfurt/Main: Suhrkamp 1997

G.W.F. HEGEL, *Aesthetics. Lectures on Fine Art*, translated by T.M. Knox, Vol. I, Oxford/New York: Oxford University 1998

Hermann HERLINGHAUS, Heinz BAUMERT, Renate GEORGI (Ed.), *Sergei Eisenstein. Künstler der Revolution*, Berlin: Henschel 1960

Karla HIELSCHER, "S. M. Eisensteins Theaterarbeit beim Moskauer Proletkult (1921–1924)," in: *Ästhetik und Kommunikation. Beiträge zur politischen Erziehung*, 13/1973, 64–75

Kurt HILLER, "Philosophie des Ziels," in: Wolfgang Rothe (Ed.), *Der Aktivismus 1915–1920*, Munich: dtv 1969, 29–54

Justin HOFFMANN, *Destruktionskunst. Der Mythos der Zerstörung in der Kunst der frühen sechziger Jahre*, Munich: Schreiber 1995

Werner HOFMANN, Klaus HERDING (Ed.), *Courbet und Deutschland*, Cologne: DuMont 1978

Werner HOFMANN, "Gespräch, Gegensatz und Entfremdung—Deutsche und Franzosen suchen ihre Identität," in: Werner Hofmann, Klaus Herding (Ed.), *Courbet und Deutschland*, Cologne: DuMont 1978, 71–171

Christian HÖLLER, "Popping Up and Zocking Off," in: Otto Muehl, *Aspekte einer Totalrevolution*, Cologne: König 2004, 74–83

John HOLLOWAY, *Change the World Without Taking Power. The Meaning of Revolution Today*, London/Ann Arbor, MI: Pluto Press 2002, 2005

"Hörst du, Moskau?!," in: Peter Gorsen, Eberhard Knödler-Bunte, *Proletkult 2. Zur Praxis und Theorie einer proletarischen Kulturrevolution in Sowjetrussland 1917–1925*, Stuttgart: Frommann 1975, 127–129

Gilles IVAIN, "Formulary for a New Urbanism," http://www.cddc.vt.edu/sionline/presitu/formulary.html

James JOYCE, *Finnegans Wake*, London: Minerva 1992

Olaf KALTMEIER, Jens KASTNER, Elisabeth TUIDER (Ed.), *Neoliberalismus— Autonomie—Widerstand. Soziale Bewegungen in Lateinamerika*, Münster: Westfälisches Dampfboot 2004

Marie Luise KASCHNITZ, *Die Wahrheit nicht der Traum. Das Leben des Malers Courbet*, Frankfurt/Main: Insel 1950

Jens KASTNER, "Zapatismus und Transnationalisierung. Anmerkungen zur Relevanz zapatistischer Politik für die Bewegungsforschung," in: Olaf Kaltmeier, Jens Kastner, Elisabeth Tuider (Ed.), *Neoliberalismus—Autonomie—Widerstand. Soziale Bewegungen in Lateinamerika*, Münster: Westfälisches Dampfboot 2004, 251–275

Fritz KELLER, *Wien, Mai '68—Eine heiße Viertelstunde*, Vienna: Junius 1983

Fritz KELLER, "Mailüfterl über Krähwinkel," in: Bärbel Danneberg, Fritz Keller, Ali Machalicky, Julius Mende (Ed.), *Die 68er. Eine Generation und ihr Erbe*, Vienna: Döcker 1998, 36–67

Hubert KLOCKER (Ed.), *Wiener Aktionismus 2. 1960–1971. Der zertrümmerte Spiegel*, Klagenfurt: Ritter 1989

Fritz KRAUSE, *Pariser Commune 1871*, Frankfurt/Main: Verlag Marxistische Blätter 1971

Julia KRISTEVA, *Revolt, She Said*, Los Angeles: Semiotext(e) 2002

Rüdiger KROHN, "Richard Wagner und die Revolution von 1848/49," in: *Wagner-Handbuch*, Stuttgart: Kröner 1986, 86–100

Peter KROPOTKIN, "The Paris Commune," http://www.marxists.org/reference/archive/kropotkin-peter/1880/paris-commune.htm

Harald KUEMMER, "Border Camp // Strasbourg // July 19 to 28, 2002," http://eipcp.net/transversal/0902/kuemmer/en

Maurizio LAZZARATO, "Immaterial Labour," translated by Paul Colilli & Ed Emory, in: Paolo Virno & Michael Hardt (Eds.), *Radical Thought in Italy*, Minneapolis: University of Minnesota Press 1996, 132–146

Maurizio LAZZARATO, "Struggle, Event, Media," http://eipcp.net/transversal/1003/lazzarato/en

Henri LEFEBVRE, *La Proclamation de la Commune. 26 Mars 1871*, Paris: Gallimard 1965

Henri LEFEBVRE, "Die Bedeutung der Pariser Kommune," in: *Situationistische Internationale 1958–1969. Gesammelte Ausgabe des Organs der Situationistischen Internationale*, Vol. II, Hamburg: Nautilus 1977, 456–460

Marian LEIGHTON, "Der Anarchofeminismus und Louise Michel," in: *Louise Michel et al., Louise Michel. Ihr Leben*—Ihr Kampf—Ihre Ideen (=Frauen in der Revolution, Band 1), Berlin: Karin Kramer Verlag 1976, 17–56

Tina LEISCH, "Gescheitheit kommen langsam," in: *Volksstimme*, August 2001

Tina LEISCH, "Provokation und Propaganda. Zehn Jahre Ernst Kirchweger-Haus," in: *Volksstimme* 29/20 July 2000, 13

Tina LEISCH, "Partizan/Remix. Strategien für Kärnten/Koroska," http://igkultur.at/transversal/1019392168

Tina LEISCH, "Minimal thinking. Ein strategisches Geheimdokument," in: Ljubomir Bratic? (Ed.), *Landschaften der Tat. Vermessung, Transformationen und Ambivalenzen des Antirassismus in Europa*, St. Pölten: SozAktiv 2002, 157–166

W.I. LENIN, The State and Revolution, http://www.marxists.org/archive/lenin/works/1917/staterev/

W.I. LENIN, "Plan of a Lecture on the Commune," http://www.marxists.org/archive/lenin/works/1905/mar/00b.htm

W.I. LENIN, "The Paris Commune and the Tasks of the Democratic Dictatorship," http://www.marxists.org/archive/lenin/works/1905/jul/17.htm

W.I. LENIN, "In Memory of the Commune," http://www.marxists.org/archive/lenin/works/1911/apr/15.htm

Prosper LISSAGARAY, *History of the Paris Commune of 1871*, translated from the French by Eleanor Marx, http://www.marxists.org/history/france/archive/lissagaray/index.htm

Silke LOHSCHELDER et al., *AnarchaFeminismus. Auf den Spuren einer Utopie*, Münster: Unrast 2000

Anatoli LUNACHARSKY, "Revolution and Art," in: John E. Bowlt (Ed.), *Russian Art of the Avant-Garde: Theory and Criticism* 1902–1934, London: Thames & Hudson 1988, 190–196

Rosa LUXEMBURG, "Sozialreform oder Revolution," in: ibid., *Schriften zur Theorie der Spontaneität*, Reinbek bei Hamburg: Rowohlt 1969, 7–67 / "Reform or Revolution," http://www.marxists.org/archive/luxemburg/1900/reform-revolution/index.htm

Rosa LUXEMBURG, "Massenstreik, Partei und Gewerkschaften," in: ibid., *Schriften zur Theorie der Spontaneität*, Reinbek bei Hamburg: Rowohlt 1969, 89–161 / "The Mass-Strike," http://www.marxists.org/archive/luxemburg/1906/mass-strike/

Heinrich MANN, "Geist und Tat," in: Wolfgang Rothe (Ed.), *Der Aktivismus 1915–1920*, Munich: dtv 1969, 23–28

Heinrich MANN, "Das junge Geschlecht," in: Wolfgang Rothe (Ed.), *Der Aktivismus 1915–1920*, Munich: dtv 1969, 95–99

MAO Tse-Tung, "Untersuchungsbericht über die Bauernbewegung in Hunan," in: ibid., *Ausgewählte Werke*, Vol. 1, Peking: Verlag für fremdsprachige Literatur 1968, 21–63 / "Report on an Investigation of the Peasant Movement in Hunan," http://www.marxists.org/ reference/archive/mao/selected-works/volume-1/mswv1_2.htm

Oliver MARCHART, "Staging the Political. (Counter-)Publics and the Theatricality of Acting," http://eipcp.net/transversal/0605/marchart/en

Greil MARCUS, *Lipstick Traces. A Secret History of the Twentieth Century*, Cambridge: Harvard University Press 1989

Karl MARX, "Der achtzehnte Brumaire des Louis Bonaparte," in: Karl Marx, Friedrich Engels, *Werke*, 8, Berlin: Dietz 1978, 111–207 / "The Eighteenth Brumaire of Louis Napoleon," http://www.marxists.org/archive/marx/works/1852/18th-brumaire/

Karl MARX, "Der Bürgerkrieg in Frankreich (Adresse des Generalrats vom 30.5.1871)," in: Karl Marx, Friedrich Engels, *Werke*, 17, Berlin: Dietz 1976, 313–362 / "The Civil War in France," http://www.marxists.org/archive/marx/works/1871/civil-war-france/index.htm

Karl MARX, "Erster Entwurf zum 'Bürgerkrieg in Frankreich,'" in: Karl Marx, Friedrich Engels, *Werke*, 17, Berlin: Dietz 1976, 493–571 / "First Draft of 'The Civil War in France,'" http://www.marxists.org/archive/marx/works/1871/civil-war-france/drafts/index.htm

Karl MARX, "Zweiter Entwurf zum 'Bürgerkrieg in Frankreich,'" in: Karl Marx, Friedrich Engels, *Werke*, 17, Berlin: Dietz 1976, 572–610 / "Second Draft of 'The Civil War in France,'" http://www.marxists.org/archive/marx/works/1871/civil-war-france/drafts/index.htm

Karl MARX, "Fragment über Maschinen," in: *Grundrisse der Kritik der politischen Ökonomie*, MEW 42, Berlin 2005, 590–609 / "Fragment on Machines," http://www.marxists.org/archive/marx/works/1857/grundrisse/ch13.htm#p690

Karl MARX, *Das Elend der Philosophie*, MEW 4, Berlin 1990, 63–182 / *The Poverty of Philosophy*, http://www.marxists.org/archive/marx/works/1847/poverty-philosophy/

Karl MARX, *Das Kapital*, MEW 23, Berlin 1998 / http://www.marxists.org/archive/marx/works/1867-c1/index.htm

Louise MICHEL, *Memoiren*, Münster: Verlag Frauenpolitik 1977

Louise MICHEL et al., *Louise Michel. Ihr Leben—Ihr Kampf—Ihre Ideen* (=Frauen in der Revolution, Band 1), Berlin: Kramer 1976

Fritz MIERAU, *Erfindung und Korrektur. Tretjakows Ästhetik der Operativität*, Berlin: Akademie 1976

John MILNER, *Art, War and Revolution in France 1870–1871*, New Haven/London: Yale University 2000

Otto MUEHL, "warum ich aufgehört habe. das ende des aktionismus," in: *Neues Forum*, January 1973, 39–42

Otto MUEHL, *Aspekte einer Totalrevolution*, Cologne: König 2004

Gini MÜLLER, "Widerstand im Haiderland," http://www.prairie.at/artikel/20010415125340

Gini MÜLLER, "Transversal or Terror? Moving Images of the PublixTheatreCaravan," http://eipcp.net/transversal/0902/mueller/en

Gini MÜLLER, "10 Jahre Volxtheater," http://no-racism.net/article/948/

Antonio NEGRI, *Marx Beyond Marx: Lessons on the Grundrisse*, New York : Autonomedia 1991

Antonio NEGRI, *Insurgencies. Constituent Power and the Modern State*, Minneapolis/London: University of Minnesota 1999

Antonio NEGRI, "Constituent Republic," in: Werner Bonefeld (Ed.), *Revolutionary Writing. Common Sense Essays in Post-Political Politics*, New York: Autonomedia 2003, 243–253

"… A New Idea in Europe," http://www.cddc.vt.edu/sionline/presitu/potlatch7.html

Stefan NOWOTNY, "World Wide World. Is There a World of Anti-Globalism?," http://eipcp.net/transversal/0303/nowotny/en

Stefan NOWOTNY, "The Condition of Becoming Public," http://eipcp.net/transversal/1203/nowotny/en

Stefan NOWOTNY, Michael STAUDIGL (Ed.), *Grenzen des Kulturkonzepts. Meta-Genealogien*, Wien: Turia+Kant 2003

Roberto OHRT, *Phantom Avantgarde. Eine Geschichte der Situationistischen Internationale und der modernen Kunst*, Hamburg: Edition Nautilus 21997

Roberto OHRT (Ed.), *Das große Spiel. Die Situationisten zwischen Politik und Kunst*, Hamburg: Nautilus 2000

On Fire. The battle of Genoa and the anti-capitalist movement, London: One Off Press 2001

Franz PFEMFERT, *Ich setze diese Zeitschrift gegen diese Zeit*, Ed. Wolfgang Haug, Darmstadt: Luchterhand 1985

Franz PFEMFERT, "Der Karriere-Revolteur," in: ibid., *Ich setze diese Zeitschrift gegen diese Zeit*, Ed. Wolfgang Haug, Darmstadt: Luchterhand 1985, 121–129

Erwin PISCATOR, "Die politische Bedeutung der *Aktion*," in: Paul Raabe (Ed.), *Expressionismus. Aufzeichnungen und Erinnerungen von Zeitgenossen*, Olten/Freiburg im Breisgau: Walter 1965

Michaela PÖSCHL, "'beyond the limitations of the rectangular frame'. La Commune, DV, 345 Min., Peter Watkins, 1999," http://eipcp.net/transversal/1003/poeschl/en

Pierre Joseph PROUDHON, *Bekenntnisse eines Revolutionärs*, Reinbek bei Hamburg: Rowohlt 1969

Gerald RAUNIG (Ed.), *Kunsteingriffe. Möglichkeiten politischer Kulturarbeit*, Vienna: IG Kultur Österreich 1998

Gerald RAUNIG, *Charon. Eine Ästhetik der Grenzüberschreitung*, Vienna: Passagen 1999

Gerald RAUNIG, *Wien Feber Null. Eine Ästhetik des Widerstands*, Vienna: Tura+Kant 2000

Gerald RAUNIG, "Grandparents of Interventionist Art, or Intervention in the Form. Rewriting Walter Benjamin's 'Der Autor als Produzent' (The Author as Producer)," http://eipcp.net/transversal/0601/raunig/en

Gerald RAUNIG, "*Spacing the Lines*. Konflikt statt Harmonie. Differenz statt Identität. Struktur statt Hilfe," in: Stella Rollig und Eva Sturm (Ed.), *Dürfen die das? Kunst als sozialer Raum*, Vienna: Turia+Kant 2002, 118–127

Gerald RAUNIG (Ed.), *TRANSVERSAL. Kunst und Globalisierungskritik*, Vienna: Turia+Kant 2003

Gerald RAUNIG, "Transversal Multitudes," http://eipcp.net/transversal/0303/raunig/en

Gerald RAUNIG, "Bruchlinien des Schönen. Heterogenese politischer Ästhetik," in: Stefan Nowotny, Michael Staudigl (Ed.), *Grenzen des Kulturkonzepts. Meta-Genealogien*, Vienna: Turia+Kant 2003, 205–220

Gerald RAUNIG, "A War Machine Against the Empire. On the Precarious Nomadism of the PublixTheatreCaravan," in: Marita Muukkonen (Ed.), Helsinki: NIFCA 2002, 132–141 (http://www.eipcp.net/transversal/0902/raunig/en)

Gerald RAUNIG (Ed.), *Bildräume und Raumbilder. Repräsentationskritik in Film und Aktivismus*, Vienna: Turia+Kant 2004

Gerald RAUNIG, "Here, There AND Anywhere," http://eipcp.net/transversal/0303/raunig2/en

Gerald RAUNIG, "Walking Down the Dead-End Street and Through to the Other Side. Lines of Flight of (from) Governmentality," in: *Open House. Kunst und Öffentlichkeit*, Vienna/Bozen: Folio 2004, 140–144

Gerald RAUNIG, "La inseguridad vencerá. Anti-Precariousness Activism and Mayday Parades," http://eipcp.net/transversal/0704/raunig/en

Gerald RAUNIG, "Für eine Mikropolitik der Grenzen. Spacing the Line, revisited," in: Beatrice von Bismarck (Ed.), *Grenzbespielungen. Visuelle Politik in der Übergangszone*, Cologne: König 2005, 88–101, publication pending

Gerald RAUNIG, Ulf WUGGENIG (Eds.), *PUBLICUM. Theorien der Öffentlichkeit*, Turia+Kant 2005

Gerald RAUNIG, "Instituent Practices. Fleeing, Instituting, Transforming," http://transform.eipcp.net/transversal/0106/raunig/en

Helena RECKITT (Ed.), *Art and Feminism*, New York: Phaidon 2001

Judith REVEL, "Il limite di un pensiero del limite. Necessità di una concettualizzazione della differenza," http://digilander.libero.it/aperture/articoli/2.2.html

Hilary ROBINSON (Ed.), *Feminism—Art—Theory. An Anthology 1968–2000*, Oxford: Blackwell 2001

Stella ROLLIG, "Between Agitation and Animation: Activism and Participation in Twentieth Century Art," http://eipcp.net/transversal/0601/rollig/en

Stella ROLLIG, Eva STURM (Ed.), *Dürfen die das? Kunst als sozialer Raum*, Turia+Kant 2002

Kristin ROSS, *The Emergence of Social Space. Rimbaud and the Paris Commune*, Minneapolis: University of Minnesota Press 1988

Wolfgang ROTHE (Ed.), *Der Aktivismus 1915–1920*, Munich: dtv 1969

Danièle ROUSSEL, *Der Wiener Aktionismus und die Österreicher*, Klagenfurt: Ritter 1995

Ludwig RUBINER, "Die Änderung der Welt," in: Wolfgang Rothe (Ed.), *Der Aktivismus 1915–1920*, Munich: dtv 1969, 54–72

Gonzalo J. SÁNCHEZ, *Organizing Independence. The Artists Federation of the Paris Commune and Its Legacy, 1871–1889*, Lincoln/London: University of Nebraska 1997

Robert SCHINDEL, *Kassandra (Roman)*, Innsbruck/Vienna: Haymon 2004

Henning SCHMIDGEN (Ed.), *Ästhetik und Maschinismus. Texte zu und von Félix Guattari*, Berlin: Merve 1995

Jürgen SCHMIDT, "another war is possible // publiXtheatre," http://eipcp.net/transversal/1203/schmidt/en

Dieter SCHOLZ, *Pinsel und Dolch. Anarchistische Ideen in Kunst und Kunsttheorie 1840–1920*, Berlin: Reimer 1999

Antje SCHRUPP, *Nicht Marxistin und auch nicht Anarchistin. Frauen in der Ersten Internationale*, Königstein/Taunus: Helmer 1999

Lutz SCHULENBURG, "Franz Pfemfert. Zur Erinnerung an einen revolutionären Intellektuellen," in: *Die Aktion* 209, late August 2004, 9–98

Dieter SCHWARZ, Veit LOERS (Ed.), *Wiener Aktionismus I. Von der Aktionsmalerei zum Aktionismus. Wien 1960–1965*, Klagenfurt: Ritter 1998

Rolf SCHWENDTER, "Das Jahr 1968. War es eine kulturelle Zäsur?," in: Reinhard Sieder, Heinz Steinert, Emmerich Tálos (Ed.), *Österreich 1945–1995*, Vienna: Verlag für Gesellschaftskritik 1995, 166–175

Rolf SCHWENDTER, *Subkulturelles Wien. Die informelle Gruppe (1959–1971)*, Vienna: Promedia 2003

Shuddhabrata SENGUPTA, "No Border Camp Strasbourg : A Report," http://mail.sarai.net/pipermail/reader-list/2002-July/001732.html

Emmanuel Joseph SIEYES, "Qu'est-ce que le tiers état?," NewYork: Arno Press 1979

SITUATIONIST INTERNATIONAL ONLINE, http://www.cddc.vt.edu/sionline/index.html

SITUATIONIST INTERNATIONAL, "Contribution to a Situationist Definition of Play," http://www.cddc.vt.edu/sionline/si/play.html

SITUATIONIST INTERNATIONAL, "Preliminary Problems in Constructing a Situation," http://www.cddc.vt.edu/sionline/si/problems.html

SITUATIONIST INTERNATIONAL, "Definitions," http://www.cddc.vt.edu/sionline/si/definitions.html

SITUATIONIST INTERNATIONAL, "Report on the Construction of Situations and on the International Situationist Tendency's Conditions of Organization and Action," http://www.cddc.vt.edu/sionline/si/report.html

SITUATIONIST INTERNATIONAL, "The Meaning of Decay in Art,"http://www.cddc.vt.edu/sionline/si/decay.html

SITUATIONIST INTERNATIONAL, "The Third SI Conference in Munich," http://www.cddc.vt.edu/sionline/si/munich.html

SITUATIONIST INTERNATIONAL, "The Theory of Moments and the Construction of Situations," http://www.cddc.vt.edu/sionline/si/moments.html

SITUATIONIST INTERNATIONAL, "Situationist Manifesto," http://www.cddc.vt.edu/sionline/si/manifesto.html

SITUATIONIST INTERNATIONAL, "The Avantgarde of Presence," http://www.cddc.vt.edu/sionline/si/avantgarde.html

SITUATIONIST INTERNATIONAL, "All the King's Men," http://www.cddc.vt.edu/sionline/ si/kingsmen.html

SITUATIONIST INTERNATIONAL, "Now, the SI," http://www.cddc.vt.edu/sionline/si/nowthesi.html

SITUATIONIST INTERNATIONAL, "Questionnaire," http://www.cddc.vt.edu/sionline/si/questionnaire.html

SITUATIONIST INTERNATIONAL, "Our Goals and Methods in the Strasbourg Scandal," http://www.cddc.vt.edu/sionline/si/strasbourg.html

SITUATIONIST INTERNATIONAL, "The Beginning of an Era," http://www.cddc.vt. edu/sionline/si/beginning.html

Peter STARR, *Logics of Failed Revolt. French Theory after May '68*, Stanford: Stanford University 1995

Peter STARR, "The Uses of Confusion. Lefebvre's Commune," manuscript of a lecture held in English in the framework of the Twentieth-Century French Studies Colloquium at the University of Illinois, 27–29 March 2003

Hito STEYERL, "The Articulation of Protest," http://eipcp.net/transversal/0303/steyerl/en

Hito STEYERL, Encarnación GUTIÉRREZ RODRÍGUEZ, *Spricht die Subalterne deutsch? Migration und postkoloniale Kritik*, Münster: Unrast 2003

Max STIRNER, *Der Einzige und sein Eigentum*, Leipzig: Zenith 1927 [*The Ego and his Own*, http://www.dis.org/daver/anarchism/stirner/theego0.html]

Maxim STRAUCH, "Erinnerungen an Eisenstein," in: Hermann Herlinghaus, Heinz Baumert, Renate Georgi (Ed.), *Sergei Eisenstein. Künstler der Revolution*, Berlin: Henschel 1960, 59–83

Christof ŠUBIK, "'Ein Vakuum, und da soll man tanzen'. Anmerkungen zur 'Kassandra,'" in: Robert Schindel, *Kassandra (Roman)*, Innsbruck/Vienna: Haymon 2004

SUBVERSIVE AKTION, *Der Sinn der Organisation ist ihr Scheitern*, Frankfurt: Neue Kritik 2002

Sergej TRETJAKOV, *Feld-Herren. Der Kampf um eine Kollektiv-Wirtschaft*, Berlin: Malik 1931

Sergej TRETJAKOV, *Die Aufgabe des Schriftstellers*, Reinbek bei Hamburg: Rowohlt 1972

Sergej TRETJAKOV, "Fortsetzung folgt," in: *Die Aufgabe des Schriftstellers*, Reinbek bei Hamburg: Rowohlt 1972, 74–79

Sergej TRETJAKOV, *Gesichter der Avantgarde. Porträts—Essays—Briefe*, Berlin/Weimar: Aufbau 1985

Sergej TRETJAKOV, "Woher und wohin? Perspektiven des Futurismus," in: ibid., *Gesichter der Avantgarde. Porträts—Essays—Briefe*, Berlin/Weimar: Aufbau 1985, 38–53

Sergej TRETJAKOV, "Theater der Attraktionen," in: *Gesichter der Avantgarde. Porträts—Essays—Briefe*, Berlin/Weimar: Aufbau 1985, 66–73

Sergej TRETJAKOV, "Notizen eines Dramatikers," in: ibid., *Gesichter der Avantgarde. Porträts—Essays—Briefe*, Berlin/Weimar: Aufbau 1985, 98–101

Sergej TRETJAKOV, "Sechs Pleiten. Erwin Piscator," in: ibid., *Gesichter der Avantgarde. Porträts—Essays—Briefe*, Berlin/Weimar: Aufbau 1985, 186–218

Alexander TROCCHI, "A Revolutionary Proposal: Invisible Insurrection of a Million Minds," http://www.cddc.vt.edu/sionline/si/invisible.html

René VIÉNET, *Enragés and Situationists in the Occupations Movement*, http://www.cddc.vt.edu/sionline/si/enrages.html

Paolo VIRNO, "Wenn die Nacht am tiefsten … Anmerkungen zum General Intellect," in: Thomas Atzert, Jost Müller (Ed.), *Immaterielle Arbeit und imperiale Souveränität*, Münster: Westfälisches Dampfboot 2004, 148–155

Paolo VIRNO, "Un movimento performativo," http://eipcp.net/transversal/0704/virno/it

Paolo VIRNO, *A Grammar of the Multitude*, Los Angeles/New York: Semiotext(e) 2004

Paolo VIRNO, "Die Engel und der General Intellect," in: ibid., *Grammatik der Multitude*, Vienna: Turia+Kant 2005, 165–188 / "Gli angeli e il general intellect," http://multitudes.samizdat.net/Gli-angeli-e-il-general-intellect.html

VOLXTHEATER FAVORITEN, *Dreigroschenheft*, http://no-racism.net/volxtheater/_html/_drgrop0.htm

VOLXTHEATER FAVORITEN, *Penthesilea. Eine Hundsoper sehr frei nach Kleist*, http://www.no-racism.net/volxtheater/_html/_penth1.htm

VOLXTHEATER FAVORITEN, *Bezahlt wird nicht! Programmheft*, http://www.no-racism.net/volxtheater/_html/_bwn1.htm

VOLXTHEATER FAVORITEN, "Konzept," http://www.no-racism.net/volxtheater/_html/_konz0.htm

VOLXTHEATER FAVORITEN, "Schluss mit lustig: ein Land dreht durch!," http://no-racism.net/volxtheater/_html/_sml1.htm

VOLXTHEATER FAVORITEN, "EKH-Tour 2000," http://www.no-racism.net/volxtheater/_html/_ekht1.htm

Richard WAGNER, "Die Kunst und die Revolution," in: ibid., *Ausgewählte Schriften*, Leipzig: Reclam 1982, 144–178

Peter WEIBEL, "Kunst: Störung der öffentlichen Ordnung?," in: *Im Namen des Volkes. Das "gesunde Volksempfinden" als Kunstmaßstab*, Duisburg: Wilhelm-Lehmbruck-Museum 1979, 48–65

Ulf WUGGENIG, "Fragmentation and Cooptation. On the problematic aspects of "hybridity" in oppositional art forms," http://eipcp.net/transversal/0902/wuggenig/en

Ulf WUGGENIG, "The Empire, the Northwest and the Rest of the World. 'International Contemporary Art' in the Age of Globalization," http://eipcp.net/transversal/0303/wuggenig/en

Slavoj ŽIŽEK, *Revolution at the Gates. Žižek on Lenin*, London/New York: Verso 2002

"Zwei links—zwei rechts: Ex-Linke verstricken sich im rechten Netz," http://www.nadir.org/nadir/initiativ/daneben/archiv/antifa/intervention/track02.html

INDEX

Ernst-Kirchweger-Haus (EKH), 206–207, 209, 211, 215–216, 218, 220–223
Evreinov, Nikolai, 152
EXPORT, Valie, 171, 197, 204

Fascism, 17, 20, 22, 35, 68, 122, 192
February Revolution (1917), 26, 78
Feminism, 93–94, 204, 206, 208, 241. *See also* Paris Commune—Women of
Feuerbach, Ludwig, 10
Fleury-Husson, Jules Francois Felix (Champfleury), 97, 100
Food, 69, 74, 92, 258
Foucault, Michel, 34, 48–53, 60,125, 128, 163, 203, 252–254; and the figure of the writer, 124; universal vs. specific intellectual, 123; on *parrhesia*, 211–219 *passim*
France, 28, 36, 49, 61–62, 67, 87–88, 91, 94, 105, 119, 183–184, 255
France, Anatole, 119
Franco-Prussian War. *See* German-French war
Frankfurt, 224
Freedom Party of Austria (FPÖ), 219–220, 222
French Revolution, 37, 61–62, 81, 91
Fried, Michael, 99
Futurism, 22–23, 145, 150–152, 157, 170

G8, 21, 55, 224, 228, 230, 232, 234
General Intellect, 129, 139, 142, 148–149
General Workers Union Unity Organization (AAUE), 121
Genoa: G8 summit and its effects in, 20–21, 213, 224–225, 228; 230–235 *passim*; 239, 242–244, 259
Genoa Social Forum, 230, 232; protest against commercialization of, 231
Géricault, Théodore (*Raft of Medusa*), 136

German-French war, 67, 76, 105
Germany, 9, 26–27, 75, 105, 114, 118, 120–122, 169, 187–188, 201, 206, 221, 255
Globalization, 21, 32, 35, 40, 54, 55–56, 78, 224, 227–228, 234, 237, 239, 241–243, 250–251, 256, 260; invidious standardization of movements against, 238
Göteborg, 234, 242–243, 295 n.60
Gouges, Olympe de, 91
Gould, Roger V. (*Insurgent Identities*), 71–72
Graffiti, 174, 180, 260–261
Greek tragedy, 11–12, 138
Giuliani, Carlo, 21, 231
Guattari, Félix, 32, 40; on machines that elude state structuralization, 31, 147; and the machine concept, 138–139, 147, 149, 157; on machine vs. structure, 146, 148; and global economies, 33; and critique of the party form, 38; on dissolving of knowledge production as privilege of intellectuals, 129; on truth work, 130; and the subject group, 180; on architecture, 182; and transversality, 205. *See also* Deleuze, Gilles

Haider, Jörg, 219, 222, 294 n.38
Hardt, Michael. *See* Negri, Antonio
Hausmann, Raoul, 118
Hegel, Georg Wilhelm Friedrich, 58, 115, 150, 172, 178, 186, 190; *Lectures on Aesthetics*, 131–138
Heidegger, Martin, 131
Heidelberg, 132
Hielscher, Karla, 160
Hiller, Kurt, 22; 113–124 *passim*
Hoffmann, E.T.A., 137
Holloway, John, 41–42, 45, 50–52, 60

149–150, 153, 158, 160, 162, 172, 178, 204, 225, 229–230, 234, 246, 254–255, 260, 263; vs. action, 63, 132; Commune as attempt to get beyond, 90; as division between representee and represented, 64; organic vs. orgiastic, 80

Representative democracy, 33, 55, 65, 80

Reterritorialization, 66, 108, 138, 196, 211, 227

Revel, Judith, 245

Revolution, updated concept of, 25

Revolutionary machine, 18–22; 25–66 *passim*; 68, 70, 75, 77–79, 89, 96–97, 112, 177, 179, 184, 200, 203, 205, 211, 216, 218–219, 237–238, 243–244, 252, 255, 261, 263–265

Richter, Hans, 118

Riefenstahl, Leni, 17

Rimbaud, Arthur, 97

Ross, Kristin (*The Emergence of Social Space*), 79, 90, 95–97, 107

Rubiner, Ludwig, 115

Russian Revolution (1917), 12, 27, 29–30, 37, 63, 68

Sartre, Jean-Paul, 131

Saxony, 10

Schengen Agreement, 246

Schengen Information System (SIS), 256–258, 262–263

Schindel, Robert, 189–190, 201

Schneemann, Carolee, 171, 204

Schüssel, Wolfgang, 219

Schwendter, Rolf, 188–189

Seattle 1999, 55, 237–238, 240

Sengupta, Shuddhabrata, 246, 255, 259

Shakespeare, William, 133, 137

Sieyès, Emmanuel Jospeh, 60–61, 65

Situationist International, 18, 48, 120–121, 131, 170, 173–175, 177–187. *See also* Dérive; Détournement

Social brain, 142, 148

Socialism, 26, 30, 49, 68, 80, 100, 115–116

Socialist Austrian Students Union (SÖS), 189–190, 192, 196–200, 202

Socialist German Students Association (SDS), 187, 190

Socialist Party of Austria (SPÖ), 191

Society of the spectacle, 59, 132, 172, 179, 185

Socrates, 214–215, 218

Sorbonne, 181, 183

South America: national revolts in, 57; standardized image of protest overlooks struggles in, 238

Soviet Union, 10, 12, 23, 29, 151, 156, 164, 169,

Spinoza, Baruch, 45, 60

Stalin, Joseph, 10, 39, 122, 163, 169, 177

State apparatus, 19, 24, 26, 28–36, 38, 43–44, 53, 57, 66, 79–82, 84–87, 90, 92, 94, 96, 110–112, 146–147, 189, 196–197, 213, 216, 229–230, 234–235, 240–241, 243, 259

State power, 28, 31, 35–36, 46, 51, 60, 80–82, 87–88, 90, 94, 240

Stendhal, 137

Steyerl, Hito, 240

Strasbourg, 180–181, 187, 244, 255–257, 259–262

Strike, 37, 42, 73, 86, 140, 155, 183, 263

Structuralization, 16, 31, 38, 43, 49, 58, 66, 108, 147, 190, 192, 196, 202, 204–205, 211, 215–216, 231, 241, 259, 265

Surrealism, 22, 184

Switzerland, 20

ACKNOWLEDGMENTS

Martin Pyrx Birkner, Alex Demirovic, Aileen Derieg, Marcelo Expósito, Marion Hamm, Peter Heintel, Christian Hessle, Oleg Kireev, Jens Petz Kastner, Tina Leisch, Isabell Lorey, Sylvère Lotringer, Birgit Mennel, Raimund Minichbauer, Gini Müller, Klaus Neundlinger, Stefan Nowotny, Alice Pechriggl, Michaela Pöschl, Gerhard Rauscher, Gene Ray, Burghart Schmidt, Jürgen Schmidt, Rolf Schwendter, Gerald Singer, Hito Steyerl, Christof Šubik, Ingo Vavra, Beat Weber

Thank You!

Very special thanks to http://eipcp.net/